Difer nachuerzeychenter Eren oder Triumph wagen ift dem allerdurchleuchtigiften Großmechtigiften herren twey, lund Keyfer Marimilian/ hochlöblicher gedechtnuß vnferem allergnedigiften herr zu fonderen eren erfunden vnnd verordent/ vnnd zu vnterthenigem gefallen dem großmechtigften yetz Regieren zu Keyfer Karolo rc. durch Albrecht Dürer dafelbft in das werck gepracht.

Erftlich/ dieweyl ihr Keyferlich May. alle König vnnd herren mit glori /magnificent/ eer/ vnd wirdigke yt vbertrifft/ fo ift der felb wagen auff vier eren reder / darauff ihr Keyferlich May. folcher vbertrefflichkeyt halben biilich empore gefürt werden foll gestelt. Nemlich auff Gloriam/Magnificentiam/ Dignitatem/ vnnd Honorem.

Nachuolgent feindt an den vier orten des wagens die vier angetuigent/an ftat vier feulen gefetzt. Nemlich Juftitia Fortitudo / Prudentia / Temperam. rc. Auß welchen all ander tugent iren anfang vnnd vrfprung haben /an die auch keyn khönig odder herr volkumen feyn kan oder mag. Dann wo die Gerechtigkeyt/ Manlich fterck des gemüts/ die Vernufft/ vnnd Befcheidenheyt mangelt/kan keyn Reych beftendig feyn.

Nach dem Moderatio/vnnd Prouidentia der vernufft am nachften find füren die felben zwo tugent die zwen nachften pferd vor der vernufft/ damit der wag mit rechterm.ß vnnd fürfichtig keyt feinen gang haben mag.

Dieweyl auch dife vier tugendt aneynander hangen/ vnnd von einander nit gefondert werden mögen/ alfo /wo eyne der felben mangelt/das die ander nit volkummen feyn kan. So find die felben vier mit den andern iren anhangenden tugendten/fo auß inen flieffen zufamen gefügt/ vnd ineinander verfchloffen. Nemlich/ dieweyl Juftitia gepürt/ vnd haben muß Veritatem/ fo helt fie in der incken handt den krantz der Warheyt. In den auch die Meffigkeyt mit der rechten handt greyfft/ dan wo die Warheyt nit ift /kan die Gerechtigkeyt nit ftat haben. Die Meffigkeyt mag auch/ fo fie von der Warheyt weycht/ nit mer Meffigkeyt genant werden.

Mit der rechten handt greyfft Juftitia in den krantz Clementie/ das zaygt an / daß die Gerechtigkeyt nit ganntz zu ftreng/ fonder mit Miltigkeyt foll vermifcht feyn. In difen krantz ift geflochten der mitler krantz Equitatis/ dann fo wol als die Gerechtigkeyt nit zufcharpff fein/ alfo foll fie auch nit alle mal/ vnd in allen fachen zuvil odder barm hertzig/ fonder Equa vnd gleych fein/ on welche Gleicheyt die Gerechtigkeyt nit beften mag.

Die nachuolgende zwey pferd werden durch Alacritatem vnd Oportunitatem gefürt. Darumb als wol fich gezimpt daß zu bequemer zeyt der wagen für fich gee/ alfo gepürt fich auch/ das fölchs frölich vnnd mit eyner frecheyt befchehe.

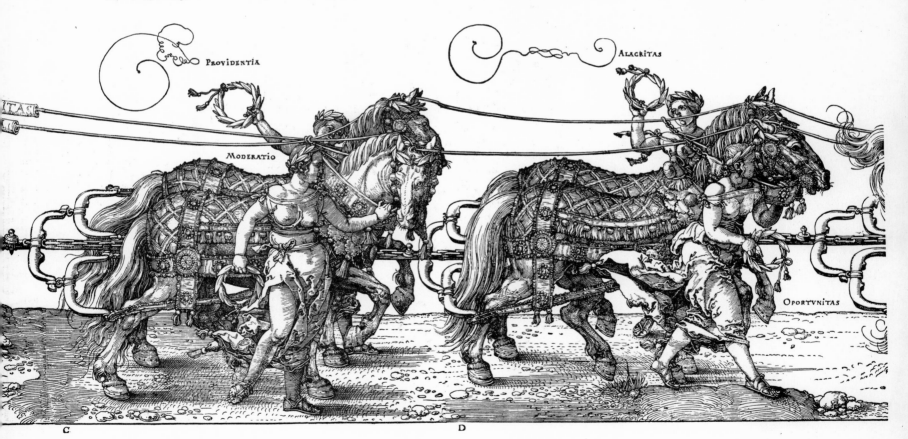

PROVIDENTIA

ALACRITAS

MODERATIO

OPORTVNITAS

C

D

ALBRECHT DÜRER

PAINTINGS • PRINTS • DRAWINGS

By

Peter Strieder

Translated by

Nancy M. Gordon
and
Walter L. Strauss

ABARIS BOOKS • NEW YORK

2

THE THIRD KNOT
The artist's device in the center was added at a later date.
Woodcut. 270 x 210 mm.

This woodcut is part of a series of six after engravings by a follower of Leonardo da Vinci. This relationship, as well as the fact that these woodcuts are printed on paper used by the artist during his visit to Venice in 1506, suggest that they date from that time. Their exact purpose and meaning has not been discovered. Dürer, in the diary of his journey to the Low Countries in 1520/21 refers to them simply as "knots": "I presented Master Dietrich [the glass painter and engraver Dirck Vellert], glazier, with an Apocalypse and the six knots."

ALBRECHT DÜRER OF NUREMBERG

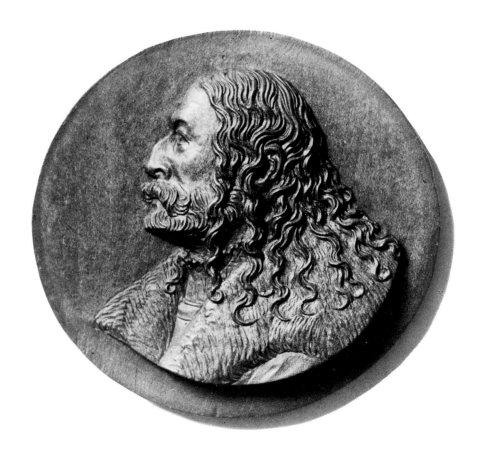

3
PORTRAIT MEDAL OF ALBRECHT DÜRER
Hans Schwarz.
Boxwood. Diameter 58 mm. Brunswick, Herzog Anton Ulrich Museum.

Model for a cast medal that bears the inscription around its circumference:
ALBERTVS DVRER PICTOR GERMANICVS and the initials *H.S.*

Diary entry by Dürer, September 1520, in Antwerp: "I sent two gold guilders to Hans Schwarz for my portrait...in a letter to Augsburg."

Life and Personality

The particular importance of Albrecht Dürer in an era of exceptionally talented artists in Europe has always been recognized. His fellow citizen, the humanist and theologian Johannes Cochlaeus, praised Nuremberg's artists in 1512 in these words: "Not only the Germans, but also the Italians and French, and even the distant Spaniards, admire their works and buy them frequently. This is evident from the works themselves, which are dispatched to far-away places. Eminent are the images of the Passion of Our Lord, drawn recently by Albrecht Dürer, and engraved and printed by him (323-338). Indeed, they are so exquisite, and executed in the correct perspective, that merchants from all over Europe purchase them to serve as models for their artists." As late as 1678, when the direct influence of Dürer's graphics had long waned, Carlo Cesare Malvasia wrote at Bologna: "All the great artists, who seem to us replete with their own ideas, would be beggars if one day they were forced to return to Dürer everything that they borrowed from him." It was the first time in Germany that the impressions an artist's contemporaries had gained of his manner and effect were recorded in print. Dürer's utterances, real and imaginary, were quoted by learned men like Philip Melanchthon (49) in their lectures, and were written down by students like anecdotes and proverbs of famous men of history. This was not merely the effect of his formal oeuvre, but must be attributed to the recognition and admiration of the accomplishments of an extraordinary personality who impressed his audience with his uncustomary goals, as well as by the methods he used to attain them. His entire being and course of action were founded on the recognition of values which were unprecedented for an artist of his time. The absence of a tradition of these new spiritual and social aspects forced him to act independently to a considerable degree.

At the early age of thirteen or fourteen he sought to explore and record his own likeness in front of a mirror (5). The drawing, executed while he served as a helper in his father's goldsmith's shop and before he was apprenticed to the Nuremberg painter, Michael Wolgemut (283), is the work of a budding genius. At the same time it represents one of the earliest self-portraits in the art of the Western world. Another portrait, although its authorship and date have been the subject of controversy, pictures Dürer's father holding in his hand a statuette of a standard bearer (6). It might be a self-portrait by the elder Dürer that served his son as inspiration and as model.

Both sheets are drawn in silverpoint, a medium that requires a specially prepared paper and a sure hand because it precludes erasures. The beholder's amazement over the self-assured and expressive lines is compounded by the realization of the seriousness with which the handsome lad has analyzed his own features and put them down on paper. Was it his father who saved this remarkable

4
COAT OF ARMS OF THE DÜRER FAMILY
With space for an inscription, Dürer's monogram, and the date 1523. Woodcut. 355 x 166 mm.

The open door is emblematic for the name Dürer [or Türer], i.e, "door," after the birthplace of the elder Dürer, Ajtos, near Gyula, the capital of county Békés in Hungary. The Hungarian word ajtó means "door."

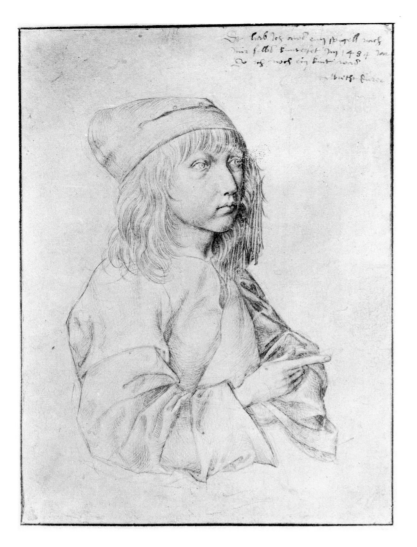

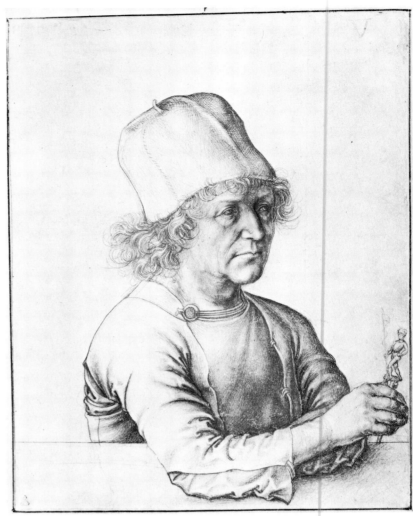

artistic expression of his young son, thus enabling the latter to note on its upper margin, many years later, and from memory: "This I drew using a mirror; it is my own likeness, in the year 1484, when I was still a child / Albrecht Dürer." The emphasis on the young age betrays the mature artist's justified pride in the accomplishment of his early youth. The outer form of the portrait, in three-quarter profile and in half-length, is partly in accomodation of the technical difficulties imposed by sitting in front of a mirror while drawing one's portrait. But it also follows the schematic contours developed for portraits in the Wolgemut workshop (84, 85). Perhaps the young Dürer, imbued with the desire to become a painter — not a goldsmith like his father — had already acquainted himself with the methods of his future teacher, whose house was only a few doors down the street.

The desire to record his own likeness, and thus pass it on to posterity, has its parallel in the record of the history of Dürer's family and of important experiences written down by Albrecht's father. Based on those notes, Dürer prepared a family chronicle that has come down to us in copies of the 17th century. In the awkwardly exact details concerning his own birth, the son quotes his father

5
SELF-PORTRAIT AS A BOY
Inscribed in the upper right corner: "This I drew, using a mirror; it is my own likeness, in the year 1484, when I was still a child / Albrecht Dürer." Silverpoint on prepared paper. 275 x 196 mm. Vienna, Graphische Sammlung Albertina.

6
SELF-PORTRAIT OF DÜRER'S FATHER
Albrecht Dürer the Elder. Silverpoint on prepared paper. 284 x 212 mm. Vienna, Graphische Sammlung Albertina.

Although outwardly this appears to be a self-portrait of the goldsmith, Friedrich Winkler, Walter L. Strauss, and the author of the catalogue of the Dürer Exhibition in Vienna, 1971, cling to the

10

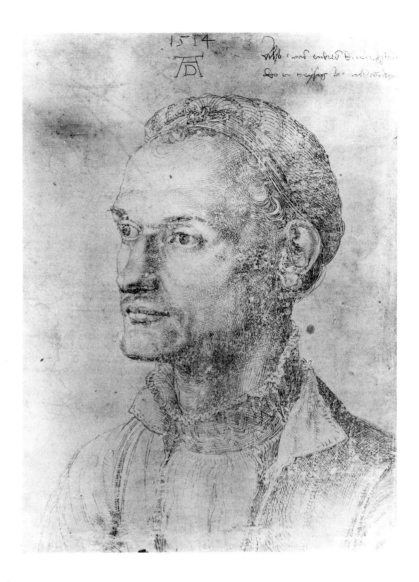

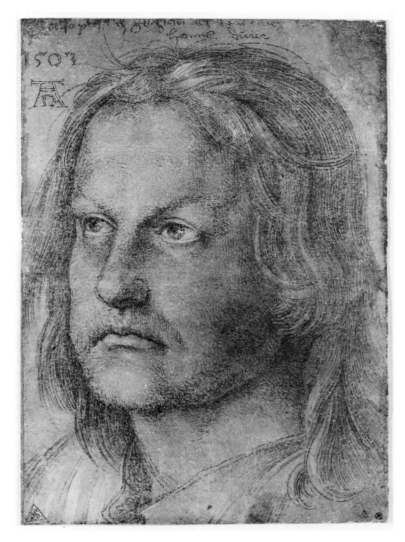

older attribution of this portrait to the young Dürer. A copy of this drawing, formerly at Rheinstein Castle, reputedly bore the inscription: "This is Alb. Dürer's father," Dürer's monogram, and the year 1486.

7
ENDRES DÜRER
The date 1514 appears near the upper margin, and Dürer's monogram below it. Inscribed: "These are the features of Endres Dürer, when he was thirty years old." Silverpoint on bluish white prepared paper. 266 x 210 mm. Vienna, Graphische Sammlung Albertina.

Endres (Andrew) Dürer (1484-1555), Albrecht Dürer's brother, entered the Nuremberg goldsmiths' guild as a master in 1514.

8
HANS DÜRER
Near the upper border, partly lost because the sheet was trimmed, appears the inscription: "These are my features, I ...some...a...Hanns Dürer." Below it the date 1503 and Dürer's monogram. Silverpoint,

heightened with white, on brown prepared paper. 208 x 147 mm. Washington, National Gallery of Art (Lessing J. Rosenwald Collection).

The discrepancy between the date, the age of the sitter, and the year of the birth of Hans Dürer, Dürer's youngest brother (1490-1534/35) has been explained by the (reputed) subsequent addition of a slight beard to his face.

verbatim, merely adding at the end that at the time of his writing only he, Albrecht, his brother Endres, and his youngest brother Hans, the third of that name, are still alive. Birth followed birth as rapidly at the Dürers' as did deaths. And like Albrecht Dürer, his brothers had no descendants. The family ceased with the generation of its greatest member. The exact date and hour of his birth, on

11

May 21, 1471, were recorded by the elder Dürer: "Item: In the 1471st year after Christ's birth, the sixth hour, on St. Prudentia's day, a Tuesday during Rogation week, my wife Barbara bore me a second son. Anthony Koburger was his godfather, and he named him Albrecht after me." The second surviving son, Endres, was born in 1484 and followed in his father's footsteps as a goldsmith. The portrait sketches of Endres that have come down to us record his sympathetic, modest features (7). Hans Dürer, the youngest brother, was born in 1490 (8). At age twelve he was to lose his father, and he became a cause of concern to Albrecht. In a letter from Venice in 1506 to his mother, Dürer suggested that she approach Michael Wolgemut or another painter to give employment to Hans. Dürer would have preferred taking him along to Venice, but his mother had feared that "the sky would fall on him." Hans did not stay in Nuremberg very long, next to his famous brother. He is last recorded in his native city in 1510. He died in 1534/35 at Cracow, not very famous, but artistically quite independent from his brother, as Court Painter of King Sigismund of Poland.

The family records touch on the early history of the forebears, and speak with implied pride of their craft. They were originally breeders of cattle and horses in the Hungarian village of Ajtos, near Gross-Wardein, the city where Emperor Sigismund lies buried. Ajtos was destroyed by the Turks in 1566 and not rebuilt. It was the name of this village, however, that is the origin of the name Dürer, for the Hungarian word *ajtó* means door, as does the German word *Türe [Dür]*. It is for that reason that an open door appears on the coat of arms of Dürer's father (4, 9). One of Dürer's grandfathers, Anton Dürer, left Ajtos for Gyula, the capital of county Békés, where he was active as a goldsmith. His son Albrecht took up the same profession, but left Hungary in order to get additional training. His nephew Niklas was to follow him to learn the same trade at his uncle's shop in Nuremberg. On account of his native land, the nephew was to become known as "Niklas the Hungarian." He settled in Cologne where his cousin Albrecht was to visit him in July 1520 during his journey to the Low Countries. Evidence of the intellectual endowment of members of the Dürer family is the fact that Anton Dürer's third son served as vicar at Gross-Wardein. The records are silent concerning the family's nationality. The area of Békés was during the 15th and 16th centuries considered to be Magyar heartland, yet the resettlement of members of two generations in Germany speak for active ties with that country. Brief remarks in the Dürer family chronicle indicate that the elder Dürer, probably after having completed his apprenticeship with his father, resided briefly at an unidentified German city. A list of riflemen and archers of 1444, naming those who might be called to arms in case of war in the city of Nuremberg, includes the name of Albrecht Dürer (the elder), who was at that time seventeen years of age, and thus supplements the family record. After an extended absence, during which he worked with the "great artists" of the Netherlands, he entered the workshop of Hieronymus Holper in Nuremberg on the feast day of St. Eligius, patron of goldsmiths, in 1455. His

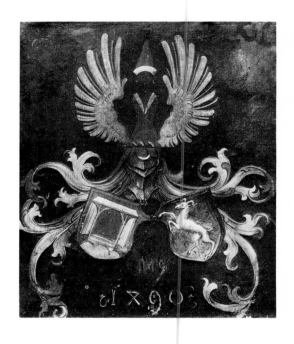

9
COMBINED COAT OF ARMS OF THE DÜRER AND HOLPER FAMILIES
The date 1490 appears below. Above it an old inventory number "19" may be discerned. Oil on wood. 47.5 x 39.5 cm. Florence, Galleria degli Uffizi.

On the verso of the portrait of Albrecht Dürer the Elder (cf. 263, 267) appears for the first time the family crest with the emblematic open door (cf. 4). It is united with the coat of arms of his wife, Barbara née Holper, whom the goldsmith had married 6 August 1467. This combination of crests was customary for hinged double portraits in the form of a closable diptych. The companion portrait of Dürer's mother is mentioned in the inventory of the Imhoff collection (cf. 266).

12

marriage with Holper's fifteen-year-old daughter Barbara, August 6, 1467, made it possible for him to become a citizen of Nuremberg in the same year, and to become a master goldsmith in 1468, the only degree then available to those who were neither natives of Nuremberg nor owners of property. He resided initially in a back building in the courtyard of the house of Dr. Johannes Pirckheimer in Winkler Street, a few steps from the central market square of the city. In 1475 he purchased the house "below the castle" for the sum of 200 florins. It is no longer extant, but then it stood at the corner of today's upper Schmiedgasse and Burgstrasse. In this house the younger Dürer spent his childhood. It is uncertain whether he lived and worked there until he purchased the stately dwelling at Tiergärtner Gate in 1509 from the estate of the astronomer Bernhard Walther. Even today the "Dürer House" reminds the observer of the formative influence its location, immediately below the mighty, high city wall, had on its inhabitant.

The son has recorded his father's features in two painted portraits (14, 263). He described him as an "artful and pure man." The panels reveal the character of the man, his integrity, and his religious convictions. The earlier portrait (263), painted in the spring of 1490, at the end of Dürer's apprenticeship in the workshop of Michael Wolgemut, pictures the goldsmith without reference to his craft, wearing a modest red cape lined with black fur. His hat is equally modest, and also black. In his hands, placed closely together, he holds a string of bright red prayer beads, while his glance is upward, marked by tranquility. Seven years later Dürer painted his father a second time, now with the experience of his travels as a journeyman and his first Italian sojourn behind him. The portrait in the National Gallery in London is most probably the very one that formerly hung in Nuremberg's city hall until it was sold by the City Council to the Earl of Arundel in 1636 on account of the dire situation caused by the Thirty Years War. The earl presented it to King Charles I of England (14). Scholars have sometimes questioned the authenticity of the London portrait, and regarded it as a mere copy of a lost work; however, the fine quality of the face speaks for the master's hand, whereas the remaining portions — garment and background — might be the work of restorers. The focus of this later portrait is only slightly larger, but the figure makes the impression of greater freedom and increased dignity. The father's face, lined by effort and sorrow, echoes the son's words in the family's chronicle: "Albrecht Dürer the Elder has spent his life with great effort and hard and difficult work without the benefit of anything except the labor of his own hands to support himself, his wife, and his children. Because of this, he had little." We know the features of his mother from a charcoal drawing of 1514, sketched two months before her death (11). In 1467, the bridegroom, who was her senior by twenty-five years, had referred to the daughter of his master as a "pretty and proper young woman." The portrait shows her spent after a difficult life and eighteen births. Two years after his father's death, the son had to take her, now without means, into his own home. It was the year 1504. The drawing belongs among the most

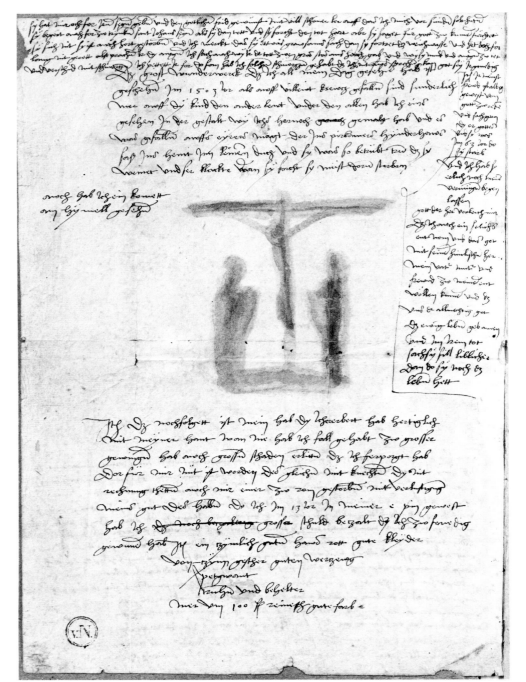

important of Dürer's works and was to exert a powerful influence on the style of subsequent portrait studies. Every line of the soft stylus retraces details of the life of the sitter. Nothing is hidden or beautified, and yet the sheet speaks emphatically of her reverence for God and her love of children. Dürer's impressions on the days of the deaths of his parents are set down in a *Memorial Book* of which only a single page has come down to us, the one with these entries (10). He recorded his mother's death struggle with the same precision of observation that is the hallmark of his artistic oeuvre. Like an artist taking into account the beholder of his picture, Dürer seems to have had in his mind the reader of his writings when he

11

DÜRER'S MOTHER BARBARA, NEE HOLPER

On top, in the center, the year 1514. Next to it, *"an oculi,"* the third Sunday of Lent, i.e., March 19. In the upper left corner, in charcoal: "This is Albrecht Dürer's mother when she was 63 years old." Below, in pen and ink: "and she passed away in the year 1514, on Tuesday before Rogation Week [May 16], about two hours before nightfall." Charcoal on paper. 411 x 303 mm. Berlin, Staatliche Museen Preussischer Kulturbesitz, Kupferstichkabinett.

Barbara Dürer (1451-1514) was the daughter of the Nuremberg goldsmith Hieronymus Holper and his wife, Kunigunde Ellinger. She married Albrecht Dürer the Elder on June 8, 1467.

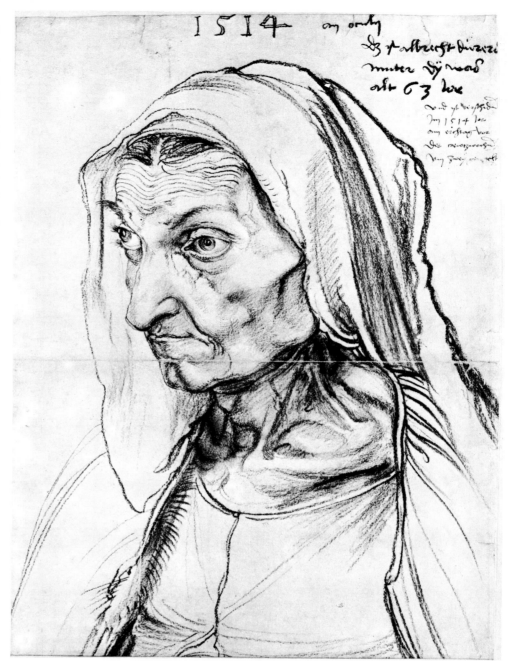

described the event in *Memorial Book.* Friends reading about his father's death were asked to say a prayer for his soul. The record of his mother's death commenced with "now you must know."

The need for an analysis of his own position was for Dürer a continuing need. Three self-portraits have come down to us for the time from Easter 1490 to Whitsuntide 1494, two of them in pen and ink, the third in color on vellum (13, 15, 19). The undated drawing in Erlangen shows the young artist in a critical phase. His tranquility appears to have been disturbed, perhaps by an illness, suggested by

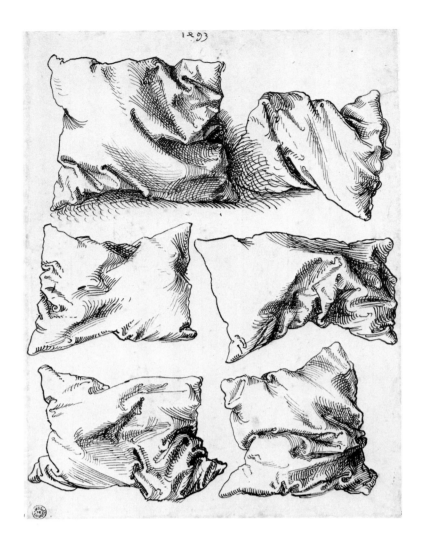

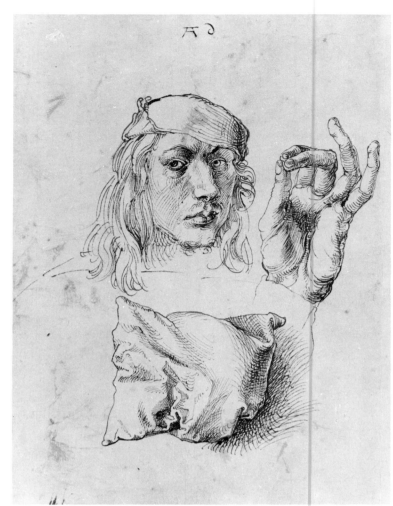

the cloth—could it be a bandage?—around his head. Quite in contrast, he pictures himself in the painted portrait as a handsome young man with long blond hair, in modern dress, and a red cap with a tassel of the same color placed daringly over his ear.

12
SIX PILLOWS
The date 1493 is written near the upper margin in Dürer's hand-writing. Pen and ink on paper. 276 x 202 mm. New York, Met-ropolitan Museum of Art, Robert Lehman Collection.

13
SELF-PORTRAIT; THE ARTIST'S LEFT HAND; A PILLOW
On top the spurious monogram in its early form. Pen and ink on paper. 276 x 202 mm. New York, Metropolitan Museum of Art, Robert Lehman Collection.

This portrait is contemporary with the drawing of six pillows, dated 1493, on the verso (cf. 12).

14
ALBRECHT DÜRER THE ELDER
Inscribed near the top: *1497. ALBRECHT. THVRER. DER. ELTER. VND. ALT. 70IOR* [Albrecht Dürer the Elder at age 70]. Oil on limewood. 51 x 40 cm. London, National Gallery.

It is most likely the very picture of Albrecht Dürer's father that the city of Nuremberg presented to King Charles I of England through the good offices of the Earl of Arundel. Perhaps only the face was painted by Dürer himself; the clothing and back-ground have been brought to their present state by another hand.

16

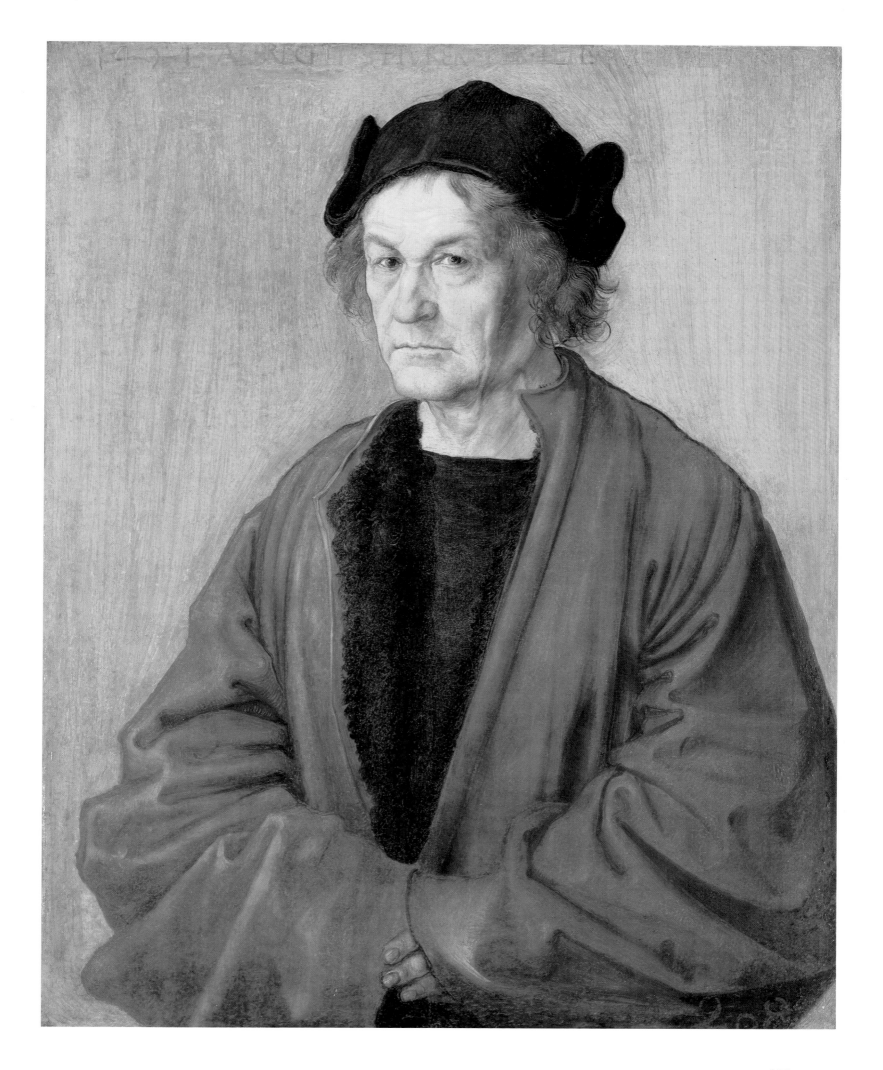

17

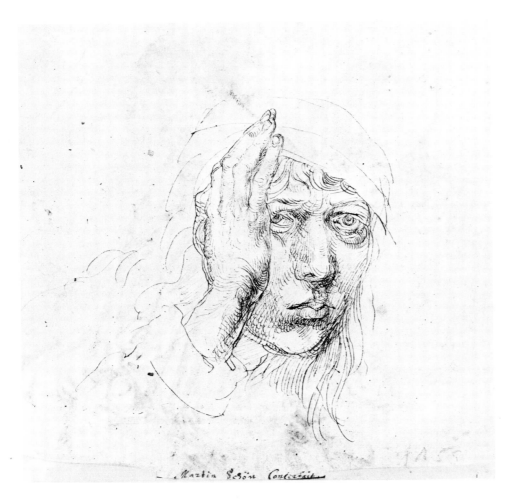

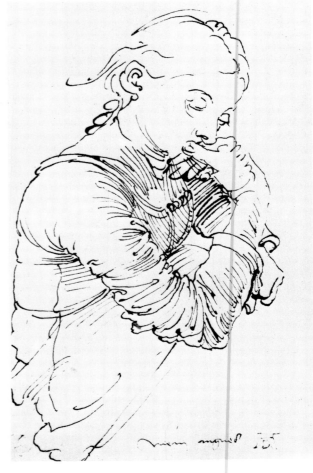

15
SELF-PORTRAIT WITH BANDAGE
Below in ink, *Martin Schön Conterfait* [Made by Handsome Martin], and in black chalk, 1455; both by later hands. Pen and ink on paper. 204 x 208 mm. Erlangen, University Library.

"Handsome Martin" was the name by which the painter and engraver Martin Schongauer (1440/50-1491) of Colmar was known. The drawing is not dated, yet surely dates from Dürer's travels as a journeyman, 1491 or 1492. A contemporary representation of the Holy Family appears on the sheet's verso (100).

16
DÜRER'S WIFE AGNES, NEE FREY
Inscribed: *Mein angnes* [My Agnes], and the monogram of the artist by another hand. Pen and bistre on white paper. 156 x 98 mm. Vienna, Albertina.

The wholly unpretentious, spontaneous depiction of the artist's wife probably dates from before the separation brought about by Dürer's trip to Venice in autumn 1494. Agnes Dürer (1475-1539) was the daughter of the coppersmith Hans Frey and his wife Anna Rummel. She married Dürer on 7 July 1494.

18

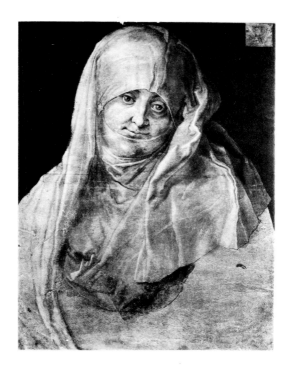

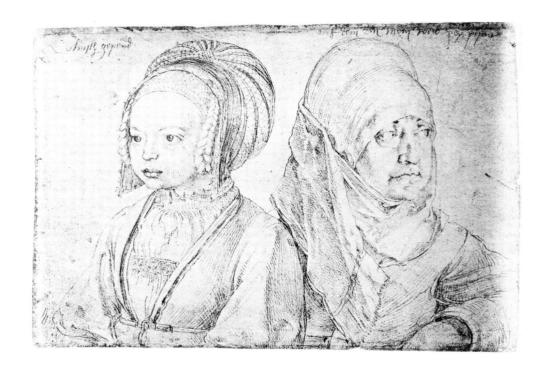

17

AGNES DÜRER AS ST. ANNE
Brush drawing in gray, heightened with white, on slate-gray paper. The background is covered with black. In the right upper corner a square piece of paper has been glued on bearing the monogram of the artist and the date. 395 x 292 mm. Vienna, Albertina.

This is a preparatory study for a painting, commissioned by Linhart Tucher, of the Infant Christ, the Virgin, and St. Anne, now in New York, Metropolitan Museum of Art (33).

18

GIRL IN COLOGNE ATTIRE AND AGNES DÜRER
Inscribed: "Cologne headdress," and "My wife on the trip near Bopard." Silverpoint on yellowish-white paper. 129 x 190 mm. Vienna, Albertina.

Page from a sketchbook in square format, that Dürer had used during his trip to the Low Countries, beginning October 1520. Fifteen sheets survive in various collections. (For the verso of this drawing, see 252.)

An inventory notation dated 1573-74 of the collection of Willibald Imhoff of Nuremberg speaks of two portraits, also painted on vellum, as being likewise the work of Dürer. They depict his Strassburg teacher and the latter's wife. The use of vellum, unusual in paintings of larger dimensions, can be taken as an indication that the self-portrait also derived from the Strassburg studio.

In this self-portrait (19), produced towards the end of his travels as a journeyman, Dürer showed himself still intellectually bound by the pictorial conventions typical of the Nuremberg of his time. As with the drawings, the artist painted the portrait directly from the mirror image rather than from a preliminary sketch. The working hand, in the mirror image the left, but in reality the right hand, was not originally depicted, but was added in recent times.

Still, this, the first autonomously painted self-portrait of western art, should not be viewed, as has sometimes been proposed, as an advertisement for a bride, one in which the young painter sought to present himself as favorably as possible to a selected young lady of Nuremberg. How the engagement came about, after the manner of the times, was reported by Dürer in his family chronicle: "and after I had returned home, Hans Frey negotiated with my father and presented me with his daughter, a young lady named Agnes, and with her a dowry of 200 florins." The romantic interpretation of the self-portrait is not supported by the stalk of sea holly in the hand of the young man; Goethe, who had seen a copy of the picture in Helmstedt, called the plant *Mannstreu* [faithful to man]. Actually, the symbolic meaning of this thistle is many-sided, including religious connotations, as indicated by the inscription which the young painter added at the top, next to the year 1493, in the form of a two-line rhyme: *My sach die gat/Als es oben schat* [Things with me fare/as ordained from above]. This formula of subjection to the

19

will of God follows the tradition of adding personal tenets to paintings, a common practice among medieval painters, even on ecclesiastical commissions.

For Dürer's father, the marriage of his son with the daughter of a highly respected craftsman, one who had held honorary office in Nuremberg and whose in-laws were one of the governing families of the city, must have seemed a confirmation of the position his own skill and proficiency had earned. The coppersmith Hans Frey was not only a well-known harpist, but also an inventive creator of table fountains powered by forced air. It is easy to suppose that the young Albrecht's designs for such devices, carried out in precious metal and intended for use at ceremonial dinners, had been stimulated by the experiments and the achievements of the father-in-law. His own training as a goldsmith and the knowledge he had thereby gained of the possibilities of the material doubtless also played an important part.

Dürer's marriage, which remained childless, cannot be described as a happy one, even without taking at face value the suspicions of Willibald Pirckheimer, who ascribed the early death of his friend to a lack of understanding on the part of his wife. The intellectual contrast seems to have been simply too great. Agnes Frey had deceived herself if she thought that she had married, like the other young girls of her class, a master craftsman who would industriously pursue his trade in order to insure the support of his family and increase the respect accorded him by his fellows. To be sure, Dürer desired all that, and did it too. He must have been enormously industrious, his skill as a craftsman exceeded by none, his business sense well-formed and successful. But he wanted more. He wished to step out of the well-worn paths of the traditional artisan. He was driven to explore the fundamentals of his art, to learn to know its origins and those things which powered its growth, to gather and extend knowledge.

In the year of his marriage Dürer drew his young wife in a very lifelike pen drawing, as she sat before him at the table and supported her chin on her hand (16). The inscription on the lower border, "My Agnes," conveys affection and commitment. Later pictures reveal that Frau Agnes developed into a lady of seemingly dry temperament and fullness of body (18). In 1519, when she was not quite fifty years old, her husband used her as a model for a painting of St. Anne together with the Virgin and the Infant Christ (17,33). The preliminary study is carefully executed in gray color with a brush on gray prepared paper. The concealing kerchief surrounding her head encircles the face just over the eyes and below the mouth. The head is inclined towards the left shoulder, apparently a gesture of resignation most likely dictated by the figure's role in the picture whose composition Dürer had clear in his mind's eye. The meditative glance directed at the artist is picked up and recorded by him. In the painting, the personalized expression gives way to a more generalized rendering appropriate to the saintly mother of

19
SELF-PORTRAIT WITH SEA HOLLY
Inscribed: *My sach die gat/Als es oben schat* [Things with me fare/as ordained from above]. Oil, transferred from vellum onto linen. 56.5 x 44.5 cm. Paris, Louvre.

Sea holly reportedly has aphrodisiac qualities but also occurs in religious context. The left hand in the picture, actually the right hand of the sitter, was subsequently revised.

20

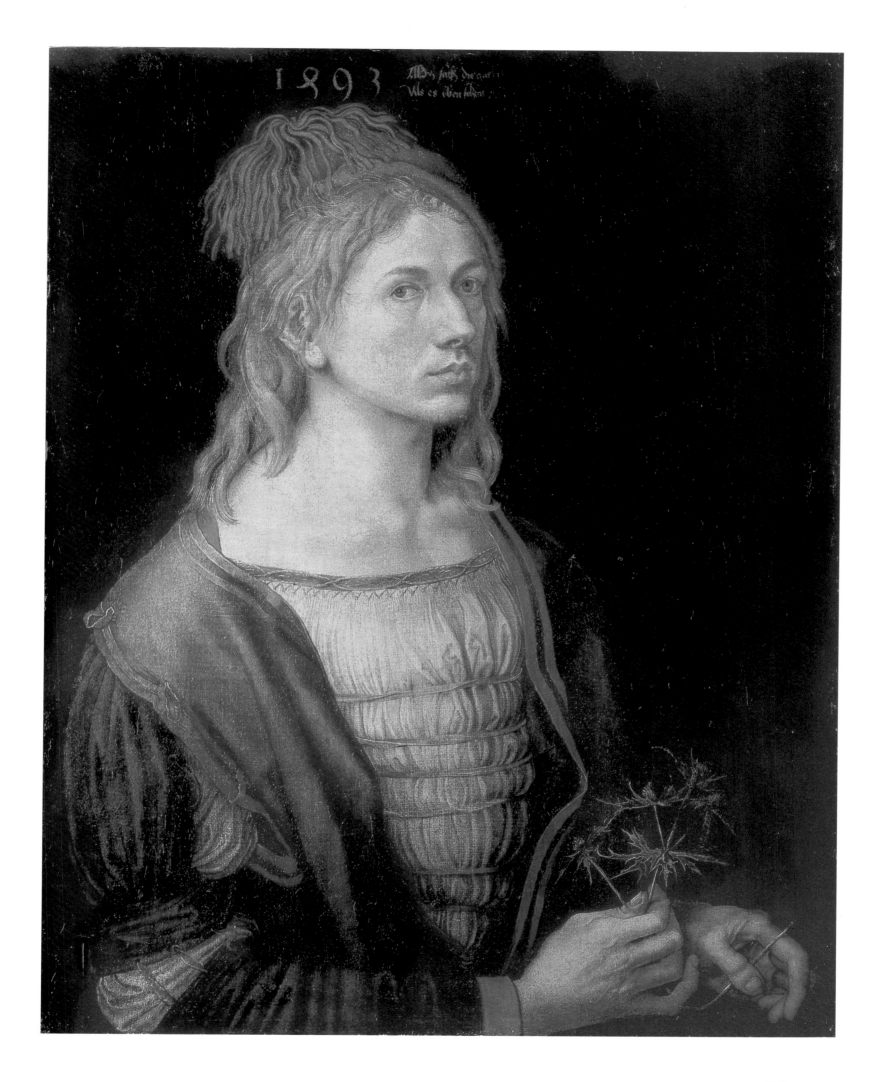

21

Mary. Twice Dürer left his wife behind in Nuremberg for considerable spans of time as he journeyed to Venice to study and to work: first in October 1494, a few months after the wedding, and again in the late summer of 1505, when he remained away for more than a year and a half. The plague, which raged in Nuremberg on both occasions, can hardly have been the reason for his going; but concern for the life and health of his wife did not hold him back, either.

Three years after his return from the first trip to Italy, in a period of intensive graphic production that laid the basis for his fame and carried his reputation well beyond the borders of Germany, Dürer sought to depict his nature and his ambition in a self-portrait (23). A bit smaller than the one produced in Strassburg, it is carefully painted on wood. The artist identified the picture as a self-portrait in an extensive inscription which cites the year of the painting, his own age, and his full name; and underneath he placed the now famous monogram that he had used since 1496, the letter D placed with a larger A. Dürer pictured himself before the dark background of an interior lighted by a window on the right; half his figure is visible, turned toward the viewer in three-quarter profile. The self-confident, upright pose is reinforced behind the shoulder by a column and by the drapes. The carefully graduated white and gray of curtain and cap are interrupted by black stripes, enhancing the effect. The cord of alternating white and blue that anchors the light brown coat at the shoulder provides a colorful accent. The subdued color effects of the clothing make the flesh and the golden hue of the well-groomed hair light up. The brightness of neck and face is a reflection of the light entering the window from the landscape outside.

The delicately painted, miniature-like mountain landscape, flooded by light, is the distillate of the painter's experiences and studies made during his journey to Italy. The combination of portrait and landscape occurs earlier in the art of Italy as well as the Low Countries. What is new is the realism of this small slice of nature, seen as a whole and constructed of light and form. This picture makes clear Dürer's accomplished use of color.

The elegant clothing is more than a mark of good taste and a certain pride in the pleasing effect of his own person. When Dürer painted himself here in festive clothes, it was to make clear his conviction that a special, elevated social position rightfully belonged to an artist. Social rank had just then begun to manifest itself in the clothing worn by a town's citizens. In Nuremberg, the regulations which governed excessive display in clothing and jewelry during the 14th and 15th centuries had applied to all classes equally. At the end of the 15th century gradations according to social class began to manifest themselves so that dress became a significant distinguishing feature.

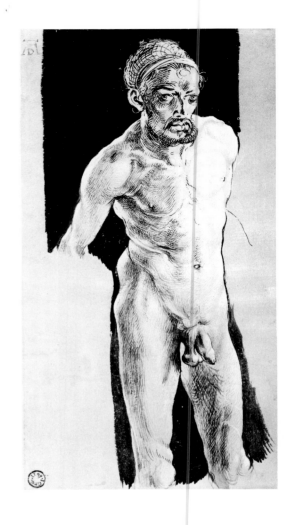

20
SELF-PORTRAIT IN THE NUDE
Upper left: the monogram of the artist. Pen and brush, heightened with the white on green paper. 291 x 153 mm. Weimar, Staatliche Kunstsammlung.

This undated sheet probably dates from sometime between 1500 and 1512. Compared with other self-portraits and its relationship to Adam in the engraving of 1504, it can be linked with Dürer's studies of nudes around that time.

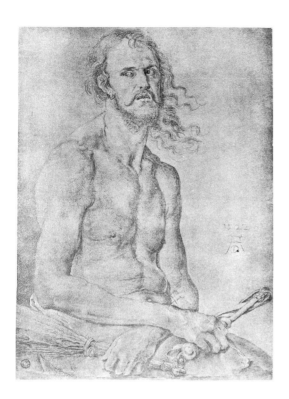

The third and last painted self-portrait departs from the pattern of the three-quarter profile (28). Dürer stands facing the mirror and places his left hand, which in the mirror image becomes the right, on his chest. The fingers lightly touch the fur trim of the brown coat, which, though of secondary importance, has given the picture its name. If the "Self-Portrait with Landscape" bespoke a new sense of class standing on the part of the artist, the "Self-Portrait in a Fur-Trimmed Coat" became the expression of a consciousness of mission which had not manifested itself earlier and was not to appear again. In this Dürer was thinking less of the person than of the "thing," less of the artist than of the origin and the mission of art. Even the year 1500, clearly designated by the painter as the date of the painting just above the monogram, is no accidental choice for a new self-presentation. The turn of the century, the beginning of the second half of the millenium, had been eagerly awaited; yet the year fell in a time in which much that had once been firm and secure became fragile, a time overshadowed by religious and social change. Pope Alexander VI had proclaimed a Holy Year. A mighty throng of pilgrims heeded the call, seeking the "jubilee indulgence" to assure a happy eternity.

On the right side of the picture the painter gives further details about the painting and himself, using Latin, the language of the Church and the Humanists: *Albertus Durerus Noricus/ipsum me proprijs sic effin/gebam coloribus aetatis/anno XXVIII* [Thus I, Albrecht Dürer of Nuremberg, painted myself in indelible colors in the 28th year of my life]. Dürer had painted his picture with indelible colors so that his features should thus be indelibly passed on to future generations. Dürer's learned friend Willibald Pirckheimer (25) was presumably the author of the inscription; it was he who chose the seldom used word *proprius* to express enduring quality, and instead of the customary *fecit* the imperfect form *effingebam*, following the custom of the classical painters Apelles and Polycletus, as recorded by Pliny. In the family chronicle, Dürer recorded his gratitude that his father had early recognized his gifts, and had sent him to school until he had learned "to read and write." He had not been able to take part in the Latin instruction that normally followed, but he later learned as much of that tongue as he required to understand and judge the Latin sources for his studies in the theory of art.

The demand for recognition implied by the drastically frontal, symmetrical form of the artist's representation of himself has its origin in depictions of Christ as *vera icon*, based in turn on renderings of the sudarium, i.e., the kerchief that Veronica offered to the Savior on his way to Golgotha. Contributing to this overall effect is the underlying construction of a circle and a triangle, which accounts for the severe symmetry of Dürer's face. This construction can be traced back to Byzantine images of the Redeemer. In this self-portrait the artist calls on Christ as source in much the same way he calls on God in the introduction to his projected textbook on painting. In the surviving manuscript, he reveals a sense of fundamental priorities, namely his belief that God is the source of art. "Art

21

CHRIST, MAN OF SORROWS, WITH DÜRER'S FEATURES
At the right the monogram of the artist, above it the date 1522. Drawing in lead-point, delicately heightened with white on bluish-green paper. Bremen, Kunsthalle (lost during World War II).

23

derives from God; it is God who has created all art; it is not easy to paint artistically. Therefore, those without aptitude should not attempt it, for it all is an inspiration from above."

The self-portrait of 1500 was the last the artist painted. In it Dürer said all that he wanted to record permanently about his person and his relationship with art, as the inscription makes clear, not just for his own time but for a distant future as well. At a date which cannot now be determined, but probably not long after the death of the artist, the self-portrait along with other works of Dürer's found a place in an upstairs chamber of the Nuremberg City Hall, a room which served as a kind of art gallery. The Dutch painter Carel van Mander saw the portrait there on the occasion of his visit to Nuremberg in 1577. Following a reconstruction of the City Hall, the portrait was hung in the Small Meeting Hall of the City Council. Towards the end of the 18th century, through neglect on the part of the city, the portrait was disposed of, and in 1805 was acquired by the royal collection in Munich.

Two drawings portraying himself, not intended for the public, contribute to our understanding of Dürer's personality. One of these, carefully executed and of substantial size, is done with pen and brush in black on green paper. Dürer depicts himself naked (20). By heightening the white elements the plasticity of the body is emphasized: in reproducing it the artist quite clearly followed the model with great exactitude. The eyes stare into the mirror with great seriousness. It is probably not by coincidence that the beholder is reminded of Christ standing naked at the column of the flagellation. Dürer's constant intimacy with religion becomes especially evident in a drawing in which he views himself as the Man of Sorrows, the upper body bared, marked by illness, the instruments of martyrdom in the hands (21). This large drawing, done in lead-point on bluish-green paper, is marked with the monogram of the artist and the year 1522. It was probably not drawn before a mirror. The sheet, along with other important Dürer items, has been missing since the end of World War II, having disappeared from the Bremen museum.

There remains also a small pen drawing, lightly tinted with watercolor, done at the spur of the moment, in which Dürer pictures himself wearing only a small pair of pants and pointing with his finger at the area near his spleen (22). It bears the inscription: "This is where the yellow spot is, and I am pointing to it with my finger: that is where it hurts." One may surmise that the drawing dates from c. 1512-13, and is connected with a consultation with a physician in another city; yet this does not exhaust its significance. According to the medical opinion of the time, the spleen to which Dürer pointed was the seat of melancholy. So it may be that the feeling of pain in this organ was a circumstantial way of expressing a psychological state. That similar references to psychological conditions were not uncommon is shown by the existence of a small statue, cast in Nuremberg and dating from c. 1520-30, that graces a

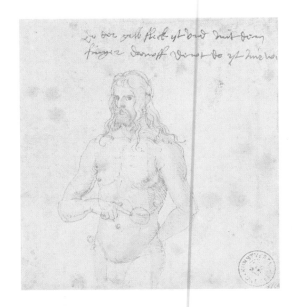

22
SELF-PORTRAIT
Inscribed: "This is where the yellow spot is, and I am pointing to it with my finger: that is where it hurts." Pen and ink, with delicate touches of watercolor. 118 x 108 mm. Bremen, Kunsthalle.

Dürer is pointing at the area of the spleen, supposedly the seat of melancholy. The facial features, the handwriting, and the age speak for a date of c. 1512/13. Citing Pirckheimer's comment in the margin of a letter from Thomas Venatorius of 18 January 1519, "Dürer is unwell," W. L. Strauss dates this drawing from that year.

23
SELF-PORTRAIT WITH LANDSCAPE
Below the window (on the right) dated 1498, and the monogram of the artist. Inscribed: "I have thus painted myself, I was 26 years old/Albrecht Dürer." Oil on panel, 52 x 41 cm. Madrid, Prado.

24

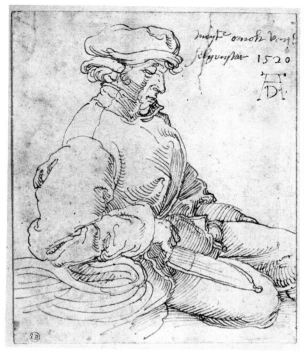 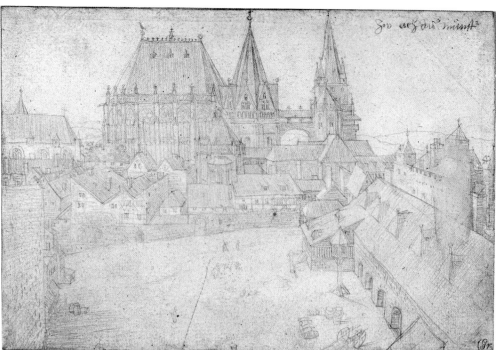

Nuremberg. He did not underrate the freedom offered him at home, where he was in truth his own master, and one who was not denied financial success for his work.

Financial security was also the reason for his last great trip. In 1515 Maximilian I had granted him a lifelong pension of 100 florins per annum, to be paid out of taxes, in compensation for numerous graphic works extolling the Emperor and the imperial family. The city of Nuremberg was obliged to make these payments. At the death of the royal patron on 12 January 1519, the cautious city council stopped the payments, pending confirmation of the grant by the new ruler, Maximilian's grandson, Charles V. Early in 1520, probably hoping that in this way his complaint would reach the ear of Spalatin's master, the Elector Frederick the Wise, he complained to George Spalatin: "Once my eyesight fails and my hand loses its dexterity, my affairs would not go well. I must then suffer want in my declining years, having lost the fruits of my longtime effort and work for His Imperial Majesty."

In the summer of that year he set out, this time accompanied by his wife Agnes and a maid, to attempt to settle the affair by personal attendance. He left Nuremberg on 12 July 1520. After a sojourn at Antwerp, Brussels and Malines, the pension was confirmed on November 12 in Cologne, "after great effort and work," by the new ruler, whose coronation ceremony Dürer had attended at Aix-la-Chapelle. Thus, the principal purpose of the trip had been accomplished, yet Dürer retraced his steps once more to Antwerp, where he remained with some interruptions until 2 July 1521. He returned to Nuremberg by way of Brussels and Cologne.

26
ARNOLD RÜCKER OF SELIGENSTADT
Inscribed: "Master Arnold of Seligenstadt, 1520" and the monogram of the artist. Pen and ink on paper. 123 x 99 mm. Bayonne, Musée Bonnat.

The date and the coil of rope show that Dürer did this drawing aboard ship en route to the Low Countries. The sitter was an organ-builder and owner of the Great Star Inn in Seligenstadt.

27
THE CATHEDRAL OF AIX-LA-CHAPELLE
Inscribed: "The Minister of Aachen." Silverpoint on prepared paper. 126 x 177 mm. London, The British Museum.

Drawing in Dürer's oblong sketchbook of his journey to the Low Countries, where he attended the coronation of Charles V, October 1520, at Aix-la-Chapelle, and noted in his diary: "I have drawn Our Lady's Church with its environs."

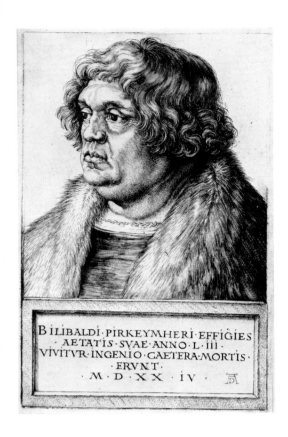

25

WILLIBALD PIRCKHEIMER
Below the portrait on a tablet:
*BILIBALDI. PIRKEYMHERI.
EFFIGIES / AETATIS SVAE
ANNO L.III. / VIVITVR. IN-
GENIO. CAETERA. MORTIS /
ERVNT. / M.D.XX.IV.* [Portrait
of Willibald Pirckheimer in his
53rd year. The mind endures,
nothing else is immortal. 1524].
Engraving, 188 x 120 mm.

*Dürer was a close friend of this
scion (1470-1530) of a patrician
merchant family of Nuremberg.
The learned Pirckheimer aided
the artist's theoretical studies
with his knowledge of Greek and
Latin. The form of the picture
and its tablet are reminiscent of
ancient Roman tombstones.*

Carmine in Padua, there unmistakably appears, among the im-
personal faces of the suitors surrounding the young Virgin, the head
of Dürer, his long blond hair reaching to his shoulders and his gaze
fixed on the viewer.

From his correspondence with Pirckheimer we learn that the
painter intended to travel further south in the summer of 1506. He
hoped to reach Rome in the entourage of King Maximilian who was
making preparations to receive there the imperial crown. We may
surmise that Dürer longed to experience the great ceremonial of the
coronation; we know that he did not miss that of Charles V at Aix-
la-Chapelle on 23 October 1520, during his sojourn in the Low
Countries. But there is no later word of Dürer's traveling plans in
that direction, once Maximilian's project was stymied by the French
invasion of Italy and by Venetian opposition (cf. p. 127).

It appears that the painter became acquainted with both antiquity
and the art of the Renaissance solely from the point of view of the
North Italian artists. Towards the end of his stay in Venice he wrote
to Pirckheimer of his plan to visit Bologna before returning to
Nuremberg. The visit was "for art's sake, for there is one there who
will instruct me in the secret art of perspective." The unnamed
teacher was probably Luca Pacioli. This mathematician was a
friend of both Leonardo da Vinci and Piero della Francesca; it was
the latter who was responsible for the first systematic presentation
of the theories of perspective as they interest artists. The Bolognese
was in a position to pass on to Dürer the knowledge of this great
Italian painter and theoretician. Dürer's acquisition of a Latin edi-
tion, published in Venice, of Euclid's geometry is presumably con-
nected with these studies of perspective. The artist's copy with his
autograph inscription, "acquired in 1507," remains in the library at
Wolfenbüttel. That Dürer did, in fact, go to Bologna is documented
in Christoph Scheurl's biography of Anton Kress, Provost of St.
Lawrence's Church in Nuremberg.

Once a date had been set for the return to Germany in the begin-
ning of 1507, he cried out as if in pain: "Oh, how I shall freeze,
craving the sun. For here I am treated like a gentleman, but at home
I am a parasite." The letter-writer uses a metaphor also used by the
Nuremberg poet Hans Sachs to describe the frosty mood induced in
him by the contrast between his positions in Venice and Nurem-
berg. He feared to be looked upon as a parasite; behind this fear lay
perhaps a sense of the derogatory bourgeois opinion about way-
faring poets and writers looking for a wealthy patron. There can be
no doubt that the position of an artist in the service of the Pope or
of one of the powerful princes of the Italian city-states was quite dif-
ferent from that of the proprietor of a workshop in a German city.
Nevertheless, Dürer had turned down the offer of the Doge to enter
the service of the wealthy city of Venice, and had passed up private
commissions valuing 2000 ducats in order to return to his native

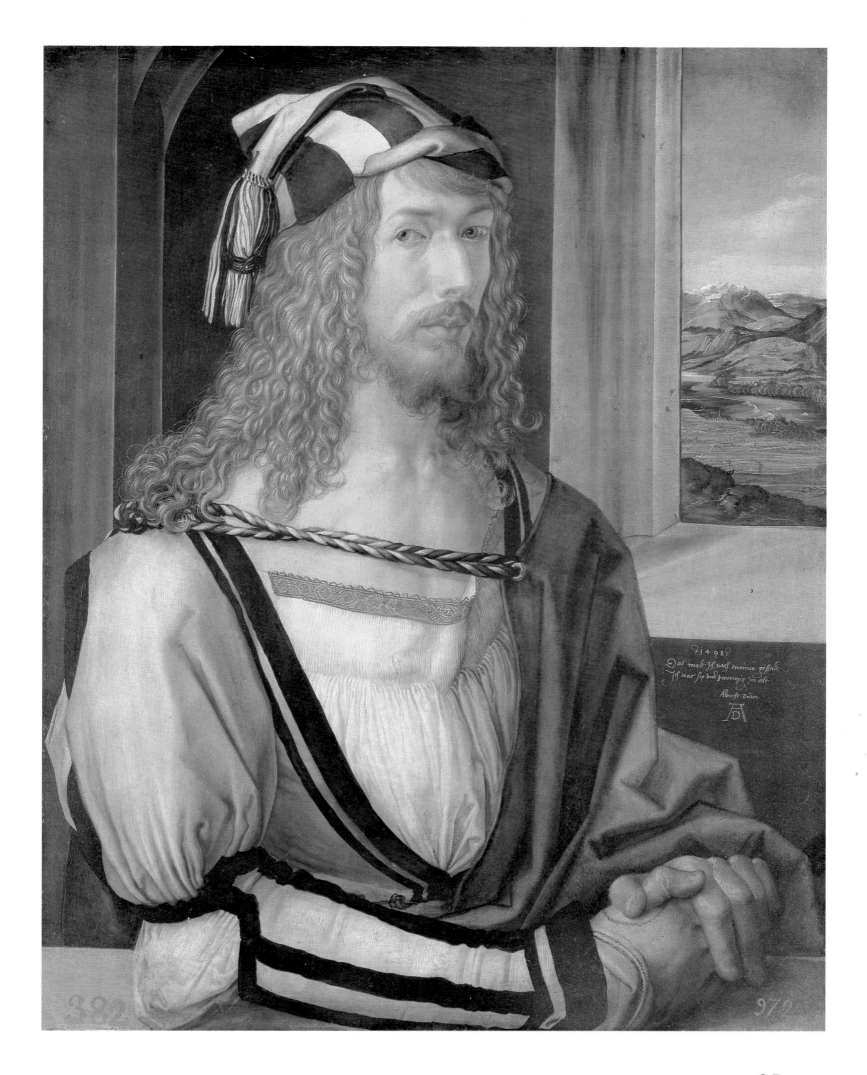

25

fountain in Florence (Bargello). The small bronze Venus is standing on a sphere, covering breast and mid-section with her hands. The inscription reads: *Ubi Manus ibi Dolor* [Where the hand is, there is the pain].

Additional information about Dürer's personality is found in ten letters written to Willibald Pirckheimer in Nuremberg during Dürer's second stay in Venice, from autumn of 1505 to January or February of 1507. A diary of a journey to the Low Countries, from the 12th of July 1520 till the second half of July 1521 has also come down to us. The correspondence with Pirckheimer (24) deals with Dürer's experiences and successes in Venice, as well as errands for his friend who was not hesitant in his demands; sometimes it touches also on his family at home: instructions to his wife and mother regarding the sale of his graphic works, concern about the future of his younger brother Hans, and a request to lend his mother, if necessary, the sum of 10 florins until his return.

The German artist must have drawn wide attention in Venice, on account of his appearance as well as his manner. In Giulio Campagnola's representation of the Miracle of Joseph's Sprouting Rod among the frescoes depicting the life of the Virgin in the Scuola del

24
ALBRECHT DÜRER TO WILLIBALD PIRCKHEIMER
Autograph letter, dated Venice, 8 September 1506. 298 x 222 mm. Nuremberg, Stadtbibliothek (Pirckheimer Papers, 394.7). Closing seal of green wax on the underside of the paper.

Among other things Dürer reports that the Doge and the Patriarch of Venice had looked at his "Feast of the Rose Garlands."

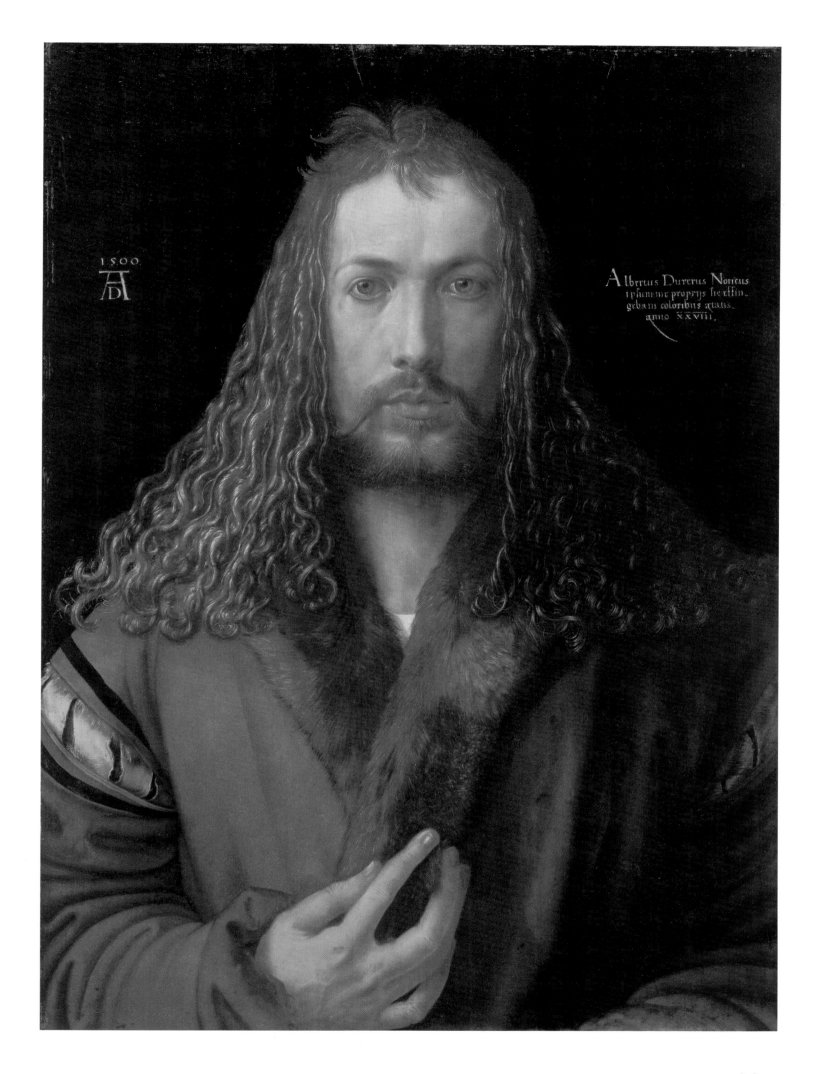

1500.
AD

Albertus Durerus Noricus
ipsum me proprijs sic effin-
gebam coloribus ætatis
anno XXVIII.

29

The trip exercised a powerful influence on him, as a man as well as an artist. His diary, which has been preserved in a 17th-century copy, gives precise details about his route of travel, the people he encountered, and the great works of art by such 15th-century Flemish and Dutch masters as Jan van Eyck, Rogier van der Weyden, Hugo van der Goes, and Hans Memling. Included in the diary are reports about the honors accorded Dürer by the artists of Antwerp and Bruges. All of his daily expenses are listed in great detail, as well as the income derived from the sale of prints, and the rewards received for large-scale portraits, produced in considerable numbers, mostly in charcoal. The regent of the Netherlands, Margaret, the daughter of Maximilian I, received him, even though she refused to accept the portrait of her father that he wanted to present to her. This too is recorded in his diary. For himself, the traveler filled two sketchbooks with impressions of men and landscapes, drawn quickly but carefully, with a sure hand (26, 27, 31, 32).

The diary was meant principally as no more than a careful accounting of income and expense by a man away from home who wanted to make sure that his funds would suffice for himself, his wife and his maid. This makes the infrequent personal remarks stand out all the more: his pleasure in the honors done him; his enormous astonishment upon seeing the works of art brought from Mexico, from Charles V's possessions overseas; his delight in the precious things displayed for the occasion of the coronation. In one passage, the diary entry is tantamount to a personal confession, expressed with extraordinary eloquence. Dürer chose to believe a rumor that Luther had been taken prisoner following the meeting of the Imperial Diet at Worms, that perhaps he had even been murdered. He expressed his lament, addressed in the form of a prayer to God and to Christ the King. At the end he called on Erasmus of Rotterdam (29) to stand up as defender of the faith, to fight for the truth and to aim for the crown of a martyr. The outburst, in its vehemence and manner of expression, is unique as compared to the sober, factual entries in the rest of the diary. Indeed, this contrast has led some to suggest, probably in error, that it was added later by another hand.

28
SELF-PORTRAIT IN A FUR-TRIMMED COAT
With the monogram of the artist, above it the date 1500. Inscribed: *Albertus Durerus Noricus/ipsum me proprijs sic effin/gebam coloribus aetatis/anno XXVIII* [Thus I, Albrecht Dürer from Nuremberg, painted myself with indelible colors at the age of 28 years]. Oil on limewood, 67 x 49 cm. Munich, Alte Pinakothek.

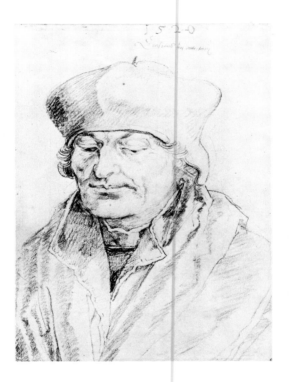

29
DESIDERIUS ERASMUS OF ROTTERDAM
On top, 1520, below in another hand, *Erasmus fon rottertam.* Charcoal on paper. 373 x 271 mm. Paris, Louvre, Cabinet des Dessins.

In the diary of his journey to the Low Countries, Dürer noted at the end of August 1520, Brussels, that he had portrayed the scholar (1466 or 1469-1536) a second time.

30

THE HARBOR AT ANTWERP
Above in the middle, "Antorff,"
and "1520." Pen and ink on
paper. 213 x 283 mm. Vienna,
Albertina.

*During his journey to the Low
Countries, Dürer reached Ant-
werp on 2 August 1520.*

31

THE CITY HALL OF AIX-LA-
CHAPELLE
Inscribed: "The city hall of
Aachen." Silverpoint on pre-
pared paper. 127 x 189 mm.
Chantilly, Musée Condé.

*Drawn by Dürer during his stay
at Aix-la-Chapelle in October
1520. From the oblong sketch-
book. (Cf. 27).*

32

THE CHOIR OF THE GREAT
CHURCH IN BERGEN OP ZOOM
Near the upper border: "That is
the new choir at Bergen." Silver-
point on prepared paper. 132 x
182 mm. Frankfurt am Main,
Städel Kunstinstitut.

*From the oblong sketchbook.
(Compare 27, 30, 31.) During a
trip from Antwerp to Zeeland
Dürer stayed at Bergen from 3 to
6 December 1520, and again
from 10 to 14 December.*

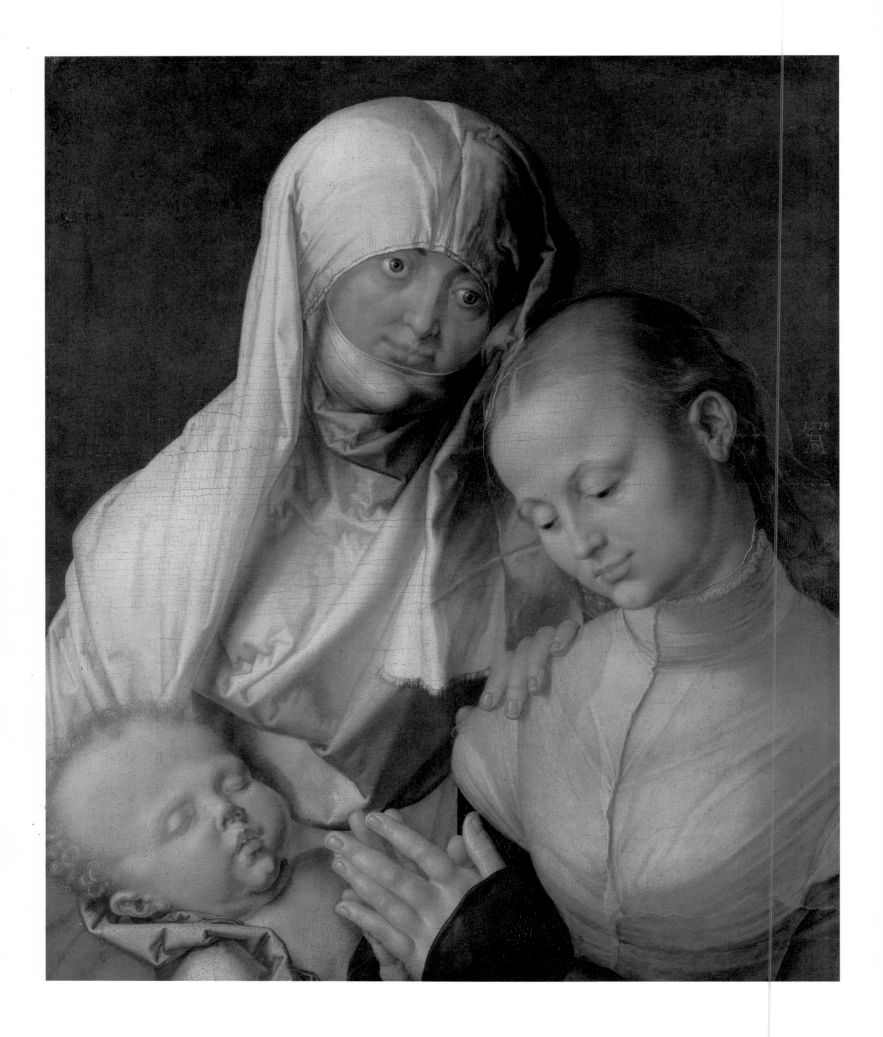

32

Writings on Art

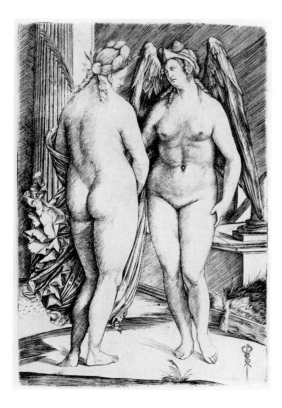

34
VICTORY AND FAME
By Jacopo de' Barbari.
Signed below with his emblem
and a serpent and staff. Engrav-
ing on copper. 181 x 123 mm.

*Jacopo de' Barbari (1440/50-
1516) lived in Nuremberg from
1500 to 1503 and was acquainted
with Albrecht Dürer. His prints
are not dated.*

← 33
ST. ANNE WITH THE VIRGIN AND
THE INFANT CHRIST
With the monogram of the artist
and the year, 1519. Oil, trans-
ferred from wood to canvas.
60 x 50 cm. New York, Metro-
politan Museum of Art, B.
Altmann Collection.

*A drawing by Dürer of his wife,
made in the same year, served as
a model for St. Anne. (Cf. 17).*

Dürer returned from Venice to Nuremberg at the end of the winter
of 1506/07, busy with a plan for a comprehensive manual for art-
ists. He felt committed to this project, since German artists, par-
ticularly, created their works based on tradition, on mere practical
training without any theoretical or scientific basis. In his own
words: "So that such art should not rest on custom alone, but
gradually shall have a firm and proper basis and be understood in
this manner — in God's honor and for all those who love art, for use
and enjoyment." Modestly he emphasized that he was driven to at-
tempt this project only because the relevant books by the great art-
ists of antiquity — Apelles, Protogines, Phidias, Praxiteles, Parr-
hasius — of whom tradition speaks, were lost. Of what had been
created on the basis of the classical canons, only fragments dating
from Roman times remained in Dürer's day, and there was little
evidence of these tenets in contemporary works. The great living
masters — Dürer was probably thinking particularly of Leonardo da
Vinci, with whose efforts to develop a theoretical basis for art he
was acquainted — had published nothing. But only a good master
who had proven his gift through the works of his own hands was
qualified to speak about art: "Take care not to learn from those who
might have much to say about the subject, but with their hands
always produce disgracefully poor work, of which I have seen a
great deal." The introduction, as evident from the extant manu-
script, advised how to avoid reproaches for man's desire for art and
for knowledge of its laws, and in fact the desire to understand in
general. In 1525, Dürer appealed to Willibald Pirckheimer in a simi-
lar vein, in his dedication of a portion of his *Manual of Measure-
ment,* speaking against those who regarded art as idolatry and were
propagating that notion. He could count on Pirckheimer's concur-
rence. Such statements expressed clearly the artist's concern, not
merely with the survival of his own works, but with the future of
art as a whole, which he could never imagine as a solely profane
mode of expression.

Since his first stay in Venice, and thereafter more extensively,
Dürer had been studying the external appearance of the nude
human body, utilizing live models. This, combined with the echo of
antiquity in nudes found in the works of Italian artists, "the naked
picture of the Italians," led Dürer to think about the proportions of
a body imbued with the highest degree of beauty. By the word "pic-
ture" Dürer understood simply the representation of the figure of
man, whereas for the present-day usage of "picture" he employed
the words "painting" or "panel." Accordingly, work on the projected
book initially concentrated on the study of human proportion. This
was to be the subject of the first section of the book.

In the draft of the dedication to Willibald Pirckheimer, written in
1523, Dürer relates how he came to direct his efforts towards uni-
versally valid relationships of measurements. As he tells it, he

first looked in vain for a scientific treatment of the problem. But then the painter Jacopo de' Barbari, who resided in Nuremberg from 1500 to 1503, showed him a sketch of "man and a woman, based on measurements," yet the Venetian either could not or would not explain to him the method of construction (34). Dürer therefore began his study with the relevant section of the work by the Roman architect, Marcus Vitruvius Pollo, that was probably written in the year 27 B.C.: "and as at the time I was young, I really took this matter to heart and read Vitruvius, who writes briefly about the proportions of man's body." It was probably Willibald Pirckheimer who had called Dürer's attention to the work which appeared in print for the first time in 1486. It had a profound influence on Italian artists and theorists ever since a manuscript had been discovered at Montecassino in 1414. A translation of the section on the proportions of man has come down to us in Dürer's hand, probably from c. 1508.

The Roman architect divided the human body into sections and related each of these to the body's entire length. According to his plan, the height of the head between chin and scalp is ⅛ of the body length; the face from chin to hairline and also the outstretched hand from wrist to the end of the middle finger, ⅒; the portion from the bottom of the neck to the lowest roots of the hair ⅙; and finally, a proportion that was understood only by an interpolation in the illustrated edition, published at Como, in 1521, from the center of the chest to the scalp ¼ of the body length. The foot corresponds to ⅙, the lower arm from elbow to the end of the hand, and likewise width of the chest equal ¼ of the body length. The face is divided into three sections of equal size between chin and hairline, marked by the nostrils and the eyebrows. Vitruvius also relates the body to geometric figures. The outline of a man on the ground with arms and legs extended at an angle can be placed within a circle whose center is at the man's navel, whereas a standing man with outstretched arms fits neatly into a square. What must have particularly impressed Dürer in Vitruvius's layout of proportions was the observation that the renowned painters and sculptors of antiquity utilized these measurements and thereby won lasting approbation.

Dürer broadened his knowledge of art theory during his second stay in Venice. Luca Pacioli, a native of Borgo San Sepolcro, who had perhaps been his instructor at Bologna, had dealt extensively with the proportions of men in two of his works: *Summa de Arithmetica* appeared in 1494, whereas *La Divina Proportione*, though completed in 1498, was only published in 1509. In these works he concentrated on the measurements of the head and its relationship to the other members of the body, problems to which Dürer had also given great attention.

Leonardo da Vinci's unpublished studies were also known to Pacioli. Leonardo was among the greatest contemporary thinkers dealing with the theory of art. His system of human proportion partly uses fractions of the body length, as Vitruvius, but also

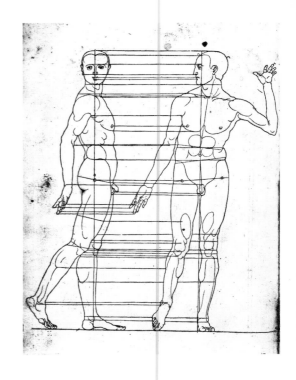

35
WALKING MAN SEEN FROM THE FRONT AND IN PROFILE.
Woodcut from *Four Books on Human Proportion*, Nuremberg (Hieronymus Andreae) 31 October 1528, fol. X IIIIv.

The preliminary study in the Dresden Sketchbook is dated 1519 on the verso. (Strauss, Dresden Sketchbook 75–Strauss, Dürer Drawings HP: 1519/1).

34

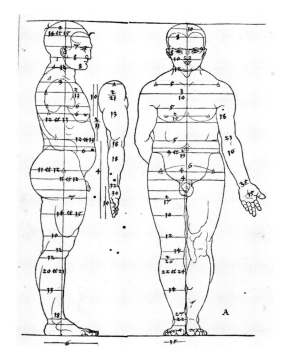

uses length of the face. The effect of Leonardo's studies is manifest in Pomponius Gauricus's *De Sculptura,* published in Florence, 1504, a copy of which was in Willibald Pirckheimer's library; we may surmise that it was not unknown to Dürer. The author, a dilettante in sculpture, had been educated in Padua and probably still lived in that neighboring city during Dürer's second stay in Venice.

Neither Pacioli nor Gauricus were artists in the true sense, and Dürer's critical remark might refer to them: "some write about the subject but are unable themselves to do it." What disappointed him in the works of these Italian theoreticians was the meager reference to practical applications for an artist. Their concern with proportion was more one of mathematical and philosophical speculation than for use as the basis of the representation of the human body by painters and sculptors.

When he returned home from Venice in 1507, Dürer began to use a new principle. He had realized that universally valid human proportions were unattainable, and that there was no such thing as perfect beauty. He confessed: "what beauty may be I do not know — one person may view or make a more beautiful picture than another, but never to the point of perfection so that a yet more beautiful one might not be made, for that is not within the scope of man; only God knows it, and to whomever he reveals it, he will know it too." Dürer recognized that aesthetics are temporal: "as to the judgment of men, at a given time they consider one figure beautiful, but in another instance they prefer another."

Abandoning the notion of a concept of ideal beauty, yet wishing to arrive at a systematization of the outward form of the human figure, all that was left was to rely on an exact study of nature, based on patient, exact, and systematic measurements. He began to measure the proportions of a great many men, women and children. In 1512 he wrote, "after investigating some two or three hundred individuals, one learns scarcely anything." This gives us an idea of the scope of his investigations.

Systematically measured distances were determined between specific points on the body, and related to the entire length. By organizing these data, and eliminating any major deviations, he arrived at standard body types. As a rule he retained Vitruvius's system that the head from chin to scalp was equivalent to $1/8$ of the body length. In a second rule he followed Vitruvius in establishing that the relationship between specific parts and the body in its entirety corresponds to an increasing proportion that Dürer had probably learned about from Euclid. For the determination of the numerical relationships between the segments from the nape of the neck to the hip, and the hip to the knee, as well as from knee to ankle, Dürer proposed a device that he called *Vergleicher* [comparer]. However, the problem, as modern mathematics has demonstrated, cannot be resolved precisely in the geometrical manner proposed by Dürer.

36
Nude Male Figure from the Front and in Profile.
Woodcut from *Four Books on Human Proportion,* Nuremberg (Hieronymus Andreae) 31 October 1528, Fig. A, fol. A VIr.

The small roman numerals represent fractions of the total body length. Cf. the drawings in the Dresden Sketchbook: Strauss, Dresden Sketchbook 62 - Strauss, Dürer Drawings HP: 1513/12.

Dürer measured his models standing, arms hanging down, in three dimensions, and constructed each illustration for his work in three views (36). In order to facilitate determining the segments, Dürer used a measure called "the divider," since it contained the established fractions of the total length as individual segments based on the circle.

A second procedure for determining the proportions of the human body Dürer took from Leon Battista Alberti's *De Statua*. Alberti, for the most part a resident of Florence, like Vitruvius, was neither sculptor nor painter but an architect and theoretician. He too might have belonged to that group of skillful writers of whom Dürer had warned his reader. His work on sculpture, the author's fourth tract dealing with the theory of art, was first published in 1568, but the impact of numerous copies circulating in manuscript is evident.

Alberti describes a procedure called *Exempeda*, [i.e. six feet], based on a module derived from the division of the entire body length into six equal parts. This module is then employed for all further measurements. Dürer called the basic measure that likewise served as a measuring device, and varied for each model, *Messtab* [ruler]. As with Alberti, subdivisions are, according to the decimal system, divided into ten "numbers," which in turn are divided further into ten "parts," and finally into three "bits." Each of these magnitudes were assigned individual symbols (37).

Around 1508/09 Dürer began drafting the introduction for his book on painting, originally intended to be very comprehensive. By 1513 its program had been shortened and divided into independent parts. The one dealing with human proportions, following the measuring system of Vitruvius, was complete and constituted Book I of Dürer's *Four Books on Human Proportion*. A fair copy of it, dating from 1523, has come down to us. Immediately after completing the first part Dürer was occupied with the first drawings utilizing the *Messtab* [ruler]. They comprise Book II of the *Four Books on Human Proportion*, which was also largely finished in 1523.

Even if Dürer had by now presented a great number of figural types of various proportions, he nonetheless recognized that the somewhat limited selection would not suffice for artists, especially painters who needed to incorporate a great many figures into one panel. He therefore invented methods and drafting devices which he gave descriptive names corresponding to the use to which they were put, i.e. "pointer," "inventer," "selector," "duplicator," and "falsifier." These were utilized to alter the proportions of figural types which had been constructed by measurements and methods of Books I and II (38, 39). In Dürer's words: "I want to show how one may alter and convert the aforementioned measurements, so that anyone may enlarge or diminish anything as he may wish." The term "alter" means a uniform change of all proportions, so that the newly gained

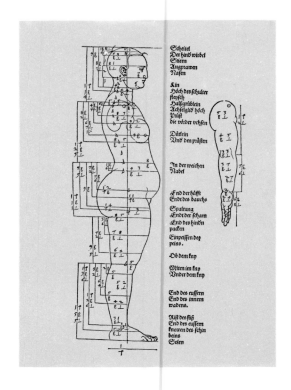

37
NUDE SEEN IN PROFILE
Woodcut from *Four Books on Human Proportion*, Nuremberg (Hieronymus Andreae) 31 October 1528, fol. G II v.

The numerals represent measurements based on the Exempeda method of L.B. Alberti. Cf. the drawing London, British Museum, Sloan 5228/94r, Strauss, Dürer Drawings, HP: 1515/17.

39
A SLIM WOMAN
Woodcut from *Four Books on Human Proportion*, Nuremberg (Hieronymus Andreae) 31 October 1528, fol. R IIIIv.

The proportions have been changed by means of the "duplicator."

38
A Stout Man
Woodcut from *Four Books on Human Proportion*, Arnheim (second German edition) 1603, fol. OVv.

The proportions have been changed by utilizing the "selector."

figure will be proportionally related to the original, just as a sphere, whether large or small, always remains a sphere. By "falsifying" Dürer meant various changes of proportion such as the lengthening of the torso that was to be compensated by a shortening of the legs. Then follow sections devoted to the construction of heads, as well as changes in the physiognomy which go beyond the boundaries of the normal and become caricatures (40).

In presenting his method Dürer cites pairs of concepts, which define each other with greater precision by "comparison," and can be altered by "inversion," e.g. "big or small, long or short, high or low. Nothing would be recognized as being large or small unless seen next to its opposite." At the end of his list of comparative pairs he speaks of "young or old," "lovely or ugly" which indeed can be shown in human figures, but cannot be measured. The outward appearance of the man reveals in its differentiation—Dürer called it "inversion"—something about the inner qualities which the creative artist can only convey by the form he gives the body. Dürer had formulated this thought and its practical implications as early as 1512/13. He cited the art of antiquity in support: "they said: Jupiter has a certain proportion, Apollo another, Venus a third, and Hercules yet another, and so on with all the other [deities]."

Nature has set limits to the arbitrary employment of the changes which for Dürer were ever astonishing and wonderful. His reasoning is not without humor: "Woman and man, for all their differences in so many respects, must yet remain human. In the case of animals no lion can be depicted so that it is mistaken for a donkey, nor a fox for a wolf." Dürer also cautions his readers not to use all of his models in a work of art, since some exaggeration was necessary to make his theory intelligible. If anyone wished to make use of his teachings, "he should avoid the grotesque that is the result of too much falsification. I do not maintain that mine is the only way, but merely that I have described one correct method so that anyone may use it in a pinch without going wrong." This last sentence makes clear how convinced Dürer was of the need and the practical value of his manual.

In order to insure its usefulness, the author added a fourth book to this manual, "how to bend and position any type of figure whether serious or charming. For the former requires a fierce stance, the latter a friendly one." In all this the concern was only for the outward appearance of the flexed figure without reference to anatomy, as is emphatically stated. Dürer's few drawings of the skeletal structure of a leg, arm, hand and rib cage of man are copies

based on the work of Leonardo da Vinci, who had had the opportunity to dissect bodies.

Likewise, in speaking about movement, Dürer begins with terms meant to elaborate the meaning of simple explanatory drawings. In order to demonstrate their application, he reverts to older attempts at the subdivision of the human body into stereometric elements, moving these initially along lines, parallel and vertical to the pictorial plane, and subsequently freely in space (41). A special section is once again devoted to the turning and bending of the head, developed by means of a parallel projection of ground plan and profile.

The figures used to illustrate the book are based on measurements derived from models. First, on the basis of the proportions, Dürer determines the position and extent of the major portions of the body. The fixed points and distances arrived at form the basis around which the artist then draws the contours of the body as well as the scant lines within. For this, however, aptitude as well as facility are required, i.e. "understanding and practice. Accordingly, every artist must learn to draw well, for this is an overriding consideration for all art forms." The representation of living things, Dürer insists, can only be learned from nature. "From nature one can learn the truth, so look at her diligently, be guided by her, and don't be tempted to think that you can do it better than she, for you will be wrong. Indeed, art is embedded in nature, and he who can yank her out has won her. Once you have her under control she will spare you many a mistake in your work; and by means of geometry your work will gain evidence." Here geometry is seen as given by nature. Proof of the harmony of art and nature is offered by geometry. These thoughts are without doubt linked to Dürer's efforts to follow the Italians in the development of a scientifically based theory of perspective.

Nature as reflected by the human body can only be understood through the study of living models. "For whoever wants to draw according to the directions in this little book and has not studied the subject thoroughly, he will initially have a hard time. But let him use a live model of about equal proportions. Then let him first draw his contours, as best he can, and once satisfied that it is exact and lifelike, remarkably, if it turns out handsomely, then he will be regarded as an artist and greatly praised, as is proper." The advice that Dürer passed on to his pupils tells us what it had meant to him when he had the opportunity, during his first stay in Venice, to draw from nude models. Even the changes in stance of the various parts of the body during movement, "to learn these properly and best, one must draw directly from a living model, for only in this manner can every aspect be recognized." Naturally, Dürer was also

40
THE VARIATIONS OF A FACE
Woodcut from *Four Books on Human Proportion*, Arnheim (second German edition) 1603, fol. Qr.

aware that no artist can produce all his figures strictly on the basis of a construction. But he wanted to persuade the artist to add theoretical knowledge to talent and tradition. "And once you have learned well how to measure and have overcome talent and tradition, then you can proceed freely and with assurance, and you will know what you are doing. It will then not always be necessary to measure every single thing, for your artistic sense will enable you to judge it with your eye, and your experienced hand will obey your eye. By these means the power of art will expel all error from your work." The only way for the artist to create anything is to absorb what God has created in nature and reproduce it. Relying on his own strength alone, "man could never produce a beautiful image, unless after a great deal of copying, he had absorbed things, which then no longer could be called his own but merely derived and acquired art, seeded, grown and bearing the fruit of his generation. The treasures which the heart has secretly gathered are made public through the artist's work. Drawn from the heart he gives them form."

These thoughts, in which he goes beyond anthropometry and reflects about art and its relation to God, were appended by Dürer, after much preliminary work, to Book III of his *Four Books on Human Proportion*. This "aesthetic excursus," that for the first time dealt with the subject in German, is an outstanding example of German prose. Behind the writer, molder of language, stands the artist, who with peculiar imagination shapes every sentence in a pictorial manner.

By 1523 the *Four Books on Human Proportion* were largely completed, yet Dürer's proposals demanded a more thorough knowledge of geometry and stereometry than he could expect from his readership. Therefore he decided to publish this information, and to this end wrote and published in 1525 a *Manual of Measurement*, explaining "the use of compass and ruler for plane surfaces and for solids." Finally, in 1528 he allowed Book I of the *Human Proportion*, once more revised, to be published. Before the other parts could follow, the artist died. Willibald Pirckheimer took on the task of completing the work. It appeared "by delegated authority of Albrecht Dürer, in the year of Our Lord 1528 on the last day of October." It bore the imperial copyright notice forbidding unauthorized reproduction, as well as a eulogy by the editor.

In the introduction to *Manual of Measurement*, dedicated to Willibald Pirckheimer, Dürer explained the reasons that had led him to write a book on this subject. Young artists were taught merely by daily practice but lacked the necessary theoretical knowledge, "the foundation" for doing the work and judging it properly. "Even if some of them acquire a good hand through constant practice,

41
A REPRESENTATION OF THE MOVE-
MENT OF THE SHOULDERS
Woodcut from *Four Books on Human Proportion*, Nuremberg (Hieronymus Andreae) 31 October 1528, fol. Z IIr.

39

they produce work instinctively and without thought and merely as it appeals to them. But when knowledgeable painters and true artists look at such impetus works they laugh, and for good reason, because those who understand find nothing more unsatisfactory than to look at an inferior painting, no matter how diligent its author." Although the author does not state it specifically, "knowledgeable painters" refers to Italian masters, especially Leonardo da Vinci, because a little later on he speaks of the art of the Greeks and the Romans having been brought back to light after a thousand years by the Italians. With his writings, Dürer wants to help not only painters but also "goldsmiths, sculptors, masons, cabinet makers and all those who use measurements." Dürer's training in his youth, in his father's goldsmith shop, had taught him the traditions of craftsmanship, and these were the source of the practical application of measuring and drawing procedures in the book. For information about practical methods of master masons and builders, as well as other artisans, Dürer relied not on oral tradition alone, but could draw even then on printed German sources. The master builder Matthäus Roriczer, active in Regensburg, had written and printed three small pamphlets during 1486/87. Of these, two, entitled *Das Büchlein von der Fialengerechtigkeit* [The Booklet of proper finials] and *Wimpergbüchlein* [Booklet of gables], contained the procedures followed to achieve the proper proportions of Gothic finials and gables. The third dealt with the construction of squares and regular polygons, and other geometrical problems of importance in practical applications. The Nuremberg painter Peter Wagner reprinted this book in 1498 with the title *Geometria deutsch* and added instructions for drawing helmets and shields based on simple geometric constructions. Before 1498, there appeared also Hans Schuttermayer's *Filialenbüchlein,* published by Georg Stuchs in Nuremberg; Schuttermayer has recently been convincingly identified as the Nuremberg goldsmith by the same name who had a documented connection with Albrecht Dürer the Elder. The younger Dürer knew these works and based the formulation of his geometrical descriptions in part on them. With one exception he occupied himself with all the problems treated in the *Geometria deutsch* and offered various solutions. In general Dürer applied himself to the practical applications of the problems contained in the earlier writings, and in his succinctness and directness, without any philosophical discussion, set himself apart from the writings of Alberti and the architectural treatise of Filarete. Dürer went far beyond his German predecessors in the scope of his presentation and in the systematic character of his treatment of the geometric fundamentals, based on Euclid's *Elements,* of whose work he had obtained a Latin translation in 1507 in Venice. He stimulated the abstract thinking of his readers when he referred to a point as "a thing that has neither size, length, breadth or thickness," when he

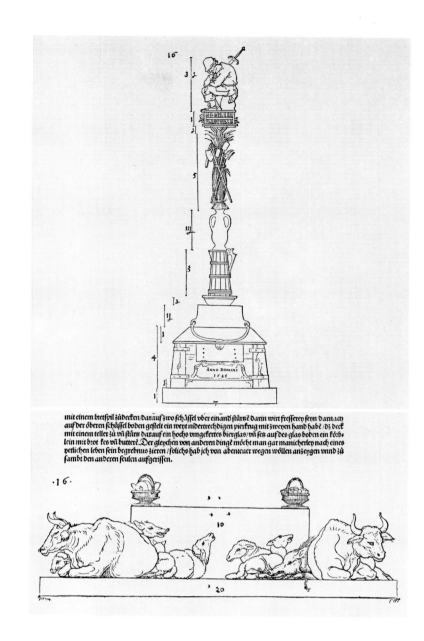

mit einem bretspil zůdecken/darauf zwo schůssel vber einand stürtz/darin wirt fresserey seyn darnach auf der oberen schůssel boden gestelt ein weyt niderrechbigen pierkrug mit zweyen hand hab/das deck mit einem teller zů vii stürtz darauf ein hochs vmgekertes bierglas/vii set auf des glas boden ein körblein mit brot kes vii butterel. Der gleychen von anderen dinge möcht man gar manicherley nach eines yetlichen leben sein begrebnus zieren/solichs hab ich von abenteuer wegen wöllen anzeygen vnnd zů sambt den anderen seulen aufgerissen.

·16·

42
A Victory Column
Woodcut from the *Manual of Measurement*, Nuremberg (Hieronymus Andreae) 1525, fol. H VIv.

43
Monument Commemorating the Victory over the Peasants
Below on the feed chest, which serves as a pedestal: *ANNO DOMINI/1525*. Woodcut from the *Manual of Measurement*, Nuremberg (Hieronymus Andreae) 1525, fol. J recto (below) and verso (above).

conceived point and line as imaginable quantities which he depicted, for "in this way the inner understanding is shown in outer form."

Dürer's book was not intended to be a textbook of geometry. A geometrical proof is introduced in only one place, and even the Pythagorean proposition appears solely in a drawing in connection with the conversion of planes into others of equal size. However, it becomes clear in the book that Dürer, always starting with a practicable application, then continues to treat the basic, theoretical aspects. Thus he presents the conic section for the first time in German and when he names the resulting curves, i.e. ellipse, parabola, and hyperbola, his familiarity with the designations used by the Alexandrian mathematician Apollonios of Perga becomes evident. For the practical craftsman he describes the construction of curves, the "parabola or focal line," of a "burning glass," just as he thinks of masons or goldsmiths when he describes the construction of serpent-conch or web-lines and explains the construction of

instruments "so that one may draw clearly a serpentine line of many kinds, high, low, on the side, forward or backward." The construction of regular polygons, from the square to the sixteen-cornered, should be carried out with a fixed compass "to facilitate the work." Dürer is very explicit when he describes for artisans the applications of the so-called Delic Problem, the doubling of a cube, a solution "which the learned have kept secret" and "until now, so far as I know, it has never been described in German . . . it can help to cast guns and bells, which then are enlarged and doubled, as one desires, and still retain the proper proportion; in the same fashion, one can enlarge barrels, chests, solid measures, wheels, rooms, pictures, etc."

After presenting the construction of columns, pillars and pyramids on round, triangular or many-sided bases with reference to the compound piers of Gothic architecture, together with the construction of pedestals, bases, capitals and the charnels, rods and grooves which belong to them, corners and angles, Dürer suggests a practical application. He proposes "a memorial, or a column on the spot where the enemy was defeated, a 'Victoria' celebrating the suppression of a peasant uprising (43), and lastly a funerary monument for a drunkard." Victory columns as memorials hark back to antiquity. Dürer's design, consisting of a mortar and a long-barreled cannon surmounted by four breastplates seemingly growing out of a bell, is a modern form of an assembly of trophies, emblematic of victory on the field of battle (42). This type of memorial was uncustomary in Dürer's time. It is not clear how seriously Dürer expected them to be used, be it after a war, a peasant rebellion, or the demise of a drunkard. Nor can we deduce his attitude regarding the defeat of the peasants on the basis of his design for this imaginary monument.

Included in Book III of the *Manual for Measurement* — the book dealing with the practical application of geometry in building construction — is an exhaustive discussion of fixed and movable sundials, accompanied by an explanation of requisite basic concepts of astronomy (44). Guidelines for inscriptions on columns, towers or on high walls are followed by designs of the letters of the alphabet, both antique, in squares of equal size drawn with the help of compass and ruler, and of a fractured Gothic script, composed of separate small squares, which can be either doubled or halved at an angle or vertically. Whereas he depended on Italian models for the design of the Roman letters, the construction of the Gothic script was entirely his own.

The intention to challenge spirit and hand in equal measure, to move from theoretical speculation to the practical solution of a problem, a way of thinking that is continuously evident in Dürer's

44
DESIGN OF A SUNDIAL
Woodcut from the *Manual of Measurement*, Nuremberg (Hieronymus Andreae) 1525, fol. J VIv.

42

45
FOLDING PATTERN OF A REGULAR
SOLID COMPOSED OF TWELVE-
CORNERED SURFACES AND
TRIANGLES
Woodcut from the *Manual of
Measurement,* Nuremberg
(Hieronymus Andreae) 1525, fol.
N IIIIv.

work, is also characteristic of his involvement with solid geometry. Citing Euclid, he constructs the five regular, Platonic solids, "which can all be embraced within a sphere, where they all impinge." They are linked to seven of the Archimedean solids, with the sphere likewise tangential at all corners, whose surfaces, however, vary in size and form, "irregular bodies," as Dürer calls them. In conclusion, he describes two solids of his own invention. The first "composed of six twelve-cornered surfaces, connected by thirty-two unequal triangles" (45); and "the second consisting of six squares joined together and twelve triangles each as high as a side of the square, and all this joined together will form a solid." Dürer pictures each solid in the form of a folding pattern, and shows how each will form one three-dimensional model, "for this kind of thing has many applications." Although he didn't say so explicitly, these solids were probably useful for painters in arriving at the correct perspective in their drawings. In publications like the goldsmith Wenzel Jamnitzer's *Perspectiva Corporum Regularium* of 1568 the effect of Dürer's explanations is evident. The author identifies Dürer as one of his predecessors, and refers specifically in his explanation to Dürer's third perspective device illustrated by a woodcut in the *Manual of Measurement* representing a man drawing a vase. Jamnitzer even refers to his classical sources in the subtitle of his book: "the five regular solids of which Plato speaks in his Timaeus and Euclid in his Elements [of Geometry]." In contrast to Dürer's folding patterns, the younger author depicts perspective views of regular solids and their variations. Related to this book in their demonstration of the possibilities of perspective are two works from 1567, *Perspectiva Literaria* by the Nuremberg goldsmith Hans Leucker, and *Geometria et Perspectiva* by the Augsburg painter Lorenz Stoer. Stoer's book was a brief manual for the use of cabinet makers.

Dürer's manual concludes with a comprehensive presentation of scientific perspective, in which he develops the knowledge gained from his unidentified teacher in Bologna. He begins with fundamental considerations concerning the process of seeing: "what is seen must previously exist, and is seen with the eye, and necessitates light, for in darkness nothing can be discerned . . . Light extends in straight lines as far as its rays reach." This realization is demonstrated by shadows cast by an object lighted from only one side. It is illustrated by the ground plan and profile of a cube casting its shadow on two surfaces placed at right angles to each other. The rays of light are directed in each case at the corners of the figures permitting the construction of the shaded surfaces of the combined sketches.

Proceeding further, Dürer describes pyramidal vision as first explained by Euclid: "between the eye and the object seen, a

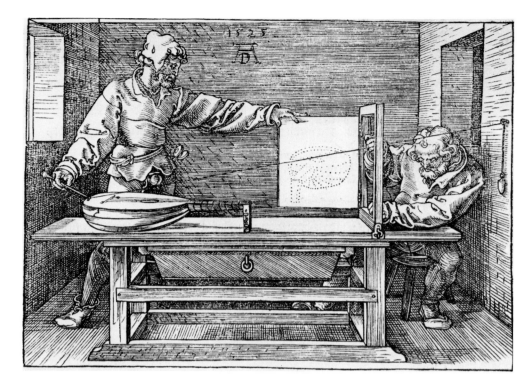

46
MAN DRAWING A LUTE
With the monogram of the artist and the date 1525. Woodcut from the *Manual of Measurement*, Nuremberg (Hieronymus Andreae) 1525, fol. Q IIIr. 130 x 182 mm.

One of four devices to attain a drawing in proper perspective.

transparent slice is taken by cutting the straight lines reaching from the eye to the object." Applying this to art, Dürer continues: "Once vision by means of its rays reaches its objective and is to be put into a painting, it is accomplished by. . .a transparent plane or flat surface that cuts through all the rays [between eyes and object]." This explanation of the method of seeing found its first practical application in a perspectively constructed model painting by the Florentine architect Filippo Brunelleschi. Dürer's knowledge of the Florentine artist's method probably derived from Leon Battista Alberti's *De pictura*, a copy of which had found its way to Nuremberg.

Dürer also followed Italian precursors in his designs for auxiliary devices which made it possible to scan objects in their correct perspective without tedious constructions by the interposition of a painting surface between eye and object. Of the four devices, he described two with accompanying explanatory woodcuts in 1525, in the first edition of the *Manual of Measurement* (46). Two more woodcuts, one depicting a man drawing a vase, and another drawing a recumbent nude, were added to the posthumous edition of the manual in 1538.

How greatly Dürer was impressed by the illusion of reality in an object portrayed in the correct perspective is indicated by his choice of words to describe this kind of depiction. He calls it "purloined painting." This is based on the concept of the transfer of an image from its actual existence into the world of pictorial illusion.

The conversion of geometric theory into practice was the impetus for Dürer's last book which appeared in Nuremberg in 1527, entitled *Etliche underricht zu befestigung der Stett, Schlosz und flecken* [Some Instruction for the Fortification of Cities, Castles and Localities]. The book was assembled hurriedly and its publication was due to a particular circumstance, as shown by the dedication to King Ferdinand, who since 1521 had been regent of the Hapsburg principalities, and since 1527 also King of Bohemia and Hungary. "Because it is now urgent, and your Majesty has ordered that various cities and localities are to be fortified, I have attempted with my limited knowledge to provide designs therefore, hoping that your Majesty will graciously find some of it useful." Dürer goes on to speak of the impending danger of a Turkish attack and of the immediate need to develop fortifications which could withstand the rapid progress in fine arms and artillery, and to place the besieged in a position to deliver counter-blows. Dürer had referred cryptically to the latent threat, as early as 1518, in his steel etching "The Great Cannon," when Emperor Maximilian I, on the occasion of the Diet of Augsburg, supported by a fiery appeal from Ulrich von Hutten, called for battle against the advancing Ottomans (261). Speaking of the uncertain situation both within and without Germany, following the suppression of the great peasant uprising, Dürer writes: "Since nowadays a great many strange things are happening, I believe it might be useful to think about how fortifications are built, so that kings, princes, lords and cities can defend themselves, not just so that one Christian can defend himself against another, but so that the principalities which are exposed to the Turks can save themselves with their might and artillery." The effect of the book on military architecture was slight, especially since it was shortly thereafter superseded by the system of polygonal bastions employed at that same time in Verona by Michele Sanmicheli. Although Dürer had based his proposals on older literature, mostly written by Italians—among them once again Filarete, Alberti, Leonardo da Vinci, etc.—and the proposals for fortifications advanced by him were not of his own invention, the importance of the work is more in that it was a "first", namely the first book in German on this subject, profusely illustrated with ground plans, profile views, cross-sections, and overall renderings, indeed, the first published theoretical treatment of the subject anywhere, constituting a compendium of the elements of the art of fortification brought together systematically, based on various invented, and in part, tested examples from many places.

Dürer's suggestions and plans for the construction of a fortified palace have been found to be of particular interest. The palace is surrounded by dwellings for every conceivable kind of artisan, so that the lord of the palace would be independent of the outside world, in peace as well as war (47). Accordingly a square installation is surrounded by walls which form yet another square. The "royal dwelling" in the center is surrounded by rectangular buildings along streets in which the remaining inhabitants of this "ideal city"

47
A City Plan
Woodcut from *Some Instruction for the Fortification of Cities, Castles and Localities,* Nuremberg (Hieronymus Andreae) October 1527, fol. D VI.

45

live. The arrangement of the dwellings around the protruding crossings of two main streets at right angles to one another derives from the layout of the camps of the Roman legions, that formed the core of many cities of antiquity, and whose form continues to exist in town plans. On the other hand, Dürer's design manifests concepts of absolute monarchy, as can also be seen in the plan of the Aztec city of Tenochtitlan. A woodcut illustration of it was included in the German translation of Hernando Cortes's report of his discovery and conquest of Mexico, published in Nuremberg in 1524. Dürer probably received the decisive stimulus, however, from Vitruvius, whom he mentions, and some Italian theoreticians. Among Filarete's unpublished treatises on architecture there is an ideal city in the form of an eight-pointed star.

In the Judgment of His Contemporaries

Long before Johann Neudörffer published his short biography of Dürer in 1547, the painter was the subject of printed appreciations by his contemporaries, and his sudden death on 6 April 1528 led to extensive eulogies. In all these the authors were of one mind on the significance of Dürer's artistic achievement and emphasized the influence of his work well beyond the borders of Germany. The highest praise accorded him came from the comparisons with the most prominent painters of the classical world, especially with the most popular of these, Apelles of Cos, about whose artistic skill many accounts were circulating. The comments on the deceptive nearness of nature in Dürer's pictures—Konrad Celtis actually reports that a dog had barked and wagged its tail at a just completed self-portrait of the master—are based on comparisons with the celebrated talents of ancient Greece and give little idea of the qualities in his work which really fascinated Dürer's contemporaries.

Erasmus of Rotterdam was an exception. In a dialogue about the proper way to speak Latin and Greek, which appeared in 1528, he came to talk about Dürer. The eminent scholar called Dürer, who had visited him in Brussels in 1520 and had drawn him (29), the Apelles of his own time, and had called special attention to his graphic representations which he praised above those of the painters of antiquity. The latter had used color to convey what Dürer had been able to express with simple black lines: shadows,

48
BURIAL RECORD OF ALBRECHT DÜRER
Large Nuremberg Burial Register 1528, "from Wednesday after Invocavit to Wednesday after Whitsuntide" (4 March to 4 June). Nuremberg, Germanische National Museum (Hs 6277). Entry: "Albrecht Dürer, Painter in Zystl Gasse." Added by another, but contemporary hand: "the outstanding artist."

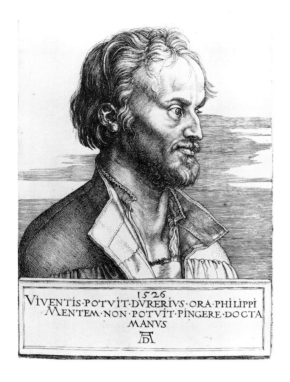

light, reflection, height and depth. If this evaluation acquires special meaning from the fact that its author took it in part from the *Historia Naturalis* by the Roman writer Pliny, it also reflects, especially in the last sentence, the deep involvement of Dürer's own time with printing. In opposing a still common practice, Erasmus spoke out against the subsequent addition of color to black and white prints by others as an injustice to the artist.

In the same work, Erasmus also praises highly Dürer's accomplishments as a writer, as Willibald Pirckheimer had done in an inscription in one of the books in his library. Philip Melanchthon (49) likewise attempted to characterize Dürer's artistic achievement by a comparison, in 1531, of the three great painters of his own time. "Dürer," he said, "painted everything raised to the sublime and achieves variety by the density of his linework. Lucas [Cranach]'s pictures are modest, and if they are impressive, they are yet quite different from the works of Dürer, as comparison shows. Matthias [Grünewald] represents the middle ground."

Dürer's contemporaries likewise spoke out about his appearance and character. The extraordinarily talented Nuremberg jurist, Lorenz Behaim, since 1504 canon in Bamberg, but earlier confidant, steward and fortifications engineer of Pope Alexander VI in Rome, prepared a horoscope of the painter after the latter's return from his second trip to Venice. Behaim's interpretation, "gained from the stars," acquires added documentary value from the fact that the two men were close friends. He expressed his satisfaction with those of the astrological conclusions correspondent with his own experiences from his association with Dürer. The chart drawn up by Behaim promised artistic genius, elegance in appearance, luck with women, financial success, and pleasure in weapons and travel. He predicted that Dürer would have but one marriage, which, given the high mortality among women at that time, made him an exception, that that although he would never be without adequate means, there would be nothing left after his death. In this latter prediction either the stars were in error or their interpreter was. Dürer was well off when he died. "Opulent," as Pirckheimer was to describe it. He left behind the sizeable legacy of 7,000 florins in cash, and property willed to his wife Agnes, who also acquired his literary and artistic estate, and to his two surviving brothers, Endres and Hans.

The appreciation accorded to Dürer's work and person immediately after his death intimates that his fame did not die with him. Eobanus Hesse (50), Professor for Rhetoric and Poetry in Nuremberg since 1526, gave elaborate expression to this idea in his eulogy, which followed classical models; he credited Dürer with representing the quintessence of the fame enjoyed by painting in his century. He wrote that whoever looks at the image of the deceased painter will say that his fame will live on forever and will earn the accolades of posterity. Hesse was referring, as the subsequent text

49

PHILIP MELANCHTHON
Below the portrait on a tablet:
1526 / VIVENTIS. POTVIT. DVRERIVS. ORA. PHILIPPI / MENTEN. NON. POTVIT. PINGERE. DOCTA / MANVS [Dürer was able to picture the features of the living Philip, but his skilled hand was unable to picture his mind]. Below, the monogram of the artist. Engraving. 172 x 126 mm.

The engraving dates from a visit of Melanchthon (1497-1560) to Nuremberg, where he advised the city council on the establishment of a free secondary school.

makes clear, to the portrait medallion by Matthes Gebel, executed in 1527; at the death of the artist it was restruck, with an appropriate inscription on its verso. Of a more personal character are the verses, albeit in Latin, with which Willibald Pirckheimer took leave of his friend. He drew consolation from a Greek epigram, saying that his friend was merely sleeping in Christ, under a flower-covered grave, but his spirit was alive.

The mention of Dürer's death in Sebastian Franck's *Chronica*, published by Balthasar Beck in Strassburg in 1531, tells how the scholarly world viewed Dürer's passing as a major event. The author, trained as a theologian and probably married to a sister of the Nuremberg painters Barthel and Sebald Beham, who were members of Dürer's circle, gave a highly appreciative description of the theoretical achievements of the painter: "So creative, artistic, in drawing, painting, and the production of woodcuts and engravings, paintings and portraits without and with color, that no one excelled him. The like in artistic skill has never before been seen, and there was simply nothing about which he did not know a great deal. Knowledgeable and inventive in construction, he knew how to design all kinds of buildings, bastions, and other monumental structures. . . . And he could depict most lifelike all kinds of battles, wars, encampments, cities, men, animals, structures, and landscapes. And he was so masterful in the use of the compass that he could relate all members of the human body and all things large, long, thick and broad to one another. About this he wrote a marvelous book, incomplete at the time of his death, that bears witness to the scope of his knowledge. . . . He also understood perspective so well that it is not inappropriate to call him a master of geometry and arithmetic."

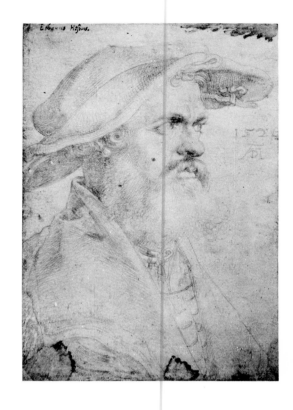

50
EOBANUS HESSE
With the monogram of the artist; above it the date 1526. Top left, in another hand: *Eobanus Hessus*. Silverpoint on prepared paper. 169 x 117 mm. London, British Museum.

The person depicted, Helius Eobanus (Koch) (1488-1540), called Hesse after his birthplace, humanist and poet, was in 1526 a teacher at the school established in Nuremberg by Melanchthon. Upon Dürer's death he composed a eulogy in Latin. Later he assisted Joachim Camerarius with the Latin edition of Dürer's book on proportion (cf. 38).

THE NUREMBERG ENVIRONMENT

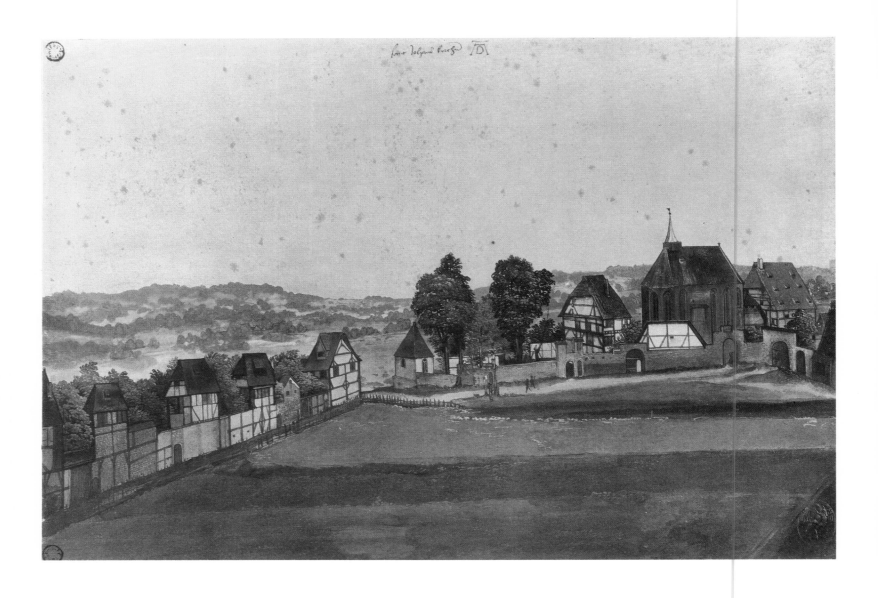

Industry and Commerce

The genius of Albrecht Dürer cannot be explained solely in terms of the artistic traditions of Nuremberg. The artist was far too independent of the local customs and practices in the creation of the visual products of craftsmanship. Still, the intellectual and economic position of the city contributed in a significant way to the development of his personality and the evolution of his artistic goals. Aeneas Silvio de Piccolomini, later Pope Pius II, a prominent diplomat and intellectual familiar with Germany, in his description of Germany called Nuremberg the hub of the Empire (69). Piccolomini's book, *Germania*, published in 1496 in Leipzig, presented the Germans with an image of their culture, their material well-being and their artistic and intellectual creativity. The astute author contributed significantly to the development of a German national consciousness. The important central position of Nuremberg — twelve major highways came together there in the 15th century — not only provided major advantages for the commercial connections spreading outward from the city in all directions, but also made the city a focal point of the new world-outlook for which the foundations were being laid towards the end of the Middle Ages. While it is

51
THE CHURCH OF ST. JOHN
Top center: *sant Johans kirche.*
Next to it a spurious monogram of the artist. Watercolor and tempera on paper. 290 x 423 mm. Formerly in Bremen, Kunsthalle.

The view is of the Nuremberg suburb, west of the old city, together with its church and cemetary, seen from the north. For the date of this watercolor see 55.

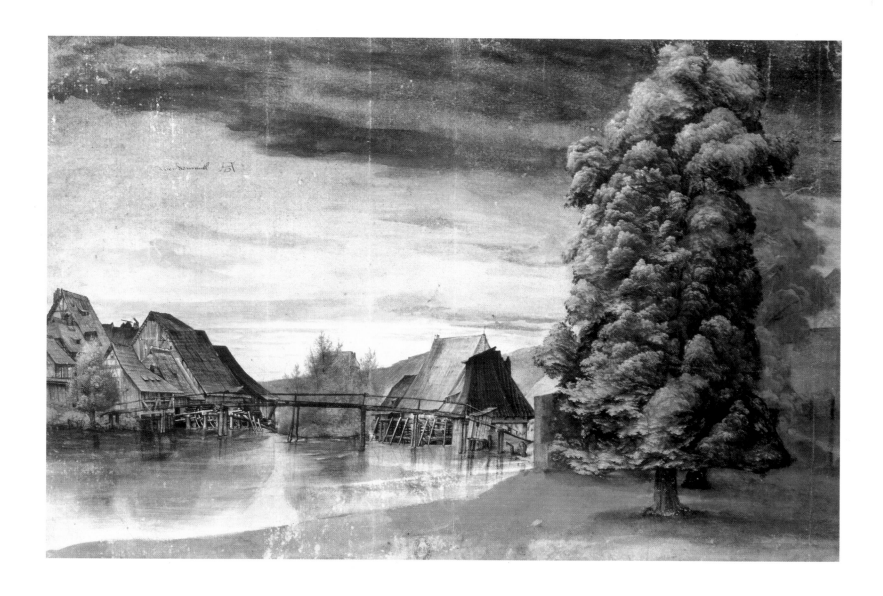

52
THE WILLOW MILLS ON THE
PEGNITZ
Inscribed in the upper left:
weidenmull. Next to it a spurious
monogram of the artist. Water-
color and tempera on paper. 251
x 367 mm. Paris, Bibliothèque
Nationale, Cabinet des
Estampes.

*The large and small "willow
mills" are depicted, seen from the
east. Fiore-Herrmann dates this
picture c. 1506 on the basis of its
stylistic autonomy, in contrast to
F. Winkler, who dated it c.
1496/97, at the same time as the
"Island Abode" (124) and the
"Forest Pond" (258), immediately
after Dürer's return from the first
trip to Venice with its booty of
landscapes in watercolor.*

true that Nuremberg remained a city in which a practical entre-
preneurial spirit and inventive skill shaped the community, never-
theless the dominant social elements, the commercial leaders, were
intellectually open-minded and conscious of the multifarious
character of their world. A prosperous economy made it possible
for Dürer and others of his generation, as it had been for their
fathers and grandfathers, to acquire a comprehensive education
abroad as a basis for a modern style of business leadership. The
principal objective of these travels were the cities of northern Italy,
which played a leading role in developing commercial and account-
ing practices suited to the times; not only that but they were the
principal agents of international monetary exchange. Thus the
young sons of Nuremberg's merchant traders were first to come into
contact with the intellectual accomplishments of the Italian
humanists, and from this new acquaintance with the writers of the
classical world developed rational methods of conducting both
business and government. Members of the leading families of
Nuremberg who elected to study theology or jurisprudence at-
tended Italian universities. Thus the grandfather of Willibald Pirck-
heimer, Hans Pirckheimer, himself the descendant of a family that
had already achieved commercial prominence in the 14th century,
and who began his career as a merchant, completed a course

of humanistic and legal studies in Perugia, Bologna and Padua, following the early death of his wife. He was later to become a member of the Nuremberg City Council. Albrecht Dürer did what all the sons of Nuremberg's leading merchant traders' families did, when he went twice to Venice, in order to learn there what no one in Germany could teach him. He sensed that these were things he had to learn, to master, even though he did not hesitate to seek work while he was abroad, in order to provide for his own support.

Nuremberg, first mentioned in 1050, had grown by 1440 to a city of over 20,000 inhabitants, a figure which by the end of the century had increased further to some 50,000. Its economic importance was based on a combination of trade and industry, with the main emphasis on mining and working metals. As early as 1363 a quarter of the 1200 artisans in the city were involved in the metal trades. Iron ore was to be had not far away in the Alb district, as well as in Upper Franconia and the Fichtel mountain range, but by the beginning of the 16th century municipal entrepreneurs dominated mining in Saxony and Bohemia as well. A new method developed around 1450 in Nuremberg made it possible to isolate the precious metal in copper ore containing silver, by means of smelting it together with lead in a liquidating furnace. This development led in time to a monopoly of the mining and marketing of copper and lead. Because of the large capital requirements, the liquidating business was financed with share certificates, or no-par mining shares, antecedents of the stocks of today's corporate world. Other mining operations did likewise. Owners of these shares included not just the leading trading families, but also well-off artisans. At least some share participation in production was, together with commercial activity, a precondition for social advance. Thus, along with many larger shareholders, the Nuremberg goldsmith Albrecht Dürer the Elder owned shares in the *Alte Zeche* [Old Mine] at Goldkronach; they had cost him 5 florins. The firm had acquired prospecting rights from the Margrave of Ansbach-Kulmbach, but the source of this information is silent about the amount of any profit. Unfortunately, this attempt by Dürer's father to join the class of investors did not pan out, as is evident from the situation of his widow, who was to be totally without means two years after his death. By contrast the son acquired capital primarily from the production of graphic works, especially the sale of his own sheets and books. In 1524 he was able to invest 1000 florins as *Ewiggeld,* a loan without termination, in the city of Nuremberg with an annual interest of 50 florins per year. It required a specific application to the city council from Dürer, who pointed out that he could "invest the money in other sound businesses but would prefer to entrust it to your excellencies," before the money was accepted and accorded the appropriate rate of interest, a circumstance that speaks well for the balanced state of the city budget.

The working of metal was carried on in hammer mills, which were to be found on the banks of the Pegnitz River in the immediate vicinity of the city, as well as upstream in great numbers in the village of Lauf. The river also powered the wire-drawing mills,

A Tournament Helmet in Three Views

Below, left, the monogram of the artist. Top center, the date 1514 by another hand; next to it on the right the monogram of the artist repeated. Watercolor and tempera on paper. 422 x 268 mm. Paris, Musée Nationale du Louvre, Cabinet des Dessins.

The impetus for this may have been the constructed helmet in Matthäus Roriczer's Geometria deutsch *(Nuremberg, Peter Wagner, 1498). Dürer used this drawing in the engraving "Coat of Arms with Rooster" and "Coat of Arms of Death," 1503 (185).*

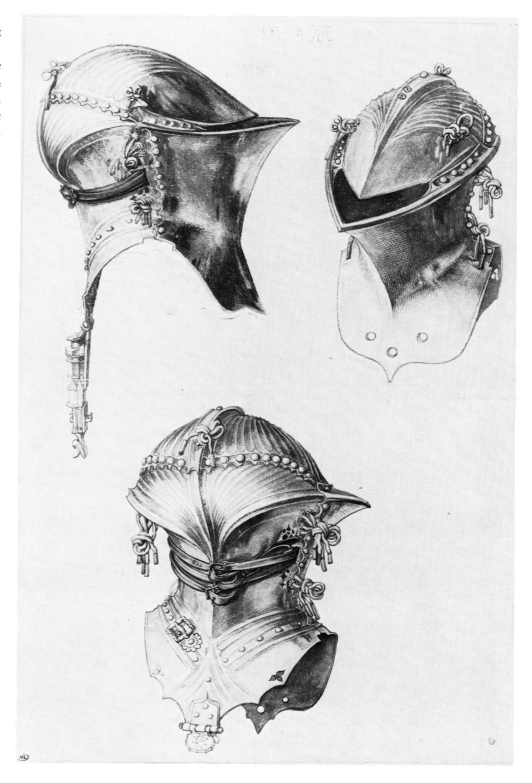

which by means of a crankshaft attached to the waterwheel drew the wire through the metal aperture. The technical equipment was a Nuremberg invention. The young Dürer depicted the building housing such an operation west of the city at that time, in the Haller-Meadow, and he labelled this watercolor "Wire-Drawing Mill" (55). Along with the contemporary depiction of St. John's Cemetery (51) the sheet is "the first autonomous portrayal of a landscape, in color, produced in the visual arts that accurately depicts a specific locality" (F. Winkler). If none of the technical equipment is to be seen in Dürer's representation, and nothing but a replacement wheel leaning

54
THE WIRE-DRAWING MILL ON THE PEGNITZ
Silverpoint on prepared paper. 151 x 228 mm. Bayonne, Musée Bonnat.

Dürer reverts to the subject of his earlier rendering (55), but has moved his point of vantage slightly to the right, thereby succeeding in achieving a unified spatial effect. No consensus has been reached for dating this sheet, but Winkler's "hardly before 1510" seems plausible.

against the wall of the building with its back to the river suggests something about the character of the business, still one cannot assume that it was merely the charm of the topography that led Dürer twice to record this scene in his oeuvre (54). The locally important character of the place must at least have played a contributing role.

The metalworking artisans of Nuremberg enjoyed the highest reputation. At the very top were to be found the makers of plate armor. Dürer's horoscope described him as a lover of weapons. His reproduction of a German tournament helmet in three views confirms this statement (53). As the careful coloring shows, he was concerned not merely with reproducing the three-dimensionality in correct perspective; the shimmer of the polished, superbly crafted metal captured his artistic fantasy.

The creation of bronze figures in Dürer's time, in the foundry of Peter Vischer and his sons, had achieved a degree of perfection that earned the bronzeworkers of Nuremberg the recognition of being superior to any others in Germany. The craft was an outgrowth of a long tradition based on the existence, nearby, of lime that was rich in clay and was particularly well suited for casting in bronze. The thin walls of the castings, which were achieved by the hollow form process, reduced the weight, resulting in a saving of metal used, and therefore costs. The city attempted to assure the continuance of its monopoly by forcing the bronze casters to remain in the city, and by preventing the export of the clay as much as possible. In return the City Council protected the casters from unfair competition within the city's walls.

When Emperor Maximilian I planned his own memorial during his lifetime and commissioned the sculptor Veit Stoss to design the figures which were to decorate the monument, his agents had to use every means at their disposal to persuade the city to allow Stoss,

55
THE WIRE-DRAWING MILL ON THE
PEGNITZ
On top in black ink: *trotzich müll.* Watercolor and tempera on paper. 286 x 426 mm. Berlin, Staatlicher Museen Preussischer Kulturbesitz, Kupferstich-kabinett.

Winkler dated the earliest water-colors to the summer of 1494, i.e., "The Wire-Drawing Mill" and the one immediately before it, "The Church of St. John." This was the time of the artist's stay in Nuremberg after his return from his years of travel as a journey-man. Fiore-Herrmann advances new arguments for a date prior to his journeyman travels. Based on the full treatment of the tree leaves, she proposes the summer of 1489.

who wanted to cast the figures himself, to negotiate with the cop-persmiths in order to obtain a one-time exemption from the rule. Albrecht Dürer also contributed to this memorial, in Innsbruck, which was completed long after the death of the Emperor. The memorial itself includes larger-than-life bronze figures of Maxi-milian's ancestors, whom the historian Johannes Stabius had traced back into the prehistoric past. They follow in a massive funeral pro-cession. Busts of the Roman emperors are meant to suggest Maxi-milian's precursors on the imperial throne. Dürer was commis-sioned to design the figure of King Artus and of the Ostrogoth king Theodoric, the legendary Dietrich of Bern. Both bronze figures carry the mark of the foundry of Peter Vischer, and display a significantly different casting technique from that of the foundry established by Maximilian at Mühlau near Innsbruck. A further design by Dürer, for a figure of Charlemagne, was never executed.

55

Nuremberg's masters in the art of working precious metals were dominant in Germany until the second half of the 16th century. Their productions were exported all over the world. Religious objects were fabricated in these workshops as well as jewelry made of gold and silver, ceremonial goblets, and table decorations. Huge treasures of silverware accumulated in the houses of wealthy citizens of Nuremberg, in some cases even items of pure gold. In 1492 Albrecht the Elder unpacked his wares before the Emperor Frederick III, presumably displaying figures made of precious metal, and thereby won the honor of a long conversation. However, he was unable to report to his wife that the noble gentleman had in fact made any purchases. If a goldsmith created articles not of his own design, there were plenty of patterns available. Martin Schongauer, the son of a goldsmith, had a number of such designs engraved on copper and printed—designs which were doubtless well known in the workshops of Nuremberg.

It is very likely that Dürer, probably instructed by his father in the proper techniques of the goldsmith and the potential of the material, was asked by goldsmiths known to him through his father to draw designs. In the *Manual of Measurement* he included the design of a richly decorated bishop's staff. The so-called *Dresden Sketchbook* includes a sheet with designs for goblets which show a marked preference for motifs drawn from the plant world and reproduced in lifelike form, such as tree trunks, roots and branches for the bases, apples and pears for the dome-shaped tops (56). The observation in Dürer's own hand, "tomorrow I will make more," suggests that the sketches were destined for a goldsmith. Well-executed designs have also survived, for table decorations incorporating various figures, as well as for table fountains. One can ascribe to Dürer a goblet dating from his time, in the Germanisches Nationalmuseum in Nuremberg; it follows closely a design in the *Dresden Sketchbook* in the shape of an apple supported by a stem, covered with leaves. It does not appear likely, however, that the painter himself produced objects in gold, even if a connoisseur like Joachim von Sandrart, writing in 1675, ascribed to Dürer a drinking vessel with engraved representations of the seven stations of the Cross. This assertion appeared in Sandrart's book, *Academie der Bau-, Bild- und Mahlerey-Künste.*

Mathematics and Astronomy

The outstanding products created by the Nuremberg metalworkers included precision instruments for measuring the earth and the heavens. Important astronomers, mathematicians and geographers were drawn to the city on account of skilled constructions of this

56
SIX GOBLETS
Bottom right: *morgen willich so mer/machn.* Pen and ink, 200 x 285 mm. Dresden, Landesbibliothek.

From the so-called Dresden Sketchbook *(fol. 193r). Since a similar goblet recurs in "The Babylonian Whore" (cf. 309), the drawing, which was probably intended for a goldsmith friend of Dürer's, can be dated 1500/03.*

sort, as well as by the highly productive publishing industry and the interest of the merchant traders in any possible improvement of land and water transport. Johannes Müller — called Regiomontanus — from Königsberg in Bavaria was the dominant figure. This learned man was busily at work in Nuremberg from 1471 until he was called to Rome to collaborate in the planned calendar reform in 1476. With the help of his student and benefactor, Berhard Walther, he established an astronomical observatory. His ephemerides, published in Nuremberg, show the daily phases of the moon and the planets for the years 1474-1506, and together with his improvement of the so-called "Jacob's staff" for measuring the distance between stars — its use was explained in a woodcut by Dürer's student Hans von Kulmbach in 1502 — made possible the charting of positions on the high seas and thus laid the basis for the voyages of discovery.

Nuremberg produced, for the first time since antiquity, a plastic representation of the earth in the form of a sphere; according to data provided by the patrician Martin Behaim, it was made in 1492. The "earth apple" was created at the instance of three members of the Nuremberg City Council and was presumably designed to demonstrate actual and possible commercial routes. Underlying this new representation of the earth were "Portulan Charts" used for navigation between the ports of the Mediterranean. The partially forgotten knowledge that the ancient world had had of the appearance of the earth and the nature of space was brought back to life by the translation and publication of Ptolemy's two great works, *Almagest*, edited by Regiomontanus in 1496, and the *Cosmographia* or *Geographia*, which appeared in the edition of Nicolaus Germanus in 1477 in Bologna, and in 1482 and 1486 in Ulm. Willibald Pirckheimer added a woodcut by Dürer of the armillary sphere, an idealized schematic construction of the circles thought to exist in the heavens, to his edition of the *Geographia* that appeared in Strassburg in 1525.

Albrecht Dürer was not merely personally linked to the circle of geographers and mathematicians, he was also well informed on the issues they dealt with. His advice on the construction of sundials is the first extensive printed treatment of the subject to appear in German. His workshop also produced the woodcuts for the celestial maps of the Nuremberg mathematician and astronomer Konrad Heinfogel (57-60). Dürer also drew the curves for the calculations of the position of the sun for the so-called *Horoscopion* which Stabius dedicated to Emperor Maximilian I and to the humanist and imperial diplomat Jacob de Pannissis. On 14 June 1509 Dürer acquired the house in which Regiomontanus and Bernhard Walther had worked, though the latter had died in 1504; Dürer lived there and worked there until his death. From the library of Regiomontanus and Walther, which was kept in the house and was administered by Willibald Pirckheimer, he purchased ten books in 1523, books "which are useful for painters and had been appraised by Willibald Pirckheimer, and for them I paid 10 florins." The proceeds of the sale were contributed to "General Charity."

57

MAP OF THE NORTHERN SKY
By a Nuremberg astronomer
(Konrad Heinfogel?) with addi-
tions by Albrecht Dürer. Pen and
brown ink on vellum, heightened
with silver and gold; the raven
beside Apollo and the eagle
beside Jupiter are in pen and
black ink by Albrecht Dürer. 674
x 672 mm. Nuremberg, German-
isches Nationalmuseum.

(Cf. 58.)

58

MAP OF THE SOUTHERN SKY
By a Nuremberg astronomer
(Konrad Heinfogel?). Top left
the crest of the city of Nurem-
berg; right, the crest of Konrad
Heinfogel, and *ANNO.DO.
MDIII.* Pen and brown ink on
vellum, the crests in tempera.
669 x 670 mm. Nuremberg, Ger-
manisches Nationalmuseum.

*(Cf. 57.) Both maps probably
served Dürer as models for his
celestial charts of 1515 (cf. 59,
60).*

59

Map of the Northern Sky

On top: *Imagines coeli Septentrionales cum duodecim imaginabus zodiaci.* In the corners (clockwise), the astronomers Aratus Cilix, Ptolemaeus Aegyptus, Azophi Arabus (Addorrhaman al-Sufi), and 'M. Manlius Romanus. Colored woodcut. 430 x 430 mm. Munich, Staatliche Graphische Sammlung.

60

Map of the Southern Sky

Top: *Imagines coeli Meridionales.* Top left, the crest of Cardinal Lang von Wellenburg; top right, the dedication to him. Bottom left: *Johann Stabius ordinavit/Conradus Heinfogel stellas /posuit/Albertus Durer imaginibus/circimscripsit.* Below are the coats of arms of those named. Bottom right, the imperial copyright and the date 1515. 427 x 431 mm. Munich, Staatliche Graphische Sammlung.

Printing and Publishing

The rapid rise in Nuremberg of printing with cast, movable letters, the invention of Johann Gutenberg, can be readily explained by the long-standing familiarity by the city's artisans with metals, a well established production of paper, and the high cultural level of a substantial proportion of its citizens. The publishers of the city succeeded, towards the end of the 15th century, in acquiring a leading position, especially in the printing of illustrated works. It was in nearby Bamberg, seat of the bishopric, within which Nuremberg was located, that a lively interchange of artistic ideas occurred. And it was there that the first book printed with movable letters and woodcut illustrations was published by Albrecht Pfister in 1461. Prior to this, in the first half of the century, only "block books" had appeared; these contained, in addition to the picture, words of text cut into wood blocks. The printing of woodcuts, like that of type, is done with raised lines. The form-cutter leaves standing only the lines of the drawing like in a rubber stamp. Everything else is cut out to a depth of a few millimeters by a knife or with hollow and flat carving tools. After inking, paper and block are brought together under the high pressure of a press. Once some of the initial difficulties had been overcome, it became possible to print pictures and letter text jointly in a single procedure. In Nuremberg, Johann Sensenschmidt introduced the promising new procedure and in 1475 published a two-volume collection of legends about the saints. Less is known about the makers of the woodcuts than about the printers, who had to be either well capitalized by themselves or be assured of the proper financing. The rendering of a woodcut illustration required several steps and types of labor. The initial sketch that established the subject and its composition was followed, in some cases, by a model drawing, the transfer to the block, and finally the cutting. Some prints were subsequently colored, since the figures were in the early years drawn with few interior lines and demanded a coloring process. In the single-leaf prints of the early 15th century, the first artistic examples in this medium, the various stages of the manufacture were very possibly carried out by one and the same person. But it was not long before specialization set in and the draughtsmen were distinctly separate from the form-cutter and the colorist. A major advance leading to the artistic autonomy of the woodcut occurred when panel painters recognized the potential of the process and began to exploit it. This happened in Nuremberg in the workshop of Michael Wolgemut under the eyes of his apprentice, Albrecht Dürer, and many believe with substantial assistance from him (61-63). At the outset, Dürer based his own woodcuts on two works: The *Schatzbehalter*, published by Michael Wolgemut with his stepson Wilhelm Pleydenwurff in 1491, a "treasure chest," as indicated by its title, of sermons by the Franciscan friar Stephan Fridolin (88), replete with full-page illustrations; and the *Nuremberg Chronicle*, edited by the Nuremberg humanist and city physician Hartmann Schedel, with 645 illustrations (64, 90). The press

61
THE FLIGHT INTO EGYPT

62
THE ENTOMBMENT
Attributed to Albrecht Dürer while apprenticed to Michael Wolgemut. Woodcuts from Bertholdus, *Horologium deuotionis.* Nuremberg, Friedrich Creussner, 11 May 1489.

E. Holzinger identified the designer of this devotional book as the young Dürer.

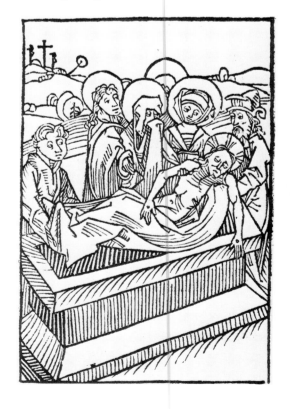

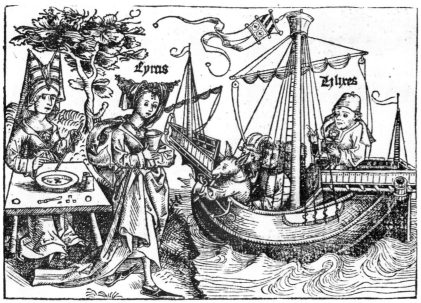

63

ULYSSES AND CIRCE
Ascribed to Albrecht Dürer while in Wolgemut's workshop. Woodcut from Hartmann Schedel, *Liber chronicarum* [The Nuremberg Chronicle], Nuremberg, Anton Koberger for Sebald Schreyer and Sebastian Kammermeister. 12 July 1493.

By 1490, at the latest, work had begun on the many illustrations for the Nuremberg Chronicle. *Panofsky and Sladeczek see Dürer's hand in this and several other woodcuts in this book, while he was apprenticed to Wolgemut (cf. 64, 90).*

64

GOD THE FATHER ENTHRONED
Michael Wolgemut.
Woodcut from Hartmann Schedel, *Liber chronicarum.* Nuremberg, Anton Koberger for Sebald Schreyer and Sebastian Kammermeister, 12 July 1493.

Wolgemut's preparatory drawing, dated 1493, is preserved in London, British Museum. (Cf. 90, 63).

date for the Latin edition was July 12, for the German edition, translated by George Alt, December 23, 1493. However, it is quite possible that the work on these was begun as early as 1487/88, at a time when Dürer was present in the workshop. The printer of both books was Anton Koberger, Albrecht's godfather.

The designs by Wolgemut and his co-workers for the decorative illustrations represented a change from simple contour drawings, subsequently enhanced by coloring, to pictorial compositions based on the rules of panel painting (89). In place of the color there are black and white values, achieved by hatching, that also made possible a plastic treatment of the subjects depicted, and enabled the artist to introduce degrees of shading. The fully finished preparatory drawing for the frontispiece of the *Nuremberg Chronicle* has survived, in the British Museum in London, and makes clear what Wolgemut demanded of his form-cutters. The necessary refinement of the cutting technique was only possible by close collaboration between artist and cutter. Wolgemut must have gone to some trouble to establish it. Since the printing process produces a mirror image, the fact that no such reversal occurs between the draft of the title

page and the illustrations of the book leads to the conclusion that in drawing on the block the artist reversed every line. This conclusion is supported by several other preliminary drawings which exist only in broad outlines, and have recently turned up in the Nuremberg municipal library.

The sequence of this complicated process, which depended on dividing the work among several specialists, becomes somewhat clearer in the execution of numerous commissions given Albrecht Dürer by Emperor Maximilian I in the years after 1512 for the purpose of honoring his dynasty and his person. The "Triumphal Arch," depicting Maximilian's own deeds and those of his ancestors, was printed from 192 large wood blocks. From the coats of arms depicted, from the variations in style, and from deductions based on documents relating to the work, the procedure was seemingly as follows (65-67): Dürer prepared sketches based on material supplied by the historian Johannes Stabius and some preliminary drawings by the court painter in Innsbruck, Jörg Kölderer; only three of Dürer's sketches have survived (in the British Museum, London, and in the Dresden Print Room), however, they suffice to give one an idea of this stage of the work. Dürer personally transferred the designs to wood blocks only in a small number of cases. But the high quality of some portions, and the ornamentation that pervades the entire structure, suggests the careful supervision of the master. His own work served as model for his assistants, Wolf Traut and Hans Springinklee, who carried out the remainder of the work. The task of cutting the blocks on which the designs had been drawn was carried out by the form-cutter Hieronymus Andreae and his assistants. The printing, at least of the sample copies that were to be delivered to the Emperor, must have been carried out in Dürer's own workshop. The division of the work went so far that the drawings for the two towers flanking the structure were produced by the Regensburg painter Albrecht Altdorfer. They were probably later additions, and meant to portray the private life of the Emperor. The year 1515 on the base probably indicates the date of completion of the design. Several changes demanded by Maximilian caused a postponement of the printing until 1517/18.

65
EMPEROR MAXIMILIAN I AND HIS FAMILY
Detail from "The Triumphal Arch of Emperor Maximilian I" (cf. 67).

66
ALLEGORICAL-SYMBOLICAL DECORATION
Detail from "The Triumphal Arch of Emperor Maximilian I" (cf. 67).

67
THE TRIUMPHAL ARCH OF EMPEROR MAXIMILIAN I

Albrecht Dürer, Hans Springinklee, Wolf Traut, Albrecht Altdorfer. Dated 1515. Bottom right, the coats of arms of Johannes Stabius, Jörg Kölderer and Albrecht Dürer. Woodcut, printed from 192 blocks. 293 x 304 cm.

Among the decorations of this Triumphal Arch, modeled after one of Roman times, is Emperor Maximilian shown enthroned in the middle with the members of his immediate family below him, and surrounded by the coats of arms of the House of Hapsburg's principalities as well as those of the acquisitions through marriage with the Burgundian and Spanish heiresses. Twenty-four important events from the reign of the emperor are pictured above the side portals, and scenes from his youth are depicted on the two round towers. The latter were drawn with the assistance of Albrecht Altdorfer. Busts represent Maximilian's predecessors in the domination of Italy and the princes related to the Hapsburgs by marriage. The first edition appeared in 1517/18.

63

The Economic and Political Position of Nuremberg in Dürer's Time

The artistry and skills which made the pictorial decoration of Schedel's *Nuremberg Chronicle* possible were obviously to be found only in a city that could support such projects repeatedly. In the second half of the 15th century Nuremberg was favored in considerable measure by the economic prosperity enjoyed by many other German cities. By the beginning of the 16th century Nuremberg had gained a significant increase in territory at the expense of the Upper Palatinate by participating in the wars of the Bavarian Succession. It now controlled six towns and several marketplaces, as well as numerous smaller communities.

In 1439 construction had begun on the East Choir of St. Lawrence Church. In 1477 this structure became a large extension of the original high Gothic main sanctuary. In 1479-85 followed the construction of the church of the Augustinian Order (razed in 1816.) These two projects completed the major architectural goals of the city. Thanks to the wealth and the readiness of the citizenry to make charitable contributions, these churches were equipped with artistically created windows, and a large complement of altars and memorial pictures. Even the Emperor, as well as several princes, contributed funds for memorial windows. Michael Wolgemut's workshop and Albrecht Dürer and his pupils, Hans Baldung Grien and Hans von Kulmbach, were involved in preparing designs for windows.

Commercial and family contacts with the Nuremberg merchants played a role in awarding commissions to the painters and sculptors of the city even for altarpieces for churches in distant cities. For example, Hans Pleydenwurff painted the wings of the high altar of St. Elizabeth's Church in Breslau, and in 1462 installed them personally. His successor in the workshop, Michael Wolgemut, delivered an altarpiece for the Church of Our Lady in Zwickau with four movable and two fixed wings. This project was completed in 1479 and earned its creator 1400 florins. Of this sum, however, numerous participants in the project received a portion: the journeymen to whom a portion of the painting was entrusted, the joiner responsible for the basic construction, the sculptor who produced figures erected in the shrine as the facette painter, and finally the artist who applied the gilding to the shrine and framework. The owner of a late medieval painters' workshop obviously also served as contractor and needed to coordinate well the work of many others.

Those masters who produced artistic items in metal, in particular copper bowls with figural ornamentation, could not have survived without an export market. This market was equally essential for foundries producing cover plates for tombs, fountain figures, and even ink wells. The financial resources of the patriciate also helped

64

68
THE COVERED FOOTBRIDGE AT THE
HALLER GATE IN NUREMBERG
Pen and ink on paper with
touches of watercolor. 160 x 323
mm. Vienna, Graphische Samm-
lung Albertina. C. 1500.

*Behind the footbridge appears
the city wall above the river,
with the Schleier Tower built on
an island. On the right, in the
background, appears the spire of
the New Gate. Beyond the city
wall may be discerned the
Pilgrim Hospital of St. John with
the Church of the Holy Cross.*

grace the city by providing large sums for the construction and fur-
nishing of churches, abbeys and elegant residences. In turn, the
city's artists benefited from these commissions. Nevertheless, the
generally favorable position of the Nuremberg craftsmen should not
be overrated; the wage earners involved in mass production, the
journeymen, and those workmen being paid piece-rates encoun-
tered difficulty in earning enough to support a family. If they suf-
fered illness or accidents, or indeed any other unexpected dif-
ficulties, they were dependent on public or private charity. An
order of the City Council in 1522 reveals that even a citizen express-
ly named as "Albrecht Dürer's relative," was not immune. He was
expelled from the city for begging, but was allowed to return, pro-
vided he stopped asking for alms except by a special permit,
evidence of which was a metal tag that he could purchase for a small
fee. In sum, as much as a third of the citizenry could be driven to
appeal for public assistance in periods of crisis, such as of wars
which throttled commerce. Only because the City Council kept a
firm hand on the tiller and maintained a well organized system of
welfare did the city escape from the conflicts which social unrest
could easily bring about during the political and religious turmoil of
the era.

But the artisans were not allowed to participate in determining
the destiny of the city. In 1348, an uprising led by members of the
metalworking crafts succeeded in disbanding the existing City
Council and establishing in its place one composed equally of crafts-
men and members of the leading families. However, this develop-
ment was closely linked with the conflict of the imperial succession

between Charles IV of Luxembourg and the son of his predecessor, Emperor Louis of Bavaria. After Charles had succeeded in consolidating his position, in 1349, he forced the return of the old power structure, and the City Council was restored to its former position. Thenceforth a few families which, economically, constituted the upper class of the city retained firm control of the city's political institutions.

In 1521, forty-two prosperous families, all of them genealogically qualified as political leaders, formed a patriciate, to which subsequently only one additional family was admitted, namely the Schlüsselfelder's. Only members of these families could hold the highest offices of the city, and the "Inner Council" was recruited from them. Three to four hundred other families, mostly related by marriage to the patriciate, were accorded the status designated as "honorable." They provided the membership of the "Greater Council." He accompanied the representatives of the city to the meeting of the Imperial Diet in Augsburg in 1518, and in 1519 accompanied Willibald Pirckheimer and Martin Tucher on an official journey to Zürich, in Switzerland. At Brussels, in 1520, he was attached to the city's diplomatic mission who were charged with bringing the imperial regalia from safe-keeping in Nuremberg to the coronation of Emperor Charles V. In that capacity, Dürer took part in the ceremony at Aix-la-Chapelle, and subsequently accompanied the mission to Cologne. All expenses were borne by the city "and they refused to accept anything from me," he noted with satisfaction in his diary.

Further evidence of the artist's special position in the city is provided by a decision of the Council in the matter of a violation on the part of the artist of the building code. As a property owner he was required to pay the fine, but it was returned to him in the form of an award.

The Emperor and the Imperial City

69
VIEW OF NUREMBERG FROM THE
SOUTH
Wilhelm Pleydenwurff and
Michael Wolgemut. Woodcut
from Hartmann Schedel, *Liber
chronicarum.* Nuremberg, An-
ton Koberger for Sebald
Schreyer and Sebastian Kammer-
meister, 23 December 1493.

The Nuremberg Chronicle,
*which appeared in both a Latin
and a German edition in 1493,
includes an account of the
economic and political condi-
tions of Nuremberg.*

On account of its central location, the emperors attached much im-
portance to the city of Nuremberg in their political considerations;
and they endowed it with many privileges. For its part, the city
always felt threatened by the encroachment of powerful neighbor-
ing princes, such as the Margrave of Ansbach-Bayreuth and the
House of Wittelsbach of Bavaria. It therefore placed great emphasis
on good relations with the head of the empire. The *caput imperii
fidelissimi cives,* a name conferred on the citizens of Nuremberg in
an official document of the 13th century, demonstrates imperial
trust at an early date. Further evidence of this was the decision of
King Sigismund in 1424 to entrust the imperial regalia for safe-
keeping to the city. These included a number of relics, among them
the venerated Holy Lance with a nail from the Cross embedded in
its tip.

67

70
EMPEROR CHARLEMAGNE
Inscribed: *Karolus magnus/ imp*[er]*avit Annis. 14.* Above the head of the emperor the German eagle and the fleur-de-lis of France on escutcheons. Explanatory text in the frame and on the verso of the panel. Oil on lindenwood. Including the frame, 215 x 115.3 cm. Nuremberg, Germanisches Nationalmuseum (Loan from the City of Nuremberg).

Commissioned, together with the portrait of Emperor Sigismund, by the city council of Nuremberg for the Treasure Chamber in the Schopper House on the market square, where the imperial regalia were kept for annual display. Dürer received his payment on 16 February 1513.

71
EMPEROR SIGISMUND
Inscribed: *Sigismu*[n]*d*[us] *imp-*[er]*avit/Annis. 28.* On top, the crests of the Empire and Bohemia, the two escutcheons of Hungary, and the crest of Luxembourg. Explanatory text in the frame and on the verso. Oil on lindenwood. Including the frame, 214.6 x 115 cm. Nuremberg, Germanisches National- museum (Loan from the City of Nuremberg).

72
EMPEROR MAXIMILIAN I
The coat of arms of the Empire, with the crest of the House of Hapsburg on the eagle's breast. The coat of arms is surrounded by the collar of the Order of the Golden Fleece, and surmounted by a crown. The inscription above is on an attached piece of vellum. Oil on canvas. 85 x 65 cm. Nuremberg, Germanisches Nationalmuseum.
A later version is in Vienna (78, 82).

69

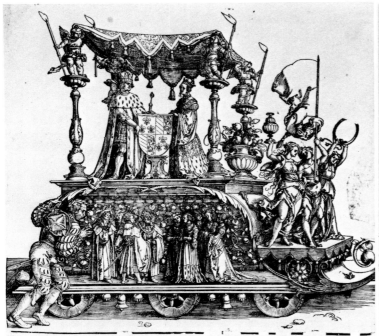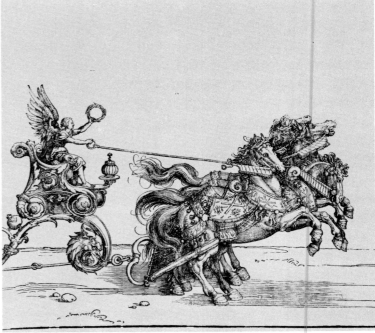

In the year when the regalia and relics were transferred to the city, the bishop of Bamberg granted Nuremberg the right to display them on the feast day of the Holy Lance, the Friday following Easter, to be accompanied by a high mass and a public sermon. The ceremonial display, that became the occasion also of an annual fair, took place on the central marketplace. A wooden platform on the west side of the marketplace was erected in front of a house that had belonged successively to members of the Schopper, Behaim and Fütterer families. It was accessible through a window of the house, and the room in which the window was located was called the "treasure chamber." The relics from the Church of the Hospital of the Holy Ghost were brought to it on the day before the public display. The city commissioned Dürer to paint larger-than-life portraits of Charlemagne and Emperor Sigismund, to be displayed in this chamber (70, 71, 77). The honorarium, 85 florins, was paid Dürer in 1513. Appropriate inscriptions on the frames, embellished very elegantly in lapis lazuli, and on the versos of the panels inform the beholder, in the case of Charlemagne, about the source of his crown and his imperial garb, and in the case of Sigismund about the transfer of the treasures from Bohemia to Nuremberg. The fact that the information was repeated on the reverse side of the pictures suggests that they were hinged to the wall. The sides showing the portraits of the emperors were meant to be viewed on the day of the display, by a limited group of individuals who had access to the "treasure chamber."

The painter regarded the imperial crown, sword, scepter and coronation robes, reminiscent of liturgical garb, as of great historical importance, and therefore had scrutinized the originals very closely

73
MAXIMILIAN AND MARY OF BURGUNDY IN THE TRIUMPHAL CHARIOT
Woodcut from "The Triumphal Procession of Emperor Maximilian I." 405 x 434 mm.

"The Small Triumphal Chariot," cut in wood by Hieronymus Andreae c. 1516/18, pictures the engagement of Maximilian with the daughter of Charles the Bold on 31 January 1476 or the wedding on 19 August 1477. It is Dürer's only contribution to the series of woodcuts forming "The Triumphal Procession"; it was published in 1526 (cf. 74).

74 ←
VICTORIA STEERING THE FOUR-HORSE TEAM OF EMPEROR MAXIMILIAN I
Woodcut from "The Triumphal Procession of Emperor Maximilian I." 415 x 520. (Cf. 73.)

in order to reproduce them with great exactitude in the painting of Charlemagne. In the case of Sigismund, Dürer had the benefit of a portrait of the Emperor in the form of either a medal or a woodcut based on a portrait in relief, and these guided in the depiction of his characteristic features, his high forehead, large nose, divided beard, and the twirled mustache. For Charlemagne Dürer created an idealized likeness, a God-the-Father type, personified in the features of Johannes Stabius, the Imperial Historiographer (Stabius had already served Hans Springinklee as a model for a woodcut of St. Coloman). This ideal likeness had such a powerful influence that well into the 19th century it determined the popular conception of Charlemagne's appearance. Following the Reformation, the liturgical display was terminated in 1525, and the imperial portraits were moved to the City Hall. This transfer had no effect on the continued interest in the imperial likenesses nor in the work of Dürer. In 1532 the painter Georg Pencz was commissioned by a Saxon prince to copy the portraits produced by his teacher, and was given official permission to do so.

Of the princes of Dürer's time, it was Maximilian I who most frequently came to Nuremberg and remained there the longest. He was there for a full five months in 1491, as the representative of his father, Frederick III, at the meeting of the Imperial Diet. Early in 1512, after he had received the imperial title, he resided there again for two months. This latter visit of the emperor to Nuremberg was of special significance for Albrecht Dürer. He was then entrusted with the artistic direction of the most important of the projects through which Maximilian proposed to immortalize himself. The tie between the emperor and the painter was probably established by the imperial literary advisors, Provost Melchior Pfinzing, Johannes Stabius, and Willibald Pirckheimer. Konrad Peutinger of Augsburg may also have played a part, for he was responsible for contributions by Suabian artists. Maximilian's death, and the lack of interest on the part of his grandson and successor, Charles V, had the result that a portion of the work remained incomplete.

The most comprehensive of these projects was a woodcut sequence portraying a triumphal procession patterned on those of victorious Roman emperors. Led by Perceo, astride a griffin, trumpeting the fame of the emperor in all directions are the princes of Germany and the members of the court. Floats show the military accomplishments of the Emperor in pictures and in groups of individuals. His ancestors are represented by figures from the tomb in Innsbruck. The procession ends with the train of the army. The series was incomplete at the time of Maximilian's death (12 January 1519). Nevertheless an edition was pulled in 1526 from the not yet fully cut blocks. The 137 individual sheets placed next to one another extend to a length of 54 meters. The greatest number of the designs were the work of the Augsburg artist Hans Burgkmair, based freely on preliminary ones by the court painter Jörg Kölderer. Dürer himself was involved only in the creation of one of the carts,

75
TOURNAMENT:
FREYDAL HAS KNOCKED FIRMIAN FROM THE SADDLE
Below on an attached strip of paper: *Hanns Glaser Brieffmaler zu Nürnberg am Panersberg.* Woodcut. 226 x 243 mm. Nuremberg, Germanisches Nationalmuseum.

In the novelized biography of Emperor Maximilian, entitled Freydal, *the tournaments and masquerades in which the emperor had taken part were to be immortalized. Of the 255 miniatures for a Codex without text (Vienna, Kunsthistorisches Museum), only 5 were converted into woodcuts. Among these only this one has been positively ascribed to Dürer.*

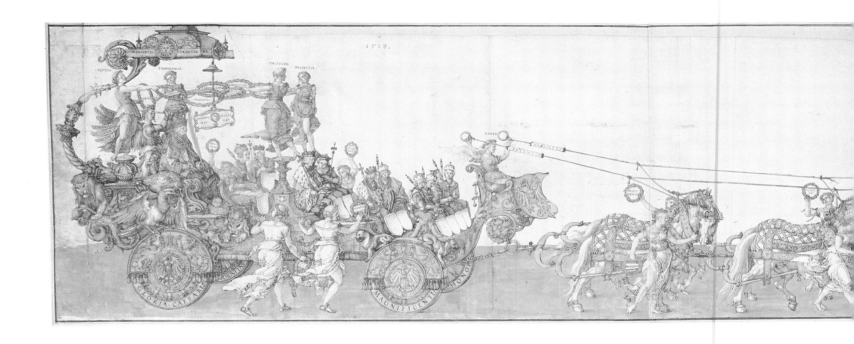

the one that depicted the event which for Maximilian was the most important of his life, personally and politically, his marriage to Mary of Burgundy, the daughter of Charles the Bold (73, 74). Victoria is steering the team of four horses which pull the chariot, in which Mary of Burgundy and her bridegroom stand under a canopy; jointly they hold the coat of arms displaying the linked fleur-de-lis of France and the lion of Flanders. The high point of the procession, which Albrecht Dürer was to provide, the march past of

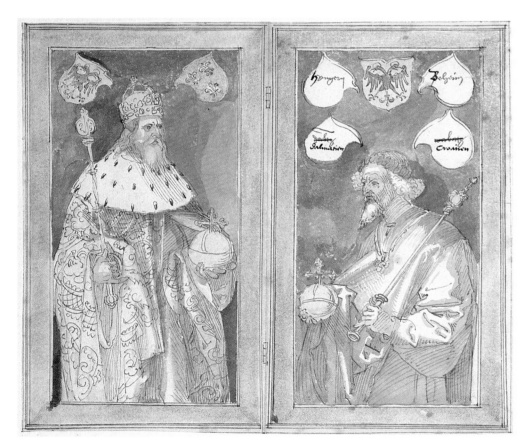

77
MODEL FOR THE PORTRAITS OF THE EMPERORS
Pen and ink on paper, with watercolor. London, Courtauld Institute, Count Seilern Collection.

The design shows a diptych consisting of two hinged panels. The emperors face each other.

72

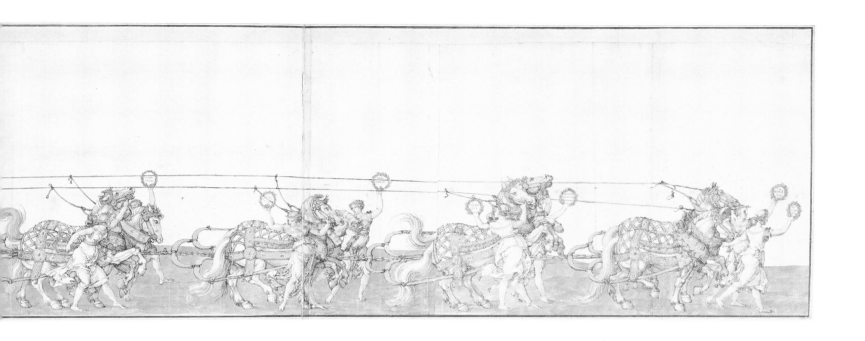

the victor, is lacking. Only a colored model drawing remains, which was sent to the Emperor in 1518 for his approval, accompanied by Willibald Pirckheimer's emphatic remark that it was done by Dürer personally (76).

In 1522 Dürer arranged for the printing of only the triumphal chariot on his own, independent of the fate of the entire procession (1). It appeared on eight sheets. Willibald Pirckheimer supplied the program and the comprehensive explanatory text, printed with movable type. Protected by personifications of his virtues, the Emperor sits on a chariot drawn by twelve horses, which are emblematic of other qualities of the ruler. The original design had called for inclusion of the imperial family, showing Mary of Burgundy, their daughter Margaret, regent of the Netherlands, their son Philip with his wife, Joanna of Castile, as well as the grandsons Charles and Ferdinand and the granddaughters. But these were eliminated in the woodcut version. Here the Emperor sits alone, as ruler, in a ceremonial carriage crowded with emblemata.

Maximilian had entrusted reproductive arts, "the press" of his day, to spread his fame and that of the House of Hapsburg in a way that strikes us as exceedingly modern. This is exemplified by a Prayer Book, intended for his personal use; the decorative pictures form a connection between the new art of printing and the older tradition of Books of Hours, which had formerly been produced individually on commission, and were usually richly decorated (80, 81). Illuminated manuscripts were still common in the 16th century among religious princes and other wealthy patrons. The emperor's collection of prayers, hymns and psalms was printed in 1513 in black and red on vellum by Johann Schönsperger in a Gothic type designed by the imperial secretary, Vincenz Rockner. Only ten

copies were planned, it appears, and they were intended as gifts for selected members of the Order of the Knights of St. George, founded by Frederick III in 1469 and supported by Maximilian as a society devoted to fend off the Turks. Six of these have survived, among them the copy intended for the Emperor. They were entrusted consecutively to several artists who provided marginal decorations for the printed text. Among those participating, besides Dürer, were his student Hans Baldung, Lucas Cranach the Elder, the Augsburg artists Hans Burgkmair and Jörg Breu, as well as Albrecht Altdorfer in Regensburg. Konrad Peutinger of Augsburg functioned as coordinator between the Emperor and the various artists. Since the unity of the whole was maintained by the harmony of the decorative principles employed, in spite of variations in the style and quality of the execution, one may surmise that Dürer's concept was made known to the other artists, and served as the model. Further evidence of this procedure is found in a fragmentary letter Peutinger sent to Freiburg, probably to Hans Baldung. Even the work on the Prayer Book remained incomplete, after a halt was called in 1515, probably because of difficulties concerning the inclusion in the calendar of sainted members of the House of Hapsburg. The part with the drawings by Dürer and Cranach is now in the Staatsbibliothek in Munich, the balance in the Bibliothèque Municipale, in Besançon, whence it was taken as part of the estate of Cardinal Granvella, minister of Charles V and Philip II of Spain.

Dürer's artistic skill and fantasy are expressed vividly in his pen drawings, in red, green or violet, wholly without restraint and free from a complicated scholarly program. The artist's hand is clearly seen without any distortion that might occur during a transfer to a wood block or in the cutting process. As a result, this project of Maximilian's is one of the most elegant and beautiful ever brought forth by the art of book illustration. The printed text is placed in the upper part of the sheet and toward the center, leaving unequally wide margins for the decorations which frame the text and in which figures and ornamentation are intertwined. A tendril-like decoration of plants, animals and grotesque figures are the leitmotif, often dissolving into pure line arabesques. The representations of figures are inspired by the text and fuse Christian, classical and medieval themes.

Interest in Dürer enjoyed a great revival, engendered by the Romantic movement of the early 19th century. It caused Nepomuk Strixner of Munich to print the marginal illustrations by means of the newly invented art of lithography, and, for the first time, the attention of a larger public was drawn to Maximilian's Prayer Book. The title chosen by Strixner, *A. Dürers Christlich-Mythologische Handzeichnung*, pointedly described the archetypical character of these paraphrases of Judeo-Christian liturgy that lent itself to various interpretations.

In 1518 the Emperor met Dürer once more. The artist sketched Maximilian's likeness during the Imperial Diet at Augsburg, "up in the tower, in his small chamber, on Monday after the feast day of

78
EMPEROR MAXIMILIAN I
Inscribed: *This is Emperor Maximilian, whom I, Albrecht Dürer, portrayed up in his small chamber in the tower at Augsburg on Monday after the feast day of John the Baptist in the year 1518* (28 June). With the monogram of the artist. Black chalk on paper, subsequently heightened in white, and with flesh tones added in colored chalk by the artist. 381 x 319 mm. Vienna, Graphische Sammlung Albertina.

Dürer accompanied the Nuremberg delegation to the Imperial Diet at Augsburg in 1518. The drawing served as a model for the painted portraits and one woodcut portrait (72, 82, 83).

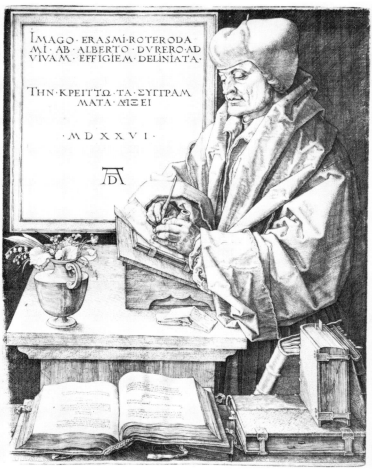

79
<small>Erasmus of Rotterdam</small>
With the inscription: *IMAGO. ERASMI. ROTERODA / MI. AB. ALBERTO. DVRERO. AD / VIVAM EFFIGIEM. DELINIATA. THN. KPEITTΩ(N). TA. ΣΥΓΓPAM / MATA. ΔᵉIΞEI* [His books depict him better]. Below, the date MDXXVI and the monogram of the artist. Engraving, 249 x 193 mm. (Cf. 29.)

In 1518 the Emperor met Dürer once more. The artist sketched Maximilian's likeness during the Imperial Diet at Augsburg, "up in the tower, in his small chamber, on Monday after the feast day of John the Baptist." In this manner he designated it succinctly as an important event in a five-line inscription on the right upper corner of the sheet (78). From the area of the chest one can readily discern that the artist was pressed for time. Only the head covered with a flat beret is drawn in more detail, yet even here Dürer is successful in conveying with but a few strokes the importance of the office in the absence of specific signs of rank. However, the artist also captures a trace of the fatigued resignation revealed in the emperor's expression and the lines of his mouth. The court vestments and the chain of the Order of the Golden Fleece are only sketchily indicated. We no longer know whether it was imperial graciousness or a specific imperial order that presented the painter with the opportunity to draw this portrait. In any event, the drawing was to be the basis for two painted portraits of the Emperor, both executed after his death, as is shown by a study of hands with a broken-open pomegranate, the personal symbol of Maximilian, carrying the date 1519 (Vienna, Albertina). The portraits show the Emperor from the waist up, and include the hands. In the transfer from drawing to painting the personal, human quality gives way to one expressing sovereign ethos. This is achieved in the paintings, of which the first, now in Nuremberg, was executed in watercolor on fine canvas (72), by the larger section of the figure shown, as well as by the stance, the facial expression and the garb. The precisely drawn chain with

80, 81

DECORATIONS FOR THE PRAYER
BOOK OF MAXIMILIAN I
With the monogram of the artist
and the date 1515 by a later
hand. The text was printed in
Augsburg by Johann Schön-
sperger the Elder, 30 December
1513. Both sheets: Munich,
Bayrische Staatsbibliothek.

*This Prayer Book was intended
for presentation to selected
members of the Order of the
Knights of St. George, founded
in 1469 by Emperor Frederick III
and specially favored by Maxi-
milian as a cadre for the defense
against the Turks. Dürer, Lucas
Cranach the Elder, Hans Baldung
Grien, Hans Burgkmair, Jörg
Breu the Elder and Albrecht Alt-
dorfer participated in its decora-
tion.*

82

EMPEROR MAXIMILIAN I
With the monogram of the artist
and the date 1519. Below the
crown, the coat of arms of the
Empire with the escutcheon of
the House of Hapsburg sur-
rounded by the collar of the
Order of the Golden Fleece. In-
scribed with the title and dates of
the Emperor. Oil on lindenwood.
74 x 61 cm. Vienna, Kunst-
historisches Museum.

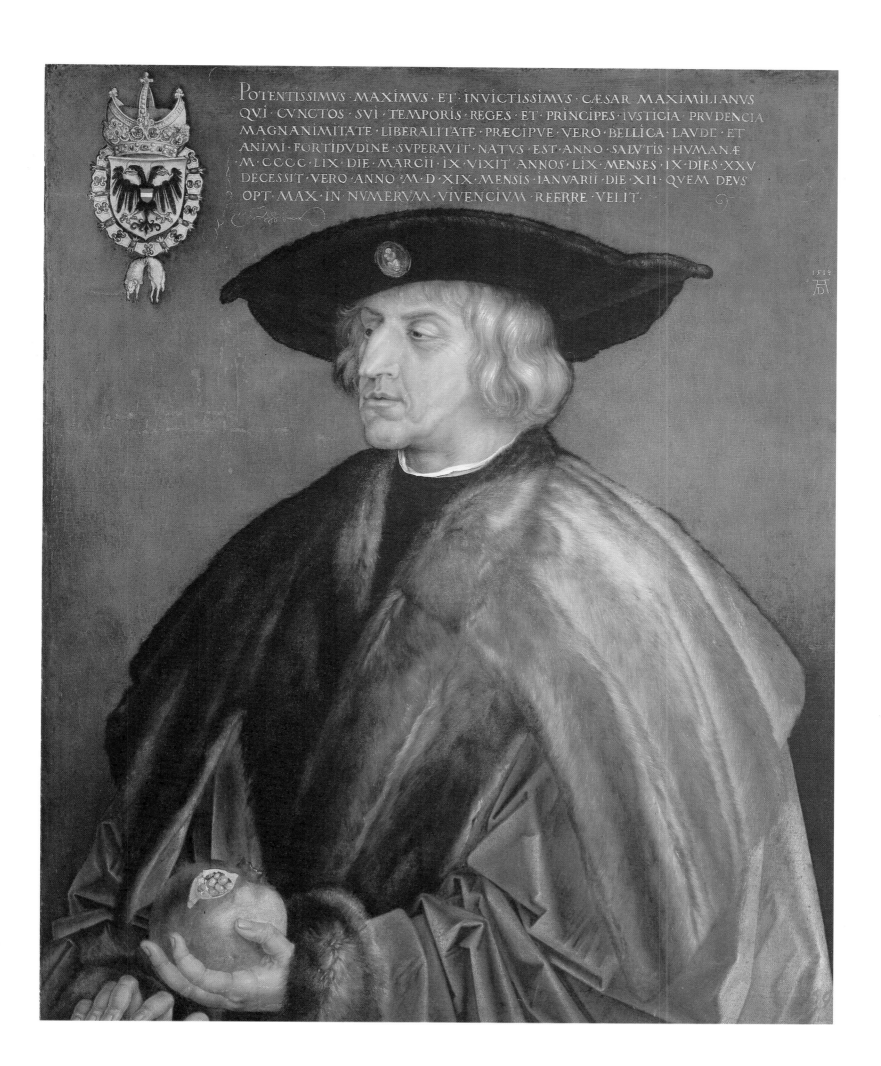

POTENTISSIMVS · MAXIMVS · ET · INVICTISSIMVS · CÆSAR · MAXIMILIANVS
QVI · CVNCTOS · SVI · TEMPORIS · REGES · ET · PRINCIPES · IVSTICIA · PRVDENCIA
MAGNANIMITATE · LIBERALITATE · PRÆCIPVE · VERO · BELLICA · LAVDE · ET
ANIMI · FORTIDVDINE · SVPERAVIT · NATVS · EST · ANNO · SALVTIS · HVMANÆ
M · CCCC · LIX · DIE · MARCII · IX · VIXIT · ANNOS · LIX · MENSES · IX · DIES · XXV
DECESSIT · VERO · ANNO · M · D · XIX · MENSIS · IANVARII · DIE · XII · QVEM · DEVS
OPT · MAX · IN · NVMERVM · VIVENCIVM · REFERRE · VELIT ·

Imperator Caesar Diuus Maximilianus
Pius Felix Augustus

83

EMPEROR MAXIMILIAN I
Imprinted: *Imperator Caesar Diuus Maximilianus/Pius Felix Augustus* [Maximilian, risen to heaven, supreme commander and emperor, gentle, successful and majestic]. Woodcut, 414 x 319 mm.

The charcoal drawing (78) served as model for this woodcut. The form of title corresponds to that used for the emperors depicted on Roman coins. The title "Divus," given to the Roman emperors only after their deaths, indicates that the woodcut was made and published after Maximilian's death in January 1519, presumably as a memorial. Prints from three different wood blocks are known, of which only one was cut directly from Dürer's design.

the golden fleece hanging from it and the large coat of arms with imperial crown and double eagle, directly in the field of vision next to the head of the ruler, enhance the effect. The second, and probably the final version, executed in tempera and oil on wood (in the Kunsthistorisches Museum in Vienna, the former imperial collection, though only recorded since 1783), eliminates these surface devices (82). The chain of the Order of the Golden Fleece is now absent. The size of the coat of arms has been reduced and it has been moved to the upper left of the picture, complementing the inscription, written carefully in *antiqua* letters, explaining the rank and the dates of the person depicted. Freed from other influences, the figure now dominates the center of the field of vision. The pomegranate is held loosely in the left hand, representing the Imperial Orb. Precious fur has been placed on the outer garment. The expression on the face is yet a step further removed from that of the drawing. The emperor appears older, more introverted, more lonely.

Dürer did not overlook Maximilian's popularity, publishing a woodcut (83) based on his drawing. Maximilian's unexpected death had stirred the hearts of his people. Dürer's picture of him is the first in which he uses a graphic technique specifically designed for printing. By using a tone block to provide a gold underlay for parts of the figure, and by the subsequent addition of color on four surviving examples, the woodcut was given the character and effect of a painting.

Encounters

Michael Wolgemut and the Nuremberg School of Painting

When Dürer made his decision to become a painter, and won a place in Michael Wolgemut's workshop, he encountered a century-long tradition in painting. There were specific ways in which the studios of the city were linked one with another both for the present and for the future that distinguished them from their counterparts in other places. Emphasis on line instead of color can be cited as a characteristic, as much as an adherence to tradition that was not, however, impervious to outside influences. Likewise, clearly defined specializations had emerged which were less emphatic elsewhere. Besides the wings of polyptychs (since the mid-15th century the centers of which were generally built as shrines for sculptures), memorial panels provided steady commissions for painters of the city. These panels were donated to the churches until well into the 16th century by members of prosperous families and well-to-do artisans to honor the memory of their departed kinfolk. Most often these panels represented passages concerning death, resurrection, or eternal life from Scripture, accompanied by a depiction of the donor or members of his family, as well as details of the person to whose memory it was dedicated (265). Portraits are closely linked to pictures of donators. They are autonomous likenesses of living persons, an artistic subject that first appeared in Germany in the second half of the 15th century (84, 85). To the extent that it is possible to draw conclusions from surviving examples, nowhere else in Germany did citizens seize so eagerly the opportunity of perpetuating their likenesses as in Nuremberg. In the process they created a new field of activity for the painters, one of great importance for the future.

As Michael Wolgemut's apprentice Dürer was exposed to the peculiar stylistic tendencies of the studio, which were bound to influence the development of his own style during his early years. Once he became independent, he chose, from the multiplicity of possibilities presented by tradition, to place his emphasis on his own ideas of artistic pursuits. From the outset, the operation of his own workshop differed from the working procedures which he had become acquainted with at Michael Wolgemut's. Above all it lacked the connection with sculptors for the production of large altarpieces. It is surely no coincidence that such collaborative efforts were left to his pupils, first Hans Schäufelein and after Schäufelein's departure for Augsburg, to Hans von Kulmbach.

In the place of such projects, Dürer's workshop was occupied during the first decade of the 16th century with woodcut decorations for many books (86, 87), and during the second decade the woodcut projects for Emperor Maximilian I. Still, for Dürer the workshop remained the necessary organizational form for artistic creation. Even though he had new ideas regarding the value of artistic achievement,

84
PROVOST LORENZ TUCHER AT THE PRAYER BENCH
Workshop of Michael Wolgemut. Inscribed: *Laurencius Tucher Decretorum Doctor/Canonicus Ratisponensis Sancti Laurencii/ in Nurmberg Plebanus 1485.* Stained-glass portrait from St. Michael's Church in Fürth. Nuremberg, Germanishes Nationalmuseum.

Tucher (1447-1503) was provost of St. Lawrence in Nuremberg and dean of the cathedral in Regensburg. This lifelike portrait is related to Albrecht Dürer's early manner of drawing.

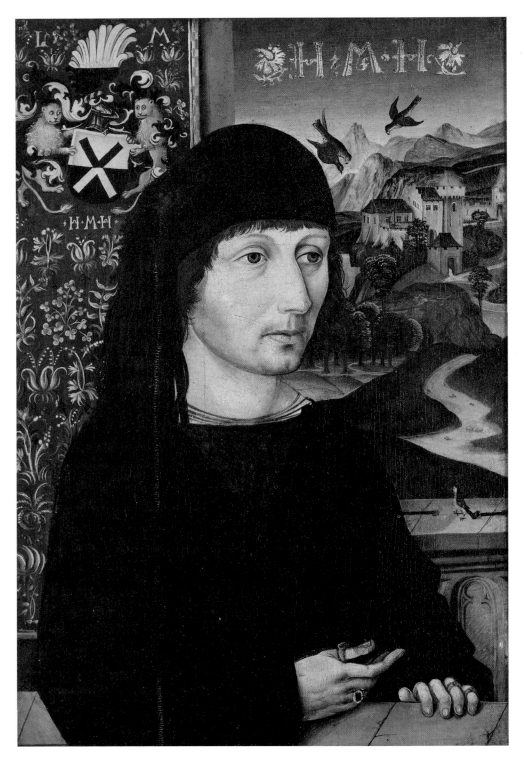

85
Levinus Memminger
Michael Wolgemut.
The letters LM appear above the
coat of arms; the letters HMH ap-
pear below it and are repeated in
the sky at the top. Oil on fir-
wood. 335 x 230 mm. Lugano-
Castagnola, Thyssen-Bornemisza
Collection.

*Memminger died in 1493 in
Nuremberg. This portrait, exe-
cuted shortly before 1490,
reveals the portrait type pro-
duced in the Wolgemut work-
shop as used by Albrecht Dürer
as early as his self-portrait of
1484.*

86 *(opposite page, left)*
Philosophy
Woodcut from Konrad Celtis,
Quatuor libri amorum, Nurem-
berg, printer of the *Sodalitas
Celtica* (1502). 217 x 147 mm.

*Besides the verses describing the
provinces of Germany from the
four compass points and the love
extended to him there by four
women, Celtis added a tribute to
Nuremberg and his Ode to St.
Sebald. Of the eleven illustra-
tions, three are ascribed to
Dürer, and the others to his
pupil, Hans von Kulmbach.*

87 *(opposite page, right)*
The Nun Hroswitha Presents
Her Book to Emperor Otto I
Woodcut from Konrad Celtis,
*Hroswitha von Gandersheim,
Opera.* Nuremberg, printer of
the *Sodalitas Celtica,* 1501.

*The poet laureate, Konrad
Celtis, edited the works of the
nun Hroswitha (c. 935-after
1000), of the convent at Ganders-
heim, on the basis of a manu-
script preserved in the St. Em-
meram Monastery near Regens-
burg. He dedicated his book to
the Elector of Saxony, Frederick
the Wise, as is shown in a second
woodcut by Dürer. The title
pages for the six comedies were
designed by Hans von Kulm-
bach.*

he remained convinced of the priority of the workshop over the indi-
vidual work of its various members. He placed his own monogram
as the mark of his workshop on woodcuts which Hans Baldung had
produced in 1505 while working for Dürer in Nuremberg, and of-
fered them for sale as late as 1520 in the Netherlands. The rational
division of labor that a workshop made possible can be documented
in individual instances. For example, Dürer had someone else
prepare the background of the panels of the altarpiece ordered by the
Frankfurt merchant Jakob Heller, but undertook personally the en-
tire execution of the center picture (411) (destroyed by fire in 1729 in
the ducal palace at Munich). He shared with assistants the painting
of the wings (Frankfurt a.M., Historisches Museum).

88
The Fall of Man
Michael Wolgemut.
Woodcut from Stephan Fridolin, *Schatzbehalter oder schrein der waren reichtuemer des hails vnnd ewyger seligkeit* [Treasure chest or cabinet of the true riches of salvation and eternal bliss]. Nuremberg, Anton Koberger, 8 November 1491.

Of the Nuremberg memorials, Dürer participated in the one commissioned by the goldsmith Albrecht Glimm in 1500 in memory of his deceased wife (264). In keeping with the purpose, the painter succeeded in expressing the all-encompassing lament. The body of the Redeemer has just been taken down from the Cross visible in the background landscape, replete with mountains, castle, and the sea. The winding sheet on which the body is to be laid is spread by Nicodemus and Joseph of Arimathea. Towered over by the ruddy features of the young John, the group gathered around the Virgin is distinctly separated from its background. The workshop produced a virtually identical representation as an epitaph for Karl Holzschuher, who died in 1480 (265).

83

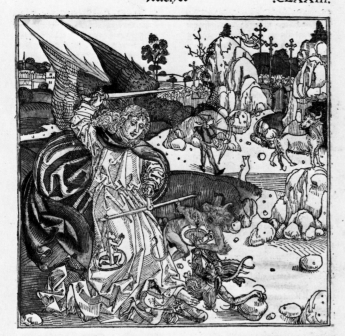

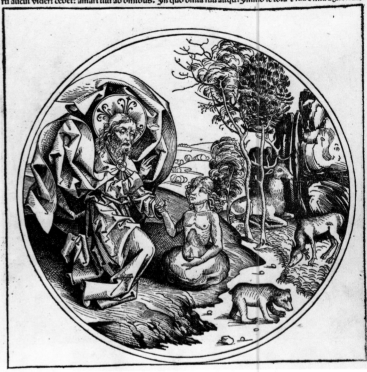

Dürer's experiences in the painting of portraits in Wolgemut's workshop were of considerable importance. From his youth he had been fascinated by the idea of expressing the essential character of a man, manifest from his outward appearance and his movement, as evident from his early self-portrait. This sort of beginning is closely related to the art of portraiture as practiced by Wolgemut. From him Dürer learned how to transfer the forms of a human face into a portrait. The earliest painted work that has survived from his apprentice days is the portrait of his father (263). Dated 1490, it is from the time after the end of his three-year training period, the winter of 1489, and the beginning of his travels as a journeyman at Eastertime 1490. The exterior form, in half-length including the hands, in three quarter profile, decidedly places it in the Nuremberg portrait tradition. Yet the uniqueness of a physiognomy conceived in its continual living transformation distinguishes the work as something altogether new in German portraiture.

89
ST. MICHAEL
Attributed to Michael Wolgemut. Woodcut with printed text from *Der Heiligen Leben* [Lives of the Saints], P.1.2. Nuremberg, Anton Koberger, 5 December 1488, fol. 173.

90
THE CREATION OF ADAM
Michael Wolgemut. Woodcut from Hartmann Schedel, *Liber chronicarum*. Nuremberg, Anton Koberger for Sebald Schreyer and Sebastian Kammermeister. Latin edition, 12 July 1493. German edition, 23 December 1493. Translated by George Alt.

84

Martin Schongauer and the Master of the Housebook

91
CHRIST AS TEACHER
Martin Schongauer.
Inscribed by Albrecht Dürer: *das hat hubsch martin gemacht jm 1496 jar* [Made by Handsome Martin in the year 1469]. Pen and ink on paper. 207 x 124 mm. London, British Museum.

This drawing was formerly regarded as the work of Albrecht Dürer, based on a design by Schongauer.

92
CAVALCADE
Dated 1489; with a spurious Dürer monogram. Pen and ink on paper. 209 x 310 mm. Formerly Bremen, Kunsthalle.

Certainly the young Dürer became familiar while still in Nuremberg with the new technique of engraving on copper, even though it was not practiced in Nuremberg. He may have learned about it in Wolgemut's workshop, or perhaps already in his father's workshop. In contrast to the woodcut, copper engraving is an intaglio process, in which the lines which are to appear on the paper are cut into the plate with a burin. The ink remains only in the grooves but is wiped off the remaining surface of the plate; in the printing process the color is absorbed by the paper from the grooves in which it has remained. On account of the necessarily considerable pressure required by this process the relatively soft copper becomes deformed, limiting the number of prints which can be pulled from a plate. The 500 impressions of a portrait of Cardinal Albrecht of Brandenburg (292), that Dürer engraved in 1523, probably was the limit attainable without deterioration.

Engraving on copper represents the individual work of an artist, all the way from the preliminary drawing up to the printing, and it afforded the possibility of varying the effect by the manner of inking on the plate, on even portions of it. But beginnng with the second half of the 16th century, reproductive engraving based on models prepared by others became more common. Initially this process was not suitable for book illustrations because of the difference between relief and intaglio printing. Engraving on copper had its origins in the engraving on precious metal done by the goldsmith, and no doubt this craft provided artists with a multitude of suitable motifs.

Around the time of Dürer's birth, a native of Augsburg working in Colmar, Martin Schongauer, had so perfected the art of engraving on copper that he was able to achieve a remarkable illusion of reality both in the depiction of objects as well as in their spatial relationships (91, 94, 95). An integral part of the artistic treasure flowing from the painting and sculpturing workshops out to the entire German art world, Schongauer's sheets created collectors, as apparent from the production of pictorial series devoted to individual themes. Affixed to the walls of rooms, these representations of the saints and from Scripture also served as an expression of piety. Since the most popular of these engravings, imbued with a modernity, were often reproduced virtually unchanged as paintings and reliefs, Netherlandish forms with which Schongauer had had direct contact penetrated in this way also the workshops of other German artists. His influence may be discerned in the painted oeuvre of Michael Wolgemut and his collaborators. It is also evident in the

93
CHRIST ON THE CROSS BETWEEN THE VIRGIN AND ST. JOHN
Pen and ink on paper. 310 x 227 mm. Paris, Musée National du Louvre, Cabinet des Dessins.

This early, painterly drawing makes evident Dürer's attention to landscapes. It dates from near the end of his apprenticeship with Wolgemut, i.e., at the end of 1489 or the beginning of 1490.

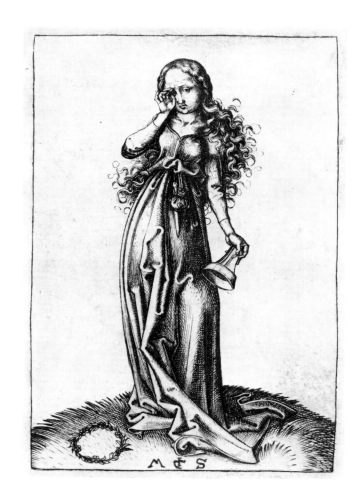

94
The Virgin on a Grassy Bench
Martin Schongauer.
With the artist's initials. Engraving. 122 x 84 mm.

Compare the similar treatment of this subject by Albrecht Dürer (99, 101).

95
One of the Foolish Virgins
Martin Schongauer.
With the artist's initials. Engraving. 120 x 84 mm.

(Cf. 97.) The wreath, which the maiden is wearing in Dürer's version, is here lying on the ground.

linear quality of drawings which Dürer produced during his apprenticeship with Wolgemut and during his travels as a journeyman (92, 93, 96, 97, 99). Short strokes and hooks are used to shade figures and objects where light falls upon them, whereas cross-hatching is employed, in varying density, to darken the shadows to black.

It seems that Dürer, during his years of travel as a journeyman, encountered the works of a painter and engraver whose depictions from life and from the technology of the late Middle Ages are contained in the so-called "Medieval Housebook" in the collection of Count Waldburg-Wolfegg. This anonymous artist, over whose identity no consensus has been attained, was active in the Rhenish Valley c. 1470-1505. Apart from the drawings in the Housebook and several paintings, his hand can be recognized in a series of drypoints dealing with religious and secular subjects (98). He employed a sharp, needlelike instrument with which the plate was scratched lightly. This procedure made it possible to work much more quickly than with the burin, and also produced freer, more spontaneous lines. The shallow grooves in the plate permitted only a few impressions because of the deformation the plate suffered during printing. As a result, prints by the Housebook Master survive in few examples, sometimes only one. The drypoint technique may be regarded as the precursor of yet another graphic technique that emerged around 1510, in which the copper plate is no longer incised with a burin or needle, but "warmed up" through the action of an acid. An acid-proof layer is spread over the metal plate, and at the places which are

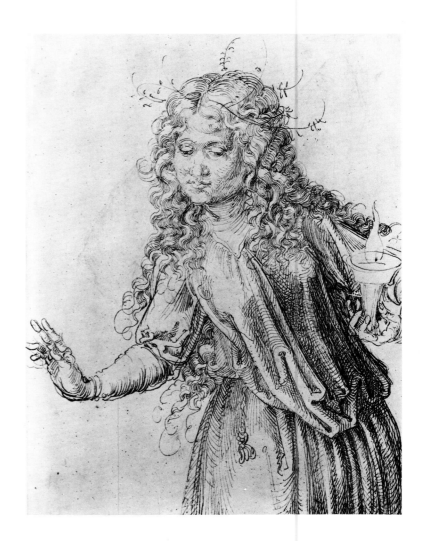

to appear black when printed, the layer is scratched away or wholly removed by means of a needle. It is then placed into an acid bath. The acid will "bite" those places where the covering layer has been removed. The resultant print is called an etching.

We can detect the influence of the Housebook Master on Dürer in the iconographic similarities as well as in the more freely drawn, less exact linework in some of his drawings, as compared to Schongauer (99, 100). Dürer's early works dealing with the picturing of the Holy Family in a landscape, dating from the time of his travels as a journeyman, reflect the shaping influence of Schongauer as well as the Housebook Master, without diminishing Dürer's own contribution in enhancing the clarity of the figures and the landscape. The large, fully developed drawing in Berlin (99) pictures the Virgin sitting on a bench constructed of boards and pieces of sod. In her right hand, still pointed in the Gothic manner, she holds the stem of a carnation between her fingers. Among its several symbolic meanings, this flower is emblematic of the Virgin. The child on her lap turns away from her and towards the elderly foster father, who has selected for himself a modest place on the ground at the side and somewhat behind the grassy bench, and is half concealed by it. His head is cupped in his right hand, and he is sunk in deep sleep. The group is depicted in a parklike landscape on the banks of a river that extends into the distance in the background. The treatment of

96
YOUTH KNEELING BEFORE THE JUDGE
With a spurious Dürer monogram. Next to it, the annotation by the owner: *Robt Sutton 1754*. Pen and ink on paper. 252 x 189 mm. Oxford, Ashmolean Museum.

The drawing was produced during Dürer's travels as a journeyman and can be dated c. 1492. A convincing interpretation of the subject has eluded scholars. The features of the young man resemble Dürer's.

97
ONE OF THE WISE VIRGINS
With the date 1508 and Dürer's initials by another hand. Pen and ink on paper. 292 x 203 mm. London, Courtauld Institute, Count Seilern Collection.

Cf. Martin Schongauer's series of the Wise and Foolish Virgins of 1493 (95).

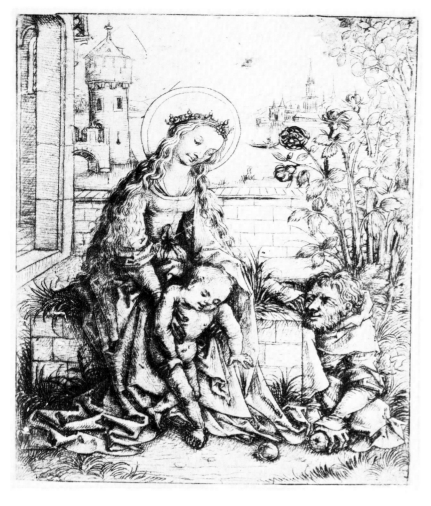

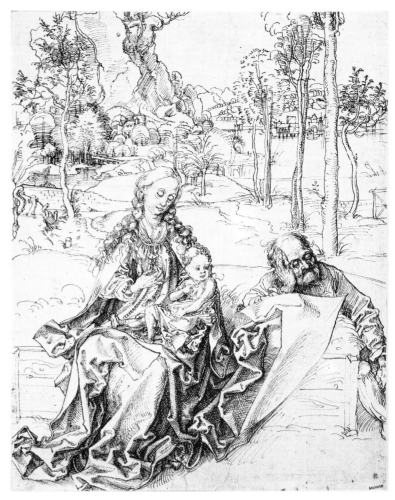

98
THE HOLY FAMILY IN A LAND-
SCAPE
Housebook Master.
Drypoint. 143 x 115 mm.
Amsterdam, Rijksprenten-
kabinet.
*This print was probably known
to Albrecht Dürer. Only one im-
pression survives. (Cf. 99.)*

99
THE HOLY FAMILY IN A LAND-
SCAPE (REST ON THE FLIGHT INTO
EGYPT)
Pen and ink on paper. 290 x 214
mm. Berlin-Dahlem, Preuss-
ischer Kulturbesitz, Kupferstich-
kabinett.
*The drawing, without doubt
produced toward the end of his
travels as a journeyman, reveals
Dürer's preoccupation with the
engravings of Martin Schon-
gauer, but also reflects the in-
fluence of the drypoints of the
Housebook Master (cf. 98). The
subject suggests that it was
preparatory for a "Rest on the
Flight into Egypt."*

the subject anticipates the one employed several years later by
Lucas Cranach and Hans Baldung in their "Rests on the Flight to
Egypt," representations which have had numerous sequels.
Schongauer's influence on Dürer is clear in the typology and the
pose of the Virgin as well as in the rich drapery of her cloak. The in-
terior modelling of the garment is carefully executed with a few long
stokes, numerous short hooks, and cross-hatching. In the perfection
of its execution, the drawing manifests an engravinglike quality
which elevates it to the level of an autonomous, finished work of
art. Iconographically the influence of a drypoint by the Housebook
Master that had appeared shortly before the drawing in 1490 is
manifest primarily in the positioning of Joseph on the ground next
to the grassy bench (98).

When Dürer began to make use of the knowledge and experience
gained during his first trip to Italy, he chose as his first subject the
one developed by Schongauer, i.e. the Virgin on a Grassy Bench.
Thus Dürer's engraving "The Virgin with the Dragonfly" (101) is
linked with his earlier drawing. In printing, the image is reversed.
As a consequence, the Infant Christ is now lifted up by the Virgin's
left hand. The sleeping Joseph now seems even more isolated, less
included in a relationship between Mother and Child. His arm now
rests next to his head on the grassy bench. The changes in the pose
and the draperies of the figure of the Virgin are clear. This is a new

100

THE HOLY FAMILY

Pen and ink on paper. 204 x 208 mm. Erlangen, University Library.

This drawing is probably contemporary with the self-portrait on its verso, dated from 1491 or 1492 (cf. 15).

kind of woman, no longer the maidenly creature of Schongauer's representation. Corporeality is present beneath the cloak, whose folds with their gradations are bright in the light shining upon them; they seem to support the upper part of the body. The reduction in individual details of the drapery and the newly conceived landscape contrasts with the increased clarity of the material. The wooden structure of the bench consisting of boards and posts is shown in great detail; the plants are clearly identifiable species and drawn so precisely that they must have been preceded by a careful study of nature. At the same time the slice of the world that is represented is not merely coincidental but is emblematic of Christian salvation. Dürer placed his monogram on the completed work after the manner of other engravers, though in this instance it takes the form of a small d inside a large A. The dimensions of the engraving (230 x 180 mm) correspond to Schongauer's larger prints.

Even his contemporaries recognized the influence of the work of the Colmar Master on the style of the young Nuremberg artist. Jakob Wimpfeling mentioned Dürer by name in his *Epithoma Rerum Germanicarum usque ad nostra Tempora* [Handbook of German History], written in 1502 but published in Strassburg in 1503. He calls Dürer "a German, and a student of Martin Schongauer." Both assertions were strengthened by Christoph Scheurl in a passage appended for this purpose to his biography of Anton Kress, published in 1515. He based it, as is emphasized, on

101

THE HOLY FAMILY WITH THE
DRAGONFLY
With the artist's monogram
featuring a small "d." Engraving.
237 x 186 mm.

*The print is closely related to the
engravings of Martin Schongauer in style as well as technique. The early monogram speaks for this being Dürer's earliest signed engraving. It dates from 1495.*

information supplied by Dürer himself. Dürer had reported that his father, the elder Albrecht, "was born in a village named Cüla, not far from Wardein, in Hungary," and that his father had wanted to apprentice the young Albrecht to Martin Schongauer at the age of thirteen. However, Schongauer had died at about that time, so that he was apprenticed instead to their neighbor, Michael Wolgemut. Finally, after he had journeyed through all of Germany, he came to Colmar in 1492, and there was received in very friendly fashion by Schongauer's brothers, the two goldsmiths Caspar and Paul, and the painter Ludwig. Subsequently, in Basel, he received a similar reception by the fourth brother, Georg, a goldsmith. He had never been Martin Schongauer's pupil, and had not even met him, although he would very much have liked to.

Even this information, apparently edited by Dürer, requires interpretation. It would have been very unusual for an apprentice to receive his first training in a workshop that was not his father's or that of a close neighbor. If the elder Dürer actually exchanged letters with Schongauer in Colmar, as Christoph Scheurl reports, this would have had to refer to the time after the apprenticeship and the years of traveling as a journeyman, just as, a decade later, Hans Baldung Grien, a young but trained painter, took the road from Strassburg on the Upper Rhine to Nuremberg. Moreover, Martin Schongauer died not in 1484 or thereabouts, but 2 February, 1491, while he was working in the Cathedral at Breisach on frescoes depicting the Last Judgment. The date of his death is consistent with Dürer's seeking out Schongauer not as thirteen-year-old, but as a journeyman, and that he first learned of the master's death when he reached Colmar. Scheurl speaks very laconically about Dürer's travels, which started at Easter 1490, interested only in setting right the report of the supposed apprenticeship. The journeyman painter, so he said, had traveled through Germany. If he had proceeded to Colmar directly he would still have met Schongauer. Journeymen's travels to southwestern Germany were not common, and can only be explained by the attraction of Martin Schongauer.

However, in the second half of the 15th century, artistic contact with the art of the Low Countries was the custom. Important examples from that area could be studied even in Cologne. This raises the often discussed questions: Did Albrecht Dürer also travel this road? Was he in the lower Rhine Valley and in the Low Countries earlier than 1520-21? It would be strange if he had not gone there, but it is equally strange that in his diary of the later trip he makes no mention of an earlier stay, and comments on the outstanding works of the great masters of the Low Countries of the 15th century as would anyone who saw them for the first time. Carel van Mander's report (in *Het Schilderboek* of 1604) of Dürer's visit to Haarlem, and Joachim von Sandrart's (in *Teutsche Academie* of 1675) mention of a four-year-long stay in the Low Countries following his apprenticeship, are too late and too inexact to serve as reliable proof. Dürer could have seen works by artists from the Low Countries in Nuremberg either in the original or in copies; he could have found the reflection of the art of Rogier van der Weyden not merely in the engravings of Martin Schongauer but also in the works of Hans Pleydenwurff in Nuremberg or Hans Herlin in nearby Rothenburg and Nördlingen. The situation is different for the masters from the northern Netherlands, such as Geertgen tot Sint Jans, the creator of the *Virgo inter Virgines,* or Hieronymus Bosch, whose direct influence on German art is not so readily seen. But recently it has been precisely to works of such artists as these that parallels have been noted, parallels which are based on a more detailed knowledge of the painting produced in the confines of present-day Holland. This lends greater credence to van Mander's report of a stay by Dürer in Haarlem.

Basel and Strassburg

Christoph Scheurl's report that Dürer left Colmar for Basel is confirmed by examples of art produced by the young journeyman in the latter city. Basel, until 1499 part of the Holy Roman Empire, was a center for scientific and literary publications. Men like Sebastian Brant and the learned printers and publishers Bergmann von Olpe, Johann Amerbach, and Nikolaus Kessler were deeply committed to the new humanism and were busily spreading it to a wide audience. The publications coming from Basel at the end of the 15th and beginning of the 16th centuries were extraordinarily varied and embraced both theological and secular knowledge. This flowering of the intellect had its roots in the Council of the Church that met in Basel from 1431 to 1437, with some parts lasting until 1448, bringing together churchmen from east and west. Konrad Witz from Rottweil worked as a painter in Basel during this period, employing the newest trends in the art of Burgundy and the Low Countries, thereby creating a personal style reflected in pictures of high and unusual quality. Their uniqueness must have helped save some of his works, at least his altarpieces, from the destructive furor of the iconoclasts in 1529.

This destruction of almost the entire body of religious art makes it impossible to form a clear picture of the level achieved in the painters' workshops in Basel during the second half of the 15th century. In any event, there is no evidence of really predominant masters, so that there were opportunities for a gifted young artist not only to earn his keep, but also to realize his own novel ideas, and thereby give impetus to the local artists. Dürer's success was based on his close connection with printers and publishers. The experience he had gathered in Michael Wolgemut's workshop made him, as regards the artistic and technical development of the woodcut technique, superior to the artists of Basel. Doors may well have been opened to him by the recommendation of his godfather, Anton Koberger, whose connection with Johann Amerbach during subsequent years is documented.

The starting point in any attempt to identify Dürer's work in Basel, in the absense of other documents or signatures, is the wood block representing St. Jerome that eventually found its way into the art collection of Basilius Amerbach, and which to this day is preserved in Basel. On its verso it bears the inscription, in Dürer's handwriting, "made by Albrecht Dürer of Nuremberg." Whether the signature refers only to the drawing on which the woodcut is based, or whether the wood block itself was also cut by Dürer to demonstrate to others the technical possibilities, cannot be conclusively decided. It is noteworthy that in later works for Emperor Maximilian, it was the form-cutters who signed the blocks, presumably for purposes of rendering their bills.

Dürer must have produced the picture of St. Jerome—who had become something of a patron of humanists because of his translation of the Bible—shortly after his arrival in Basel early in 1492, because it served as frontispiece for the edition of the letters of the saint, published by Nikolaus Kessler on August 8 of the same year. Dürer succeeded in picturing a clear, spatially correct image of the study and sleeping quarters of the saint, linking it by the view through the door with a row of houses in the city (106). The scholar, who is sitting on a low bench, has interrupted his work in order to remove a thorn from the legendary lion's paw with a pen-knife. His physical presence as well as that of the furniture and other objects in the room determine the spatial relationships. The hatching, which designates light and shade, also serves through the variations in density to convey the essential character of material objects by deliniating the peculiarity of each surface. In this development of the interpretive function of every line, Dürer went well beyond what had been accomplished in Wolgemut's workshop, and made severe demands on the skill of the form-cutter.

After his contribution to the edition of St. Jerome's letters, which the Basel publisher may have regarded as a test piece, the young Nuremberg artist received commissions for the woodcut illustrations of three works, among them Sebastian Brant's *Das Narrenschiff* [The Ship of Fools]. This proved to be one of the most successful books of its time, surely due in part to the poignant illustrations by Dürer. Spurious versions appeared in Nuremberg and Reutlingen as early as the year of publication, 1494, with copies of the woodcuts. In subtle verses, the author, who lived in Basel until 1499 and subsequently in Strassburg, had taken aim at the perverted nature of man, which led to foolish actions of every kind. An illustration adorns each of the brief chapters. The flanking ornamental borders fuse with the illustrations and the words themselves to form a well-thought-out whole (108-110). Illuminated manuscripts had a visible influence on

104
TERENCE WRITING HIS COMEDIES
Drawing on a pearwood block. 93 x 147 x 24 mm. Basel, Offentliche Kunstsammlung, Kupferstichkabinett.

Dürer drew this design directly on the block preparatory for cutting. It was meant for an edition of the comedies of Terence, planned in Basel but never published.

105
SCENE FROM TERENCE:
HEAUTONTIMORUMENOS [THE SELF-TORMENTOR, ACT 1, SCENE 1]
Drawing on a block of pearwood. 92 x 146 x 24 mm. Basel, Offentliche Kunstsammlung, Kupferstichkabinett. (Cf. 104.)

106

St. Jerome in His Study
The open books show the first words of Genesis in Hebrew, Greek, and Latin. Title page woodcut from St. Jerome, *Epistolae*. Basel, Nikolaus Kessler, 8 August 1492. 192 x 134 mm.

The wood block has survived. On its verso, in Dürer's hand: Albrecht Dürer of Nuremberg. *Basel, Offentliche Kunstsammlung, Kupferstichkabinett.*

107

The Theater of Terence
Woodcut, 19th-century impression from the partially cut block. 93 x 147 mm. Basel, Offentliche Kunstsammlung, Kupferstichkabinett. (Cf. 104).

the layout of the printed page. Dürer took up Brant's picturesque language and transferred it quite literally into pictorial images. In a sequence of grotesque activities and situations, he depicted men as deserving the donkey's ears and belled caps of fools. Compared with the St. Jerome woodcut (106), these images are simplified and can be grasped in a glance, even though the characterization of the material is in no way lessened. Dürer did not work alone in creating the 116 pictures for Brant's book. Although the form is retained throughout, variations in concept reflect the work of a local artist. Towards the end of the book the hand of yet another helper can be discerned, obviously engaged by editor Johann Bergmann von Olpe to complete the work after Dürer's move to Strassburg.

Prior to the work on *The Ship of Fools*, Dürer produced 47 woodcuts for another one of Bergmann von Olpe's publications, entitled *Der Ritter vom Turn/von den Exempeln der gotsforcht vnd erberkeit*, [The Book of the Chevalier de la Tour-Landry: Examples of the Fear of God and of Respectability]. The stories, compelling accounts despite their moralizing character, are a translation of the examples thought up and written down by Geoffrey, Chevalier de la Tour-Landry, a nobleman resident in what is now the Department of

Wer on verdienſt / will han den lon
Vnd vff eym ſchwachen ror will ſton
Des anſchlag / wurt vff kreſſen gon

Furwiſſenheyt gottes
Man fyndt gar manchen narren ouch
Der ferbet vß der gſchrifft den gouch
Vnd dunckt ſich ſtryffrecht vnd gelert
So er die bücher hat vmb kert

Wer ſpricht das gott barmhertzig ſy
Alleyn / vnd gerecht dar by
Der hat vernünfft wie genß vnd ſü

vō vermeſſenheit gotz
Der ſchmyert ſich wol mit eſels ſchmaltz
Vnd hat die büchſſen an dem halß
Der ſprechen gtar / das gott der herr
So barmyg ſy / vnd zürn nit ſer

Wer ſingt Cras Cras glich wie eyn rapp
Der blibt eyn narr biß inn ſyn grapp
Morn hat er noch eyn gröſſer kapp

Von vffſchlag ſuchē
Der iſt eyn narr dem gott in gyt
Das er ſich beſſeren ſoll noch hüt
Vnd ſoll von ſynen ſünden lan
Eyn beſſer leben voßen an

Maine and Loire in France toward the end of the 14th century, as an admonition for his daughters. The action takes place in stagelike settings, both interiors and outdoor scenes, and the actors' poses and gestures express precisely the moment of each event (102, 103). The figures are very lifelike, showing individuality of expression and movement in accordance with the purpose, drawn with stark economy of line.

Yet another project in which Dürer participated never achieved publication. Sebastian Brant planned a new edition of the comedies of the Roman poet Terence (195-159 B.C.) which were performed in Latin schools throughout the Middle Ages. With the advent of humanism, interest in them, as examples of the classical theater, was renewed. One hundred twenty-six blocks with the drawings for this work have survived, together with six blocks which had already been cut. Moreover another six prints exist, whose blocks have disappeared (104, 105, 107). Dürer had probably familiarized himself with the text by means of an old illustrated manuscript used by Brant to develop the dialogues. This classical model emerges clearly from the picture of the author, Terence, seated on the ground, wearing the poet's laurel wreath, and writing down his verses. By contrast, in the individual scenes, the persons and accessories are wholly contemporary. It is probable that the publisher, Johann Amerbach, decided not to finish the project when, in August 1493, another new edition of Terence appeared in Lyons. The illustrations for the latter conveyed a sense of the staging of the comedies on the classical stage and thus expressed the fruits of humanistic research more clearly than did Dürer's concepts with their contemporary gloss.

108
THE CRAB FOOL
Woodcut from Sebastian Brant, *Das Narrenschiff*. Basel, Johann Bergmann von Olpe, 11 February 1494. (Cf. 110.)

109
THE BARNYARD FOOL
Woodcut from Sebastian Brant, *Das Narrenschiff*. Basel, Johann Bergmann von Olpe, 11 February 1494. (Cf. 110.)

110
THE CROW FOOL
Woodcut from Sebastian Brant, *Das Narrenschiff* [The Ship of Fools]. Basel, Johann Bergmann von Olpe, 11 February 1494.

Together with an anonymous Basel artist, known as the Haintz-Narr Master, Dürer provided the illustrations for this very successful book. Dürer's departure for Strassburg was probably the reason the publisher supplemented the illustrations with some by less talented artists.

111

Jean Charlier de Gerson as a Pilgrim

Woodcut. Title page from Jean Charlier de Gerson, *Quarta pars operum....* Strassburg, Martin Flach for Matthias Schürer, 27 February 1502. 223 x 149 mm.

The title-page woodcut was prepared c. 1494, when the first three volumes of the work were published, but was only used in 1502 for the fourth volume.

112

Christ on the Cross

Woodcut on vellum. Canon sheet from *Speciale opus missarum....* Strassburg, Johann Grüninger, 13 November 1493. 220 x 133 mm (entire sheet 238 x 151 mm). Basel, Offentliche Kunstsammlung, Kupferstichkabinett.

The woodcut, although formerly not universally accepted, is now ascribed to Dürer.

The most important evidence of Dürer's subsequent stay in Strassburg is the mention of two portraits of Dürer's teacher in Strassburg and the latter's wife. These pictures are so described in the 1573/74 inventory of the collection of the Nuremberg patrician Willibald Imhoff. There are as well two woodcuts in Strassburg publications based on Dürer's designs. The frontispiece for Part 4 of the works of the French theologian Jean Charlier de Gerson (1363-1429), whose mystical theology attracted renewed interest at the end of the 15th century, was commissioned by the publisher Martin Flach (111). The last volume of the work did not appear until 1502, but the illustration planned for it was clearly prepared in 1494 when the first three volumes were being readied. Dürer's contribution shows Gerson as a pilgrim, walking through the countryside with a dog at his side. The quality was impaired by the form-cutter, who was not quite up to the task. Still, the enormous strides Dürer had made in mastering pictorial structure and in representing the human figure is shown by the organization of the composition as well as in the manner the details relate to the dominant figure. This

woodcut is closer to the sheets of the *Apocalypse* of 1498, which was to establish the international fame of the artist, than it is to the St. Jerome woodcut of 1492. Most probably Dürer also designed the canon sheet for the Missal printed in Strassburg in 1493 (112).

It is more difficult to identify Dürer's paintings of those years. Apart from the self-portrait of 1493 (19), probably done in Strassburg, only a small panel representing the Man of Sorrows can be ascribed to him with certainty (115). The fragments of the St. Dominic Altarpiece (Darmstadt, Hessisches Landesmuseum; Munich, Bayerische Staatsgemäldesammlungen), created for a Dominican convent, perhaps the one in Colmar, are closely akin to his work (113). At any rate, the collaboration of the young journeyman, now at the end of his travels, cannot be excluded.

113
THE DEATH OF ST. DOMINIC
Master of the Dominican Altarpiece.
Oil on pine. 94.5 x 78.5 cm.
Darmstadt, Hessisches Landesmuseum.

Dürer's participation in the production of this altarpiece of c. 1490/95 in a Strassburg workshop has been surmised.

114
MADONNA WITH MUSICAL ANGELS
Pen and ink on paper with touches of watercolor. 216 x 151 mm. Paris, Musée National du Louvre, Cabinet des Dessins.

This drawing, dating from the artist's travels as a journeyman, is executed in a painterly manner and was completed by addition of a tint. A relationship has been discerned between some of the heads in this drawing and the St. Dominic Altarpiece (113).

115
CHRIST AS MAN OF SORROWS
Oil on fir. 30 x 19 cm. Karlsruhe, Staatliche Kunsthalle.

This work, whose attribution as well as date of execution has been contested, was probably produced during Dürer's travels as a journeyman.

98

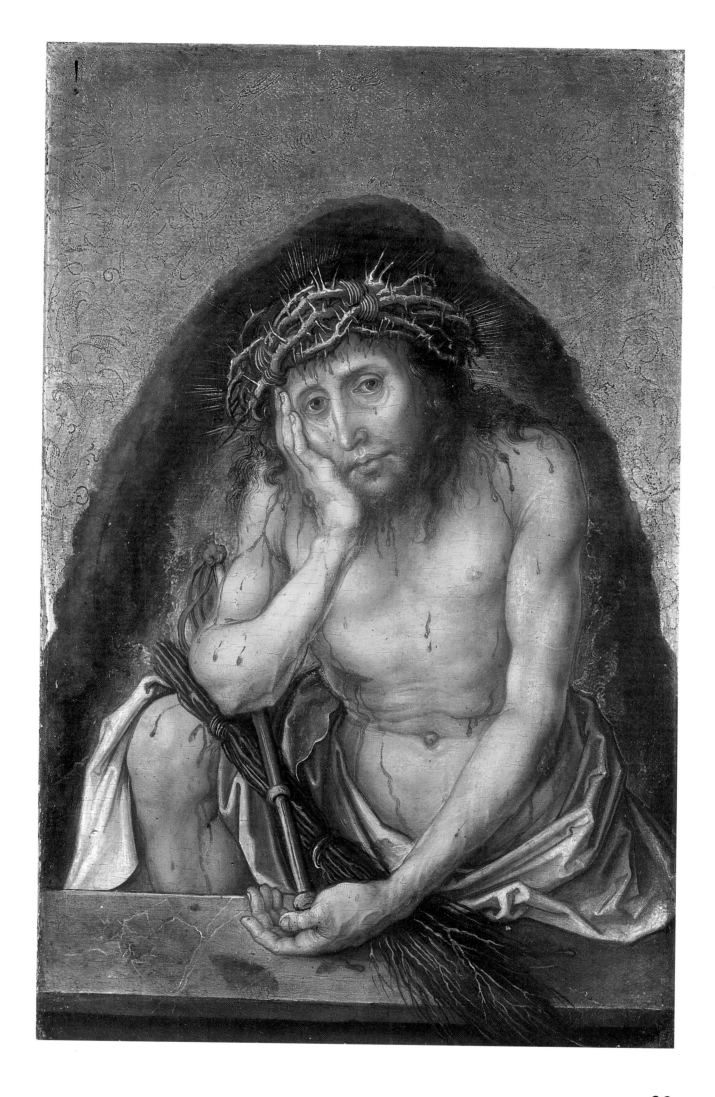

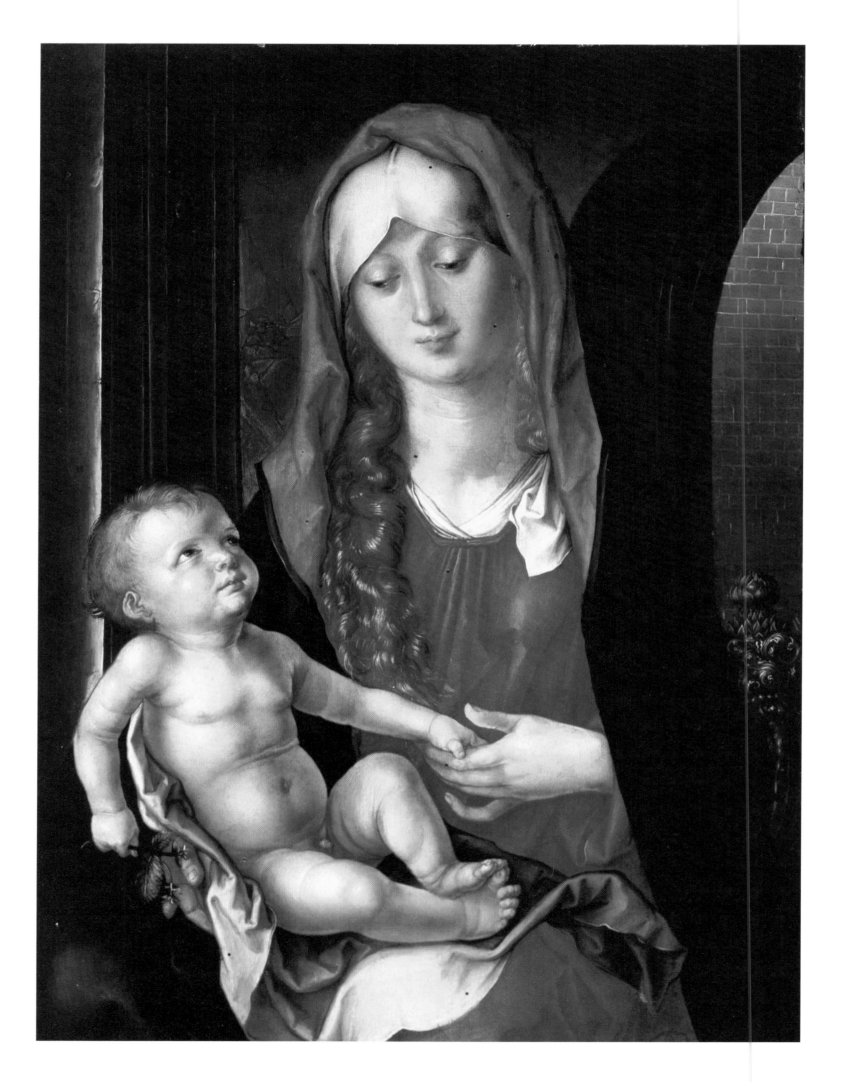

110

111

That part of his training which Dürer could enhance in Venice comprised the elements of modern oil painting, the depiction of the nude or clothed human figure and its relationship to the space in which it was placed. If there is truth in his written record that his reason for traveling to Bologna was "to master the secret art of perspective," this dates from the end of his second trip to Italy. Nevertheless his works of 1495 and immediately after his return home from the first trip reflect his intensive efforts to cope with perspective in practical application. His mentors might have included northern Italian masters like Andrea Mantegna, Gentile and Giovanni Bellini, and Vittore Carpaccio.

Ten autograph letters from Dürer in Venice to Willibald Pirckheimer in Nuremberg, written between 6 January 1506 and 13 October of the same year are still extant (24). They give some insight into the mood and success of the painter during his second sojourn in the city of lagoons, as well as his relationship to art and the painters working in the shadow of San Marco. Once more the reasons for Dürer's second trip to Italy are obscure: was it a specific offer, or were negotiations underway for the artistic commission he would receive from the German colony in Venice after his arrival? Perhaps he crossed the Alps again on account of a simple human need to escape daily life in Nuremberg, with wife and mother in the house, to rediscover things seen on earlier trips, or simply to feel like a gentleman for a while.

He provided for his support while there by taking with him a series of panel paintings to sell in Venice. This might be how a picture of the Virgin reached Italy, a picture which was rediscovered only after the second World War, after having been in strict seclusion in a Capuchin monastery near Bologna; it is now in a private collection (128). It shows the Virgin in three-quarter length, sitting before a gateway, holding the naked Infant Christ on her lap. The glances of mother and son meet and reveal a close spiritual relationship that is emphasized by the child seeking to grasp the mother's hand. The presence of architectural elements which permit a glimpse into the distance is not uncommon in German art and probably originated in the Low Countries. In his rendition of the Infant Christ, Dürer used a copy he had made in 1495 of a drawing of the Florentine artist Lorenzo di Credi (122). Dürer was acquainted with a pictorial type created by Giovanni Bellini, in which the Virgin is portrayed in half or three-quarter length with the lower portion usually concealed behind a barrier of some sort. Dürer, paying less attention to the countenance, took over the Italo-Byzantine practice of shrouding the head with a white kerchief over the forehead, which in turn is covered by a cloak whose edges are folded back. In spite of initial reactions to this picture after it was first discovered, it cannot date from Dürer's second stay in Venice, as evident from its composition as well as from individual details which still owe much to the late Gothic tradition in Germany. The mere fact of the painting's existence in the monastery in Bagnacavallo — which was not

130
A Windish Peasant Woman
Inscribed: *Vna Vilana Windisch*
[A Windish Peasant Woman],
with the date 1505 and the mono-
gram of the artist. Pen and ink on
paper, background tinted brown.
416 x 281 mm. London, British
Museum.

*Martin Waldseemüller, on his
map of Europe (1511 and 1520),
designated the inhabitants of the
Dalmatian coast as "Winds." But
the conclusion drawn by K. Gin-
hart from this inscription, name-
ly that Dürer's travel route on his
second journey to Italy led
through Carinthia, is not con-
vincing. Dürer might have en-
countered the woman in Venice,
as well as another of whom a
drawing survives in Rotterdam.*

founded until 1774 — is no proof that the painting was produced in
Italy during either of Dürer's sojourns there. (There are no other
known paintings dating from Dürer's first Italian trip.) The com-
bination of motherliness and dignity, and of German and Italian
elements of style, and the extraordinary care lavished on the execu-
tion speak strongly for a date after the first return from Italy, when
Dürer also systematically utilized in Nuremberg the fruits of his
Italian experiences in the engraving and woodcut media.

The portrait drawing of a woman that bears, next to the mono-
gram, the inscription: "a Windish peasant woman" (130) and the
date 1505, has led some commentators to suppose that Dürer may
have met the woman in the Slovenian-speaking areas of Carinthia.
Accordingly, it has been proposed that Dürer's route on his second
trip was not via the Brenner Pass. Nevertheless, it is more probable
that Dürer met the vigorous *eschiavonesca* in Venice and decided to
sketch her likeness. This supposition is supported by the fact that
the Slavic inhabitants of Carinthia and Friaulia refer to the residents
of the Dalmatian coast directly opposite Venice as "Winds," so also
on Martin Waldseemüller's map, printed in Strassburg in 1511. The
careful pen and ink drawing, complete in all its details, and its com-
panion piece that probably also depicts a Windish peasant lady
(Rotterdam, Museum Boymans-van Beuningen) show no trace of
haste as is often discernable in sketches made en route.

When Dürer arrived in Venice a second time he drew the attention
of local artists more than before. The contacts seem not to have been
entirely harmonious. The Italians criticized his paintings, particular-
ly for the absence of classical influence. Not quite a year later, Dürer,
by now certain of the success of the picture he had painted for San
Bartolommeo's, wrote to Willibald Pirckheimer on 8 September
1506 that he had reduced to silence those critics who had acknowl-
edged his skill as an engraver but not as a painter: "I have silenced all
the painters who said I am good at engraving but in painting, I don't
know what to do with color." But distrust and tension persisted;
Dürer even believed his life to be in danger. Only two artists are
mentioned by name in the letters to Pirckheimer. The venerable Gio-
vanni Bellini, in the wisdom of age above such quarrels, had visited
Dürer in his studio, praised him to many, and expressed the wish to
possess something by Dürer's hand. Dürer returned the compliment
when he referred to him as the best of the painters, in spite of his age:
"He is very old and is still the best in painting." A second artist, men-
tioned by name, is not so fortunate: Dürer deals with him in a mix-
ture of derision and criticism. The Venetian painter Jacopo de' Bar-
bari, a protegé of Anton Kolb (the agent in Venice of the great
Nuremberg printer Koberger, Dürer's godfather), had been in con-
tact with Dürer in Nuremberg in 1500/02. He lost much of his luster
when he was subjected to a comparison with the painters who truly
determined the level of painting in the city of lagoons. "Here there
are many painters who are better than Master Jacob," Dürer re-
ported to Willibald Pirckheimer, and he quoted Venetian colleagues,
"If he were good, he would have stayed here."

113

114

115

Another opinion about art, mentioned by Dürer to Willibald Pirckheimer, revised an impression of the earlier stay in Venice. Because of the abbreviated manner of expression, which presupposes the recipient's acquaintance with the subject, we can no longer evaluate fully the significance of this change of view: something that eleven years earlier had made an extraordinary impression pleased him no longer. And he had been so sure of himself that he would not have accepted that opinion from another: "The thing that pleased me so much eleven years ago no longer appeals to me. And had I not seen it myself, I would not have believed anyone else." Dürer showed himself able to approach the art of Venice without prejudice, to look at it anew, and to change old impressions and judgments. If he raised the elderly Giovanni Bellini above the younger artists, and measured his own achievement of the great altar panel for San Bartolommeo against Bellini alone, still his eyes were not closed to what was novel in the art of the new generation, that of Titian and Giorgione. Among the works produced in Venice it is primarily the portraits, with their restrained coloring and physiognomical characterization which suggest that the work of Giorgione had nonetheless made an impression on the visitor (129, 279).

In the year 1505 Dürer also produced an unfinished portrait of a woman that attracts the attention of the viewer by a most lifelike impression (131). Dürer's Venetian experience, which was to bring to fullest expression his potential as a painter, is here manifest. Light colors, verging on the brown and red, are placed against a black background: a bright red dress, reddish blond hair emerging from a cap imbricated with gold, the skin lightly tanned by the sun. The relatively large nose, the expressive mouth with full lips, and the strong chin determine the physiognomy. It is primarily a change in mood of the sitters that characterizes and links the portraits produced in Venice. The beholder no longer feels himself compelled to protect his own personality against the tension and force of will of the person portrayed which had radiated from the earlier portraits. He lets himself be caught up in the reflective and composed quietude. Dürer's tensions must have been relaxed so that he became receptive to the introverted feelings that imbue the works of Venetian painters, and it was this introversion which influenced him the most. The direct influence of Giorgione is best seen in a picture of a young man, dated 1506, now preserved in Genoa, in spite of its damaged condition which has necessitated several restorations (279). Linked closely to it is another portrait done in Venice of a woman, even though the artist did not place a date on it (132). The figure is in half length, turned only slightly toward the left, and seeming very near the viewer. What determines the artistic merit of the painting is the play of light and shadow on the skin and the relative poverty of contrast in the colors—in varied tones of brown for the figure itself, placed before a background that becomes an increasingly darker blue toward the bottom of the picture. It is today no longer possible to determine to what extent preservation—the top layer of color became lost or damaged—contributes to the softening of the forms.

131 ← ←
A YOUNG LADY OF VENICE
With the monogram of the artist and the date 1505. Oil on elmwood. 32 x 25 cm. Vienna, Kunsthistorisches Museum.

The picture is not quite finished; e.g. the ribbon on the lady's right shoulder has only the base coat.

132 ←
A VENETIAN LADY
With the monogram of the artist, perhaps added by another hand. Dürer's initials AD appear as if embroidered on the lady's dress. Oil on poplar wood. 28 x 21 cm. Berlin-Dahlem, Staatliche Museen Preussischer Kulturbesitz, Gemäldegalerie.

The poplar panel as well as the costume suggest that the portrait was done in Venice in 1506.

116

The masterpiece of Dürer's second stay in Venice was "The Feast of the Rose Garlands" (139, 140), on the altar of the right chapel of the Church of San Bartolommeo, until it was acquired by Emperor Rudolph II. Joachim von Sandrart reported how, in 1606, wrapped in wool and carpets and covered with a tarpaulin, it was carried, suspended from a pole, by four men over the Alps, to the Emperor's castle in Prague. This painting incorporated the sum of all Dürer's experiences in his encounter with the art of the Italian Renaissance. It was his vehicle for presenting himself to the artists of Venice as a painter, and with it he measured himself against them. After the transfer to Prague, an "Annunciation" by Hans Rottenhammer of Munich took its place in San Bartolommeo's.

Dürer's letters to Willibald Pirckheimer tell us a good deal about the preparation and progress of this masterpiece, as well as the attention it attracted when it was set in place. Moreover, twenty-two detailed studies in brush on blue Venetian paper have survived, although one of these is a copy (133-135, 137, 138, 143). Dürer had learned the technique of preparing panel paintings with a large number of detail studies from the Venetian artists. Each of these studies may be regarded as an autonomous work of art of superb quality. Far less is known about the individuals who commissioned the picture or about those whose likenesses appear in it; they participate in the action by their devotion. On 6 January 1506 Dürer wrote to Pirckheimer, in the first of the surviving letters, that he had been commissioned "to paint a panel for the Germans" and that he would receive 110 florins for it, though his own expenses would be less than 5 florins. The reference seems coincidental, but was perhaps meant to show Pirckheimer, whom he apparently owed a considerable

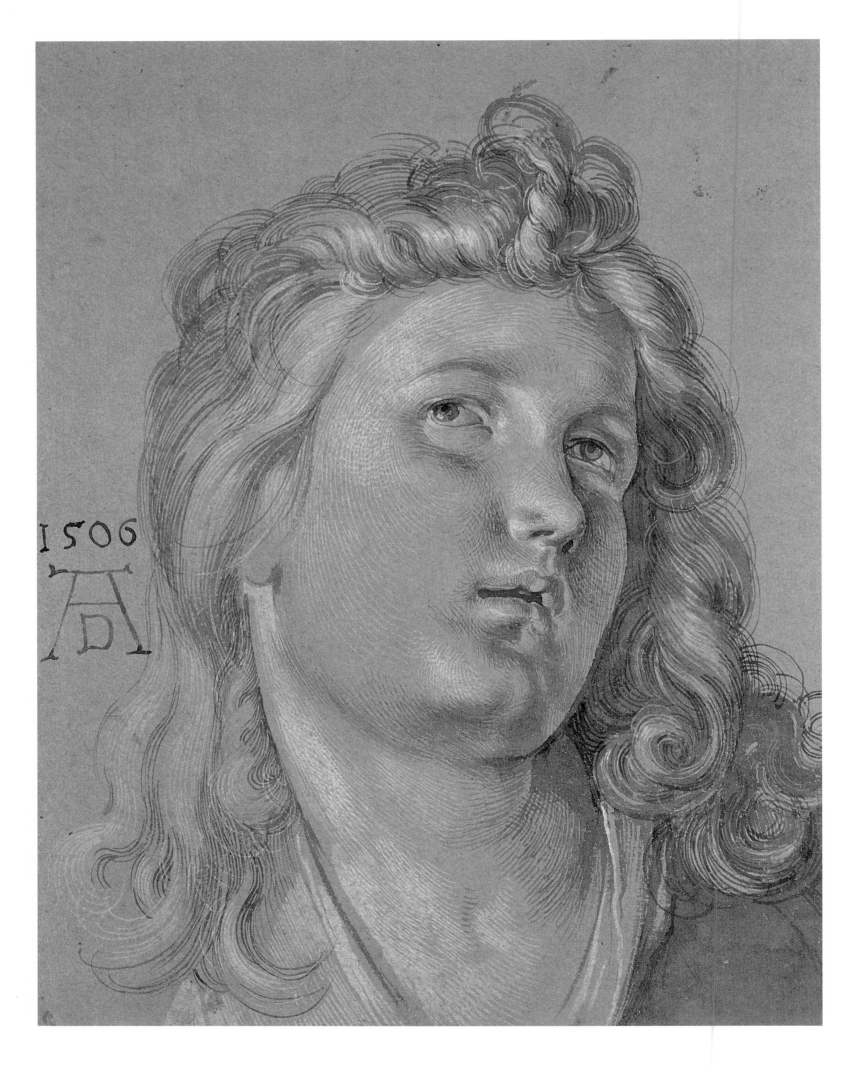

118

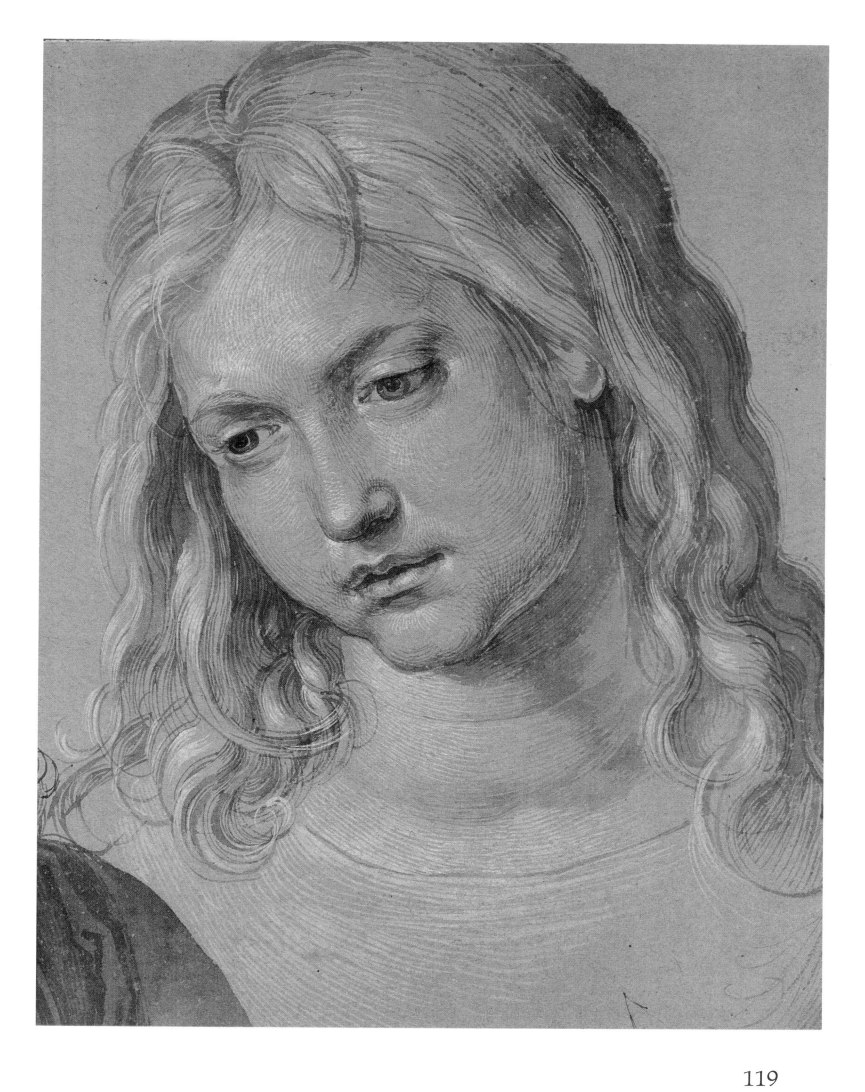

119

sum, that he was solvent. He reported also that he had begun the undercoating, since the picture was to be displayed on the altar a month after Easter.

Various suggestions have been put forward about the identity of the person or persons who proposed the picture and commissioned Dürer to produce it. In Francesco Sansovino's description of the city, *Venetia città nobilissima*, published in 1581, mention is made that several years earlier Christopher Fugger had brought to the Church of San Bartolommeo an altar panel of extraordinary beauty, depicting the Virgin, whose care in execution and in the coloring was characteristic of the hand of Albrecht Dürer. It is known also that its sale in 1606 required the consent of the Fugger family. It should be noted, however, that Sansovino erred in some details, since no Christopher Fugger is recorded in Venice prior to 1520.

The subject of the picture, which the commissioner undoubtedly specified, offers no clear hint as to who he might have been. The Virgin, the Infant Christ, and St. Dominic are distributing garlands of roses to the crowd, which includes most prominently the Pope and the Emperor. The painting stresses the adoration of the Virgin and the rite of the rosary, with which the Dominican order was particularly concerned. The introduction of the rite as well as the foundation of the order to perpetuate it was, until well into the 19th century, attributed to St. Dominic himself. Since there was available no prior iconographic tradition of the theme either in Germany or in Italy, Dürer seemingly based his composition on a somewhat mediocre woodcut that graced a tract by the Dominican Jakob Spengler about the rite of the rosary. The writer had founded the first Brotherhood of the Rosary in 1475 at Cologne. Brotherhoods of many kinds existed within the Catholic Church and often had class character. The members all appeared together at worship services and on similar occasions, and were obligated to say prayers for the souls of the members and engage in other spiritual exercises. The existence of a Brotherhood of the Rosary which included particularly bakers but also other German residents of Venice is documented for the years 1624-25, at which time they commissioned an altarpiece. This does not, however, preclude the possibility that as early as the beginning of the 16th century a group of German merchants joined in a similar rite. All that is certain is Dürer's report that he was asked to paint a panel for the Germans, and that a date was fixed for its completion: "It must, God willing, be placed on the altar one month after Easter." Liturgically, that meant Canticle Sunday. It offers no connection to a pictorial theme, except for its customary introductory hymn, "Sing a New Song to the Lord." Based on these meager data, all that can be surmised is that the work was commissioned for the entirety of the German commercial colony by its presiding officers, the *cottimieri*, and paid out of the so-called *cottimo*, to grace the church used by them. The church was probably also the parish of the German artisans.

120

135 ← ←
HEAD OF AN ANGEL: Preparatory drawing for "The Feast of the Rose Garlands"
With the monogram of the artist and above it the date 1506. Brush drawing on blue Venetian paper, heightened with white. 270 x 208 mm. Vienna, Graphische Sammlung Albertina.

The drawing originally included on the right the shoulder of the angel, as well as the study for the head of the young Jesus used in the painting "Christ Among the Doctors." The two preparatory sketches were originally painted on one large sheet and later divided (cf. 136).

136 ←
THE HEAD OF CHRIST AT AGE TWELVE: Preparatory drawing for "Christ Among the Doctors"
Brush drawing on blue Venetian paper, heightened with white. 275 x 211 mm. Vienna, Graphische Sammlung Albertina.

Cf. 135.

137
ST. DOMINIC: Preparatory drawing for "The Feast of the Rose Garlands"
With the monogram of the artist and the date 1506. Brush drawing on blue Venetian paper, heightened with white. 416 x 288 mm. Vienna, Graphische Sammlung Albertina.

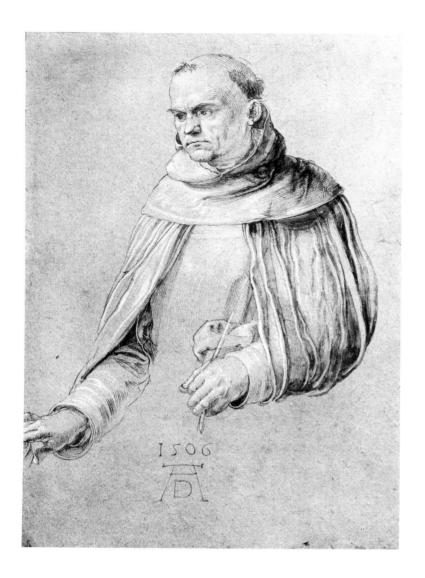
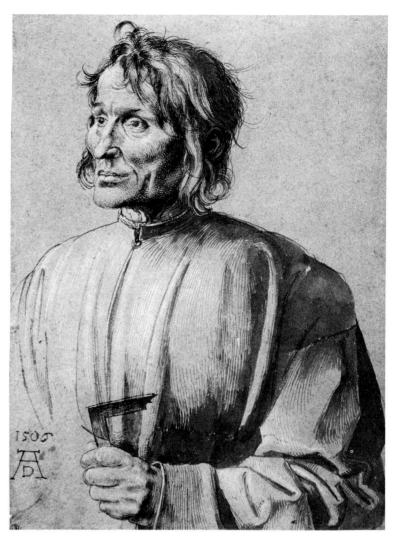

138

An Architect: Preparatory drawing for "The Feast of the Rose Garlands"
With the monogram of the artist and the date 1506. Brush drawing on blue Venetian paper, heightened with white. 386 x 263 mm. Berlin-Dahlem, Staatliche Museen Preussischer Kulturbesitz, Kupferstichkabinett.

The carpenter's square indicates the person depicted is a builder, probably Master Hieronymus of Augsburg, who drew the plans for the rebuilding (between 1505 and 1508) by the Milanese Antonio Abbondi, called Lo Scarpagnino, of the compound of the German merchants, the Fondaco dei Tedeschi, that had been destroyed by fire.

The outer form of the retable, a broad rectangular panel without movable wings, corresponds to Italian usage. There are earlier examples in Venetian painting of this composition consisting of a triangular central group within a diamond formed by four heads. The scene is dominated by the enthroned Mother of God, raised up in the center. The canopy and the crown, the latter a masterpiece of late Gothic goldsmith's artistry, denote her rank as Queen of Heaven. Emperor and Pope kneel before her as the two highest ranking representatives of Christianity. The angel between them, playing the lute with captivating charm, is a friendly nod to Giovanni Bellini, and to his enthroned Virgin on the altar of S. Maria Gloriosa dei Frari. Slightly set back and flanking the main group, in rows on their knees, appear the representatives of humanity, depicted in individual portraits. Numerous overlappings make the number of worshipers appear rather greater than are actually pictured. There are glimpses on both sides of the Virgin's throne of an alpine landscape.

121

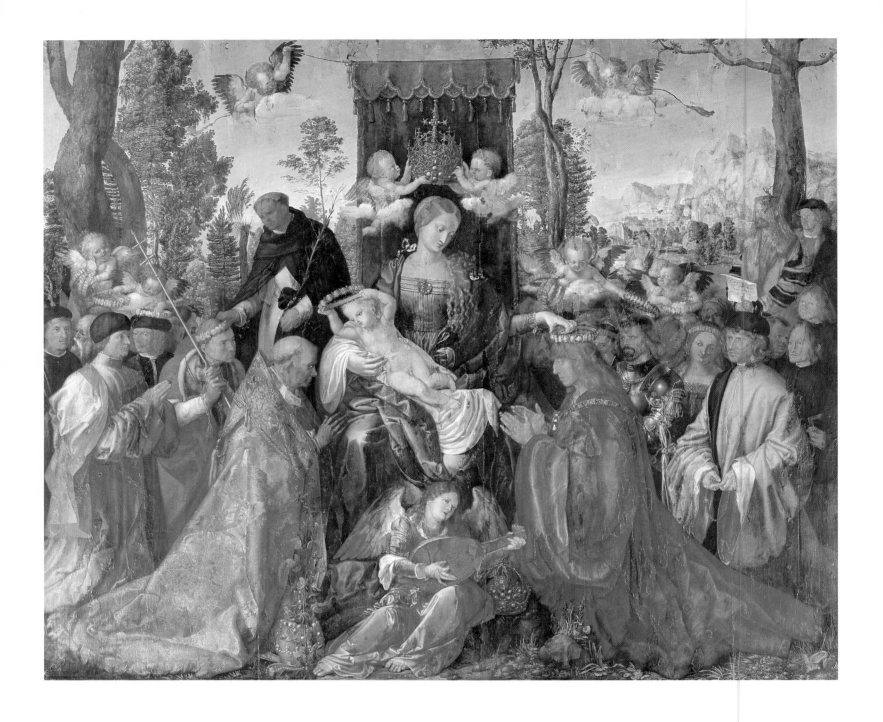

Fate has not been good to the picture since its removal from Venice. It is today no more than a carefully tended ruin, a mosaic of original and renovation; its renowned radiance remains only in a few portions, but the impression of the whole is greatly impaired. A broad strip in the middle including the Virgin has lost its original pigment almost enitrely, and has been repainted. Dürer expressed special pride in the coloristic effect of the panel. For the German artist it was a question of proving himself equal to the Venetians in an area in which they justifiably considered themselves to be masters. The iridescent effect of the colors was a consequence of the selection of color values as well as of the careful application of layers of varnishes. The gold in the Pope's robe and in the garb of the angel

139
THE FEAST OF THE ROSE GARLANDS
The Virgin, the Infant Christ and St. Dominic distribute rose garlands. In the background the artist is holding a slip of paper in his hand with the words: *Exegit quinque= / mestri spatio Albertus / Durer Germanus / .M.D.VI.* Under that the monogram. Oil on poplar wood, 162 x 194 cm. Prague, Narodni Galerie.

*"The Feast of the Rose Garlands"
was Dürer's principal work during his second stay in Venice. It
was produced on commission
from the German colony in
Venice for the Church of San
Bartolommeo. Mentioned for the
first time in a letter from the artist
to Willibald Pirckheimer dated 6
January 1506.*

140
ALBRECHT DÜRER AND AN UN-
KNOWN COMPANION: Segment
from "The Feast of the Rose Garlands"

Cf. 139.

reinforces the bright tones limited to the varied shades of red and
blue on the foreground figures. The brilliant coloring in the foreground contrasts with the sober tones of the garb of the worshipers.
The dominant central blue of the Virgin's dress is repeated, several
shades lighter, in the blue of the sky, juxtaposed, screenlike, behind
the green of the canopy and the trees. Only Emperor Maximilian I
can be identified with certainty among the crowd of living individuals whose portraitlike representations help make the scene so
lifelike. Dürer, who in 1506 had no portrait drawings of Maximilian
to fall back on, used one by a Milanese artist, probably Ambrogio
de Predis (Berlin-Dahlem, Staatliche Museen Preussischer Kulturbesitz, Kupferstichkabinett). This painter, part of the circle of
Leonardo, was in the retinue of Bianca Maria, the daughter of
Ludovico Sforza, Duke of Milan. In 1494 she became Maximilian's
second wife.

The strict profile of this portrait drawing, virtually unknown in Germany, was preferred by Italian artists and facilitated Dürer's adaptation of it. The names of the other persons in the picture can only be surmised, and the task is made more difficult because of the poor condition—the entire forward portion of the Pope's face, for example, has been repainted. The identification of the man in black on the right as the German architect, Hieronymus, is supported by the carpenter's square in his right hand. It was he who designed the reconstruction of the Fondaco dei Tedeschi, rebuilt by the Milanese Antonio Abbondi, called Lo Scarpagnino, following a fire in 1505. If this interpretation is correct, the other individuals depicted may well be important figures in the Fondaco, perhaps the *cottimieri* who had entrusted Dürer with the commission. At a distance from the central activity of the picture, but emerging from the background to catch the eye of the viewer, Dürer portrayed himself with a companion who watches the ceremony. A sheet in the hand of the painter—the beholder is invited to read it on account of its eye-catching position—carries the inscription in Latin: *Exegit quinque = / mestri spatio Albertus / Durer Germanus / .M.D.V.I.* [Albrecht Dürer, a German, produced it within the span of five months. 1506]. Below it appears the monogram of the artist.

The self-portrait and the inscription confirm Dürer's own statements to Willibald Pirckheimer about the picture, to which he proudly refers again and again in his letters. Just as he portrays himself in the picture, he may well have stood there and watched the Doge and the Patriarch of Venice as they viewed the completed picture. The information that it took five months to complete is intended to emphasize once more the effort and care required. It can refer only to the execution but not to the preparatory designs, since we first hear of the completion of the panel on September 23. There are complaints in Dürer's letters about the length of time the work was taking; in fact, in contrast to his early optimistic estimate about the commission and the purchase price, the artist found that the costs of his stay would leave nothing over from his earnings. Furthermore, a skin ailment delayed the start of the work.

In the statements concerning his origin, Dürer makes distinctions. On the wood block produced in Basel he writes, "of Nuremberg." Later he uses *Noricus* or *Norenbergensis* to designate his native city. *Germanus* appears on two paintings produced in Venice. He calls himself *Alemanus*, i.e. "upper German," on three pictures produced at home immediately after his return from Venice, a designation that may perhaps be interpreted to mean that all three were ordered by persons outside Nuremberg, among them the Elector Frederick of Saxony and the Frankfurt merchant Jakob Heller. The decision to call himself, proudly, *Germanus* in Venice suggests a developing national pride which was consciously encouraged by the German humanists and was also furthered by the publication of the idealized representation of the Germans in Tacitus's account, first appearing in print in Venice in 1470.

141
THE HANDS OF THE YOUNG CHRIST:
Preparatory drawing for "Christ
Among the Doctors"
With the monogram of the artist,
turned 90°, by another hand,
and the date 1506. Pen drawing
on blue Venetian paper, with
wash and heightened with white.
207 x 185 mm. Nuremberg, Ger-
manisches Nationalmuseum (De-
positum Frau Irmgard Petersen,
née Blasius).

142
TWO PAIRS OF HANDS WITH BOOKS:
Preparatory drawing for "Christ
Among the Doctors"
With the monogram of the artist
and the date 1506. Brush drawing
on blue Venetian paper, with
wash and enhanced with white.
249 x 415 mm. Nuremberg, Ger-
manisches Nationalmuseum (De-
positum Frau Irmgard Petersen,
née Blasius).

Many have attempted to identify Dürer's companion, but there is
no consensus. If the portraits in the foreground are those of persons
who commissioned the painting, it is proper to assume that the man
in the background, like his neighbor Dürer, did not belong directly
to this group but was connected with the painting in some other
way, either with the commission or the execution.

The mention of the length of time it took to complete the picture
links it with a painting that, according to its inscription, was com-
pleted in five days (136, 141, 142, 144). Dürer had already ad-
dressed himself to the subject of the twelve-year-old Christ
disputing the doctors in a woodcut of the "Life of the Virgin" series
(320). In this print Dürer wanted to have the action take place in a
large hall, supported by columns, simulating the Temple in Jerusa-
lem, where the disputation took place. Because of the perspective
and the relatively small size of the figures, the viewer's attention is
drawn to the young Jesus, sitting in the distant corner at the lectern.
In the painted version Dürer departs from this concept. No particu-
lar location is depicted. Space is merely suggested by the activity of
the figures in the foreground as they crowd around the young Jesus.
The lower border of the panel cuts sharply across the figures of two
of the participants in the discussion and across the tomes held by
them. The heads of four others reach to the upper border. In the
midst of men of various ages stands the young Christ, taking up the
full height of the panel. There he stands with his long blond hair,
and gestures with his fingers to make a point. His face is marked by
reflective sadness. The representatives of a self-confident and un-
instructable body of learning contend with him, citing from the
Scriptures and seeking with gesticulating hands to oppose his
arguments. Only one face, in the upper right corner, reveals
anything of the astonishment, reported in the gospel of St. Luke, at

125

126

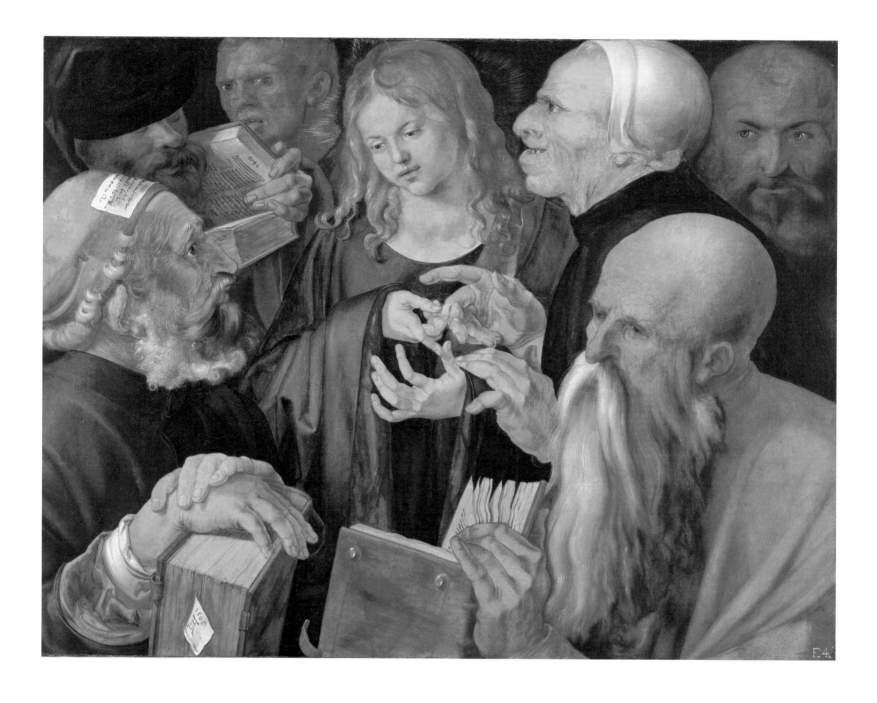

143 ←

THE MANTLE OF THE POPE: Preparatory drawing for "The Feast of the Rose Garlands"
With the monogram of the artist by another hand and the date 1514. Watercolor on paper. 427 x 288 mm. Vienna, Graphische Sammlung Albertina.

144

CHRIST AMONG THE DOCTORS
The monogram of the artist appears on a slip of paper that serves as a bookmark; above it is the date 1506 and below it the inscription: *opus qui*[n]*que dierum* [the product of five days]. Next to the monogram are traces of the letters of another line of inscription. Oil on poplar wood. 65 x 80 cm. Lugano/Castagnola, Thyssen-Bornemisza Collection.

The survival of a preparatory study for this painting, originally on the same sheet with a preparatory drawing for "The Feast of the Rose Garlands," suggests that Dürer worked on the two paintings simultaneously. This agrees with a passage in Dürer's letter to Willibald Pirckheimer of 23 September 1506, in which he reports that "The Feast of the Rose Garlands" was finished, as well as "another picture the like of which I have not painted before." *In a reproductive drawing of the 17th century,* F. ROMAE *appears below the signature on the painting. The painting was in the Galleria Barberini in Rome until it was acquired for the Thyssen-Bornemisza Collection in 1934. It remains uncertain whether in the late autumn of 1506 Dürer rode from Bologna to Rome, carrying with him the large and delicate preparatory drawings, and then painted the picture during a short stay in the Holy City, taking it back to Venice where it impressed Giorgione.*

127

the wisdom of the lad. Features twisted to the point of caricature, heavy leather-bound volumes, importunate hands depress the beholder. In spite of more recent opinions to the contrary, a brief remark in Dürer's letter of 23 September 1506 refers to the picture, confirming that it was produced in Venice. The artist wrote to his friend Pirckheimer that besides the picture of the "Feast of the Rose Garlands," he had produced yet another, "such as I have not hitherto made." A small piece of paper, a bookmark protruding from the closed book which the sage on the left is holding to signify the definite basis of his knowledge, carries next to the monogram of the artist and the date, 1506, information on how long it took to produce: *opus qui*[n]*que deirum* [the product of five days].

The connection to the "Feast of the Rose Garlands" as a work requiring five months cannot be a mere coincidence, but refers to the exact time required for the execution of the painting. This information achieved its full impact only when the two pictures stood opposite each other in Dürer's studio and could be viewed simultaneously. The panel "Christ Among the Doctors" without doubt arose from Dürer's need to have some other work at hand, which flowed more quickly and stimulated his fantasy, besides the large painting that required so much detail work. He was to describe this kind of "diligent detail work" in a letter to Jakob Heller a few years later. The vast difference between this composition and that of the same subject in the "Life of the Virgin" series justifies his statement that he had never done anything like it.

Surviving pictures, or at least those whose descriptions survive, by painters whose work impressed Dürer, besides Giovanni Bellini and Cima da Conegliano, at that time dealt also with compositions of figures in half length, harking back quite possibly to a lost picture of this subject by Leonardo da Vinci, commissioned by Isabella d'Este in 1504. The connection between the distorted faces, a device for expressing moral depravity in both German and Dutch artistic tradition, with physiognomical studies of Leonardo has a decisive part in Dürer's concept. It gave Dürer the means for a psychological interpretation of a closed religious mind. Recent Italian research has taken note of the German component in Venetian art, in the development of which the work of Dürer and the knowledge of his paintings was a decisive factor. Naturally it was not the older painters around Giovanni Bellini, but members of the generation some ten years younger than Dürer, among them Giorgione, Titian, and Lorenzo Lotto, who incorporated the "German element" into their own styles. The influence, particularly of Dürer's Christ standing isolated among the rabbis (144), is evident in the late work of the short-lived Giorgione.

145

HEAD OF A WEEPING CHERUB: Preparatory drawing for "The Great Crucifixion"
With the monogram of the artist and the date 1521. Chalk drawing on blue grounded paper, heightened with white. 211 x 167 mm. Nuremberg, Germanisches Nationalmuseum (Depositum Irmgard Petersen, née Blasius). Cf. 150 and 152.

146 ➝

MAN, AGE NINETY-THREE
Inscribed: *Der Man was alt 93 Jor vnd noch gesunt und fermuglich zw antorff* [The man was 93 years old and yet healthy and cheerful to talk to]. With the monogram of the artist and the date 1521. Brush drawing on gray-violet grounded paper, heightened with white. 415 x 282 mm. Vienna, Graphische Sammlung Albertina.

Dürer used this study for a painting of St. Jerome (147). A second study, probably earlier than this one, is in Berlin-Dahlem (Staatliche Museen Preussischer Kulturbesitz, Kupferstichkabinett). More preparatory studies for the picture, on gray-violet paper, are in Vienna (Albertina).

147 ➝ ➝

ST. JEROME IN HIS CELL
Lower left, on a slip of paper that serves as a bookmark, appears the monogram of the artist and the date 1521. Oil on wood. 60 x 48 cm. Lisbon, Museu de Arte Antigua.

The study of the 93-year-old man served as the basis of the face of the saint; Dürer sketched the man at Antwerp (146). He presented the painting to the Portuguese consul in Antwerp, Rodrigo Fernandez d'Almada (cf. 157 and 285).

The Low Countries

Dürer's last major journey was to the Low Countries, where he was to stay for an entire year. It demonstrates that, though now in his fifties, he retained an open mind receptive to new people and ideas, and bears witness to his ability to digest his experiences and employ their fruits in his art. The stimuli and the experiences of this journey also led him to take up once more work with brush and palette, a category that in the preceding years had been neglected in favor of reproductive techniques and theoretical studies. The new impulse had its full effect solely in the area of portraits. Preliminary work done for pieces with religious themes at that time was never completed. This can be explained by the crisis in religion which set in shortly after his return, a crisis that generated doubt in the justification for representing God and the saints in painted and sculpted works.

130

148
St. Barbara: Preparatory draw-
ing for a projected painting of the
Virgin with Saints
With the monogram of the artist
and the date 1521. Chalk draw-
ing on green grounded paper. 417
x 286 mm. Paris, Musée National
du Louvre, Cabinet des Dessins.

*This drawing is part of a group
preparatory for a projected* Sacra
Conversazione *that was never
completed. These chalk drawings
are carefully executed on paper
grounded with various colors (cf.
149 and 151).*

149
Concept Drawing for a Paint-
ing of the Virgin with Saints
Marked with the names of the
saints: James, Joseph, Joachim,
Zacharias, John, David (cor-
rected from Jo...), Elizabeth,
Anne. Pen and ink on paper. 312
x 445 mm. Paris, Musée National
du Louvre, Cabinet des Dessins.

*In 1521, after his return from the
Low Countries, Dürer was busily
preparing a painting that was
never executed. Besides the saints
whose names are inscribed — with
"Elizabeth" written in error above
a bearded man — it is possible to
identify, according to their attri-
butes: Dorothy, Margaret and
Catherine on the left, and Bar-
bara, Apollonia, Agnes and a
kneeling donor on the right.*

Three projects begun under the immediate impact of the ex-
periences in the Low Countries can be reconstructed on the basis of
preparatory drawings. Several designs in oblong format dating
from 1520 and 1521 were probably intended for a new engraved or
woodcut Passion series beginning with an "Agony in the Garden"
(Karlsruhe, Kunsthalle; Frankfurt, Städelsches Kunstinstitut),
(153). Two versions of "The Bearing of the Cross" followed, de-
signed under the influence of earlier Netherlandish examples,
featuring historical events by the depiction of many figures (154).
Three designs of Christ being carried to the grave were to form the
conclusion (Florence, Uffizi; Nuremberg, Germanisches Museum;
Frankfurt, Städelsches Kunstinstitut), (155). This was a popular
subject in the art of the Netherlands; in Germany it was replaced by
representations of the lamentation for Christ, or of the entomb-
ment. It remains uncertain whether a partially finished engraved
"Crucifixion" in vertical format was meant as the center sheet of the
Passion series or was intended to be autonomous (152). Trial im-
pressions from the uncompleted plate reveal the contours of the
powerful body of Christ on the Cross, facing forward, as are the

150 ➡
The Magdalen Embracing the
Cross: Preparatory drawing for
"The Great Crucifixion"
With the monogram of the artist
and the date 1521. Chalk draw-
ing on green grounded paper,
partially heightened with white.
Paris, Musée National du
Louvre, Cabinet des Dessins.

151 ➡ ➡
St. Apollonia: Preparatory
drawing for a painting of the Vir-
gin with Saints
With the monogram of the artist
and the date 1521. Chalk draw-
ing on green grounded paper. 414
x 288 mm. Berlin-Dahlem, Staat-
liche Museen Preussischer Kul-
turbesitz, Kupferstichkabinett.

Cf. 148 and 149.

bystanders. Of these only the standing figures, and the Virgin, the Magdalen, and St. John were engraved, whereas the place intended for the mounted soldiers and the captain remains empty. In an ad-joining landscape are a city and a castle.

While he was still in the Low Countries or perhaps shortly after his return home Dürer began work on a large altar panel which, in format as well as details, recalls the composition of the "Feast of the Rose Garlands" of 1506 (148, 149, 151). Italian characteristics were combined with those peculiar to the Netherlands, which associates Dürer with those painters of the Netherlands who received their training in Italy. Among these were the young Jan Scorel, who, on his way to Italy in 1519, sought out Dürer in Nuremberg, and Bernaert van Orley who, after his return from Italy, became court painter to Margaret, the regent of the Netherlands. In 1520 Dürer was van Orley's guest in Brussels and drew his portrait in charcoal (Paris, Louvre, Edmond de Rothschild Collection).

The projected painting was to depict a typical gathering of saints around the enthroned Virgin. Apart from some alternative concept drawings (Paris, Louvre), as well as one on which the planned colors were written (Bayonne, Musée Bonnat), Dürer had already produced a number of studies of individual figures and sections of attire in complete detail. He drew them in chalk on paper with a green or dark violet background, heightened with white. They be-came autonomous works of art bearing Dürer's monogram and the date. The studies of Sts. Barbara and Apollonia (148, 151), who assist the Virgin, combine individuality and a type of the maturing young girl or woman about which controversy has arisen whether the artist had used a model or simply devised ideal figures from imagination. In spite of the apparent supression of the personal ele-ment, an effect conveyed by the lowered eyelids concealing the glance, the faces are so much like portraits that they must be based on studies from life. Moreover, the light entering from behind and directed toward St. Apollonia brightens parts of the right portion of the body and face to a degree that obliterates any plasticity. The parts turned away from the light and composed of dark shadows take on three-dimensionality. It appears as if Dürer had studied the lighting effect — in which he was far in advance of his times — since he placed his models in front of a window bathed in sunlight. There is no mention in letters or diary of who might have commissioned this picture. If it was destined for one of Nuremberg's churches, then both donor as well as painter permitted the time to pass by when the cultural prerequisites for a work dedicated to the Virgin and the saints could be accepted without controversy.

The circumstances of his journey had directed Dürer's activities particularly to portraits. Nearly every day he mentioned another portrait drawing in his diary. The recognition tendered by those whom he had depicted together with the income derived from the sale of his graphics financed his stay and traveling costs in the Low

133

134

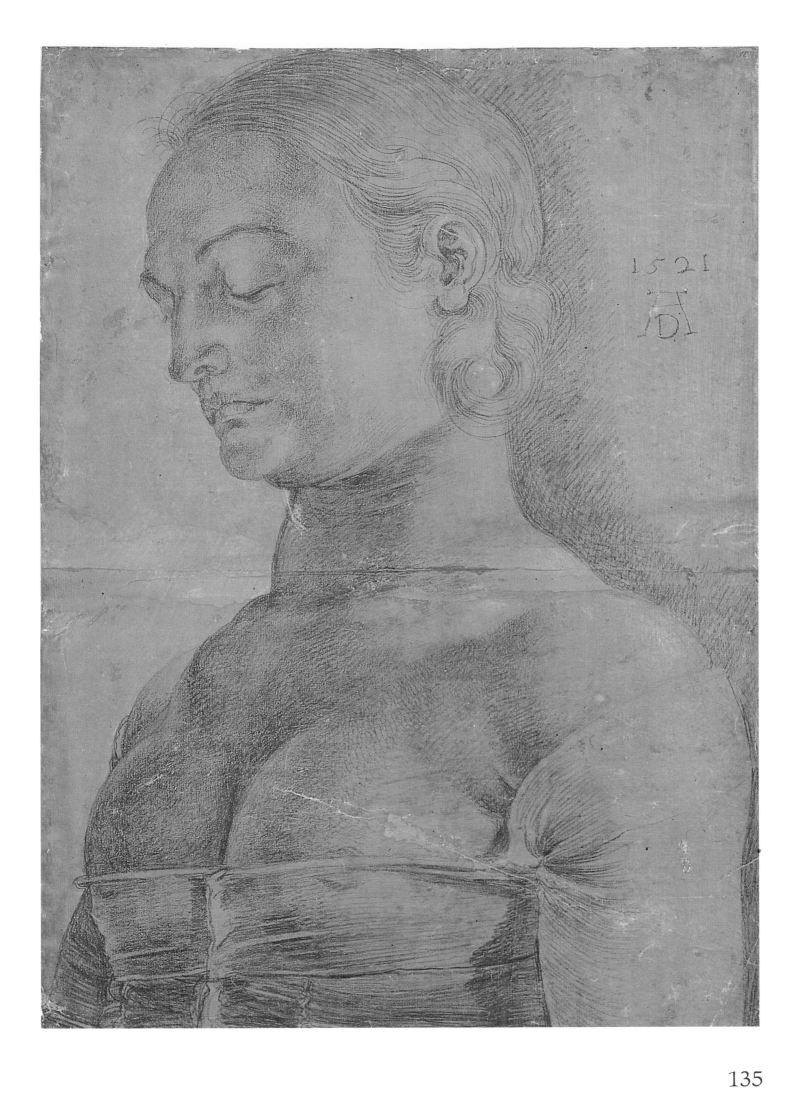

135

Countries. Dürer took up the brush only rarely. For the preparatory work entailed by oil paintings he needed the help of colleagues in his workshop.

In the portrait drawings done in the Netherlands the body portion shown is limited, ending with the chest and the beginnings of the shoulders (156, 157). Those portrayed are moved forward to the degree that they fill up almost the whole of the pictorial surface, so that the stylish berets of the male sitters barely fit within and are often cut off by the edges of the picture. The close-up enhances the impression of self-assured manliness, and thus was substantially in tune with the emotions of the Renaissance. In painted portraits the segment shown is somewhat larger, for it includes the hands (160, 285). In this Dürer followed the example of the great Dutch portraitists like Jan Gossaert, whose "Descent from the Cross" (it burned in 1568) Dürer saw in Middleburg, and Quentin Massys, whom he sought out in Antwerp; and at the same time he reverted to the older Nuremberg portrait tradition.

The diary mentions that on 16 March 1521 Dürer painted in oils a portrait of Bernhard von Resten, who requited the painter with eight florins, paid his wife Agnes a crown, and even offered the Dürers' maid Susanna a florin worth twenty-four stuivers (160). This portrait is most probably the one preserved in Dresden, in which the young sitter holds a letter with the address: "to pernh...." The remainder is covered by the fingers. It has not been possible to document this Bernhard von Resten, but there was a young Danzig merchant who bore the name Bernhard von Reesen. He was born in 1491 and died of the plague in 1521. The commercial relations of the Reesen family business with Antwerp are documented at a slightly later date. Since the spelling of surnames was not very precise in those days, and errors might have crept into Dürer's diary, and moreover the diary has come down to us only in a copied version, it seems safe to accept the identification of "pernhard" as Bernhard von Reesen, at least until a better proposal is put forward.

In this painting, as in the drawings, the portrait bust takes up the entire picture area. The sloping shoulders butt up against the frame. The angle of the right arm is taken up by the beret as it stretches across the whole width of the picture and disappears behind the frame which is part of the composition. The right hand, of which only the fingertips are visible, rests on the lower ledge. Only the thumb and two fingers of the left hand, which holds the letter, are shown. The coloring of the clothing is subdued, as was then the fashion, and the white of the shirt sparkles in a small rectangular opening of the dark, fur-trimmed tunic. Color is introduced only in the brownish-red background. The face, turned but slightly to the left between the black of the beret and the lapel and reflecting the white of the cutout, is brightly lit except for the shadow zone on the left cheek. Pronounced cheekbones, a forceful chin, a wide nose,

152
THE GREAT CRUCIFIXION: CHRIST ON THE CROSS WITH JOHN, MARY, THE MAGDALEN AND THE HOLY WOMEN
Unfinished engraving. 320 x 230 mm. Amsterdam, Rijksprentenkabinet.

The incomplete, yet carefully prepared engraving was possibly intended to be the upright rectangular central sheet for a Passion series in oblong format, planned by the artist in the Low Countries (cf. 153-155 and 145, 150).

153
AGONY IN THE GARDEN
With the monogram of the artist and the date 1531. Pen and ink on paper. 208 x 294 mm. Frankfurt a.M., Städelsches Kunstinstitut. (Cf. 154, 155, 339.)

154
CHRIST CARRYING THE CROSS
With the monogram of the artist and the date 1520. Pen and ink on paper. 210 x 285 mm. Florence, Uffizi, Gabinetto Disegni e Stampe.

In 1520/21, while he was in the Low Countries, Dürer created several pen and ink drawings in oblong format, probably preparatory for a new series of engravings or woodcuts illustrating the Passion. He recorded this project in a diary entry dated 26 May 1521: "I sketched three 'Carryings of the Cross' and two 'Agonies in the Garden' on five half-sheets." (Cf. 153, 155, 339.)

155
THE DEPOSITION OF CHRIST
With the monogram of the artist and the date 1521. Pen and ink on paper. 205 x 290 mm. Nuremberg, Germanisches Nationalmuseum.

The stimulus to treat a theme unknown in German iconography probably came from the art of the Low Countries (cf. 153, 154, 339).

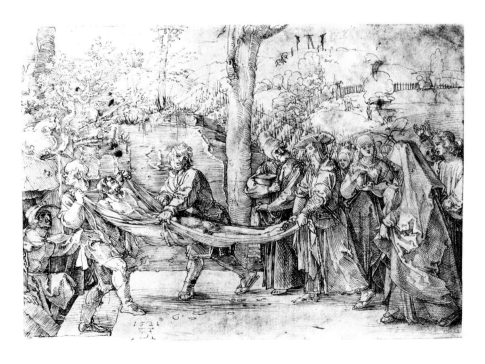

137

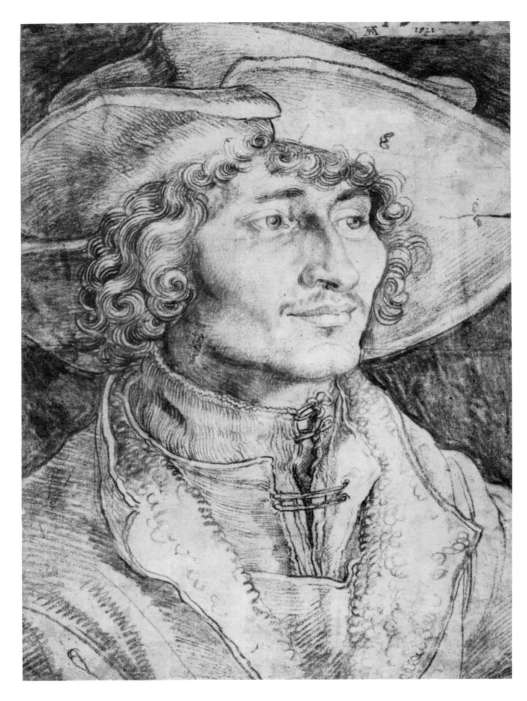

156
PORTRAIT OF A YOUNG MAN
With the date 1521 partially
obliterated because the upper
edge of the paper has been
trimmed. The date reappears,
smaller, together with the mono-
gram of the artist, both by
another hand. Charcoal on
paper. 378 x 271 mm. London,
British Museum.

*The young man has not been
identified with certainty, but the
drawing was probably done in
the Low Countries.*

157
PORTRAIT OF RODRIGO FERNANDEZ
D'ALMADA
Brush drawing on dark violet
grounded paper, heightened with
white. 373 x 271 mm. Berlin-
Dahlem, Staatliche Museen
Preussicher Kulturbesitz, Kupfer-
stichkabinett.

*Dürer noted in his diary between
16 March and 6 April 1521: "I
drew Ruderigo's likeness on a
large sheet of paper with a brush
in black and white." The entry
probably refers to this drawing
and serves to identify the person
depicted, who in 1521 and until
about 1550 served as Portuguese
Consul at Antwerp (cf. 147).*

and the slightly pouting lower lip determine the individuality of the
still youthful features. The eyes, directed at a point in the distance,
suggest something of the tension in the portrait sitting. The excellent
state of preservation, even of the top layer of color, discloses
Dürer's extraordinary technique when he found himself in sur-
roundings which stimulated him to achieve an extreme blending of
color values.

Similar to the Dresden portrait is one that captures the mature
and forceful personality of a sitter who, despite many efforts, has
not been convincingly identified (159). The tiny numerals of a date,

138

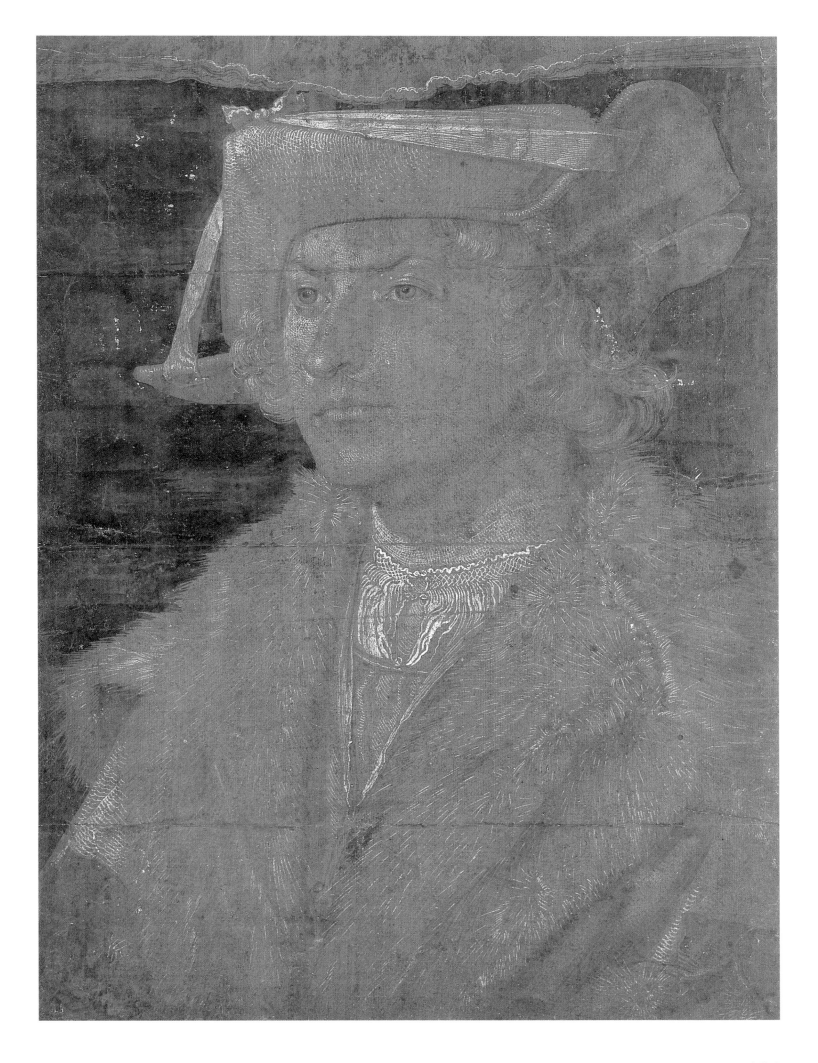

139

scarcely detectable against the background, have contributed to this uncertainty. The relationship to the other likenesses of the journey to the Netherlands and the reading of the date as 1521 suggest a personality of Antwerp. Recent investigation has, however, revised the inscribed date to 1524. Therefore the person portrayed would have to be a resident of Nuremberg or someone with whom Dürer came into contact there. There are stylistic elements which even suggest a date in the last years of the artist's life. The figure has more breathing space. The beret is no longer cut off by the edge of the picture. On the left, the green of the background becomes visible in the space between the upper arm and the frame. The left hand, grasping a rolled up sheet of writing paper, can be seen in its entirety. The collar of the tunic is laid down so that the cutout is no longer horizontally terminated, but ends in a point. The coloristic quality, dominated by the dark green background, has become harder. In the absence of convincing proof to the contrary, consideration must be given to Winkler's suggestion that this painting, characterized by forcefulness in the stance and driving will expressed by the eyes, is an idealized portrait of Willibald Pirckheimer.

The only painting of a religious subject produced by Dürer in the Low Countries is also based on a portrait drawing (146, 147). Always on the lookout for the unusual, Dürer's attention was caught at Antwerp by a ninety-three-year-old man, who, to his astonishment, was "still healthy and cheerful," as he noted on the upper edge of the drawing. The head study of the bearded ancient, his face composed of innumerable wrinkles, was executed with the greatest of care and feeling with a brush on grayish-violet paper. Dürer used the drawing for a painting which once again had St. Jerome as its subject. If the earlier depictions of the saint revealed the penitent in his isolation, chastising his body (251, 260), or the scholar working at his translation in quiet seclusion (106, 158), in this new version the skull that was present in the hermit's cell in the masterly engraving of 1514 acquires decisive significance. The index finger of the saint's left hand points to it, perched between the open pages on the lectern and the pen in the inkwell, emphasizing its association with learning which brings with it the realization of the brevity of life on earth. The elderly sage bearing the etched features of the old man of Antwerp had learned this truth, from which not even the crucified Savior could escape: the glance of the beholder is directed to Christ on the Cross, on a pillar diagonally opposite the skull. We know from Dürer's diary that he had presented the panel to one of his benefactors in Antwerp, the wealthy Portuguese merchant Rodrigo Fernandez d'Almada (157). With this gift the artist had not hesitated to point to the worthlessness of worldly goods. Although the picture thus entered a private collection, it must have become widely known, since numerous variations of it appear in other paintings, especially by artists of the Low Countries. The subject, which stresses the opposite of the humanists' "love of life," obviously was seen as relevant in Dürer's age.

158
St. Jerome in His Study
Bottom right, a small tablet with hanger, lying on the floor, bears the monogram of the artist and the date 1514. Engraving. 247 x 188 mm.

Cf. text pp. 140, 258.

159
Portrait of a Man
With the monogram of the artist and the date 1524. Oil on oak. 50 x 36 cm. Madrid, Museo Nacional del Prado.

The person depicted, who must have been an important personality, has not been positively identified. Proposals based on reading the date as 1521 and seeking the sitter among individuals encountered by Dürer in the Low Countries lack substance.

160
Portrait of Bernhard von Reesen
With the date 1521 and the monogram of the artist. On the letter held in the hand of the person portrayed can be read the address, partly covered by the fingers: *Dem / Pernh / zw.* Oil on oak, 45.5 x 31.5 cm. Dresden, Gemälde Galerie Alter Meister.

A letter with the address of the person occurs frequently in the portraits of merchants. Dürer noted in his diary in Antwerp between 16 March and 4 April 1521: "[I] made a portrait of Bernhart von Resten in oils." Since there is no record of a merchant by this name, the suggestion by E. Brand that it is a likeness of Bernhard von Reesen of Danzig is the most probable.

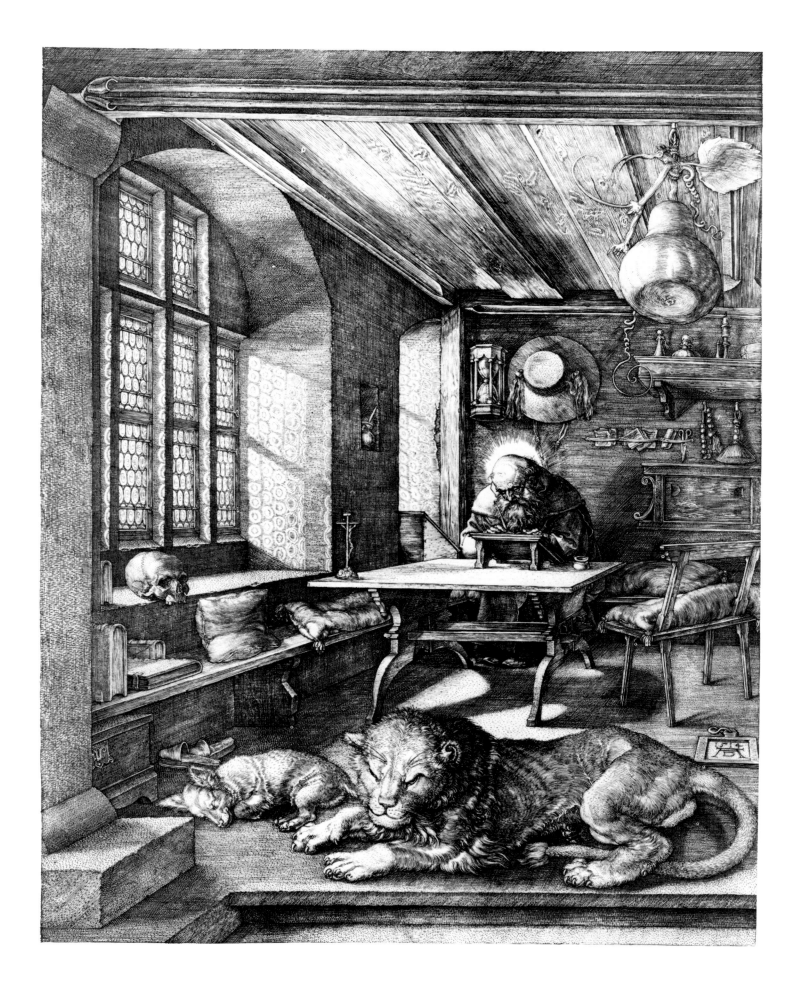

141

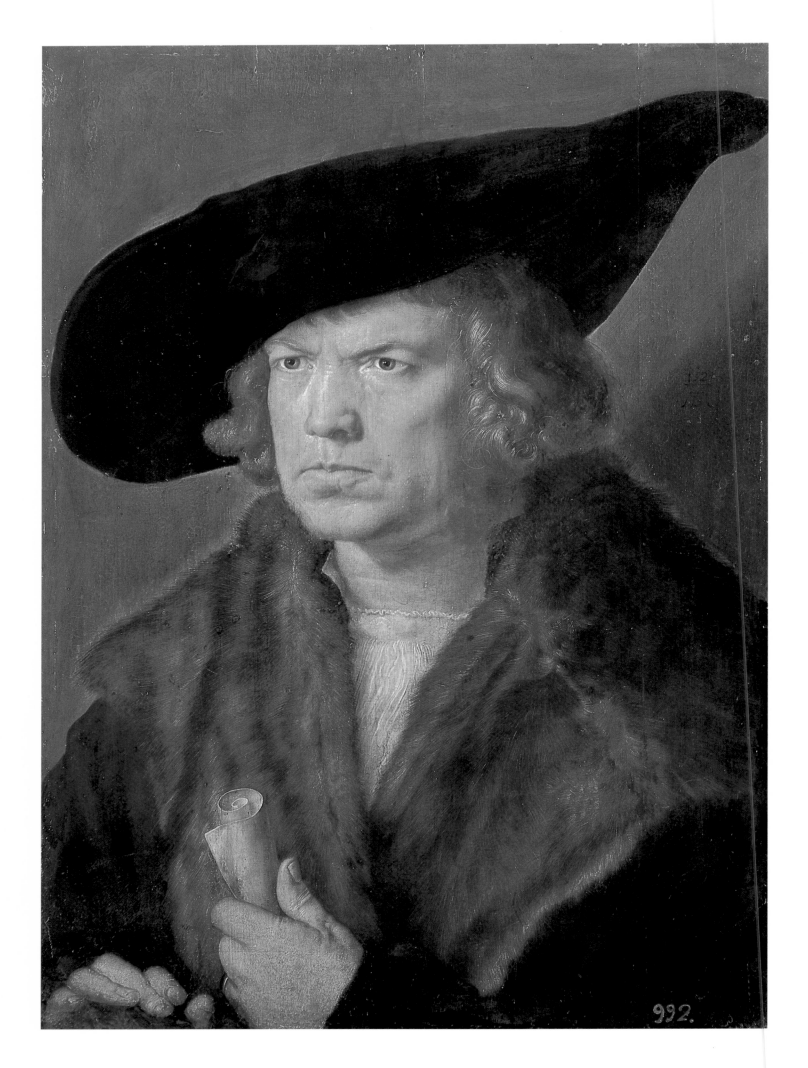

992.

142

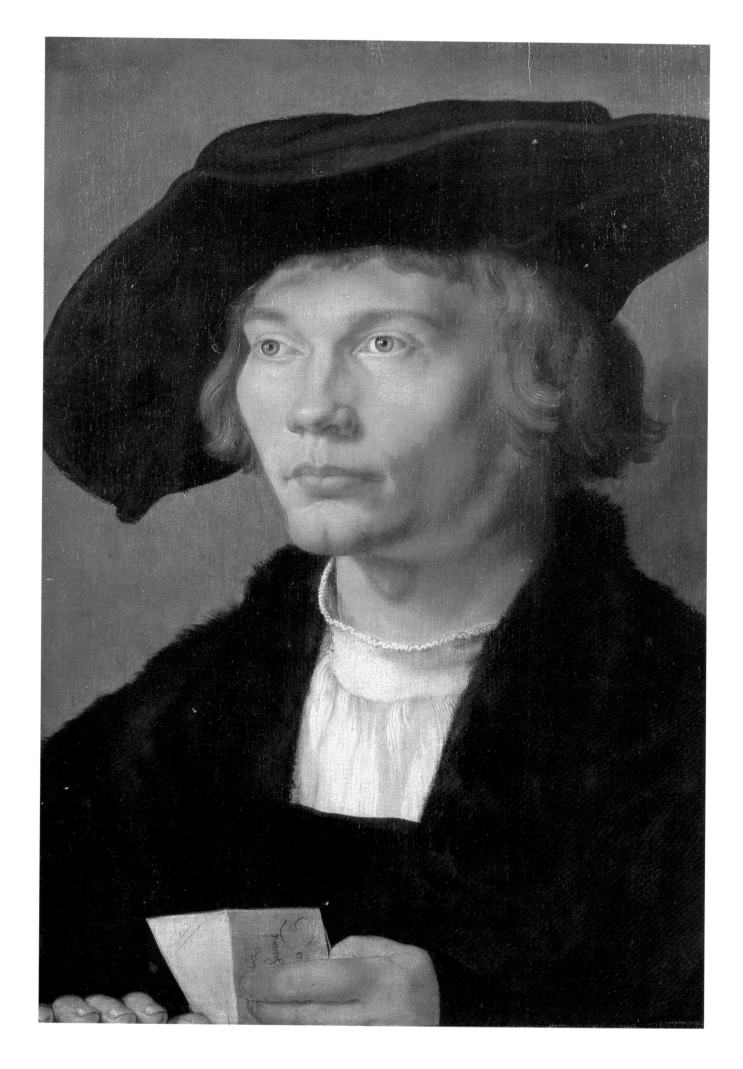

143

His Works

146

147

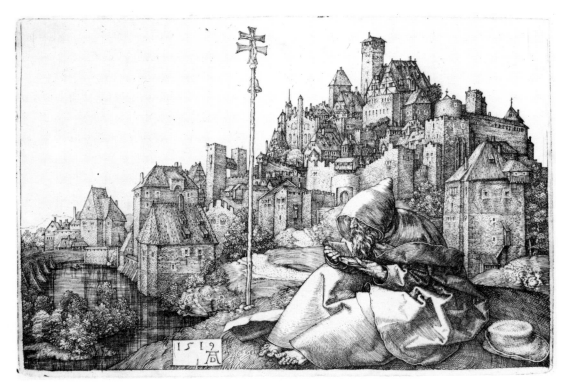

163
ST. ANTHONY THE HERMIT
With the monogram of the artist
and the date 1519. Engraving. 96
x 143 mm.

*The structure in the background,
reminiscent of the Nuremberg
Castle, is a combination of sev-
eral elements. It includes the
"five-cornered tower" which sur-
vives to this day.*

Subjects and Techniques

TWO SHEETS FROM THE
GREEN PASSION
Albrecht Dürer and Workshop

161
THE BETRAYAL OF CHRIST
On a small tablet the monogram
of the artist, to the right of it,
barely legible, the date 1503 (?).
Pen and ink on green grounded
paper heightened with white. 282
x 180 mm. Vienna, Graphische
Sammlung Albertina.

In his art, Albrecht Dürer made the fullest possible use of every
potential for creation. He made himself master of all available
techniques of artistic expression, and provided a stimulus for their
further development. He was the first artist to work with equal
facility in engraving and in woodcut; all his predecessors had not at-
tempted to master more than one of the two graphic techniques.
Following the efforts of Daniel Hopfer of Augsburg, he was the first
artist to make effective use of etching, previously the specialty of
the makers of body armor who would decorate the hardened metal
with ornamental or representational designs. Dürer adapted their
methods to the production of printing plates and inaugurated etch-
ing as an artistic medium (164, 165).

162
CHRIST BEFORE CAIAPHAS
With the monogram of the artist
and the date 1504. Pen and ink
on green grounded paper. 283 x
178 mm. Vienna, Graphische
Sammlung Albertina.

*Eleven sheets of a Passion series
on green paper have survived, as
well as preparatory studies and a
number of copies attributed to
Hans von Kulmbach. Significant
stylistic differences of the com-
pleted sheets from the concept
drawings suggest participation of
the workshop.*

The importance of his line drawings, of which nearly a thousand
have survived, is without precedent. Even those which served as
preliminary sketches for works in other media were still works of
art in themselves, expressing values peculiar to the technique,
signed and dated by the artist. For these sheets Dürer utilized vari-
ous materials, to admire that variety and to enhance the aesthetic
effect. He used metalpoint, chalk, and charcoal; and besides white
paper, used the Venetian product, generally colored blue, as well as
some tinted by the artist himself, and also materials prepared es-
pecially for that difficult vehicle, silverpoint. Dürer was so skilled
with the drawing brush that he was likened to Apelles of antiquity,
who was said to have been able to divide in two even the finest line
of any competitor.

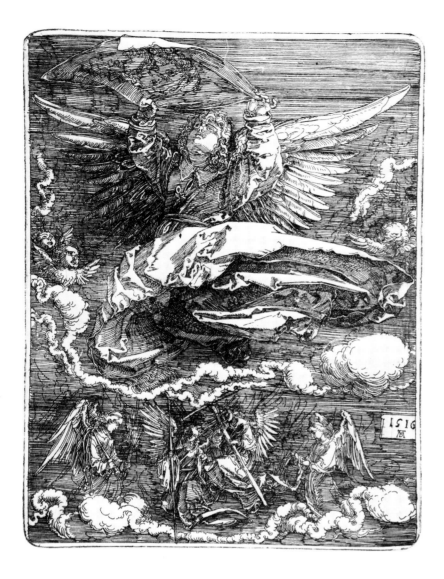

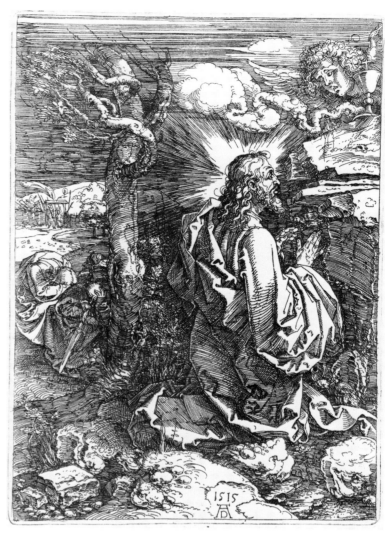

164
THE SUDARIUM HELD BY AN ANGEL
On a small cartellino, the monogram of the artist and the date 1516. Etching. 185 x 134 mm. (Cf. 165.)

165
AGONY IN THE GARDEN
With the monogram of the artist and the date 1515. Etching. 221 x 156 mm.

From 1515 to 1518 Dürer experimented with etching, then new as a graphic medium.

In painting he worked with both oils and tempera emulsions, on prepared surfaces cut from his native German conifers or linden, but during his stay in Italy he used poplar, and while in the Low Countries, oak. Each was prepared with an undercoat of lime before painting. Unusual was his use of fine linen canvas—he referred to it as *Tüchlein*—on which he painted directly, without prior preparation, in watercolor or a thin tempera. Regrettably many of these particular paintings have been ruined by a subsequent application of fatty varnish. Only a single example of larger size is still extant in Dresden, an altarpiece depicting the Virgin between Saints Anthony and Sebastian (393). It was successfully restored after World War II, and shows sufficiently the original intent of the artist.

Particular periods may be distinguished in which the artist seemed to prefer using techniques that appeared to him best suited to expressing what interested him at the moment. Even the subjects can be related to the use of specific media. He employed paintings and printed graphics for religious topics which, though conceived differently, were confined to a limited number of subjects. Painting

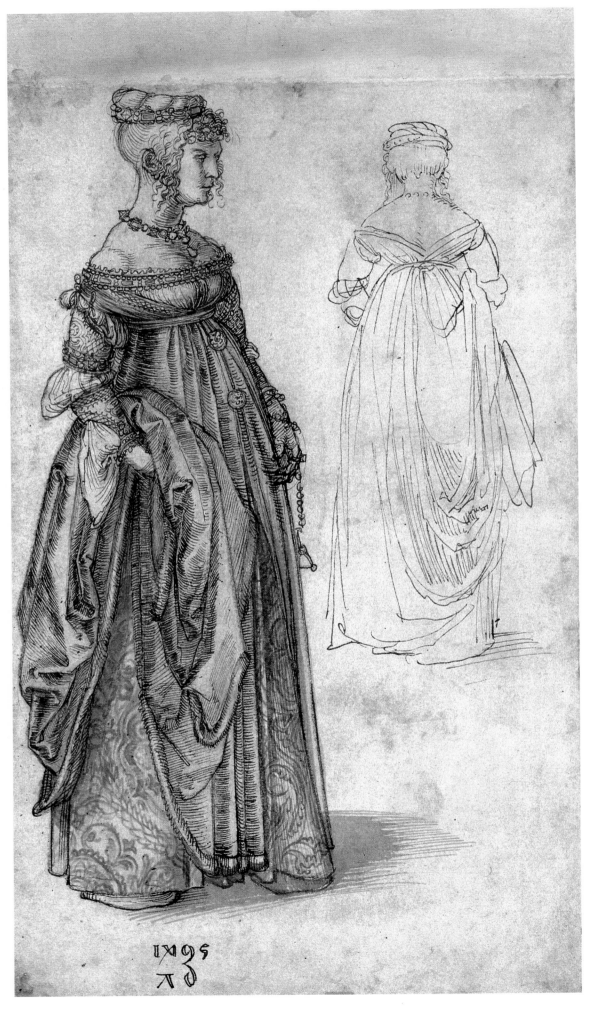

166
Two VENETIAN LADIES
With the monogram of the artist,
featuring a small d, and the date
1495. Pen and ink on paper, the
main figure lightly colored. 290 x
173 mm. Vienna, Graphische
Sammlung Albertina.

*The upper part of the study, de-
picting the costume of a young
unmarried Venetian lady, was
used by Dürer in the woodcut
"Babylonian Whore" of the
"Apocalypse" series (309).*

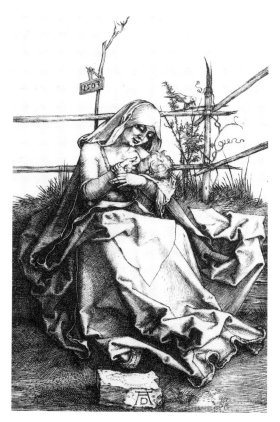

167

THE VIRGIN NURSING THE CHILD
Near the bottom, on a stone, the
monogram of the artist; above,
on a small tablet, the date 1503.
Engraving. 113 x 70 mm.

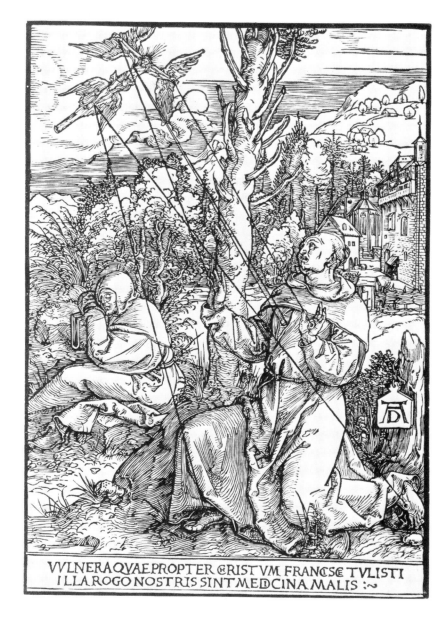

168

ST. FRANCIS RECEIVING THE
STIGMATA
On a small hanging tablet the
monogram of the artist. At bot-
tom the legend, cut into the
block: *VVLNERA QVAE PROP-*
TER CHRISTVM FRANCISCE
TVLISTI / ILLA ROGO NOS-
TRIS SINT MEDICINA MALIS
[Francis, I pray that the wounds
which you bear for the sake of
Christ may be a means of atoning
for our sins]. Woodcut. 218 x 144
mm.

This print belongs to a series of
woodcuts of popular saints, pro-
duced after 1500 and all bearing
the signature on a small writing
tablet. Dürer probably had these
in mind when, in his diary of the
journey to the Low Countries, he
speaks of "modest woodcuts."

was the medium reserved primarily for various pictures of the
Virgin. By contrast, the Passion of Christ was depicted in four
graphic cycles, of which one, the "Green Passion," consists of draw-
ings (161, 162). Saints beloved of late medieval devotion appear on
individual sheets. These saints provided comfort in all kinds of
need, and their pictures were used for both protection and consola-
tion. They were by that time no longer confined to churches, but
entered individual homes (163, 167, 168). Through the use of prints
— especially woodcuts, where skillful use of the press made possible
large print runs — the image that had hitherto been accessible only in
church now became available to the individual as a private posses-
sion. He could view it according to his taste, as an object of prayer
or of aesthetic appreciation.

Among secular themes the portrait achieved the greatest significance. Dürer was the first German artist in whose work the portrait occupied a place equal to that of the traditional religious subjects as a form of artistic expression. In most instances the drawn portrait was an autonomous work of art and only in exceptional cases was it intended from the beginning as a mere preparatory sketch for work in another medium. The drawing was able to satisfy the goal he had set himself, not just under the special circumstances of his trip to the Low Countries, but also before and after it. During the last ten years of his creative life, following in this Lucas Cranach the Elder, Dürer adopted the reproductive techniques of woodcut and engraving for portraits.

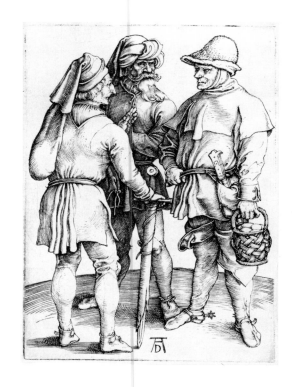

Next to his "discovery" of the individual is his discovery of nature. Probably the representations of landscapes and their details, of the mighty walls of the stone bridge in the vicinity of Nuremberg, or of a piece of turf, of live animals or some just struck by a hunter's arrow, were intended exclusively for his own needs and possession. Most of these are executed in watercolor or body color, perhaps, if the opportunity arose, to be used as models. Even if, in the case of landscapes, some were left unfinished, they were nonetheless independent works of art which did not require completion.

Subjects from classical mythology dominated Dürer's secular pictures until he began on works commissioned to glorify Emperor Maximilian I. The classical scenes were done almost exclusively in the form of prints, and played an important role in the years immediately following the artist's return from his first visit to Venice.

The reproductive media were chosen likewise for the treatment of contemporary subjects. There is a hint of the social critique exercised by the succeeding generation of "little masters" (born around 1500) in their prints, except that for Dürer this remained a marginal issue in the vast range of his pictorial representations. The peasant and village aroused his interest at an early date. In the sketches for one of Terence's comedies, the *Heautontimorumenos* [The Self-Tormentor], the large landowners of the original tale were changed to simple peasants (105). For the first time an artist offered a characterization of a village and its inhabitants that, in spite of the traditional prejudices, possessed a genuine reality. Of course, even Dürer could not altogether free himself from certain typifying preconceptions of the simple country folk, noisy, unruly, and wholly unfamiliar with the refined lifestyle which education and order had produced in the city dweller. Dürer depicted various aspects of the relationship between man and wife among the peasantry. In one scene we see the man shouting and gesticulating while his wife casts her eyes demurely down, in another they stamp the ground jointly in the enthusiasm of the dance, and all this is depicted in engravings (170, 171). Underlying all of these was a good-natured derision natural in a city dweller, the more so as these prints were destined to be bought by his own group, not by the peasants. If Dürer emphasized the uncouth manners, the neglected, often shabby clothing

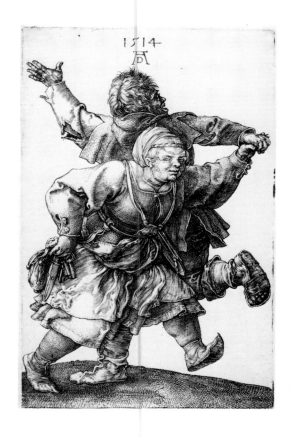

of the peasants, he nevertheless showed sympathy for the peculiarity of these burly figures with their huge hands and bony faces (169). In his design for a monument celebrating the victory over the "peasant uprising," the main shaft of the victory column is composed of the customary attributes of the class (43). Surmounting it all, the tamed peasant, head thoughtfully supported on his hand, sits on an overturned jug that in turn rests on a market cage containing a hen and a piglet — and a sword has been run through his back. Just as in his other representations of peasants, Dürer did not withhold his sympathy for those whose rebellion ended in defeat in 1524/25. This may have been all the easier for him, since none of the excesses of the revolt nor the cruel punishments imposed by the victors occurred on Nuremberg territory.

For one depiction of the peasant environment Dürer chose a peasant dwelling with a courtyard surrounded by several buildings added successively, and not according to an original plan. The architectural setting serves as vehicle for the parable of the Prodigal Son who, deprived of his inheritance, must now be glad for being allowed to tend swine (175). Dürer has shifted the scene from the field mentioned in Scripture to a peasant courtyard with the inevitable dung heap. The pigs' fodder is placed in a hollowed-out tree trunk, that for the piglets in a small tub. Between them kneels the swineherd, his tunic hanked up, his hands folded, holding a clublike staff, and with a face close to Dürer's own features. In his thoughts already confronting his father, from whom he will beg forgiveness, he has bent his knee amid the swine. The details of the buildings surrounding the farmyard, their material, and their condition are so precise and convincing that attempts have been made to identify the locality as Himpfelshof, slightly west of the Spittler Gate in Nuremberg. In any event, this engraving, produced 1496/97, goes well beyond the generalized scenes of the Terence illustrations. By now Dürer had also included peasant dwellings in his landscapes depicting the environs of Nuremberg.

169
THREE PEASANTS IN CONVER-
SATION
With the monogram of the artist.
Engraving. 107 x 76 mm.

A pen and ink drawing in Berlin-Dahlem (Staatliche Museen, Preussischer Kulturbestiz, Kupferstichkabinett) was preparatory for this engraving of c. 1497 and was perhaps drawn directly from life.

170
DANCING PEASANT COUPLE
With the monogram and the date
1514. Engraving. 118 x 75 mm.

171
RUSTIC COUPLE
With the monogram of the artist.
Engraving. 109 x 77 mm.

This print, produced c. 1497, together with 169, introduces Dürer's series of engravings picturing peasants.

172
PEASANTS AT MARKET
With the date 1519 and the monogram of the artist. Engraving. 116 x 73 mm.

153

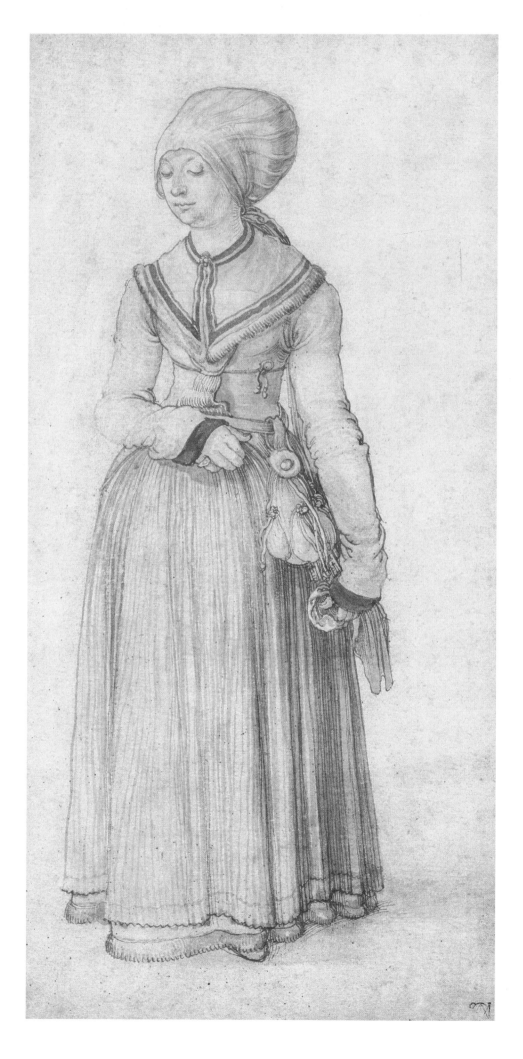

173
A Nuremberg Lady in Everyday
Attire
Pen and ink on paper with water-
color, over a scant preparatory
drawing in charcoal (?). 284 x 130
mm. Milan, Biblioteca Ambro-
siana.

*A series of aquarelled pen and
ink drawings, produced in 1500-
1501, shows the Nuremberg lady
dressed for home, church, and—
for matrons as well as unmarried
girls—for a dance. With these
drawings, for which his wife was
most likely the model, Dürer
created the category of costume
studies. A model drawing en-
larged in format with the legend,
"This is the attire in Nuremberg
homes," is in the Albertina in
Vienna.*

174
A Nuremberg Lady Dressed to
Go to Church
With the date 1500, the mono-
gram of the artist, and the in-
scription: *Ein Nörmergerin / als
man zw kirchen gatt* [A Nurem-
berg Lady as She Goes to
Church]. Brush drawing touched
lightly with watercolor. 317 x 172
mm. London, British Museum.

*The drawing is regarded as pre-
paratory for a later costume
study of the "Nuremberg Lady
Dressed to Go to Church," now
in Vienna.*

154

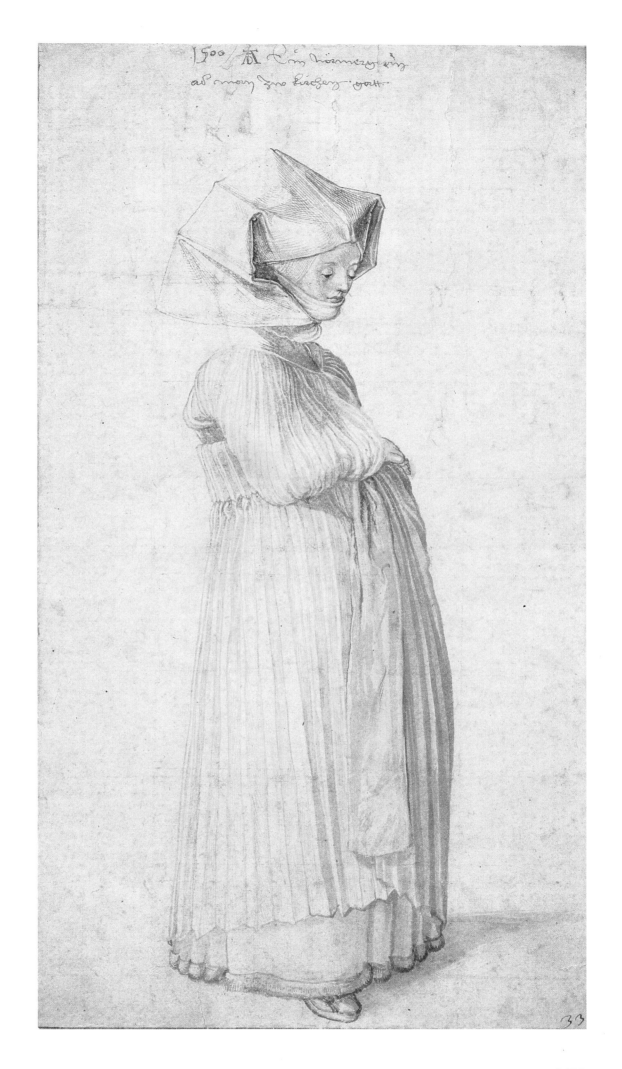

155

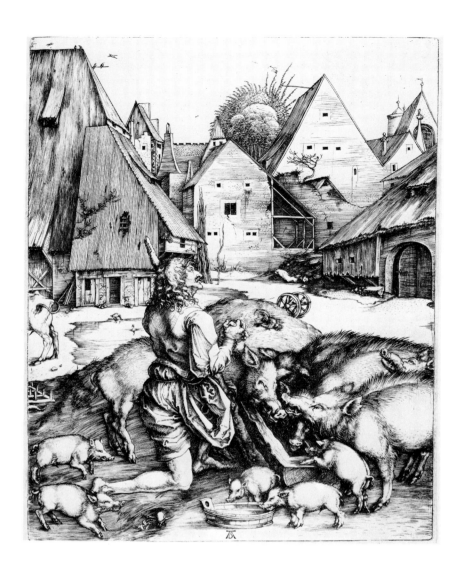

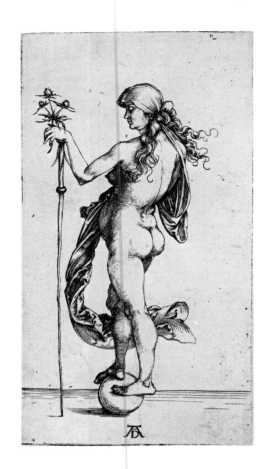

The Human Figure

Dürer's pictorial image is determined by the figure. The form and attitude of the figure were decisive in restructuring traditional motifs, most of which were concerned with Christian subjects. If new concepts of Biblical events emerged in the pictorial series and the individual representations from the Scriptures, this was due primarily to the convincing effect of the action, based on a precise understanding of the human figure, on the interpretation of it formed by the influence of antiquity as seen through the eyes of humanism. Nature, i.e., everything that grows, was Dürer's admired mentor. He "discovered" his art in nature. It was the task of the artist to capture natural form and, based on it, to arrive at pictorial representation.

Dürer approached nature by studying the human figure, both clothed and nude. He conducted measurements to determine the permanent relationships which dictate its proportions. His Italian experience and his study of classical forms must have brought him face to face with the problem of measuring bodies in motion in relation to nature and not to an imaginary concept. He realized that an intensive study of the nude was essential for the portrayal of the clothed figure. When Dürer spoke in his book on proportion about changes

175
THE PRODIGAL SON AMID THE SWINE
With the monogram of the artist.
Engraving. 248 x 190 mm.

The peasant dwellings in this engraving, produced c. 1496/97, have been identified by Fritz Zink as the Himpfelshof near Nuremberg.

176
FORTUNA
With the monogram of the artist.
Engraving. 114 x 66 mm.

Dürer made use of the experience gained in Italy in the representation of nudes after his return in a series of engravings on mythological and allegorical subjects.

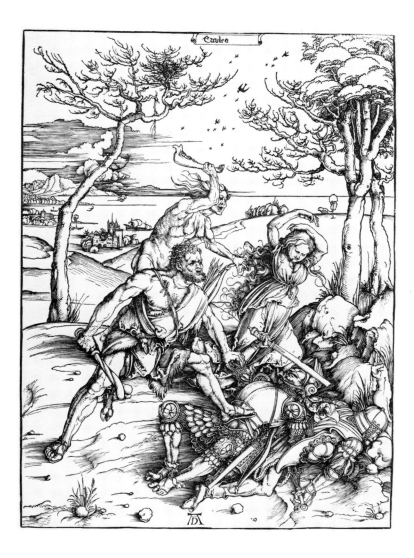

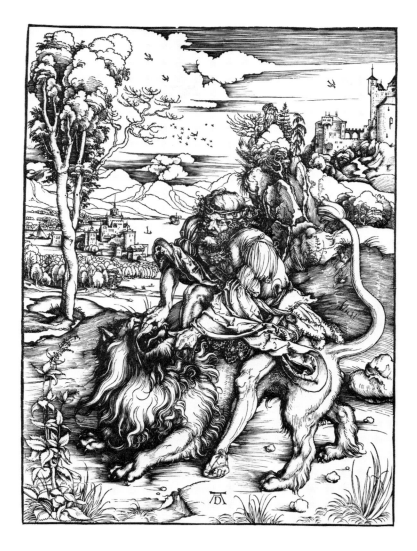

177
HERCULES KILLING THE
MOLIONIDES
With the monogram of the artist
and on a cartellino: *Ercules.*
Woodcut. 395 x 285 mm.

The subject of this print, the kill-
ing of the "Siamese twins," Eury-
tus and Kteatus, by Hercules on
his way to the Isthmian Games,
was recognized by Erika Simon
and Charmian Mesentseva. The
woman in the background is
Molione, the despairing mother
of the pair. It is Dürer's only
woodcut with a mythological
theme and dates from c. 1496/98.

178
SAMSON RENDING THE LION
With the monogram of the artist.
Woodcut. 382 x 277 mm.

The Biblical hero Samson is here
likened to Hercules. The story is
told in Judges 14: 5-6. The wood-
cut dates from c. 1497/98.

brought about by movement, he recommended drawing nude fig-
ures as the most direct way to become aware of the interplay of the
limbs of the body: "a clear understanding is gained best by drawing
many living people, then one will see how everything works."

His first efforts to acquire usable information about the structure
of the human body and its movement date from his travels as a jour-
neyman. A study of a bath attendant, dated 1493, is the first drawing
of a nude by a German artist based on a living model (184). Thin
strokes and dense hatchings delineate the contours, the interior
forms, and the shadows. The frontal view, knees closed, raised rela-
tively few problems in depicting the interrelationships of the parts of
the body. The artist retained the drawing as an important document
of his artistic development, but, as far as we know, it was an isolated
accomplishment, probably because it was his only opportunity to
sketch a living model. Finally, in Venice, he was able to focus his ef-
forts on the nude figure (181, 182) as available there to other artists.
The same holds true for dealing with the clothed figure (166, 189). It
is noteworthy that the artist evidently regarded these studies not as
mere exercises but as full-fledged pictorial representations (181).

157

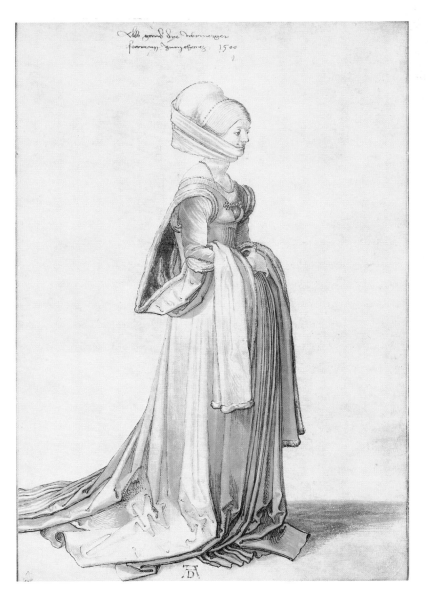

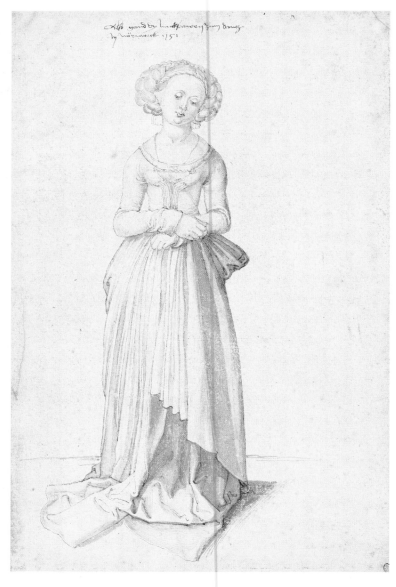

179

A NUREMBERG LADY DRESSED TO
GO TO A DANCE
Inscribed: *Also gand dye Nör-
merger / frawenn Zum thanz*
[Thus the Nuremberg Ladies Go
to a Dance]. With the monogram
of the artist and the date 1500.
Pen, ink and watercolor on
paper. 325 x 218 mm. Vienna,
Graphische Sammlung Albertina
(cf. 173).

180

A YOUNG WOMAN OF NUREMBERG
DRESSED FOR A DANCE
Inscribed: *Also gand dy Junck-
frawen zum dantz / in Nörmerck*
[Thus the Young Women of Nur-
emberg Go to a Dance]. Dated
15[0]1. Pen and ink with water-
color on paper. 324 x 211 mm.
Basel, Öffentliche Kunstsamm-
lung, Kupferstichkabinett (cf.
173).

181

NUDE WITH STAFF SEEN FROM
BEHIND
With the monogram of the artist
and the date, 1495, by a later
hand. Brush and ink on paper.
320 x 210 mm. Paris, Musée Na-
tional du Louvre, Cabinet des
Dessins.

*The supporting staff and the
drapery suggest that this was a
drawing after a model. The date,
although by a later hand, is prob-
ably correct.*

158

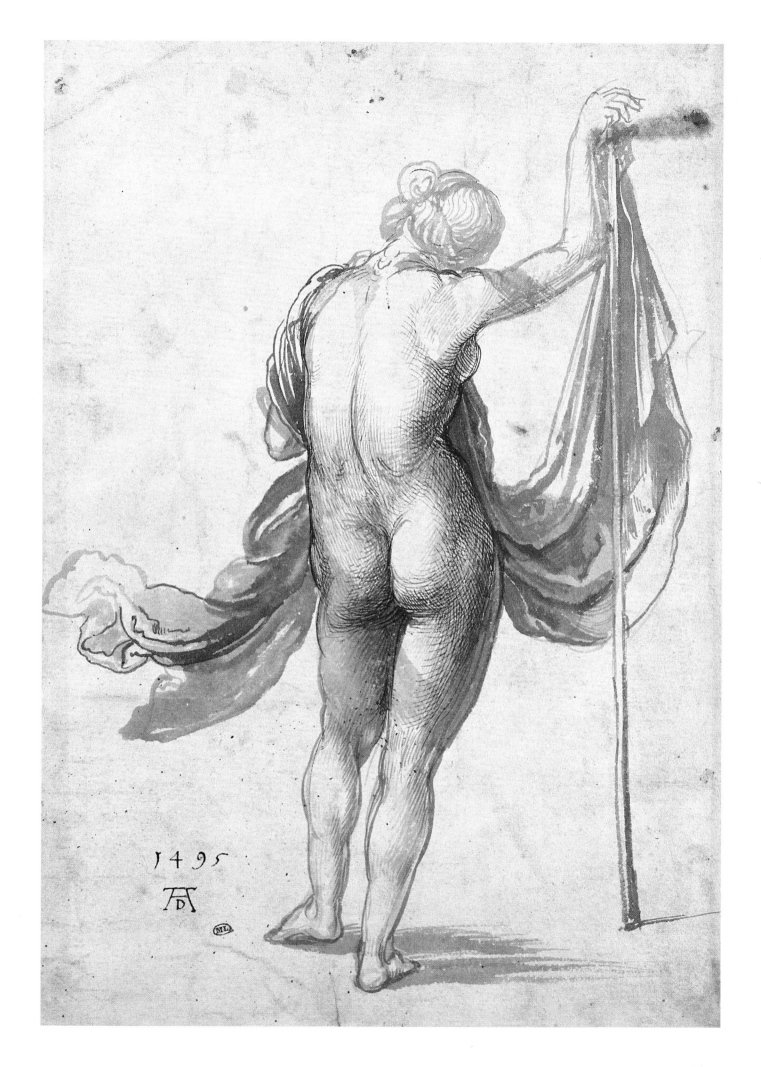

159

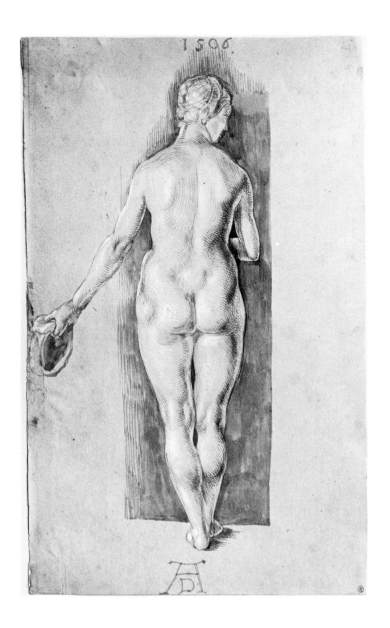

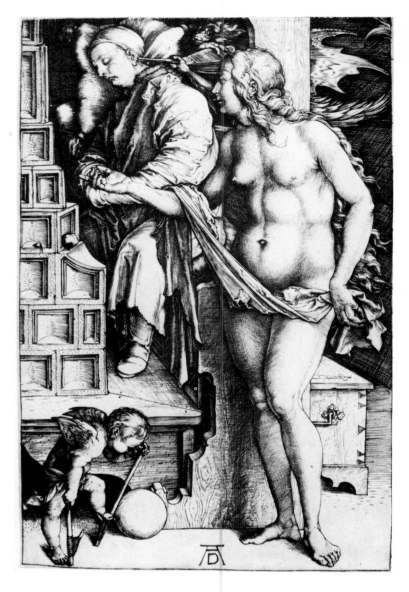

By choosing mythological subjects Dürer was able to portray nudes beyond mere sketches. Unfortunately, the preparatory studies of the nudes in the artist's engravings dealing with classical and related themes have not come down to us. Dürer produced a great number of these engravings after his return from Italy (176, 183, 213, 217, 220). After the second stay in Venice his efforts at determining fixed rules of proportion in depicting the human figure turned him away from drawing nudes after nature. We must assume that drawings from his later years were no longer based on preliminary studies sketched after living models but were drawn from memory.

A brush drawing on blue Venetian paper, subsequently dated 1495, depicting a nude woman seen from behind, comes to us from the time of his first intensive preoccupation with the nude female figure (181). The movement of the hips and the swinging line of the spine is resolved by a contrapposto arrangement. The staff on which the woman is leaning and a piece of cloth, partly hanging from it and partly draped over her left shoulder, covers her breast and the front

182

NUDE SEEN FROM BEHIND
With the monogram of the artist and the date 1506. Brush on blue Venetian paper, heightened with white. 283 x 224 mm. Berlin-Dahlem, Staatliche Museen Preussischer Kulturbesitz, Kupferstichkabinett.

This painterly sheet demonstrates that Dürer also used live models during his second stay at Venice.

183
THE DREAM OF THE IDLER
With the monogram of the artist.
Engraving. 188 x 119 mm.

One may suppose that Dürer continued his studies of nudes in Nuremberg after 1495, even though the entire complex of these drawings has been lost. This engraving, done c. 1498, is an allegory of the moral dangers of comfort and sloth. The temptress in this instance is a nude Venus, accompanied by Cupid.

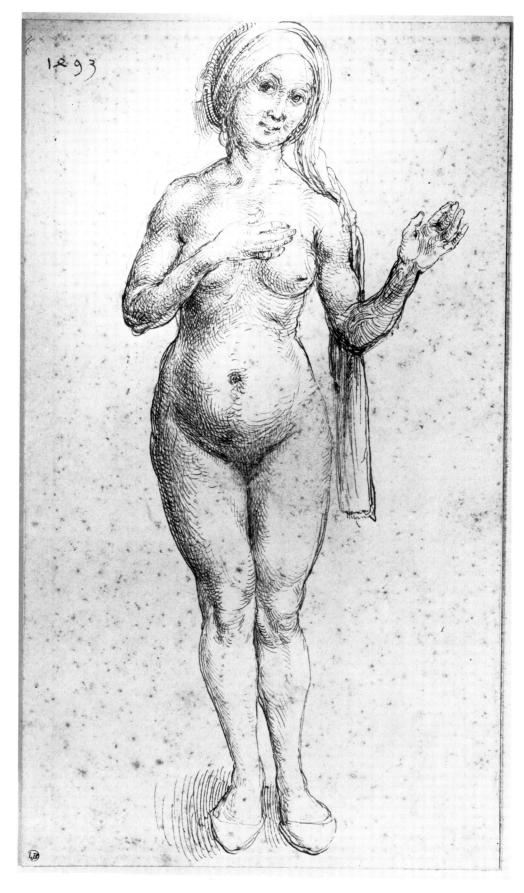

184
BATH ATTENDANT
Dated 1493. Pen and ink on paper. 272 x 147 mm. Bayonne, Musée Bonnat.

This is the earliest extant drawing of a nude by a German artist. Dürer probably espied this girl in a bathhouse.

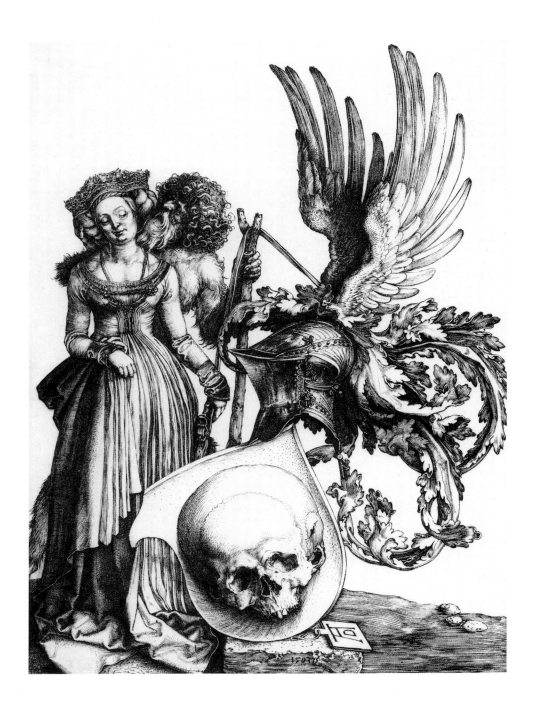

of her body. It ends in a windblown tip, lifting the image from a mere working study to an image that is endowed with a narrative quality, albeit imperfect. The figure was intended to conform to "the naked images of the Italians" as Dürer expressed it, referring both to painted figures as well as to sculptured ones. It was no accident that the sheet wound up in an album containing many drawings belonging to the Vischer foundry in Nuremberg. It might well have been small Italian bronzes that determined the stance of the woman and led Dürer to work out its sculptural form.

Studies of the nude male body seen from various angles are grouped together in a scene depicting the fondness for bathing of the

185
THE COAT OF ARMS OF DEATH
Dated 1503. The monogram of the artist appears on a small writing tablet. Engraving. 220 x 159 mm.

The artist utilized the costume study "A Young Woman of Nuremberg Dressed for a Dance" (180). He changed only the position of the hands. The young woman is being importuned by a wild man, hinting at the dance of death.

162

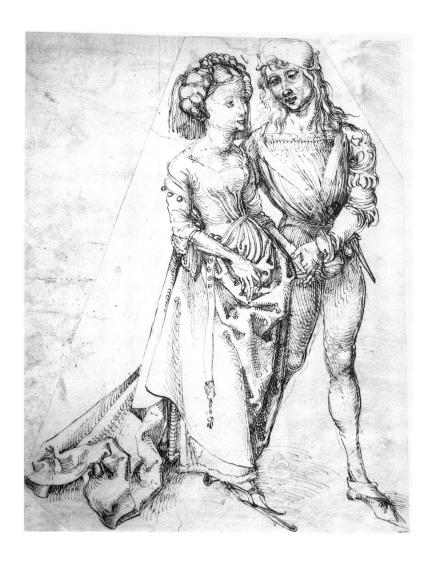

186
Young Couple
Pen and ink on paper. 257 x 191 mm. Hamburg, Kunsthalle.

The features of the amorous young man resemble Dürer's. The girl, too, has very individual features. The drawing dates from c. 1493, and was used some years later for the engraving "The Promenade."

187
The Men's Bath
With the monogram of the artist. Woodcut. 392 x 282 mm.

Studies after nude male models from Dürer's early years have not survived. Their existance can be deduced from his prints. This group of male nudes in a bathhouse was done not later than 1498.

late Middle Ages (187). Pictures of bathhouses, often used jointly by both sexes, were nothing unusual at that time and this depiction's being a woodcut suggests that it was intended for a large audience. The collection of men in scanty clothing is not shown in the bathhouse itself, which seems to be the hut on the upper right, but rather is gathered under the trees enjoying music and a drink after a sauna. Running water from a wide spout, surmounted by a suggestive rooster, is ready for cleaning and cooling, but is at the moment not needed. The bathhouses of Nuremberg in Dürer's time were almost exclusively the property of, and a source of income for, the upper crust, and leased to operators, a despised group. Municipal baths, operated by the city, were available for the use of the poorer classes. The incursion and rapid spread of syphilis largely put an end to this form of cleansing and health care in the course of the 16th century.

In his woodcut, Dürer did not limit himself to a portrayal of a genre subject or the representation of the nude male body varying in stature, age, or pose. Underlying the picture is a symbolization of the five senses interlaced with the four human temperaments shown in the build, stance and activity of the men depicted. The two men in

188
A Woman of Nuremberg and
One of Venice
With a spurious monogram. Pen
and ink on paper. 241 x 160 mm.
Frankfurt a.M., Städelsches
Kunstinstitut.

*The stylistic differences of the
costumes are emphasized in this
drawing, probably done shortly
after Dürer's return from Venice.
The late Gothic attire of the
woman from Nuremberg is op-
posed to Venetian fashion, char-
acterized by a balance of burden
and support.*

189
The Mystical Betrothal of St.
Catherine of Alexandria
Pen and ink on paper, with some
wash. 234 x 201 mm. Cologne,
Wallraf-Richartz Museum.

*The drawing, done c. 1494/95,
shows the saint in Venetian dress.
Perhaps a Venetian painting
served Dürer as model.*

half length in the foreground represent Touch and Smell; one is using
a scraper to clean his body, the other is holding a flower. The stout
man drinking denotes Taste, the one with Dürer's features, leaning
on the water post, represents Hearing, as well as Melancholy. With
his fingers flanking his ear, he is listening to the musician. The young
onlooker in the background signifies Sight.

Dürer's studies of the clothed figure reveal a fundamental, rather
than merely fashionable difference between German and Venetian
clothing (188). This divergence is evident in a drawing in which the
two are juxtaposed. The costume of the lady from Nuremberg is still
late Gothic in character. The towering headdress, the sharply break-
ing draperies, gathered in front, and the pointed shoes emphasized
by the pose of the model determine the impression. By contrast, the
clothing of her counterpart from Venice is marked by the relation-
ship between burden and support. The very high bust section with
broad horizontal lines, repeated in abbreviated length in the sleeves,
is supported by a skirt whose cut and structure with its tubular folds
is reminiscent of a fluted column. Wide shoes which protrude only

190

THREE "MIGHTY" LADIES FROM LIVONIA

Inscribed: This is the attire of the mighty in Livonia." With the monogram of the artist and the date 1521. Pen and ink with watercolor on paper. Paris, Musée National du Louvre, Collection Edmond de Rothschild.

Dürer probably encountered these ladies in the Low Countries, and did several studies of their costumes.

slightly make for a firm base. Dürer used one of his Venetian costume studies for a similarly clothed woman, pictured in two views (166).

Dürer reveals not just an artistic interest in clothing, but also an ethnographic and historical curiosity. Even during his first visit to Venice Dürer was drawing men in oriental costumes (127); followed later by a series of Nuremberg costume pictures (173, 174, 179, 180, 185). During the trip to the Low Countries Dürer depicted not only the local peasant garb (194) but also did drawings of Irish peasants and soldiers, and even oddly costumed ladies from Livonia (190).

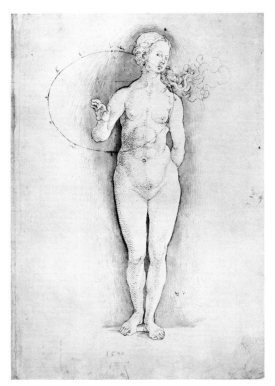

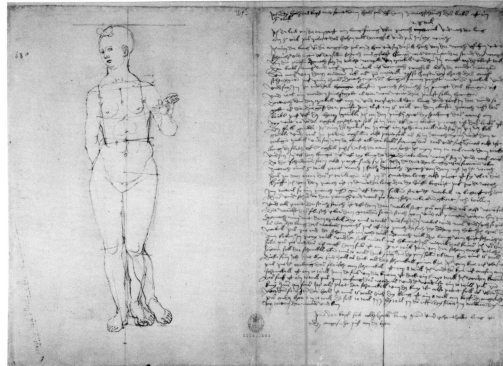

The first works reflecting Dürer's search for generally valid rules of construction applicable to the human figure occurred most probably before he became acquainted with examples shown him by Jacopo de' Barbari after 1500. These early attempts were experimental efforts to construct male and female forms with the help of ruler and circle by superimposing geometrical figures on the human body. This is exemplified by a drawing of a nude female figure, inscribed by Dürer himself on the verso with the date 1500 (191, 192). It gives us a specific starting time for these studies. The text, which

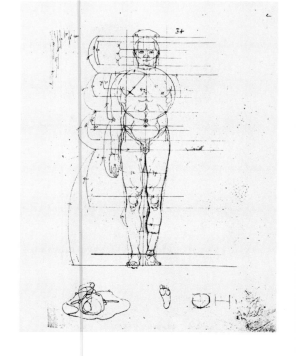

191
NUDE SEEN FROM THE FRONT
With the monogram of the artist and the date 1500. Pen and ink on paper, with green wash. 330 x 430 mm. London, British Museum.

The figure is a tracing of the nude on the recto of this sheet (cf. 192), according to the canon of Vitruvius. The correctness of the date has sometimes been questioned, but it is important in determining the onset of Dürer's studies of proportion.

192
NUDE SEEN FROM THE FRONT
Pen and ink on paper. 330 x 436 mm. London, British Museum.

Recto of 191. Instructions for constructing the figure are written on the adjacent page.

193
NUDE MALE FIGURE SEEN FROM THE FRONT
In the upper left are the proportionate lengths of the limbs, based on the entire length of the body. Center right, inscribed: *mitteill* [middle]. Pen and ink on paper. From the *Dresden Sketchbook*, fol. 132r. 294 x 208 mm.

This is part of Dürer's early studies of proportion according to Vitruvius's canon, probably dating from before the second Italian journey. Bottom: cross sections of the human figure.

194
WOMAN IN NETHERLANDISH ATTIRE
With the monogram of the artist and the date 1521. Brush on paper grounded dark violet, with washes and heightened with white. 283 x 195 mm. Washington, National Gallery of Art, Widener Collection.

166

167

describes the construction by means of a compass, is based on the meager data on proportion given by Vitruvius. Dürer's acquaintance with the Roman's architectural theories is evident from his use of the proportional length of head and body, i.e., 1:8, and the length of the face and body, 1:10, as well as in the division of the face into three equal segments. These measurements were used in the engraving "Nemesis" of c. 1501/03 (257). The nude Nemesis is shown in profile traveling on a sphere above an alpine landscape near Chiusa in the Val d'Isarca. With this engraving Dürer confronted his audience with the first distillate of his studies, which, on account of its large size, its subject and the landscape, was bound to attract attention.

Probably one of the last of this group of studies is a nude male figure seen from the front, in the *Dresden Sketchbook* (193). For the first time the lines of construction are linked with a division of the body by horizontal lines, each labeled with the proportion to the total length. The exact date of the drawing is not known, but it was perhaps produced before Dürer's second trip to Venice, i.e., before 1505, anticipating his occupation with measurement of proportions after his return.

Dürer's efforts to determine the ideal figure on the basis of proportional construction culminate in the engraving "Adam and Eve," dated 1504 (200). The subject has always offered an opportunity of depicting the naked human figure. If ever absolute beauty existed on the earth, then as the Biblical account suggests, the original pair must have been endowed with it, for Adam was created by God after his own image. "Once, the creator made men as they should be," Dürer would write somewhat later. Vitruvius's assertion that the great artists of antiquity had created their works on the basis of firm principles of proportion led the artists of the Renaissance to take a close look at what had survived from the classical world. Thus also Dürer's Adam is based on a drawing of Apollo (197) which was a proportional figure strongly influenced by the ancient statue of the god in the Belvedere courtyard of the Vatican (198). The female deity in the drawing, sitting with her back turned, points to a connection with an engraving which Jacopo de' Barbari produced at about the same time in Nuremberg (195). In that engraving of Diana and Apollo, the starry universe makes it clear that brother and sister here represent the Sun and the declining Moon. Dürer did not adopt this same interpretation in his own engraving of the two deities, dating from 1502/03 (201). For Eve in the engraving depicting the Fall of Man, an acquaintance with an ancient figure of Venus, similar to the Medici Venus, has been assumed, but the direct influence of a classical model is less certain than in the case of Adam.

The two separately constructed figures, subsequently united into a single picture, demonstrate the care with which the engraving was executed and the difficulties which arose when the two preparatory drawings were combined (199). The transfer to the plate, which

195
APOLLO AND DIANA
Jacopo de' Barbari.
With Caduceus, the emblem of the artist. Engraving, 157 x 97 mm.

This engraving is part of a group by de' Barbari that is dated by Pignatti c. 1498/1500; by J.A. Levenson, after 1500. The artist shows Apollo and his sister as emblems of the sun and moon. It is related to Dürer's corresponding drawing (197; see also 34).

196
ADAM
Oil on wood. 209 x 81 cm. Madrid, Museo del Prado.

EVE
Inscribed on a small tablet hanging from a branch, *Albertus durer alemanus/faciebat post virginis/partum 1507*, and the monogram of the artist. Oil on wood. 209 x 83 cm. Madrid, Museo del Prado.

A preparatory drawing, dated 1507 and bearing the artist's monogram, survives. It was done with brush on blue paper; the Cleveland Museum of Art.

168

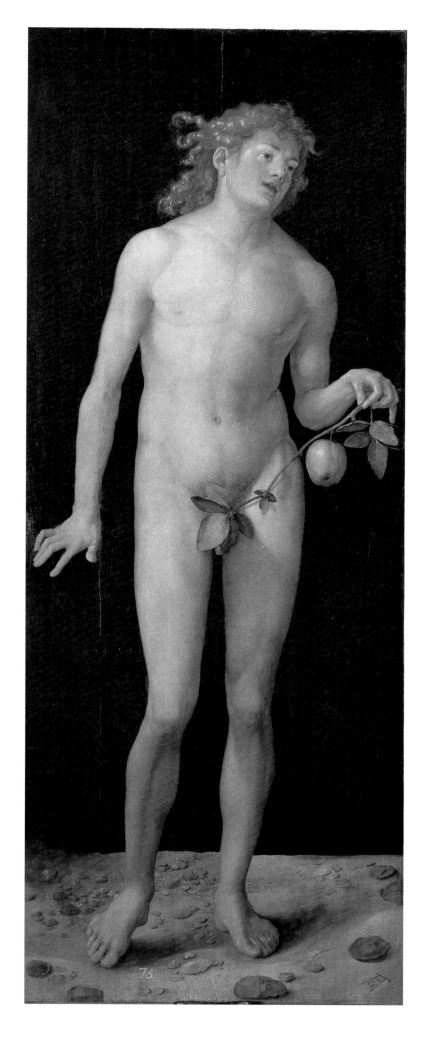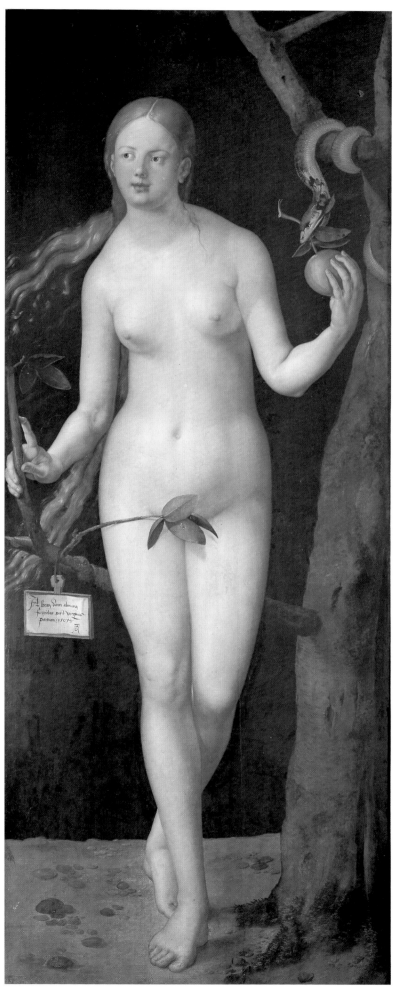

169

called for a lengthening of the figure of Adam, posed the problem of a change in the size while retaining the same proportions. Its solution by geometric means was to form at a later time a major portion of Dürer's treatise on human proportion. Here, still at the beginning of his studies, he solved his problem by extending Adam's lower leg, and in so doing relinquished the Vitruvian canon of the body consisting of eight headlengths.

The high value Dürer placed on this engraving within his oeuvre is indicated by his signature, which is similarly extensive only on his paintings: *ALBERT*[us] *DVRER NORICVS FACIEBAT 1504* [Albrecht Dürer of Nuremberg made this in 1504] is inscribed on the tablet suspended from a branch of the Tree. The figures owe their development to proportional studies based on the artist's studies of the classics, and this explains their classical coolness. The choice of animals and trees depicted also plays a role in the pictorial concept. Original sin and its impact on man is suggested in them. Adam grasps the Tree of Life, a mountain ash with a parrot perched on one of its branches. This bird is sometimes depicted with the Virgin, the second Eve, symbolic of the Virgin Birth of Christ. Death comes through woman from a fig tree, a reference which, besides it roots in the Old Testament, might also allude to the curse laid by Christ on the fig tree (Mark 11: 13-14, 20).

According to the teachings of the scholastics, the beginning of the four different human temperaments is linked to the Fall of Man that caused the once ideal character of man to become imbalanced, resulting in divergent physical and psychological types. For Dürer, man's form was influenced by his temperament. Soon after the publication of this engraving he wrote, in one of the drafts of the introduction to his projected book on painting: "There are four human temperaments, as the doctors report. All these you can measure by

197
APOLLO AND DIANA
Inscribed in mirror image, *APOLO*. Pen and ink on paper with some black chalk. 283 x 205 mm. London, British Museum.

Lines of construction, visible on the original at the head and body, mark this drawing, done after 1500, as a study in proportion. A sketch of the Apollo Belvedere served as model (198). An engraving by Jacopo de' Barbari permits us to identify the seated nude, seen from behind, as Diana, sister of Apollo (cf. 195).

198
THE "APOLLO BELVEDERE"
Pier Jacopo Alari Bonacolsi, called Antico. Signed on the quiver strap: *ANT*[ico]. Bronze statuette, partially gilded, eyes of inlaid silver, with a dark brown, in some places black, patina. Height, 41 cm. Frankfurt a.M., Städtische Galerie Liebieghaus.

This bronze reproduces (with additions) a marble sculpture found in Rome c. 1489/90, now in the Belvedere Court of the Vatican.

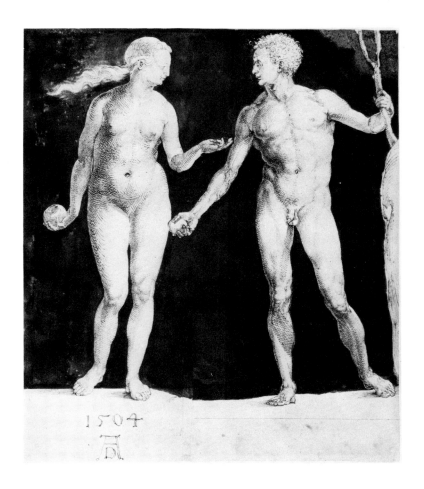

199
ADAM AND EVE
With the monogram of the artist and the date 1504. Pen and ink with brown wash on paper. 242 x 201 mm. New York, Pierpont Morgan Library.

Preparatory drawing for the engraving "Adam and Eve" (200). Dürer united two drawings, each bearing a nude figure, onto one large sheet. No consensus has been reached whether this was the final model drawing for the engraving.

200
ADAM AND EVE
Inscribed on the writing tablet hanging from a branch: *ALBERT[us] / DVRER / NORICVS / FACIEBAT / 1504*, and the monogram of the artist. Engraving, 252 x 195 mm.

This print marks the high point and conclusion of Dürer's efforts in the construction of the ideal human form by means of "compass and ruler" based on the canon of Vitruvius.

means I will state in the following." Thus at the moment of disobedience to God, which led to the coming into being of these different temperaments, the elk signifies melancholy, the hare the sanguine, the cat the choleric, and the bull the phlegmatic temperament.

Three years later Dürer once again took up the subject of Adam and Eve, this time in a painting showing the two figures on two elongated rectangular panels (196). The calligraphic signature appears on a small tablet hanging from a branch of the Tree of Life and reads: *Albertus durer alemanus faciebat post virginis partum 1507* [Albrecht Dürer, upper German, made this 1507 years after the Virgin's offspring]. Although the painter began with the concept of his engraving of three years before, he has made decisive changes in both form and content. The division into two, separately framed panels cancels any joint action. Instead each figure gains independence if compared to the other. Any connection in the eyes of the beholder presupposes acquaintance with the Biblical story. The engraving depicts the Fall of Man, whereas the panels simply portray Adam and Eve. As independent pictures Dürer's panels had no precedent, but many successors. For the life-size figures the painter might have been inspired by sculptural representations of the original pair at the portals of medieval churches. Although such figures

171

were sculpted individually, they were usually placed next to one another, and not infrequently placed within a group representing a scriptural passage. Any burgher of Nuremberg could see the pair at any time on the west portal of St. Lawrence's Church. As early as 1432 Jan van Eyck had painted Adam and Eve on individual panels placed in half-round niches, as part of the "Ghent Altarpiece." Dürer's decision to portray them as isolated individuals would perhaps be easier to understand if we knew who commissioned the work and what his intentions were. The two figures, the first life-size nudes in German art, were hardly intended to serve a religious purpose. A connection to two pictures for which Dürer received 60 florins from the City Council in 1511 cannot be established. The signature, in which Dürer refers to himself as *alemanus,* suggests that the work was commissioned by someone outside the city. The problem in clearing up the history of the panels, which are now in Madrid, is compounded by the existence of copies of which at least the two now in Florence (Uffizi) were painted in Dürer's time. Another reproduction, in Mainz since the Napoleonic Wars, hung in Nuremberg's City Hall until 1801. The Dutch painter and chronicler of art, Carel van Mander, saw the originals at Prague in 1602. From a communication of 1506 of the Bohemian humanist and later Bishop of Olmütz, Jan Dubravius, we know that Bishop Johann Thurzo of Breslau had acquired from Dürer directly a treatment of the same subject for the sum of 120 florins. Though it remains doubtful that this purchase refers to the works now in Madrid, since the report speaks of only a single picture, the name of that prince of the Church, an avid collector, gives us an inkling of the circles, liberal and aesthetically knowledgeable, who would buy a picture of large size having nude figures as its subject.

Compared to the engraving of 1504, Dürer, in the painted version, considerably altered the dimensions and the proportions. In Eve's stance he leaned more heavily on Gothic models. The legs, positioned one behind the other, and the change of the relationship of the head to overall body length from a ratio of 1:7.4 in the engraving to 1:8.2 in the painting makes the body appear more slender, seemingly ascending and hardly weighing on the ground. In his handling of Adam the painter kept to the classical contrapposto and thus held more closely to the model from antiquity of the Apollo Belvedere, though the gait is less emphasized, resulting in a seeming reduction of the body weight, as with Eve. The muted coloring corresponds to these changes, modeling the bodies with the help of light and shadow, toning down the sharp contrast between light and dark areas which lends an element of disturbance to the engraving.

The two panels have always been regarded as among Dürer's greatest achievements as a painter. The bodies gradually emerge into the light from neutral, dark background. The warm gradations of color of the masculine body are today modified by the darkened

201
APOLLO AND DIANA
With the monogram of the artist. Engraving. 116 x 73 mm.

Like the drawing (198), this engraving is connected with Jacopo de' Barbari's engraving (195).

202
THE MADONNA WITH A CARNATION
With the monogram of the artist and the date 1516 in a vine-encircled cartouche. Oil on vellum, mounted on coniferous wood. 39 x 29 cm. Munich, Alte Pinakothek.

172

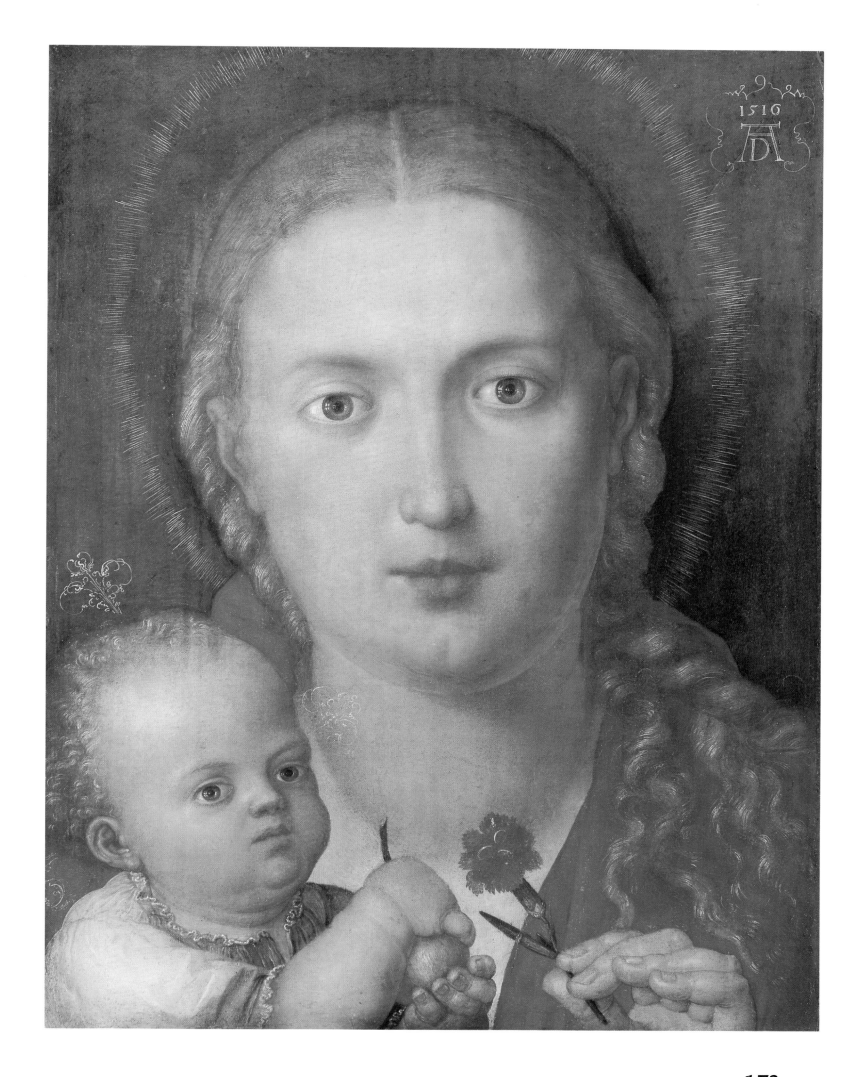

173

varnish. In contrast, that of Eve, bathed in a white light, has a cool, almost silvery effect. Here Dürer was concerned wholly with the figures, and everything else is reduced to an absolute minimum. Here there is no attempt to suggest the meaning of the story by means of symbols.

One year after he had completed these images of Adam and Eve, Dürer addressed himself to the subject of Lucretia, which again gave him the opportunity to paint a nude female figure (230). A drawing dated 1508, now in Vienna, shows his early involvement with the theme, but the life-size figure was completed only in 1518.

Along with his studies of the human figure, Dürer explored the proportions of the horse. Six months after the artist's death, in the same year in which his *Four Books on Human Proportion* appeared, his pupil, Sebald Beham, published a book entitled *Mass oder proporcion der Ross* [Measurement or Proportions of the Horse]. Even if he was unjustly accused of having stolen a manuscript of his master's — the City Council denied him the right to publish it "until all the good work that Dürer had prepared before his death has been printed, published, and brought to light" — still his preoccupation with the study of the proportions of the horse stemmed from Dürer's studies. In this area likewise, the original stimulus came from Italy. One may assume with reasonable certainty that Dürer had gained access to Leonardo's studies of horses, which were connected with the projected equestrian statue of Francesco Sforza and the tomb of Marshal Gian Giacomo Trivulzio.

The efforts to work out the construction of the horse on the basis of squares and segments of circles began around the turn of the century, scarcely later than the same efforts with the human figure and inanimate objects. Dürer's results survive in a series of engravings which culminate in the sheet "Knight, Death and Devil" (211). The series begins with Dürer's largest engraving, depicting the legend of the benevolent Roman general Placidus. While Placidus was hunting, Christ appeared before him in the form of a stag and converted him (205). On baptism he was given the name Eustace. In the rich detail of the landscape Dürer anticipates not only the characteristic elements of the Danube School, but even the idyllic landscapes of the 18th and 19th centuries, as becomes clear in his treatment of the forest pond with a bridge and swans. While the hunter has sunk to his knees before the vision of the crucifixion between the antlers of the stag, the horse, its right hindquarters slightly elevated, stands as quiet as if made from stone. The motionlessness of the animal may be caused by its being tied with a short tether to the branch of a tree, but the horse nevertheless hints at a model drawing that Dürer took over for the engraving. This is supported by the rather slight difference in size between the horse and the new convert, who is placed only a little deeper in the landscape, not adequately explained by the hunter's kneeling on a small mound. The dogs of the hunter are

203

THE SMALL HORSE

With the monogram of the artist on a stone. Near the top, in the arch, appears the date 1505. Engraving. 164 x 109 mm.

The proportions are based on the length of the head. The length of the body and the height at the rump are each equivalent to three headlengths. The height of the body alone equals one headlength.

204

THE LARGE HORSE

With the monogram of the artist, bottom right, and the date 1505 near the top. Engraving, 167 x 119 mm.

The steed was not constructed proportionally, but is most likely based on a sketch from nature.

205

ST. EUSTACE

With the monogram of the artist. Engraving. 357 x 260 mm.

This engraving of c. 1501 is one of the first results of Dürer's preoccupation with the proportions of the horse. A sketch from nature used for one of the dogs is at Windsor Castle, Collection of Her Majesty the Queen (cf. 206).

206

A GRAYHOUND

Brush on paper. 145 x 196 mm. Windsor Castle, Collection of Her Majesty the Queen.

A study after nature from c. 1500/01, used for the engraving "St. Eustace" (cf. 205).

nothing but five views of the same animal; the first of these, based on nature, is depicted in mirror image immediately to the left of the rider (206). Two smaller engravings depicting horses, dated 1505, followed on "St. Eustace" of c. 1501. In both these a horse, though in different poses, is the main object, whereas the rider walking behind it and largely obscured by it is only an incidental feature (203, 204).

Dürer's engraving "Knight, Death and Devil" of 1513 marks the end of his studies of horses (211). In his diary he referred to it quite simply as "The Rider." Among the earlier works utilized for this composition is first of all a watercolor of 1498 of an equestrian with a lance, a carefully executed model drawing, lacking any indication that it was proportionally constructed (208). This sheet had already found use in the horse of "St. Eustace." The inscription on top, "This was the armor of the time in Germany," connects the watercolor with the series of representations of Nuremberg costumes done in 1501, and confirms the role of these as dedicated to the history of costume. Even if the tradition cannot be confirmed that the rider is Philipp Link, a groom of the Paumgartner family, the person is

207A
PREPARATORY STUDY FOR THE ENGRAVING "KNIGHT, DEATH AND DEVIL"
Pen and ink on paper over a charcoal sketch. 246 x 185 mm. Milan, Biblioteca Ambrosiana.

207B
PREPARATORY STUDY FOR THE ENGRAVING "KNIGHT, DEATH AND DEVIL"
Pen and ink on paper, the background covered over with brush. 246 x 185 mm. Verso of 207a. With a dog added by the artist.

The proportions of the horse are based on a grid composed of three rectangles in two rows, the narrow sides of which correspond to the length of the head. The grid lines can be clearly seen on the recto. On the verso is a tracing, augmented by a dog, on a dark background (cf. 211).

176

clearly a Nuremberg mounted guard and is accordingly included in a history of Nuremberg costume.

The portrayal of man on horseback is one of the great continual challenges that can be traced throughout the entire history of western art. Stimulated by surviving Roman equestrian statues, Italian artists of the Renaissance had again taken up the subject. Dürer might have seen, as early as his first visit to Italy, the monument of the Venetian general Donatello Gattamelata on horseback in front of the Santo in Padua. He might even have been present at the unveiling on 21 March 1495 in Venice of Verocchio's statue of Bartolomeo Colleoni which, including the horse, had been cast in 1492. But even German artists responded to this challenge. In 1501 Sixt Syri of Nuremberg carved an equestrian statue in wood of Bartolomeo Colleoni for the family's tomb in Bergamo. As early as

208
EQUESTRIAN KNIGHT IN ARMOR
Inscribed: "This was the armor of the time in Germany." With the monogram of the artist and the date 1498. The helmet is marked with the letters *WA*. Pen and ink on paper, tinted with watercolor. 410 x 324 mm. Vienna, Graphische Sammlung Albertina.

The inscription connects the drawing with the costume studies of Nuremberg (cf. 173, 174, 179, 180).

177

1509 the rough-cut block from which Gregor Erhart was to hew a statue of Emperor Maximilian on horseback, based on a design by Hans Burgkmair, was put in place in front of the Church of Sts. Ulrich and Afra in Augsburg.

Dürer's engraving "Knight, Death and Devil" should be viewed in conjunction with these as well as with the equestrian monuments planned by Leonardo. A surviving preparatory drawing of horse and rider (207) reveals, through the still visible lines of construction, that the artist developed the horse on the basis of squares, following Leonardo's model, and that its proportions were determined by the length of the head. Many have sought to puzzle out the deeper meaning of this engraving, which together with "Melencolia I" (302) and "St. Jerome in His Study" (158) constitute the trio of so-called master engravings. It is even unclear whether Death and the Devil encounter the Knight as opponents or whether they are his attributes as a possible robber baron. It has also been suggested that he represents the Florentine religious reformer Savonarola, on account of the letter "S" next to the date 1513. The dog and the salamander have been claimed to be hieroglyphs of Horus Apollo denoting a holy author or seer and a man burned at the stake. Dürer had provided illustrations, in the form of pictographs, for a translation from Greek into Latin of the hieroglyphs by an Egyptian of the 2nd or 4th century; it was produced by Willibald Pirckheimer for Emperor Maximilian in 1512/13 (209, 210).

In contrast to the watercolor "Equestrian Knight in Armor" (208), the Knight in the engraving is enhanced by proportional depiction of the horse and its gait. The artistic, carefully constructed form makes it impossible to regard the rider negatively, i.e., as an irresponsible mercenary of the sort that threatened the merchants of Nuremberg on the open road. The basis for an explanation seems clear: The rider, armed for the fight, has left the Devil behind, and takes no notice of Death, who attempts to frighten him by pointing to the hourglass whose sand has nearly run out. The victory over Death

209
HIEROGLYPH OF HORUS APOLLO: A GOAT
Pen and ink on paper. 80 x 77 mm. Nuremberg, Germanisches Nationalmuseum (Loan of Irmgard Petersen, née Blasius).

Cf. 210. The goat signifies impurity.

210
HIEROGLYPH OF HORUS APOLLO: A LION WITH TWO (ORIGINALLY THREE) JUGS

Pen and ink on paper. 59 x 82 mm. Nuremberg, Germanisches Nationalmuseum (Loan of Irmgard Petersen, née Blasius).

These two illustrations were intended for Pirckheimer's Latin translation, prepared in 1512/13 for Emperor Maximilian I, of a book purportedly interpreting the meaning of hieroglyphs by an Egyptian of the 2nd or 4th century A.D. who called himself Horus Apollo. Pirckheimer used a Greek text that had become

known in Italy in 1419. Fourteen of Dürer's illustrations for the no longer extant manuscript have survived. The lion with jugs denotes Egypt as the gift of the Nile.

211
KNIGHT, DEATH AND DEVIL
With the monogram of the artist and the date 1513, prefixed with an "S" [salus?]. Engraving. 244 x 189 mm. (Cf. text pp. 178-80 and fig. 207).

179

and the Devil is valid for all Christians. One may assume that the passages in Scripture on which the engraving was based were well known to Dürer's audience. It would be hard to think of a passage closer to this pictorial representation than St. Paul's call to all to join the spiritual battle: "Put on the whole armor of God, that you may be able to stand against the wiles of the devil" (Eph. 6: 11). The Devil has already been beaten through Christ. The frightful figure with the horned head of a boar is made of the same stuff as the lord of the underworld who, in the woodcut of the "Large Passion," attempts in vain to defend his realm with a broken lance against the victoriously advancing Savior (315). For Death, Christ's message applies: "Verily, verily, I say unto you, if a man keep my saying he shall never see death" (John 8: 51). Dürer includes even this promise, quite literally, in his engraving. The message is heightened by the power of symbols, even those perhaps intentionally endowed with multiple meanings: the dog as a sign of watchfulness, the salamander who is not harmed by fire, the castle on the mountain, perhaps the heavenly Jerusalem, and finally the monumental character of the entire image. In changing the fighting armor of the Nuremberg knight into defensive equipment affording protection against the powers of darkness, the "armor of justice," the "helmet of healing," and the "sword of the word of God" take on clear meaning. In contrast to the purely representational drawing of 1498, Dürer has added moral values in the engraving through the Knight's confrontation with other powers. Taken together with the two other master engravings, "Knight, Death and Devil" signifies the moral road to salvation, as compared to the theological route of St. Jerome and the intellectual path of Melencolia.

The Influence of the Classical World

Among the graphic works Dürer published immediately after his return from Venice and in the succeeding years, there are to be found a series of woodcuts and engravings dealing with subjects from antiquity, as well as the Old Testament. Knowledge of the Greek and Roman legends which fuse history and myth was not wholly lost during the Middle Ages; numerous traces of it are found in medieval art. A new catalogue of pictorial topics was made available to the artists of the Renaissance, however, when the humanists rediscovered the writings of the classical world. Acquaintance with these subjects can therefore be assumed among those interested in art.

180

212
PAGE DECORATION FOR WILLIBALD PIRCKHEIMER
Miniature in body color, heightened with white and gold, for Theocritus, *Idyllia* (in Greek). Venice, Aldus Manutius, February 1495/96. 300 x 210 mm. Private collection.

The largest and most beautiful of the miniatures which Dürer painted around 1504 as decorations in twelve surviving volumes in Greek and Latin from the library of Willibald Pirckheimer. On the left the coat of arms of the owner, on the right that of his wife, Caritas Rieter (d. 17 April 1504).

ΘΕΟΚΡΙΤΟΥ ΘΥΡΣΙΣ Η ΩΔΗ

ΕΙΔΥΛΛΙΟΝ ΠΡΩΤΟΝ.

ΘΥΡΣΙΣ Η ΩΔΗ.

Αδύ τι τὸ ψιθύρισμα καὶ ἁ πί
τυς αἰπόλε τήνα,
Ἅ ποτὶ ταῖς παγαῖσι μελίσ
δεται· ἁδὺ δὲ καὶ τὺ
Συρίσδες· μετὰ Πᾶνα τὸ δεύ
τερον ἆθλον ἀποισῆ.
Αἴκα τῆνος ἕλη κεραὸν τρά
γον· αἶγα τὺ λαψῆ.

Αἴκα δ' αἶγα λάβη τῆνος γέρας ἐς τὲ καταρρεῖ
Ἁ χίμαρος, χιμάρῳ δὲ καλὸν κρῆς ἔςκα μελέξης
Ἄ Γ. Ἄδιον ὦ ποιμὰν τὸ τεὸν μέλος ἢ τὸ καταχὲς
Τῆν' ἀπὸ τᾶς πέτρας καταλείβεται ὑψόθεν ὕδωρ.
Αἴκα ταὶ Μῶσαι τὰν οἴιδα δῶρον ἄγωνται·
Ἄρνα τὺ σακίταν λαψῆ γέρας· αἰδέκα ἀρέσκη
Τῆνας ἄρνα λαβεῖν· τὺ δὲ τὰν ὄιν ὕςτερον ἀξεῖς.
Θ. Λῆς ποτὶ τᾶν νυμφᾶν λῆς αἰπόλε τῆδε καθίξας
Ὡς τὸ κάταντες τοῦτο γεώλοφον ἆ τε μυρῖκαι
Συρίσδεν, τὰς δ' αἶγας ἐγὼν ἐν τῷδε νομαςῶ;
ΑΙ. Οὐ θέμις ὦ ποιμὰν τὸ μεσαμβρινὸν, ὀυ θέμις ἄμμι
Συρίσδεν. τὸν Πᾶνα δεδοίκαμες· ἦ γὰρ ἀπ' ἄγρας
Τανίκα κεκμακὼς ἀμπαύεται· ἐντι πικρὸς
Καί οἱ ἀεὶ δριμεῖα χολὰ ποτὶ ἡινὶ κάθηται.
Ἀλλὰ τὺ γὰρ δὴ θύρσι τὰ δάφνιδος ἄλγε ἀείδες
Καὶ τᾶς βωκολικᾶς ἐπὶ τὸ πλέον ἵκεο μώσης.

A . A ii

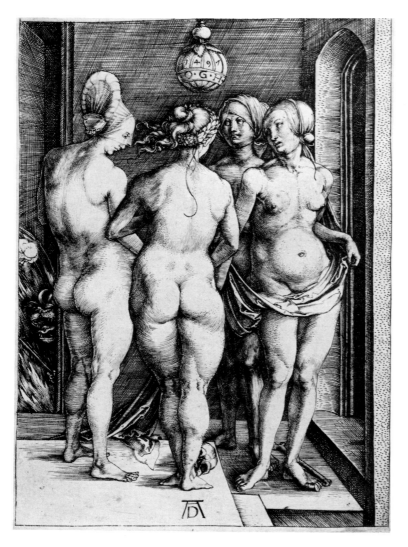
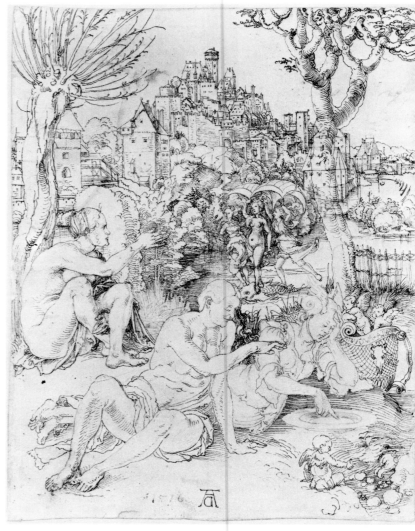

To be sure, these subjects were rarely identical with those popularized in collections of legends during the 19th century. It is therefore sometimes difficult to interpret Dürer's representations, and only recently has some success been achieved in this regard, but many uncertainties remain. The humanist of the Renaissance saw the literary account when he looked at the surviving monuments of the classical world, chiefly sarcophagi and tombs. A linking of the artists with the ancient pictorial tradition did not occur, nor would it have been possible, because the principal examples of illustration of the Greek myths, in the decoration and painting on vases and monuments of the archaic and classical periods, were still buried. The painters of the 15th and 16th centuries were impressed by the artistic means employed by the masters of antiquity. Surviving groups, as well as individual figures, can be recognized as models even when they are transposed and changed. Thus the Roman copy of a Greek statue of Apollo of the 4th century before Christ, set up in the Belvedere court of the Vatican, acquired special significance as a model for the representation of the male nude figure (198). Even Dürer had become familiar with the work through imitations (cf. p. 168).

213
THE FOUR WITCHES: DISCORDIA
Below in the middle, the monogram of the artist; above on the suspended fruit (mandragora?) the date 1497 and the letters *O.G.H.* Engraving. 190 x 131 mm.

Erika Simon interpreted this print as representing the goddesses of the judgment of Paris with Discordia, the goddess of discord. The letters on the fruit probably stand for Odium Generis Humani *[repugnant to the human race].*

182

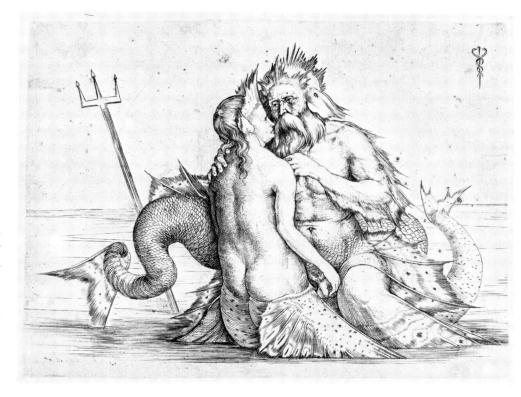

214

The treatment of classical themes was for Dürer intimately connected with his study of the unclothed human figure. The engraving "The Four Witches" first offered him an opportunity to portray a female nude seen from three different angles (213). It is likely that Dürer referred to some studies done in Venice, studies for which he had probably used the same model in several positions. The nude figures of the engraving are placed in a room from whose ceiling a pumpkin-shaped object is suspended in the manner of a lamp. Besides the date, 1497, it bears the letters *O.H.G.* Opposite the dominant group of three, a fourth nude is positioned, though it is substantially obscured by the former and so darkened by shadow that, except for the head and shoulders, which are lighted, only portions of the body and the extremities can be discerned. A rectangular opening in the left side wall is filled, in its lower half, with flames flickering around the head of a demon.

Not only Albrecht Dürer, but Lucas Cranach the Elder as well, shrouded the unaccustomed, offensive nakedness of female figures with moralistic elements, a circumstance that could lead to alterations of the original literary concept. In this sheet, for example, the revealing exhibition of feminine charm is placed in opposition to the fires of hell and the devil. The subject is without doubt the story of Paris and his choice among the three goddesses, Juno, Minerva and Venus. His pick of the goddess of love led eventually to the outbreak of the Trojan War. By the attributes he assigned to each of the three women Dürer identified them as participants in the competition. Juno, Jupiter's spouse, wears a bonnet, the symbol of a married woman; Minerva, the patron of the arts, is crowned with a

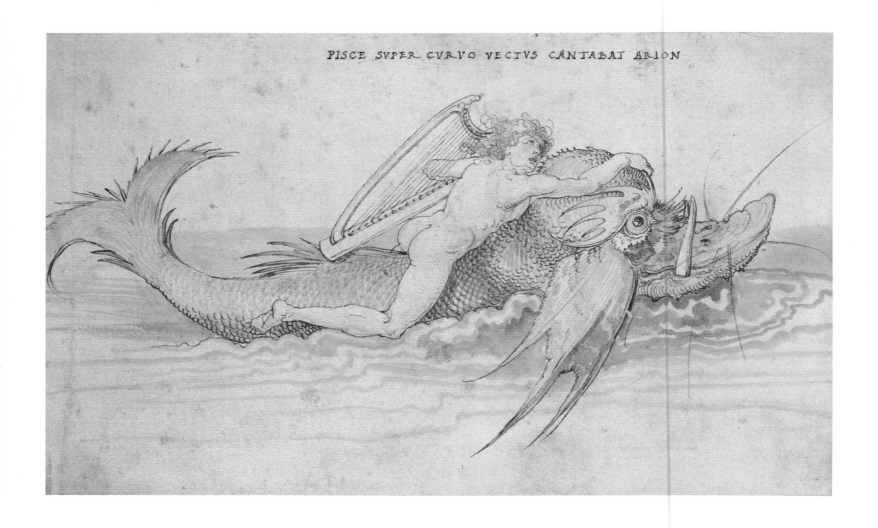

PISCE SVPER CVRVO VECTVS CANTABAT ARION

laurel wreath. The attribute of Venus is her complete nakedness as she faces the viewer, who stands in the place of Paris; even a towel, hanging from her head down to her thighs, conceals nothing essential. The most recent interpretation of the engraving, the one we follow here, identifies the woman opposite the three goddesses as Discordia, the goddess of discord, who had instigated the strife when she tossed the golden apple, inscribed "The Most Beautiful," among the deities gathered for the wedding of Thetis and Peleus. Hell with its sea of flames would then be Hades that swallows up the victims of discord, the fallen heroes of war. Ulysses, whom Homer allows to descend into the underworld, encounters there the heroes leading a joyless existence. If this explanation of the sheet is correct, it means that Dürer had delved intensively into the classical theme and, as he formed the picture, interpreted it in his own way. This conclusion is supported by other mythological representations by Dürer. When Lucas Cranach the Elder first dealt with the Judgment of Paris in a woodcut in 1508, and subsequently in several paintings, he did not attempt an analysis of the ancient myth, but merely reproduced the story according to Guido da Columna's *Historia destructionis Troiae*. Transposed to a German landscape, it became a tale of a traveling knight's dream.

216
ARION
Inscribed: *PISCE SVPER CVRVO VECTVS CANTABAT ARION* [Carried by a fish above the deep, Arion sang]. Pen and ink on paper over preparatory drawing in brush, tinted with watercolor. 142 x 234 mm. Vienna, Kunsthistorisches Museum.

From the Ambras Album (cf. 426). Arion, singer from Lesbos, saved himself from pirates by jumping into the sea. His singing and playing of the zither attracted dophins, who carried him safely to land. Contemporary and in the same technique as "Venus and Cupid, the Honey-Thief," dated 1514, likewise in the Ambras Album.

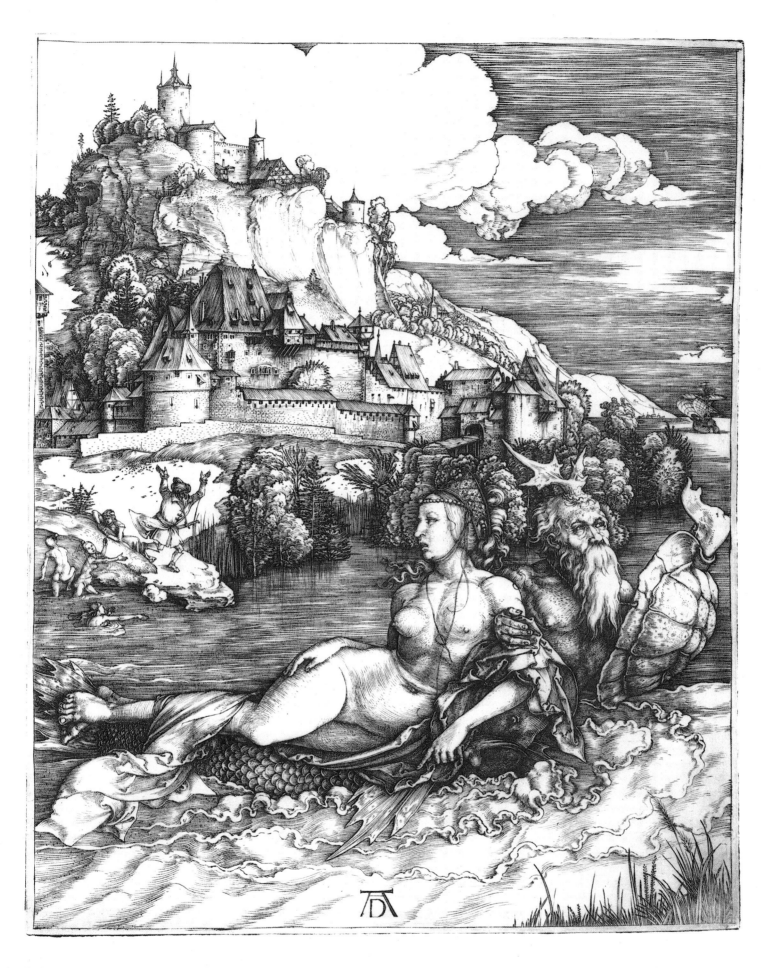

217

THE SEA MONSTER
With the monogram of the artist.
Engraving. 246 x 187 mm.

The engraving dates from c. 1498. Dürer referred to it in this manner in the diary of his trip to *the Low Countries. A classical source has not been found for this scene.*

Dürer, too, attempted to link mythical figures with the present or with his native surroundings. In an engraving that he referred to as "The Sea Monster" in his diary of the Low Countries on the occasion of his sale of a large number of graphics, a creature, half-man and half-fish, has abducted a young woman from the circle of her playmates who, having bathed in the sea, now struggle shrieking toward the shore (217). The father, identified by his attire as an Oriental, plunges toward the shore with upraised arms. The scene is cut off at the rear by a rising hill, and between its steep slopes and the sea there is a walled castle with palace and numerous ancillary buildings. In the distance a fortress with a high keep surmounts a plateau above the cliffs.

It is not just the form of the tower and castle which is alien to the Greek homeland of the water god. Instead of the customary lobster claws of the classical concept, the rack of an elk grows from his head. Earlier versions of the unequal pair are found on antique sarcophagi and in mosaics, showing a feast of Nereids and masculine creatures of the sea. The erotic character of the encounter is often

218
SKETCH SHEET WITH THE RAPE OF EUROPA
With a spurious monogram of the artist; inscribed on the spherical container: *LVTV. / S* [Lutum Sapientiae]. Pen and ink on paper. 290 x 415 mm. Vienna, Graphische Sammlung Albertina.

Beside the abduction of Europa by Zeus in the form of a bull, there are also the head of a lion in three views, an Apollo based on the Eros of Lysippus, and an alchemist in oriental clothing, regarding a skull. The studies were probably produced during Dürer's first stay in Venice, in 1495/96.

186

219

THE ABDUCTION ON THE UNICORN
With the monogram of the artist
and the date 1516. Etching. 350 x
254 mm.

*The preparatory drawing for the
sheet is in New York, Pierpont
Morgan Library (Washington
XXV). The sheet has defied
precise interpretation (cf. 165).*

220

HERCULES AT THE CROSSROADS
With the monogram of the artist.
Engraving. 323 x 223 mm.

*Dürer illustrated Xenophon's tale
of Hercules' choice between vir-
tue and sin in very self-assured
fashion. The cock surmounting
the helmet designates the hero as
Hercules Gallicus. The engrav-
ing, the most mature of those
produced during the early,
mythological period, probably
dates from 1498/99.*

pointed up by the inclusion of Venus. Dürer could have first en-
countered the creature composed of man and fish, as well as the
beautifully shaped woman in an engraving of Andrea Mantegna,
which he had copied (120). Still, departures from the Italian model
show that Mantegna's engraving was not his only source. The name
given the sheet by its creator, with its reference solely to the fish-
man, suggests that Dürer was moved to depict the episode not by
the classical story of the abduction of a woman but rather by the
picture itself. We cannot know, now, how he came into contact
with the idea of a feast of Tritons and Nereids whose actual mean-
ing, with its ties to conceptions of the world beyond, remained
closed to him. In his shaping of the Nereid, whose half-upright torso
leans on the shoulder and arm of the abductor, Dürer selected the
pose of the reposing figure which had already attracted the atten-
tion of the painters of the Quattrocento and remained in the suc-
ceeding century a major theme in the portrayals of nudes.

Another mythological representation likewise makes clear that
the artist was moved less by a desire to depict literary material in art

187

form than by efforts to capture different poses of the human body as they affect its proportions. If a story was suitable for the presentation of figures and groups in whose forms Dürer was interested, it was utilized for that purpose, reflected upon and transformed. The individual choice remained without iconographic consequence. Dürer did not create a canon of mythological subjects, as he did with respect to the Scriptures.

How independently Dürer interpreted the classical myths is evident in his engraving "Hercules at the Crossroads," which depicts the legend recorded by Xenophon about the hero's decision between virtue and vice (220). It offers the leitmotif of the relationship between nude and clothed figures in various poses. The right half of the engraving depicts the powerful naked back of the hero as he raises his club. Dürer did not use a study from nature, at least not exclusively, for this portrayal. A model, probably in the form of a small bronze from the circle of the Florentine goldsmith, painter and sculptor Antonio Pollaiuolo, was presumably available to him. Opposite Hercules is a woman, seen in full length. She is poised to strike with a large branch which she holds firmly in her raised hands. The movement is given emphasis by the helical twist of her body. The belted, sleeveless garb, reaching to her feet, has a covering drapery seen in classical models. Examples can be found in Italian painting of the 15th century. The shape of the draperies is dictated by the form of the body. A slit on the side reveals the advancing left leg up to the thigh. A trace of the autonomous life which owns to the folds of Gothic drapery remains only in the piled-up fabric on the ground. The threat is made against a nymph who, in the company of a satyr, has found concealment in a thicket. Alarmed by the sudden attack, the naked woman raises her arm in a protective gesture. A nude Cupid, bird in hand, takes flight.

Various possibilities for depicting the human figure are united in this representation. Standing and reposing figures, views from the

221
A Battle of Nude Men
Antonio Pollaiuolo.
Left, on the tablet: *OPVS. ANTONII. POLLAIOLI. FLORENTINI.* Engraving. 404 x 590 mm.

Dürer porbably knew this engraving, produced around 1470, or similar works of the artist (cf. 222).

222
Abduction of Women
With the monogram of the artist featuring a small d, and the date 1495. Pen and ink on paper. 283 x 423 mm. Bayonne, Musée Bonnat.

Copy of a work of Antonio Pollaiuolo that probably represented the rape of the Sabine women (cf. 221).

223
HERCULES KILLS THE STYMPHALIC
BIRDS
With the monogram of the artist
and the date 1500. Oil on canvas.
85 x 110 cm. Nuremberg, Ger-
manisches Nationalmuseum.

*The expulsion or killing of the
birds, who lived in a marsh near
the arcadian Stymphalos and
who could shoot off their brass
feathers like arrows, is one of the
twelve labors of Hercules. Dürer
depicts the birds as half human,
following Dante's description of
the harpies. The painting was
perhaps intended for the palace
of Frederick the Wise in Witten-
berg.*

front and from behind, nude and clothed bodies are in juxta-
position. The action takes place, screened by shrubbery, against a
backdrop of hills and river, without being linked to it directly.
Voluptas, the untamed sensual passion directed solely at fulfill-
ment, is placed in opposition to Virtus, in whom virtue is equated
with deed. In contrast to the story, both silently attempt to win the
hero over to their very different philosophies of life. With surprising
vigor Virtue, having descended from the lofty height of her castle,
attempts to displace her opponent. Dürer challenges Hercules to end
the unequal duel in the manner of a referee. His grip on the bole of a
sapling, torn from the ground and held as a club with both hands,
precludes his entering the fight as a participant. The hero rather
makes use of the primitive weapon in much the same fashion as
does the herald in a tourney, who separates the combatants so that
he can announce who is the victor.

189

224
PRUDENTIA
An engraver of Ferrara.
Engraving. 202 x 135 mm. (Cf. 226).

225
PRUDENTIA
Pen and ink on paper. 172 x 103 mm. Paris, Musée National du Louvre, Cabinet des Dessins. (Cf. 226).

226
THE MUSE CALLIOPE
An engraver of Ferrara.
Engraving. 201 x 141 mm.

The sheet belongs to a series of fifty engravings produced prior to 1467 and designated by letters and numbers as "Tarocchi," playing cards. Their exact use is not entirely clear. They were copied in Wolgemut's workshop in woodcuts, probably between 1493 and 1497, and also redrawn by Dürer at about the same time.

227
THE MUSE CALLIOPE
Inscribed below: *DI CALIOPE. XI.* Pen and ink on paper. 202 x 108 mm. Paris, Musée National du Louvre, Cabinet des Dessins. (Cf. 226).

190

228

THE DEATH OF ORPHEUS
With the monogram of the artist featuring a small d, and the date 1494. Inscribed on bandarolle in the tree: *Orfeus der Erst puseran* [from Italian *buggerone* — Orpheus the first homosexual]. Pen and ink on paper. 288 x 225 mm. Hamburg, Kunsthalle.

Dürer based the drawing on an Italian work that in turn reflects an engraving by an anonymous north Italian engraver (unique, Hamburg, Kunsthalle; cf. 229).

229

THE DEATH OF ORPHEUS
North Italian engraver. Engraving. 145 x 216 mm. Hamburg, Kunsthalle.

This engraving, of which only one impression survives, reproduces a model from the circle of Andrea Mantegna. Whether Dürer knew the original or used this engraving for his drawing of the same subject is uncertain (cf. 228).

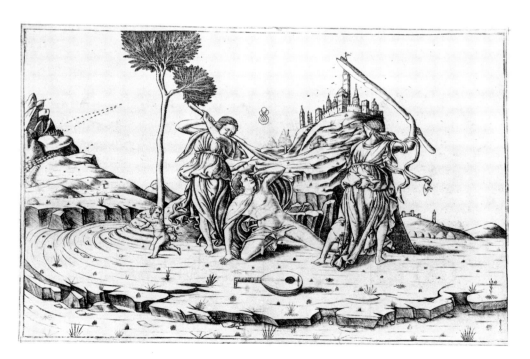

191

A reclining female nude occurs again. Dürer used her, almost two decades later, in 1516, for one of his etchings (219). Dürer has moved here from the clear light of Greek mythology to the shadowland of the uncouth Celtic-Germanic popular imagination. While clouds gather for a thunderstorm, a bearded man with tangled locks, mounted on a unicorn, abducts a naked woman who defends herself with all her force, her thighs drawn up, her arms raised high, calling with wide mouth for help, yet unable to free herself from her abductor's grip around her waist. The portrayal, seemingly not based on any particular literary source, has been variously interpreted. At its roots appears to be the leader of the wild hunt, riding a storm, spreading fear and destruction. Another explanation interprets the nakedness of the woman as that of a witch who is being dragged by force into the realm of the wild hunter.

Not just in theme but also in method the master has distanced himself from the classical world. An interaction between content and technique has occurred. In contrast to the precise lines of engravings, the etching technique, with which Dürer experimented on a number of occasions between 1512 and 1516, offers the artist the opportunity to shape lines more expressively and gives him a wider range of lighting effects. The medium with its particular potential must have played a role in the choice of subject, as well as its execution. Since nude studies drawn from nature had lost their attraction for Dürer after his return from the second trip to Venice, there were probably no special preliminary studies after nature for the figures in "The Abduction on the Unicorn"; more likely these were done from memory and from his knowledge of forms. The mount is a mixture of horse and goat from whose forehead emerges a down-curving horn. As with the other fantastic animals which he drew, Dürer succeeds here through his exact observation and reproduction of naturalistic forms in creating in the beholder belief in the existance of such a creature. In this sense his fantastic animals differ fundamentally not only from the dual creatures in medieval scenes of struggle and hell, but also from the ghosts and gremlins who populate the pictures of his contemporaries, Hieronymus Bosch and Matthias Grünewald.

In Dürer's paintings classical themes play only a subordinate role. A canvas dated 1500 shows Hercules battling the Stymphalic birds (223). It may have been commissioned by Frederick the Wise, since the wall decorations of his new palace in Wittenberg are known to have included a series of classical subjects, among them the labors of Hercules. The depiction of the Stymphalides corresponds exactly to Dante's description of the Harpies in his poem dealing with these other fabled creatures of Greek mythology.

The second picture dedicated to a classical subject deals with the suicide of Lucretia, who had been dishonored by Sextus Tarquinius, the son of a Roman king (230). It is dated 1518. The subject belongs to those accounts which celebrate Roman virtue and exemplary deeds by Roman men and women, well known also in the Middle

230
THE SUICIDE OF LUCRETIA
With the monogram of the artist and the date 1518. Oil on linden wood. 168 x 75 cm. Munich, Alte Pinakothek.
As evident from a preparatory drawing of Lucretia's right arm and a study of the entire figure dated 1508, the artist had already begun work on the subject at that time, probably following the similarly nude "Adam and Eve" of 1507; but he completed "Lucretia" ten years later under different conditions.

192

193

Ages and often the topic of pictures. Renaissance artists liked to portray the heroine in the nude, whereby the sensuousness of the disclosure was counterbalanced by the morality of the subject. At a later time on Dürer's painting, listed as early as 1598 in the inventory of the ducal collection in Munich, the piece of clothing circling the lower body was extended and the picture hidden behind a "Lucretia" by Lucas Cranach the Elder, clothed by way of addition (Munich, Alte Pinakothek). Dürer's life-size "Lucretia" is, besides the Eve in Madrid, his only painted female nude. She was originally intended, as evident from a preparatory drawing dated 1508 in Vienna (Albertina), to follow directly the depiction of Adam and Eve. Perhaps it was the important commission of the Frankfurt merchant, Jakob Heller, who ordered a large altarpiece, that first prevented its completion. When Dürer took up the subject again in 1518 the fortuitous hour had passed when he, stimulated by his experiences in Venice, had created the Madrid pictures. If it can be said that Dürer's prints dealing with mythological subjects seem in some inexplicable way to be genuinely expressive of the classical spirit of ancient Greece, there is little of that in this "Lucretia"; placed in a middle-class setting of a bedroom with all its accessories, she seems strangely restrained in composition as well as in color.

The Discovery of Nature

The accurate reproduction of nature in lifelike form constitutes one of the most important of Dürer's contributions to art. In this he succeeded in building on the accomplishments of the 15th century. The old formulas for rendering trees and plants were replaced by depictions based on detailed and exact studies of nature. Once the illustration of growing things had been accomplished, it could be passed on as "workshop property." In the realm of Nuremberg painting, just such a development can be shown in the reproduction of irises which occur as a flower symbolic of the Virgin in the paintings of the circle around Hans Pleydenwurff. This thematic use was further extended in Michael Wolgemut's workshop. A life-size depiction of the same plant after nature is ascribed to Albrecht Dürer (Kunsthalle, Bremen). This large, carefully executed drawing done in watercolor and body color belongs to a series of plant studies whose exact date and relationship to Dürer's oeuvre is difficult to judge. Similar botanically exact reproductions of plants are assumed to have been preparatory for the woodcut illustrations of herbals which appeared at that time or a little bit later. A group of plant drawings ascribed to Dürer is in the Albertina in Vienna. They are all on vellum and were later marked with the date 1526. Vellum, used by Dürer with success in earlier years as a base for oils, fails to produce the airy effect of the watercolor because it is not very absorptive. This makes it difficult to compare them with plant studies on paper which are more securely ascribed to Dürer.

231
THE GREAT TURF
Bottom right, hard to detect, the date 1503. Watercolor and body color on paper. 410 x 315 mm. Vienna, Graphische Sammlung Albertina.

This small segment of turf includes common yarrow (Achillea millefolium), dandelion (Taraxacum officinale), meadowgrass (Poa pratensis) and greater plantain (Plantago major).

194

195

A very early plant study by the young painter is that of sea holly shown in the self-portrait of 1493 (19). Even though painted from nature, the thistlelike plant clearly reveals late Gothic stylistic characteristics. Even if separated from the dated picture it would not be difficult to date accurately.

If the detailed depiction of individual plants retained something of the character of specimen, Dürer's "Great Turf" represents a convincing segment of a living whole (231). Executed in watercolor and body color on paper that today is severely yellowed, the drawing reproduces in microcosm a meadow with plants of many varieties at different stages of growth. The horizon is extremely low. Yarrow, dandelion, meadowgrass and greater plantain are among the plants pictured. The date 1503 can be seen, with difficulty, near the bottom right, done in brush. This seemingly casual juxtaposition of plants on a tiny piece of damp earth proves on closer inspection to be a carefully thought-out construction based on artistic considerations. Through a grid of fine grass the glance falls on the plantain, growing up in the middle of the scene; its broad, light-catching leaves are backed by a wall of grass and dandelions that becomes gradually sparser toward the left. Growing up toward a shadowed zone, the stalks and the blossoms are airily positioned at intervals on the once white paper. By means of a powerful yellow ocher, the

232
A Nosegay of Violets
Watercolor heightened with white on vellum. 117 x 104 mm. Vienna, Graphische Sammlung Albertina.

Probably part of the group of plant studies of c. 1503. The leaves of the flowers have been gone over by a later hand.

233
Linden Tree on a Bastion
Watercolor and body color on vellum 343 x 267 mm. Rotterdam, Museum Boymans-van Beuningen.

The drawing dates from the same time as "The Wire-Drawing Mill" and "The Church of St. John" (55, 51), though the precise date of the group, whether the summer of 1489 or 1494 is undetermined.

197

stems and blossoms of three dandelions detach themselves by degrees from the prevailing green. The structures and surfaces of the plants are captured with the utmost exactitude, from the roots up, as one perceives whether they have sharp edges or are soft. Both the composition and the color values arouse the illusion of depth. The segment created by Dürer reveals something of the development as well as the degeneration of the whole. The high quality of the invention and execution is matched by none of the other plant studies ascribed to Dürer. It is likewise lacking in the nosegay of violets (232), in which only the petals with their fine variations achieved by light and shadow still reveal the master's hand, though lack of structure of the leaves and stems arises from later restoration.

Dürer's representations of animals may also have symbolic value, be related to the content of the picture and serve as attributes to explain it. The early woodcuts and engravings depicting the Virgin or the Holy Family contain rabbits (242), a long-tailed monkey (241), and a grasshopper (101), which have provided the names of these pictures. Their symbolic meaning is traditional. In the drawing of "The Virgin with a Multitude of Animals," produced around 1503 (237), the variety of animals represented refers to the conditions in paradise; and the fox, representing evil, is held in check by a long leash. The humorously depicted animals acquire thereby something

234
A LOBSTER
With the monogram of the artist and the date 1495. Pen and ink on paper, light brown and black heightened with white. 247 x 429 mm. Berlin-Dahlem, Staatliche Museen Preussischer Kulturbesitz, Kupferstichkabinett.

The earliest of Dürer's nature studies drawn from life; done in Venice.

235
WING OF A BLUE ROLLER
(*Corracias gerula*)
With the monogram of the artist and the date 1512. Watercolor

198

and body color on vellum. 197 x 200 mm. Vienna, Graphische Sammlung Albertina.

Related studies by Dürer had already been used in the engravings "Nemesis," c. 1501/02 (257) and "Coat of Arms of Death," 1503 (185). It therefore must be assumed that the drawing in the Albertina repeats a model of the year 1500 or the date on the vellum is spurious.

of the anthropomorphic features attached to them in fables. The moralistic animal stories linked with the name of Aesop became known again to a wide public in the second half of the 15th century through the appearance of a variety of illustrated editions brought out by the printing houses of Ulm and Augsburg. For each of the living creatures depicted, just as for the flowers, among which the iris reappears here, individual preparatory studies must have been made. The delightful topic was probably intended for reproduction in an engraving. When this did not materialize, Dürer touched up two of these drawings with bright watercolors (Vienna, Albertina; and Paris, Louvre).

236
A YOUNG HARE
With the monogram of the artist
and the date 1502. Watercolor
and body color on paper. 251 x
226 mm. Vienna, Graphische
Sammlung Albertina.

237
THE VIRGIN WITH A MULTITUDE OF
ANIMALS
Pen and ink on paper, with
watercolor. 321 x 243 mm.
Vienna, Graphische Sammlung
Albertina.

*Produced around 1503, this
drawing was perhaps prepara-
tory for a projected engraving.
An earlier version is in Berlin, a
variation in Paris (Strauss, Dürer
Drawings, 1503/21, 23).*

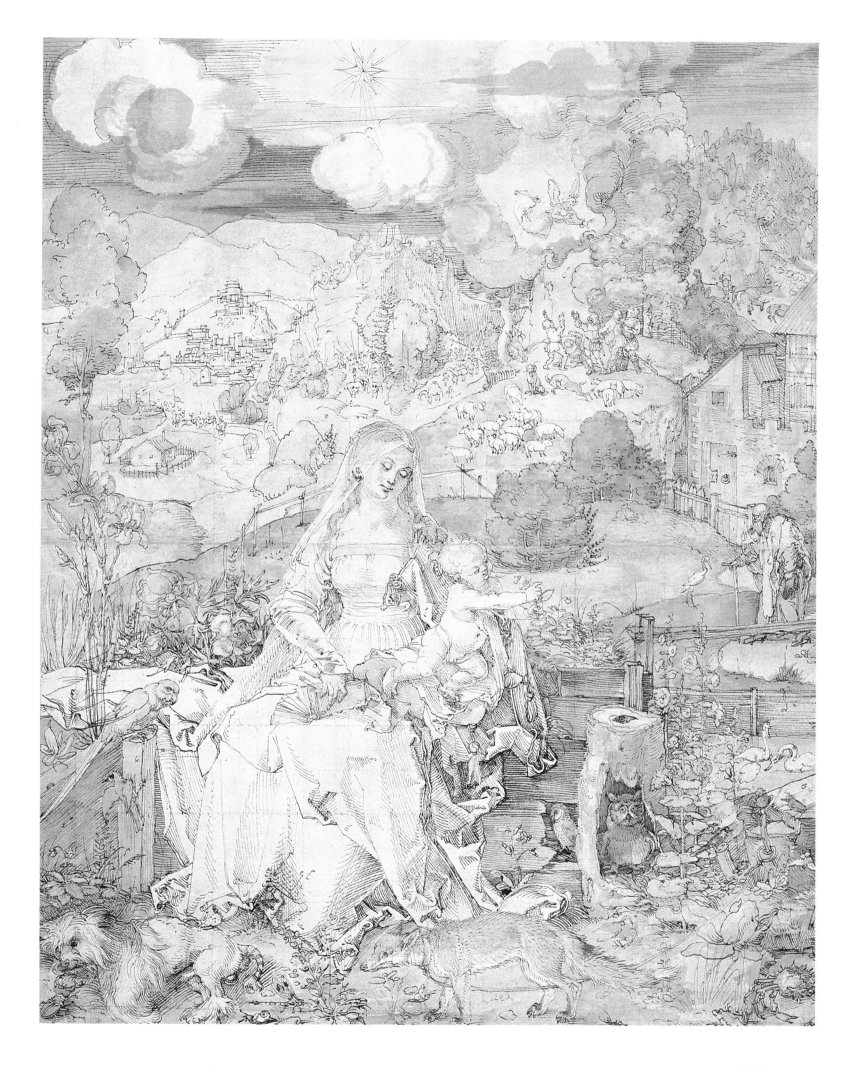

201

202

238
THE HEAD OF A STAG
With the monogram of the artist by another hand, and the date 1514. Brush and watercolor. 228 x 166 mm. Bayonne, Musée Bonnat.

The date, entered by another hand (Hans von Kulmbach?), is not convincing as a date of execution of the drawing. It was produced with the other animal studies in the first years of the 16th century.

239
THE HEAD OF A STAG KILLED BY AN ARROW
With the monogram of the artist and the date 1504. Watercolor on paper, heightened with white, retouched in pen. 252 x 392 mm. Paris, Bibliothèque Nationale, Cabinet des Estampes.

The presence of the artist's monogram and the date 1502 certifies that the watercolor of the hare (236) is a complete, autonomous work, thus raising the subject of "animals" to the level of a legitimate pictorial category. The effect of the sheet rests on the convincing visualization of the appearance and peculiarity of this animal. The artist probably used a stuffed version as a model, but his depiction gives no hint of it. The hare, fearful, has cowered down, carefully testing the surroundings, ready to spring up and flee. The combination of watercolor, which permits the colors to flow into one another, with body color, in which a pointed brush can bring out the tiniest details, succeeds in reproducing a furry quality whose softness the viewer is almost tempted to touch. Reddish and gray color tones emerge from the white of the paper, a white which here and there is utilized in the lighting effect.

The many reproductions of this drawing, isolated from other material, have created an incorrect impression of Dürer's concept of nature as idyllic and harmless. More accurately, his autonomous studies of animals bring out something of the painful, alternating relationship between men and animals. Among the very carefully and thoroughly executed heads of deer is the head of a stag, in

203

240
A DUCK
With a spurious monogram and the date 1515. Watercolor and body color on vellum, heightened with gold. 233 x 127 mm. Lisbon, Museo Gulbenkian.

Since the date is spurious, the drawing probably belongs with the many animal studies of the early years of the century.

241
THE MADONNA WITH THE MONKEY
With the monogram of the artist.
Engraving. 191 x 122 mm.

For this engraving, produced c. 1498, Dürer utilized the drawing of the Island Abode in Anger's Pond, produced only shortly before (cf. 124). The chained monkey is symbolic of evil overcome.

242
THE HOLY FAMILY WITH THREE RABBITS
With the monogram of the artist.
Woodcut. 390 x 280 mm.

This early woodcut of 1496/97 combines several themes related to the Virgin and anticipates the "Rest on the Flight to Egypt." The rabbits are symbolic of fertility.

which the hunter's arrow is shown as it has penetrated the flesh below the shattered eye (239). The approximately contemporary "Head of a Stag" goes well beyond the innocuous, judgment-free reproduction of a natural object (238).

The discovery and study of nature occupied Dürer particularly during the first decade of his independent creativity, during which he worked out the basic form of his art. His conviction that knowledge of nature and attention to its details are essential qualities of the artist is stated in an essay on aesthetics in his *Four Books on Proportion.*

205

206

207

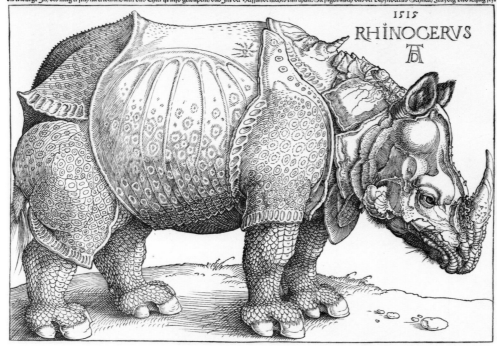

Viewing nature as the origin and measure of art was an idea which Dürer not only formulated for the first time, but he was the first, at least in Germany, to follow up on this approach and translate it into practice. In this process he did not deny the fruits of his experience nor the tradition of the workshop, he merely demanded that they be submitted to the control of reality as expressed in nature.

Dürer viewed the world, inhabited concurrently by men, animals and plants, in a new light. His relationship to nature found its purest expression in his landscapes. These were the first complete, autonomous works of their kind in western art. To be sure, here as in the other areas of his creativity, Dürer had earlier accomplishments of others on which to build. The earliest identifiable landscape occurs in the St. Peter Altarpiece of Konrad Witz, dated 1444, for the Cathedral of Geneva (Geneva, Musée d'Art et d'Histoire). The Sea of Galilee, on which Christ appears to the apostles after his resurrection, has become Lake Geneva, behind which appear the Voirons mountain range, the bulk of the Môle and the rise to the Petit Salève. If the artist adapted the distinctive contours of these mountains to the requirements of his composition, he must have produced first a preparatory drawing directly from nature recording the exact features of the locality. Such drawings, preparatory for panel paintings of a slightly later time, have survived, at least of architectural subjects. A group of six pen and ink drawings gone over with watercolor and body color, produced between 1480 and

208

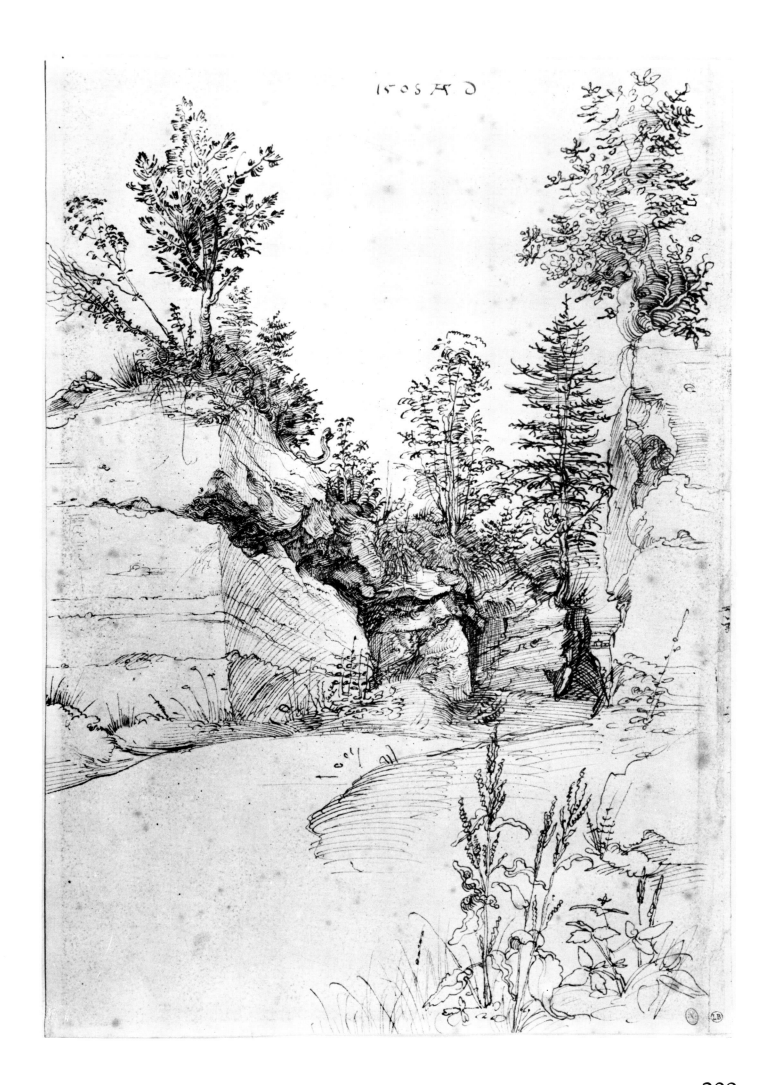

209

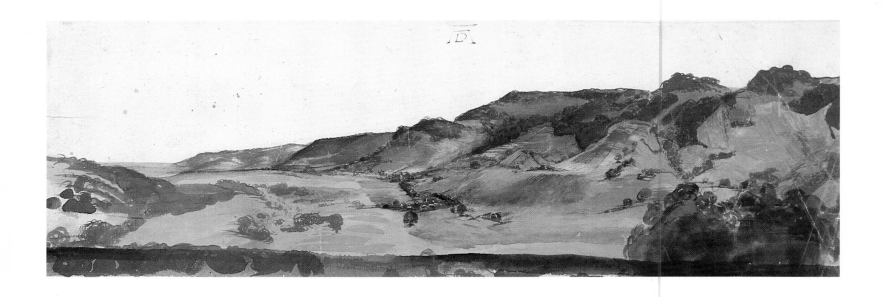

1500, have come down to us; they depict the groups of buildings on the elevation crowned by the Bamberg Cathedral (Berlin-Dahlem, Staatliche Museen Preussischer Kulturbesitz). Drawings of the actual site were essential also for the many topographically accurate city views in the *Nuremberg Chronicle*.

Albrecht Dürer's watercolor landscapes, which exactly reproduce the local details of the Nuremberg surroundings, begin in late spring or early summer of 1494, after the artist had returned home from his travels as a journeyman. The notion has also been advanced that the first examples, isolated by their character, go back to the time of

247
VALLEY NEAR KALCHREUTH
With the spurious monogram of the artist. Watercolor and body color on paper. 103 x 316 mm. Berlin-Dahlem, Staatliche Museen Preussischer Kulturbesitz, Kupferstichkabinett.

Fiore-Herrmann has convincingly eliminated this landscape from those produced prior to 1500. It is now dated between 1516 and 1520.

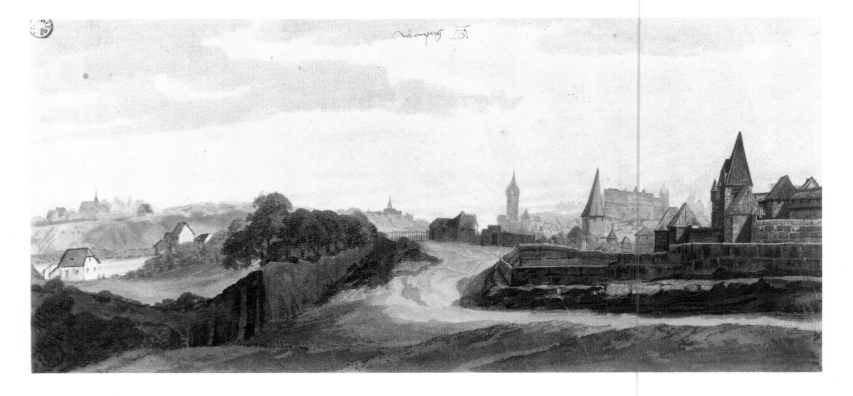

248 ←

NUREMBERG SEEN FROM THE SOUTH
Inscribed: *nörnperg;* with a
spurious monogram. Watercolor
and body color on paper. 163 x
344 mm. Bremen, Kunsthalle
(lost during World War II).

*The watercolor shows the
western part of the city seen from
the south. In the background are
the Imperial castle and the land-
scape outside the moat with Holy
Cross and St. John's. It was pro-
duced in connection with the
cityscapes of the first Italian trip,
probably 1496/97.*

249

THE VILLAGE OF KALCHREUTH
Inscribed: *kalk rewt;* with a
spurious monogram. Watercolor
and body color on paper. 216 x
314 mm. Bremen, Kunsthalle
(lost during World War II).

*With 247, this drawing has been
dated between 1516 and 1520.*

Dürer's apprenticeship with Michael Wolgemut. If we consider the
circumstance that all the trees appear in this case with full foliage,
the summer of 1489 is the only plausible time. These earliest local
scenes are labeled along the upper border as "Wire-Drawing Mill"
(55) and "St. John's Church" (51), in such fashion that the inscription
forms a part of the picture; the intruding monogram is the work of a
later hand. The localities in the succeeding views of the Tyrol are
likewise identified by inscriptions in a somewhat larger hand. The
rather generalized information on several pictures, such as "Italian
Mountain" or "Italian Castle," suggest that all the sheets were
labeled after the trip, when the painter was no longer sure of the
precise names of the localities depicted.

The first of the landscapes betray, both in their richness of detail
and in their horizontal layout, their roots in background landscapes
of panel pictures. The relationship is very clear in the horizontally
layered color structure of the wire-drawing mill with gray, violet
and brown tones in the foreground, green in the middle ground and
the blue mountainous background. Had there been a group of
figures instead of the houses standing on this side of the river,

211

250

THE PENANCE OF ST. JOHN
CHRYSOSTOM
With the monogram of the artist.
Engraving. 181 x 117 mm.

*In the background is the saint,
creeping on all fours as penance
for having impregnated a king's
daughter who had lost her way in
the desert. C. 1495/96 (cf. 251).*

252

A LION IN REPOSE
Inscribed: *zw gent* [at Ghent].
Silverpoint on prepared paper.
129 x 190 mm. Vienna, Graphi-
sche Sammlung Albertina.

*From the oblong sketchbook of
the trip to the Low Countries.
Verso of fig. 18. On 10 April 1521
Dürer wrote in his diary: "After
that I saw the lions and drew one
of them in silverpoint."*

251

ST. JEROME IN THE DESERT
With the monogram of the artist.
Engraving. 305 x 224 mm.

*This print was produced along
with the engravings of myth-*

*ological subjects around 1495/96
together with several depicting
legends of saints, utilizing studies
after nature from Dürer's trip to
Venice or from the surroundings
of Nuremberg.*

253
A Tree in a Quarry
With the monogram of the artist by another hand. Watercolor and body color on paper. 296 x 219 mm. Milan, Biblioteca Ambrosiana.

Instead of the traditional dating of the drawing as following immediately after the watercolors of the first Italian journey, Fiore-Herrmann has with good reason suggested a date no earlier than 1506/08.

254
A Mountain Hut in Disrepair
Pen and ink with watercolor on paper. 372 x 262 mm. Milan, Biblioteca Ambrosiana.

This dates from the time of Dürer's first trip to Venice.

together with the shed with its roof of reeds that is partly cut off by the right edge of the picture, one would have recognized a pictorial composition very like that of Konrad Witz's depiction of St. Peter's draught of fishes. The background landscapes of Nuremberg paintings probably provided Dürer's first inspiration. A more pronounced influence can probably be ascribed to his experiences along the Upper Rhine Valley, perhaps also in the Low Countries. In Basel he was on the scene where Konrad Witz, who died relatively young in 1445, had been active; unfortunately none of the great sequence of wall paintings by Witz in St. Peter's Kornhaus have survived. Such considerations argue that the most likely time for the beginning of Dürer's watercolor landscapes dates from after his return from his travels as a journeyman.

Even more astonishing than his elevation of the depiction of nature into the autonomous form of landscape painting are the development and objectives of Dürer's watercolors. The panorama of Innsbruck still reflects the older city views (118), although only in the framework of the composition, the stringing along of a sequence of buildings till they form a city silhouette in which the most significant buildings do not overlap. Aside from this, however, completely new artistic means are employed in order to give a sense of

reality to the picture, one which changes according to season, state of the sun and of the weather. Thus effects, such as the mirroring of the houses in the flowing water of the Inn, although seen and depicted before, achieve a larger impact through the observation of the particular situation. The sky — overcast with multiple layers of clouds which only break up in the south over the mountains, still partly covered with snow — along with its reflection in the water, gives a suffused light in which the city appears to swim. Even in the exactitude of some of the architectural details, such as the scaffolding on the heraldic tower, which was built and painted on order of Emperor Maximilian I in the last decade of the 15th century, Dürer succeeds in achieving a fusion of all elements into a unified pictorial whole, combining city and landscape, filled with air and light.

There is no locale attached to two views of the interior courtyard of a castle which has been identified as that of Innsbruck; this facility was entirely reconstructed in the 18th century (243, 244). These

255
THE CASTLE AT TRENT
Inscribed: *trint*. Pen and ink with watercolor on paper. 196 x 250 mm. London, British Museum. (Cf. 118, 119).

architectural segments viewed in close proximity stand alone in Dürer's work, so that doubt has been expressed as to whether they are truly his, especially because they seem to lack that atmospheric quality which attaches to the panoramic view of Innsbruck. Nevertheless, the high artistic quality of the exact reproduction of details together with the uniformity of the color composition leave no other reasonable alternative than to ascribe them to Dürer. Quite clearly the young artist was not yet able to combine the portrayal of complicated structures, a difficult task in perspective, with the same spatial quality that he achieved so effectively in the sweeping view of the city seen from a greater distance.

How quickly his capabilities expanded in the rendering of architecture embedded in landscape is revealed in two sheets from the next portion of his trip to Venice and particularly in those which were probably done during his return trip. Just as in his stay at Innsbruck, Dürer at Trent juxtaposed to his panoramic view of the city a detailed view of the castle (255, 256). Since little of this edifice of the bishops of Trent has to this day been altered, we can check the accuracy of his portrayal. True, the change in the bed of the Etsch has altered the situation north of the city. Just as in Innsbruck, the lay of the land in Trent is conditioned by the connection between

256
Trent Seen from the North
Inscribed: *Try*[n]*t*. With a spurious monogram. Watercolor and body color on paper. 198 x 257 mm. Bremen, Kunsthalle (lost during World War II). Cf. 118, 119.

215

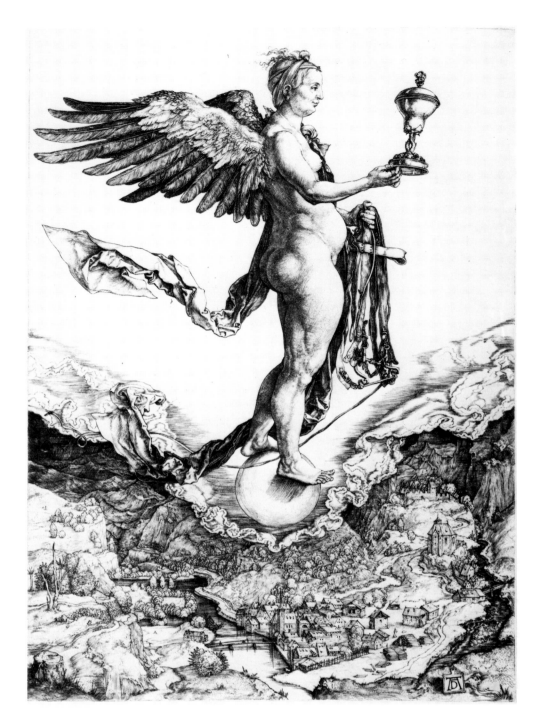

257
NEMESIS
With the artist's monogram on a tablet. Engraving. 325 x 232 mm.

Dürer in his Low Countries' diary referred to this figure as Nemesis, the principal Greek goddess of fate. The proportional construction of the figure is in accordance with the rules laid down by Vitruvius: the head is 1/8 the length of the body, the face 1/10, the feet 1/7. The background landscape of this 1503 engraving depicts the Val d'Isarca near Chiusa in the South Tyrol, based on a lost drawing from Dürer's first trip to Venice.

river and hill. That which was begun with the watercolor describing his entry into the world of the Alps is here completed to an astonishing degree. Architecture and landscape, city, river, and hills are all brought together into a masterfully laid out composition. All connection with the old city views has vanished. A building up of color dominated by blue tones determines the overall impression of the sheet, and by thus fully exhausting the technical potentialities of watercolor, an effect of colored light is produced, so that the contours become hazy and evoke a sense of great depth. It was not until the 19th century that artists would once again seek to create similar effects.

258
A Pond in the Woods
With a spurious monogram of the artist. Watercolor and body color on paper. 262 x 365 mm. London, British Museum.

On the occasion of the 1971 exhibition in London a sketch of a celestial occurrence was discovered on the verso of this drawing. Produced at the same time as the "Island Abode," probably around 1496, this watercolor shows a typical landscape outside Nuremberg, characterized by sandy soil, conifers, and small ponds.

During the extended journey through the Alps Dürer's eye for a landscape, both in its underlying geologic structure as in the unique aspects of lighting, was so finely honed that there arose in him a feeling for the romantic beauty of even small things, a mill in the mountains, a crumbling hut (254), and, once back in Franconia, a small pond surrounded by evergreens (258). Even though he never again produced landscapes on the scale of those stemming from his first journey to Italy — any belonging to the second trip have not survived — throughout his life he continued to portray landscapes which interested him (68, 125, 246, 247, 249, 253, 261).

The topographical landscape portrayals found their way into works intended for the public in only a few cases. Of the studies made in the South Tyrol, a no longer extant view of Chiusa was used in the engraving "Nemesis" (257), an island abode in a small pond along the Pegnitz entered the background for the engraving "Madonna with the Monkey" (124, 241), and a drawing in metalpoint of the Franconian Jura, including the village of Kirchehrenbach with the saddle-shaped mountain of the Ehrenbürg (before World War II in Rotterdam), was used in the 1518 etching "The

217

259
A LION
With the monogram of the artist featuring a small d, and the date 1494. Body color on vellum, heightened with gold. 125 x 170 mm. Hamburg, Kunsthalle.

Not a study from nature, but probably done in Venice based on a Lion of St. Mark (cf. 260).

Great Cannon" (261). This remarkable sheet has a special, personal relationship to Dürer, since one of the Orientals standing next to the great field piece bears his features. Wherever the artist brought together a pictorial design with a landscape, behind what the viewer sees stands the most intensive preoccupation with nature either as it is or shaped and changed by the hand of man (250, 251, 259, 260). The landscapes remained in the possession of their creator, and thus could exercise no immediate effect on contemporary art. Today the watercolors, at first the possession of Dürer's widow Agnes, are scattered through ten collections. A group which contained some of the most important sheets was detached from the Albertina in Vienna in the early 19th century, and in 1851 came into the possession of the Kunsthalle in Bremen. These sheets have been missing since the end of World War II. The fact that it is no longer possible to see the originals, and to check the available colored reproductions against the originals, is probably the greatest loss suffered by German art during the war.

260
THE PENANCE OF ST. JEROME
Oil on pear wood. 231 x 174 mm. Cambridge, Fitzwilliam Museum (loan from Sir Edmond Bacon).

The small, unsigned panel was first recognized as a work of Dürer in 1957. Studies of quarries from the area around Nuremberg are used in the landscape; the lion appears to be related to a drawing of Dürer's in Hamburg (259).

218

261
THE GREAT CANNON
With the date 1518 and the monogram of the artist. Etching. 227 x 330 mm.

The man standing alone in Turkish garb has Dürer's features. For the landscape with the village of Kirchehrenbach and the Ehren- *bürg in the background Dürer used a metalpoint drawing done in c. 1517 on a trip to Bamberg (formerly Rotterdam, Koenigs Collection; Strauss, Drawings, 1517/18).*

262
BEARDED MAN IN A RED CAP

With the monogram of the artist and the date 1520. Watercolor on canvas, 40 x 30 cm. Paris, Musée National du Louvre, Cabinet des Dessins.

A superbly preserved painting on canvas, probably produced in the Low Countries, even though it is not mentioned in the diary.

220

221

The Discovery of the Individual

The emergence of the autonomous portrait is an unmistakable indication of a change in the concept of the self during the 15th century. The continually changing outward appearance of a man becomes an artistic subject and is intended to give immortality to the personality beyond its own lifetime. Albrecht Dürer described this new attitude in the various introductions to his manual on the art of painting, for example: "A painting preserves the image of a man after his death." Here the word "image" means primarily the countenance, as is clear from the inscriptions on many portraits giving the age of the person depicted. When Dürer cited the likeness as a basic justification for the importance of the art of painting, he associated himself with Leon Battista Alberti, who in *De Pictura* claimed the portrait as proof that the efforts required to learn the art of painting are justified: "Painting has the virtue that those who have been dead many centuries still appear to live, so that we look at them again and again with admiration for the painter and with great pleasure for ourselves.... Thus it is certain that the outward appearance of one who has been long dead enjoys a long life through painting." Other references in his own texts make it clear that Dürer had had an opportunity to become familiar with this work of 1435/36 in manuscript, even though it would appear in print only in 1540. After likenesses of individuals had appeared in both Italy and the Netherlands, the autonomous portrait began to make its appearance in Germany as well, from the middle of the 15th century on. It was the citizens of Nuremberg who first seized the opportunity to live on through the portrait. In capturing both the individuality and the character of the man Dürer gave qualities to the portrait that the late medieval likeness had not possessed, or had possessed only as intimation. The change in the concept of man, introduced by Renaissance philosophy, propelled the artists beyond the mere depiction of attributes through the characteristics of physiognomy to conveying a sense of the whole personality through the portrayal of its physical form. Creating a recognizable image through stature and facial features was but an element in the new and enlarged task.

The identifiable living or recently deceased person first entered German art as the picture of the donor, which was an integral part of altarpieces so popular in the late medieval period. Identification of the individual occurred through dedicatory inscriptions or coats of arms, but through the actual physiognomy only from the second half of the 15th century onward. The donor families which Dürer incorporated into the memorial panel for the goldsmith Glimm or in the central picture of the Paumgartner altarpiece correspond to Nuremberg convention (264, 265, 408). The possibility that the portrait would preserve the appearance of a man after his death is an integral part of the concept underlying the incorporation of the donor picture into the salvation scheme. Those represented should be remembered in prayer during their lifetimes and after their deaths; in this fashion their periods of purgatory would be shortened through

222

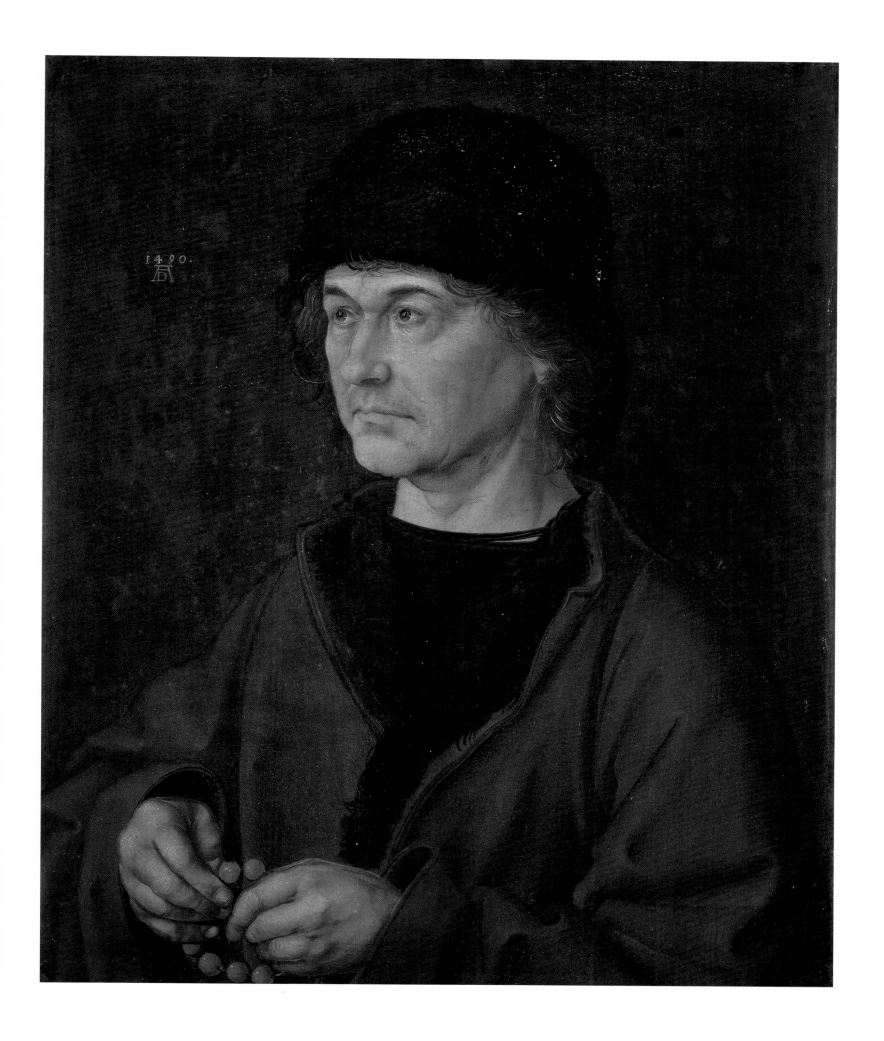

223

224

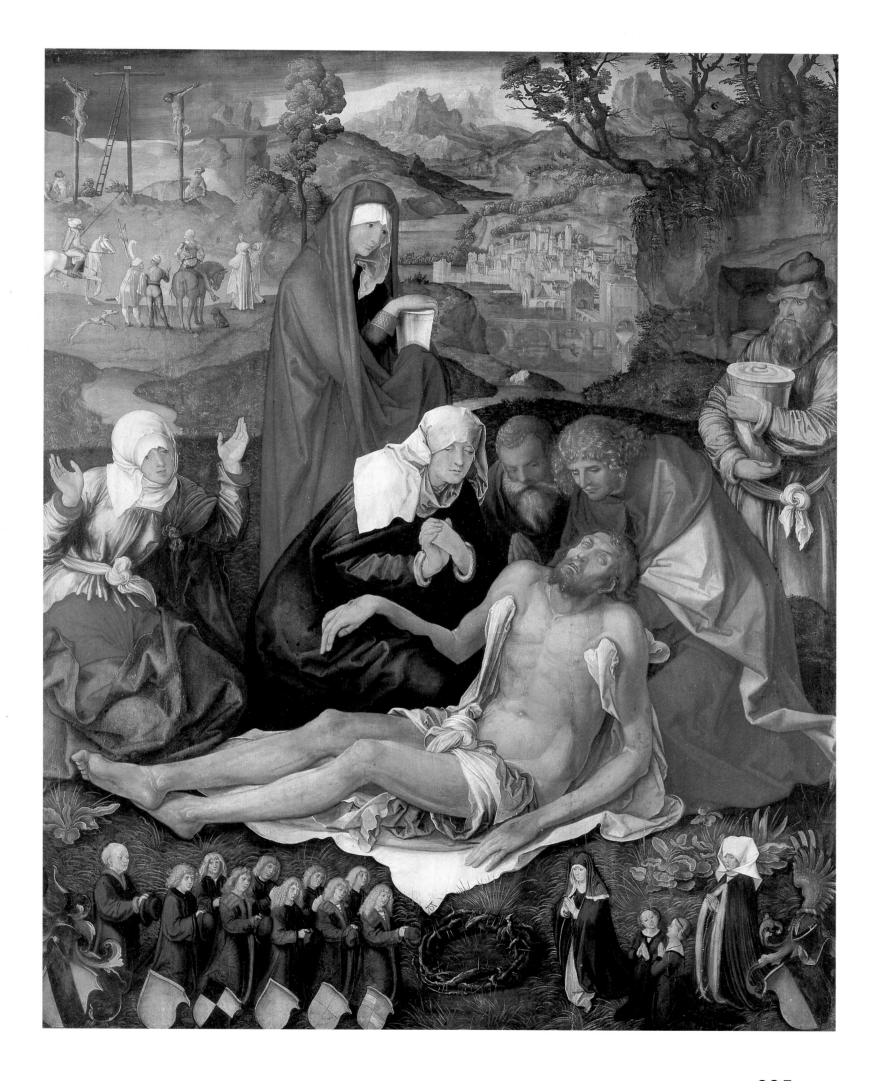

225

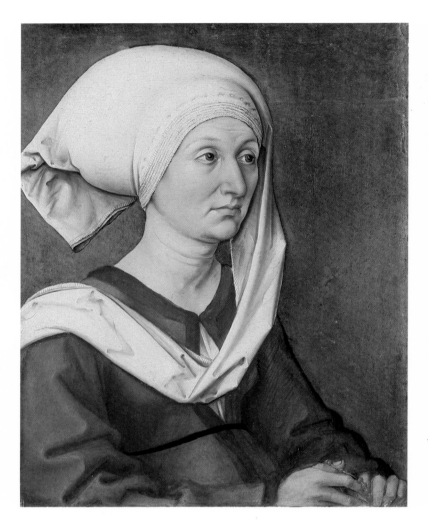
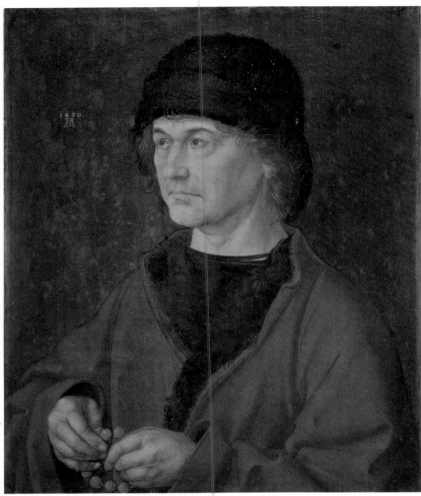

intercession and the use of indulgences. The contrasting view, toward which the portrait moved during the 16th century, was expressed by Eobanus Hesse (50). The professor of Latin and, from 1526 on, instructor in rhetoric and poetry at the Edigien Gymnasium in Nuremberg, in his elegy to Dürer has an observer standing before the painter's likeness say: "Your fame lives and will last forever." The man who conceives of himself as an individual, and wishes to be known as distinct from any other, lives on through the fame of his accomplishments by which he differentiates himself from all others. The craving for fame which outlasts one's short life is one of the most striking characteristics of Renaissance man. The interest of the artist in his own person as well as in other individuals assured the likeness a central position in Dürer's work, assuming equal importance with religious subjects. Portraits appear right at the beginning of Dürer's career as a painter: the likeness of his father (263, 267), the self-portrait of 1493 (19), the portrayals of his Strassburg master and the latter's wife recorded in the Imhoff collection inventory.

After his return from Italy, it was primarily commissions for portraits which Dürer received. The first of these was the Elector Frederick the Wise of Saxony who asked Dürer to paint his portrait during a visit to Nuremberg in 1496 (268). Here for the first time the painter made use of fine canvas without a primer, working only with watercolors with a binder added. It has remained in good condition, without having been spoiled by the addition of a coat of varnish.

266
PORTRAIT OF A WOMAN (BARBARA DÜRER, NEE HOLPER?)
Nuremberg School, c. 1490.
On the verso an old inventory number "19." Oil on coniferous wood, c. 1490. 47 x 36 cm. Nuremberg, Germanisches Nationalmuseum.
Based on the inventory number of the Imhoff collection, L.B. Philip accepts this panel as a likeness of the c. 40-year-old Barbara Dürer, painted by her son — the companion piece to the portrait of Dürer's father (cf. 9, 263, 267). The former owner was sceptical, as evident from Hieronymus Imhoff's entry in his secret inventory: "Many people don't accept it as a work by Dürer himself." In 1630 Elector Maximilian I of Bavaria refused to buy the picture; in 1633 it was sold to Amsterdam.

267
ALBRECHT DÜRER THE ELDER WITH ROSARY
Cf. 9, 263, 266.

226

227

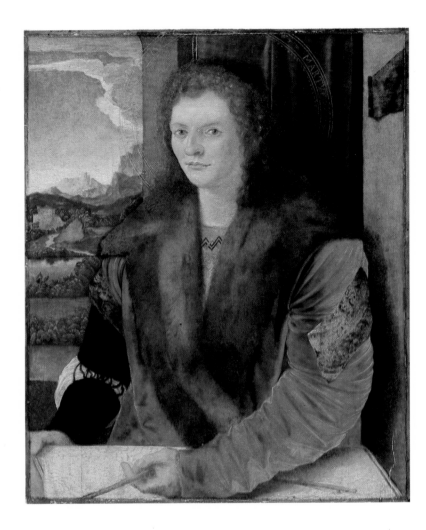

268 ←
ELECTOR FREDERICK THE WISE
The monogram of the artist was probably added later. Watercolor on canvas. 76 x 57 cm. Berlin, Staatliche Museen Preussischer Kulturbesitz, Gemäldegalerie.
Probably produced during the stay of the Elector in Nuremberg, 14-18 April 1496.

269
YOUNG MAN AS ST. SEBASTIAN

The inscription on the cartellino has disappeared. On the subsequently added nimbus: *SANC- TVS SEBASTIANVS - MAR- TY*[R]. Oil on wood. 52 x 40 cm. Bergamo, Accademia Carrara.
Restoration makes judgment of the picture, done c. 1498, diffi- cult. The arrows in the hand of the sitter and on the board are part of the original concept, the nimbus and possibly the green drapery may be later additions.

270
ELSBETH TUCHER
The monogram of the artist is on the left, above the fingers on the balustrade, difficult to make out and probably by another hand. Traces of color under it are probably remnants of the date. Near the upper border by another hand (?): *ELSPET NICLAS TVCHER- IN* [*IN* ligature]. *26 ALT* [ligature] *1499*. In the clasp of the gown the letters *NT* [Niclas Tucherin]. On the scarf covering the cap the letters *MHIMNSK* have defied interpretation. The letters *WW* worked into the shirt. Oil on linden wood, 29 x 23 cm. Cassel, Staatliche Kunstsamm- lungen.

The portrait constitutes the right wing of a diptych whose left wing, with the likeness of the husband, Niclas (1464-1521) has disappeared.

271 →
HANS TUCHER
On the upper border, left, by another hand (?): *Han*[n]*s Tucher. 42iergig. 1499*. Oil on wood. 28 x 24 cm. Formerly Weimar, Schlossmuseum.

On the verso appears the com- bined Tucher-Rieter coat of arms. Hans XI Tucher (1456- 1536) was the senior financial of- ficer of the city of Nuremberg. In 1482 he married Felicitas Rieter (1465/66-1514). Cf. 272.

272 → →
FELICITAS TUCHER, NEE RIETER
On the upper border, right, by another hand (?): *Felitz.han*[n]*s. tucherin.33.Jor.alt.SALVS.1499.* The letters *HT* are worked in the fastening of the gown. Oil on wood. 28 x 24 cm. Formerly Weimar, Schlossmuseum.

With the portrait of the husband (271), this forms a diptych.

This technique does not produce the representative sheen of oils on primed wood. Its special charm lies in the soft, subdued coloring, which laid on but thinly permits the knobbiness of the canvas to con- tribute to the effect. The use of watercolor had an advantage for the prince, whose stay in Nuremberg was short, because it would dry more quickly. The depicted segment is large, set back a bit in com- parison with the self-portrait of 1493, so that the arms, crossed on a horizontal shelf, are not cut off by the frame. A predominantly verti- cal format emphasizes the pronouncedly upright stance of the upper body. The neutral background directs the viewer to the countenance crowned by a high beret and from which wide open eyes stare out. The general scheme that Dürer used in the pose of the model is still

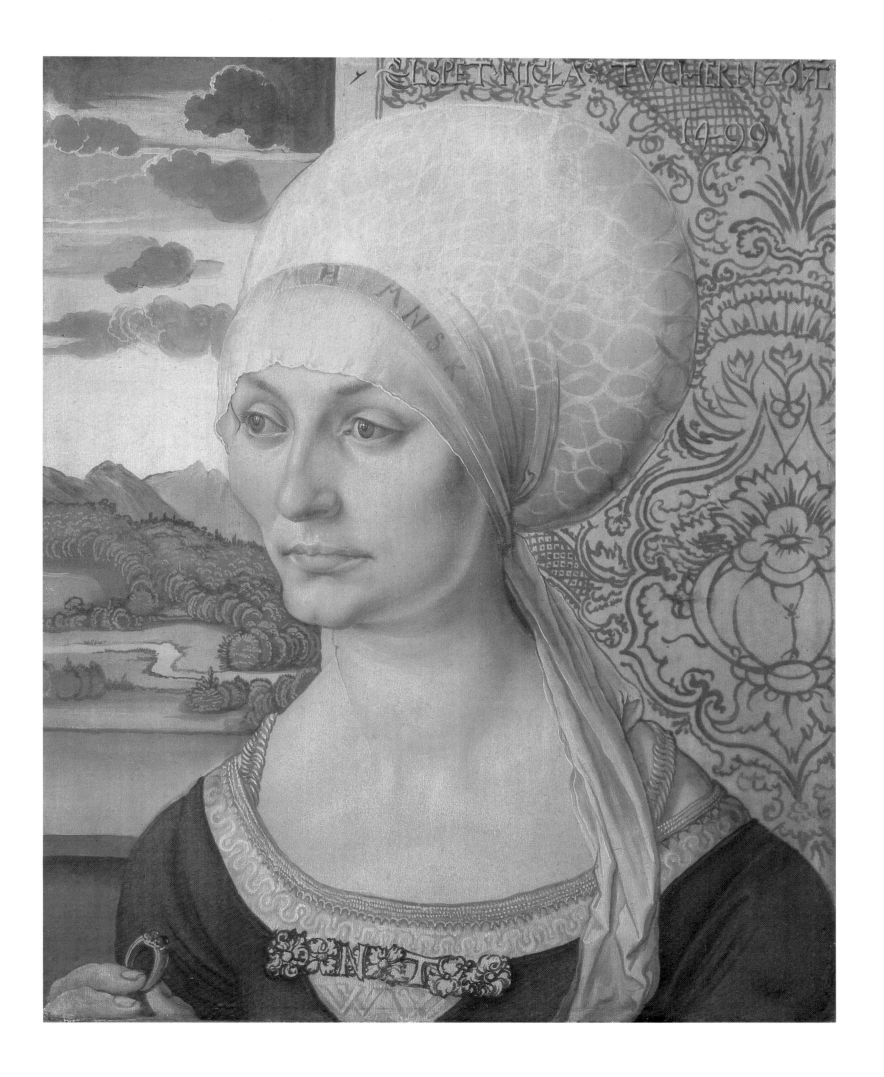

229

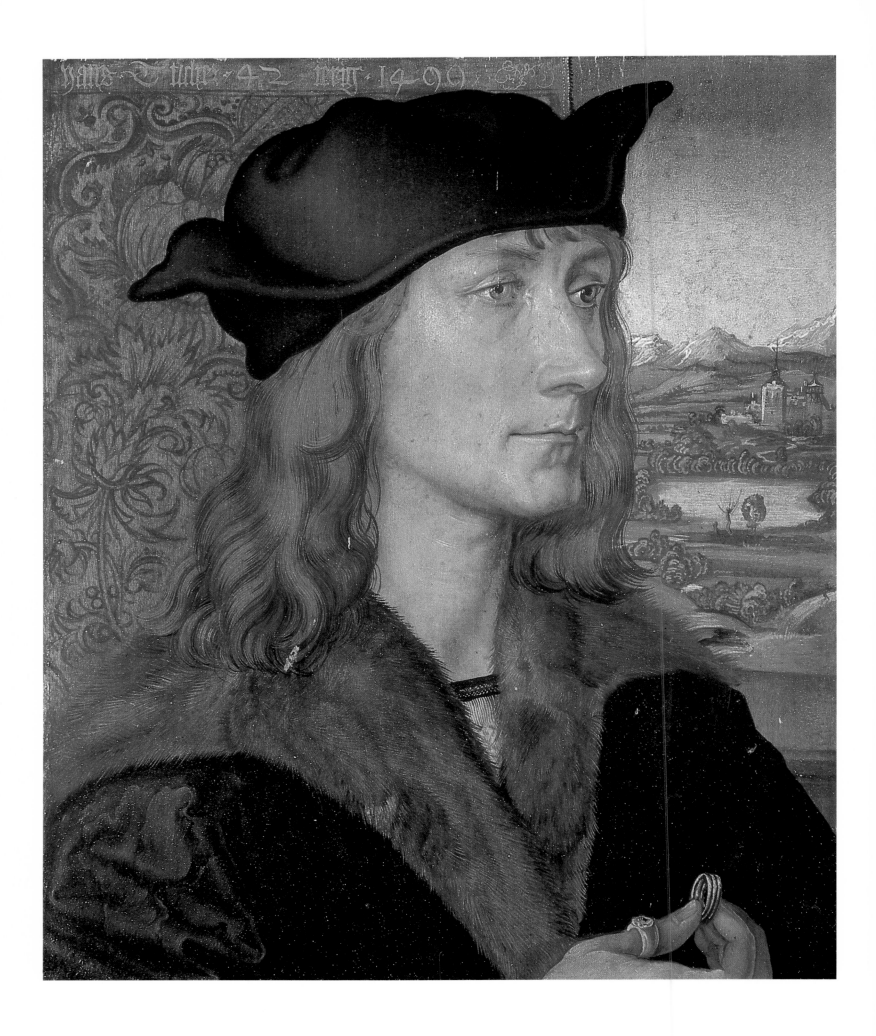

230

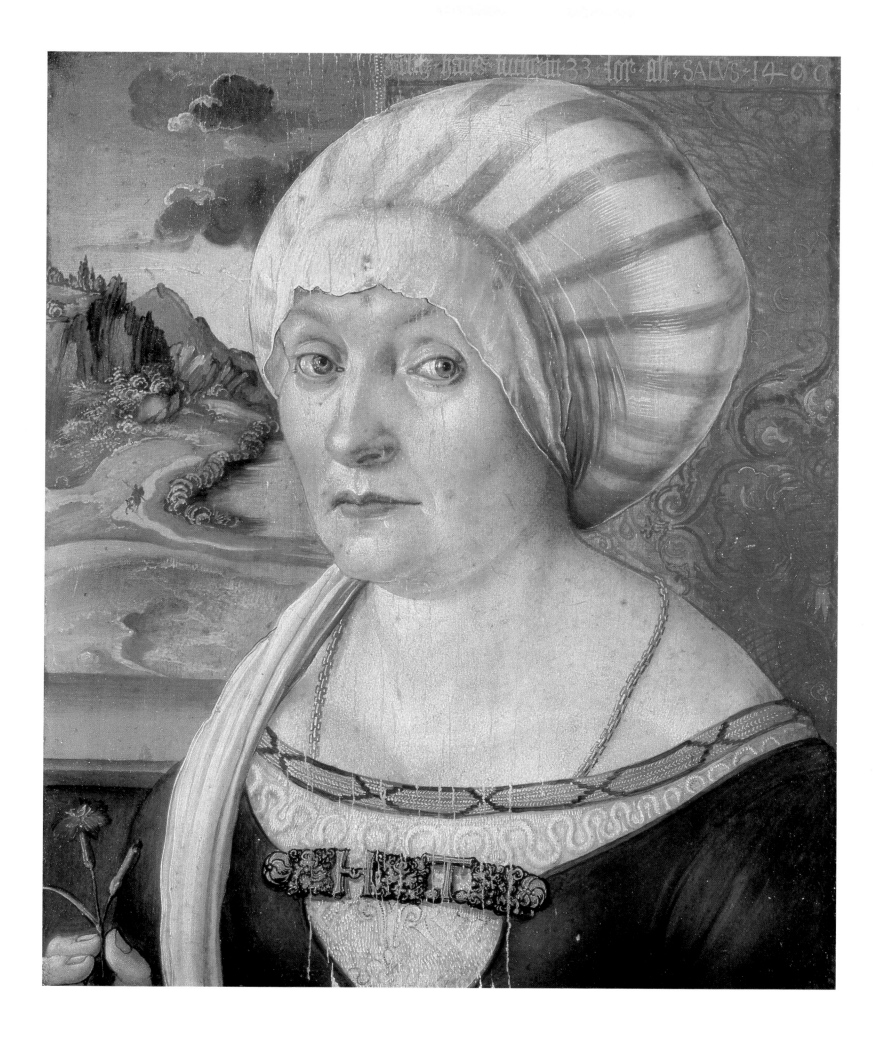

231

the old one that he derived from Hans Pleydenwurff and Michael Wolgemut. What is new is the purpose of this stance, which expresses a lively attentiveness and an assured peace of mind commensurate with the personality of the subject.

The portraits commissioned by Nuremberg citizens followed the example of the Elector. The portraits of two couples from the Tucher family are dated 1499 (270-272). The married pairs were in each case linked in a diptych in which the movable wing to the left, from the viewer's standpoint, contained the likeness of the man and carried, on the reverse side, the coats of arms of the allied families; the portrait of one of the male partners has disappeared. The parties placing the order presumably specified the importance of uniformity of the pairs of pictures, all busts, as well as their positioning in front of a parapet. Behind this in each case the glance is led along the outer margin towards a distant landscape framed by a curtain with a brocade pattern. The link between portrait and landscape is to be found before Dürer in the art of both Italy and the Low Countries, and in the form of a glance through a window even in German art of the 15th century. This scheme, but slightly changed by the use of parapet and curtain, is taken over by Dürer.

If the Tucher portraits appear singularly uninspired, by contrast Dürer's skill in the portrayal of men reached an early peak in his depiction of Oswolt Krel, the Nuremberg representative of the great Ravensburg commercial enterprise (274, 275). The young man, of the same age as Dürer, had, notwithstanding his important position, made the acquaintance of the Nuremberg prison, since he had mocked a citizen of the city in a Mardi Gras game. Perhaps it was simply the personality of the individual portrayed that made his portrait seem so much more decisive than those of the Tucher series. The painter used every means to focus on the figure depicted and in this fashion to enhance his importance. The portrait is more decidedly vertical, the segment of the body depicted larger. On the solid red background, which leaves just a narrow strip for the landscape, appears only the name of the young merchant in large letters and the date 1499. The view into the distance occurs through the grillwork of boles and foliage created by a group of slender trees. It is behind this barrier, which substitutes for a balustrade, that a winding river becomes visible in the distance. The impression made by the figure is enhanced by the plastic modeling of the angular face, from which a sharp glance passes by the viewer to the right. The man knew what he wanted and obviously insisted that this should be evident in his portrait. The incisive demand is emphasized by the aggressive red of the background. In the landscape, painted with the finest coloristic detail, Dürer allowed his accomplishments in the field of watercolor to make a contribution. The red is taken up again as a faint coloring of the sky suggestive of dawn or dusk, while a yellowish light flickers over the foliage of the trees. Two panels are today attached to the portrait as wings. They depict wild men holding coats of arms; originally these probably functioned as a protective cover, also painted by Dürer.

232

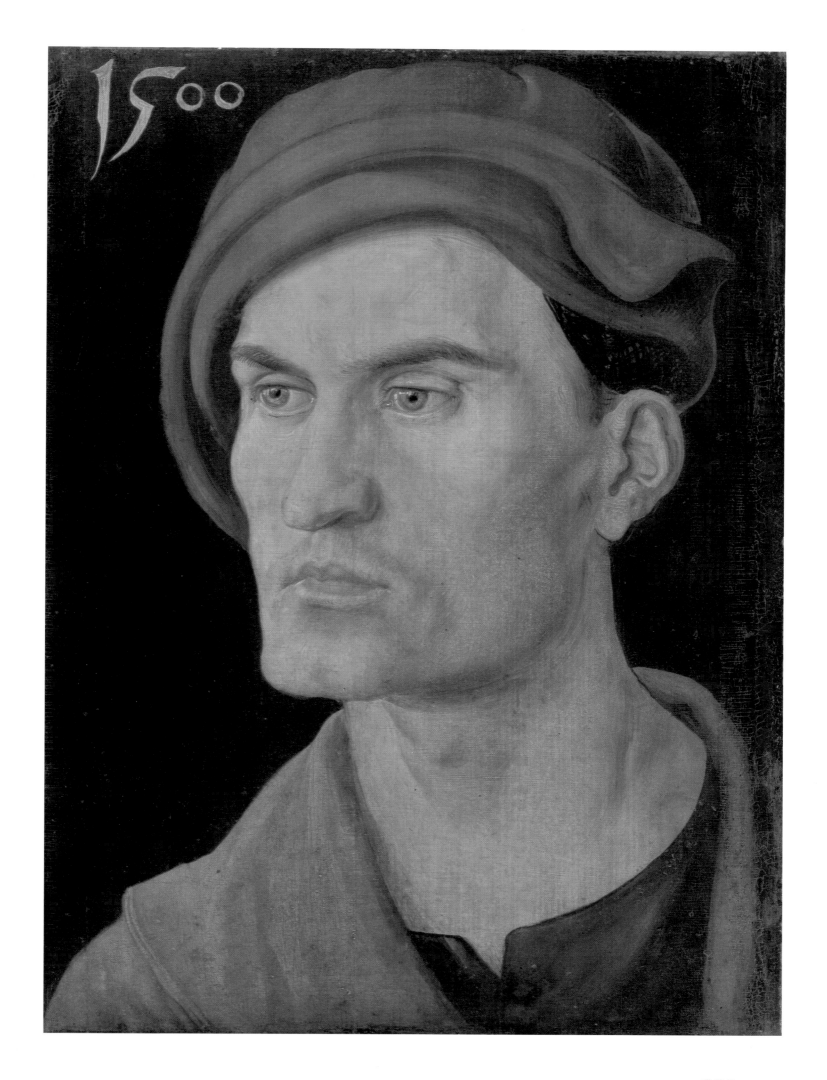

234

OSWOLT·KREL

1499

235

The cubical modeling of face and chin sections lend a similar expression of energy to yet another young man (273). The portion depicted in this small portrait is narrowly defined and is limited to head, neck and right shoulder. In the left corner, remarkably large, is the date 1500. The picture, which since the beginning of the 17th century was part of the famous collection of Paulus Praun in Nuremberg, has been described, with some ambiguity, by earlier writers as a portrait of one of the painter's brothers named Hans. He might be the Hans Dürer who was enrolled in the Nuremberg tailor's guild in 1507.

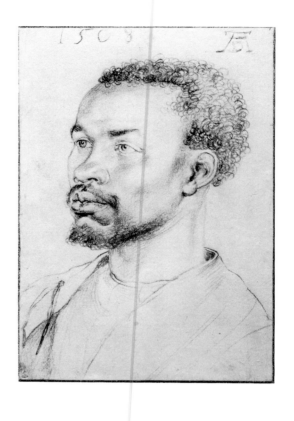

Commissions for altarpieces and the preparation of prints reduced Dürer's attention to portraits in the first years of the new century. By contrast, during his second stay in Venice, commissioned portraits helped to defray his living expenses (129, 131, 132, 279-281). The old approach characteristic of the Nuremberg School was abandoned in the portraits produced in the years 1505-06. Dürer chose the bust as the portion to depict, turned slightly to one side. The landscapes, balustrades and drapes have disappeared from the background, making easier a uniform execution of the color. Even the intense concentration of the person portrayed on the beholder has given way to an expression of greater relaxation, without losing the impression of individuality. In these portraits it is clear that Dürer had come to be familiar with the Venetian color technique and had incorporated it into his own. Soft light and transparent shadows determine the forms of the faces, though they appear more forceful than those painted by Italian artists. The capabilities of the German were without doubt recognized by his contemporaries who wished to be portrayed with that special life-likeness.

276
BUST OF A NEGRO
With a spurious (?) date 1508 in brown charcoal and the monogram of the artist. Charcoal on paper. 320 x 218 mm. Vienna, Graphische Sammlung Albertina.

Since the dating does not seem to be entirely reliable, the sheet may have been done any time from Dürer's stay in Venice 1505/07, where an encounter with a Negro would have been most likely, to 1515.

277
YOUNG WOMAN WITH BOUND HAIR (KATHARINA FREY?)
The inscription on the cartellino can no longer be read. Below it is

the coat of arms of the Fürleger family of Nuremberg. Oil on canvas. 55 x 42 cm. Berlin-Dahlem, Staatliche Museen Preussischer Kulturbesitz, Geläldegalerie.

The painting was for a long time in the collection of the Paris banker Leopold Goldschmidt. It was acquired by Berlin in 1977. A second version, painted on linden wood, and likewise regarded as a Dürer original, was transferred in 1945 from the Speck von Sternburg Collection to the Leipzig Museum der Bildenden Künste. The legible inscription on that painting reads: "This is my likeness at age 18, 1497." The Fürleger coat of arms is absent. Since the information on age cannot be related to any member of the Fürleger family,

Agnes Dürer's sister, Katharina Frey, has been suggested as the sitter, because of a facial resemblance.

278 ⟶
YOUNG WOMAN WITH A RED BERET
With the date 1507 and the monogram of the artist. Oil on vellum, mounted on wood. 30.4 x 20 cm. Berlin-Dahlem, Staatliche Museen Preussischer Kulturbesitz, Gemäldegalerie.

279 ⟶ ⟶
PORTRAIT OF A YOUNG MAN
Inscribed: *Albert*[us] *dürer german*[us] *faciebat post Virginis partu*[m] *1506*; next to it the monogram of the artist. Oil on wood. 46 x 35 cm. Genoa, Galleria di Palazzo Rosso.

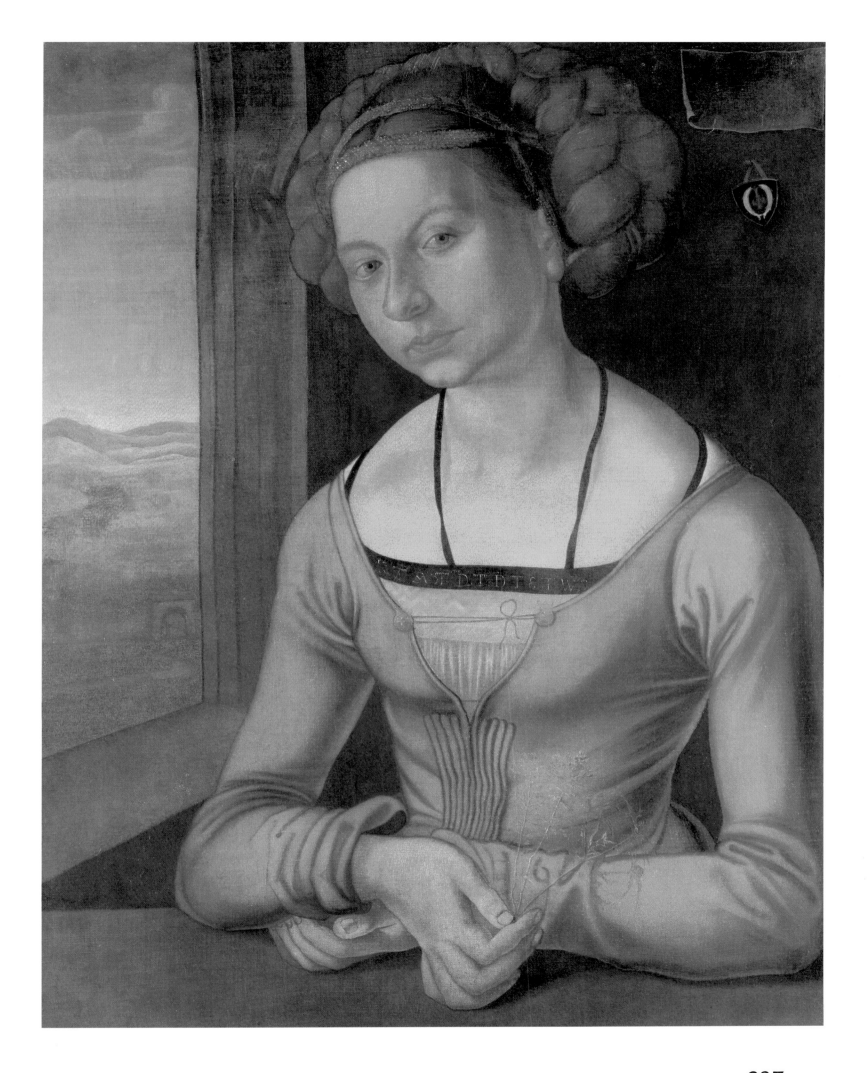

237

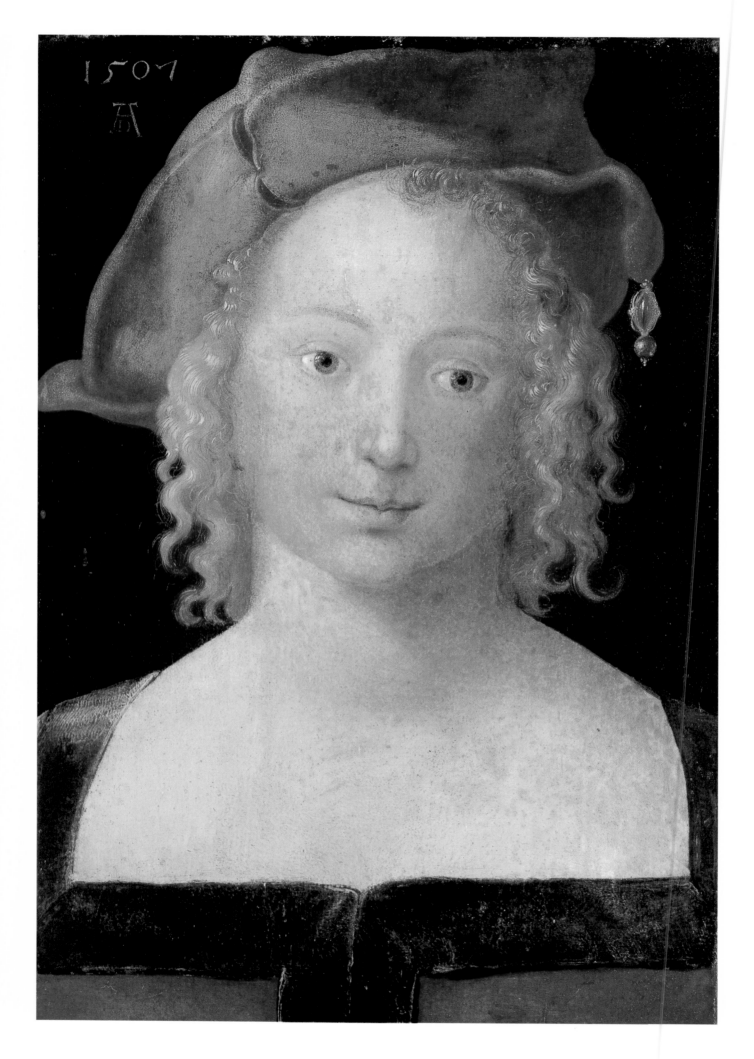

238

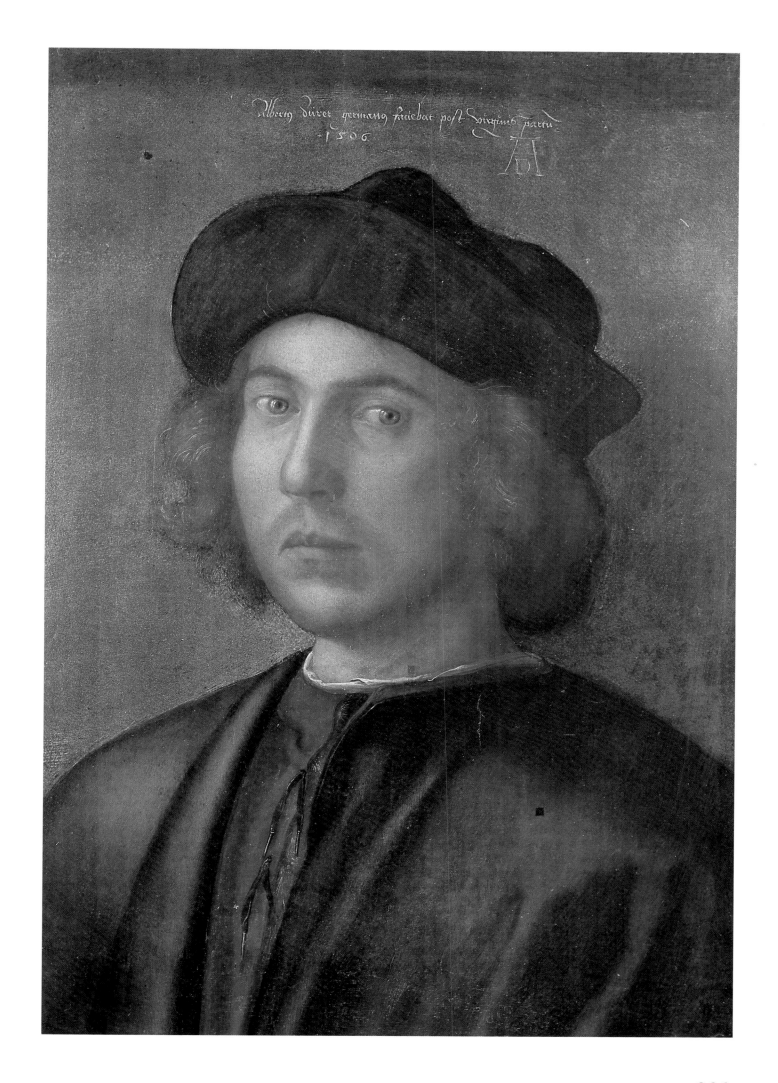

239

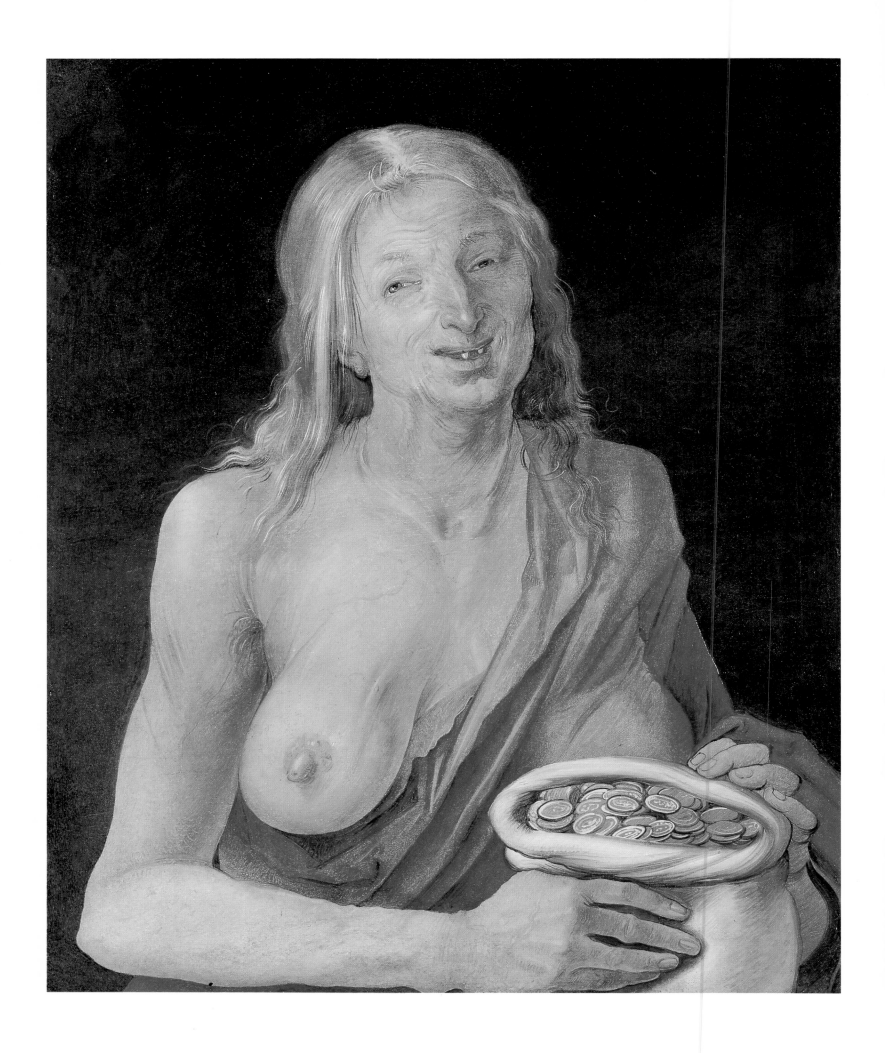

240

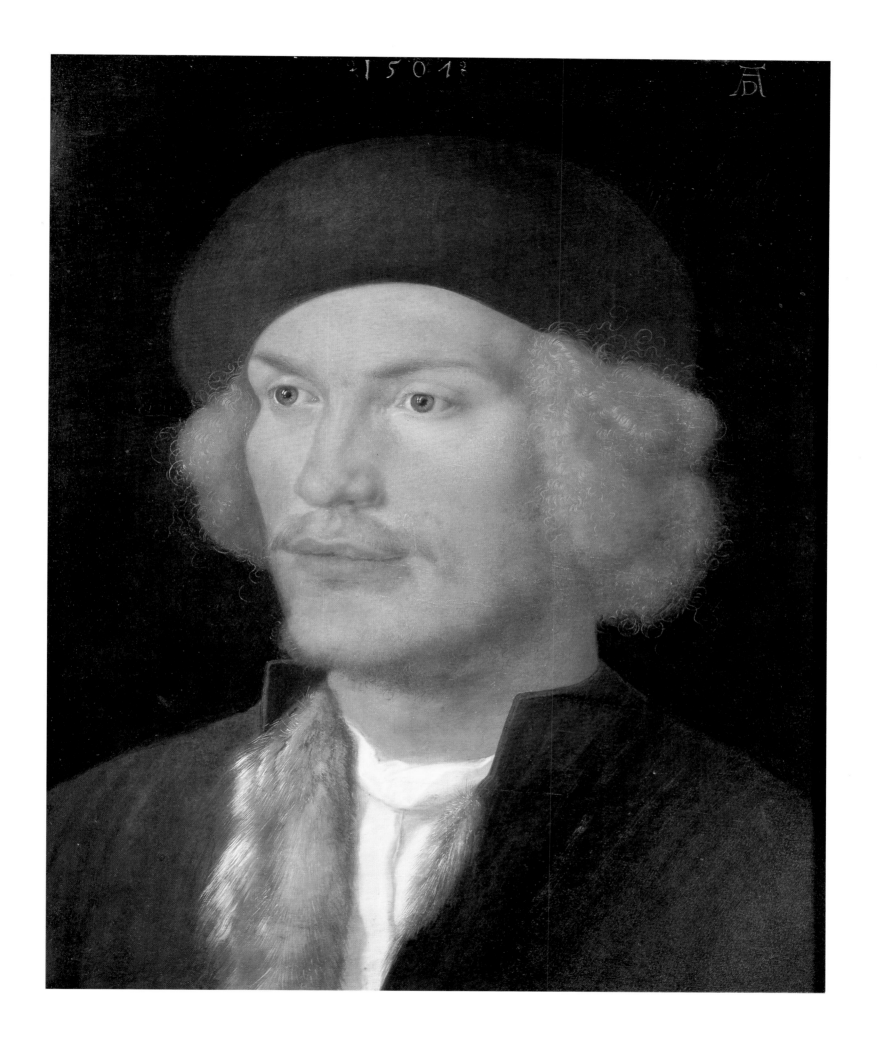

241

Two likenesses of 1516 have survived, showing the changes introduced by Dürer into his portrait style ten years after his return from Venice (283, 284). The painterly effect has receded, as in his other work of this period. The protuberances and indentations of the face are outlined with the brush as the painter attempts to penetrate ever deeper into the personality of his subject. The most beautiful of these efforts is the portrait of his teacher Michael Wolgemut, painted for himself rather than on commission, as becomes clear from the inscription at the top: "This portrait was done by Albrecht Dürer of his teacher, Michael Wolgemut in [the year] 1516." When the latter died three years later Dürer added: "and he was 82 years old and lived till one counted the 1519th year, he died on St. Andrew's day, early, before sunrise." Wolgemut is pictured, as was customary for portraits, in distinguished attire, a fur-trimmed tunic. The painter left him the kerchief wound around his forehead that he was accustomed to wear in the workshop as protection against color sprays. Dürer's brush spared nothing in depicting all the signs of age, with the result that the untroubled, sharp and directed look has a yet more profound effect. The portrait is the first picture of a painter in oil that is not a self-portrait.

At the Augsburg Diet of 1518, to which the painter accompanied the Nuremberg delegation, Dürer was able to draw not just Emperor Maximilian I (78), but also several other important personages, among them the Augsburg financier and merchant trader Jakob Fugger. Fugger's financial resources had played a major role in securing the election of Maximilian's grandson, Charles, as King of Rome. A charcoal drawing from life (Berlin-Dahlem, Staatliche Museen Preussischer Kulturbesitz, Kupferstichkabinett) provided the basis for a portrait which in its representational effect is enhanced by the substitution of a richly fur-lined tunic for the everyday clothing of the drawing (282). Only the likeness of Fugger created by Dürer — there are also portraits by Hans Holbein the Elder and by Hans Burgkmair — singles out the merchant from the rest of the commercial world as someone special, the "royal merchant." Besides the surviving portrait on fine canvas, a final version in oil on wood probably did exist, since two extant copies reveal the same significant differences in the garb as compared with the surviving canvas.

280 ← ←
OLD WOMAN WITH BAG OF COINS (VANITY)
Oil on linden wood. 35 x 29 cm. Vienna, Kunsthistorisches Museum.

Verso of the portrait of a young man (281). It is probably meant to represent Vanity. The prosperous subject on the recto avows the worthlessness of earthly goods.

281 ←
PORTRAIT OF A YOUNG MAN
With the date 1507, and the monogram of the artist. Oil on linden wood. 35 x 29 cm. Vienna, Kunsthistorisches Museum.

On the verso appears an old, half-naked woman with a bag of coins (280). The linden wood panel suggests that it was painted in Nuremberg in the year after Dürer's return from Venice. Anzelewsky surmises that it once

formed part of a diptych whose female counterpart is lost.

282
JAKOB FUGGER THE RICH
Oil on canvas, glued to a softwood panel. The monogram of the artist is by another hand. Dated 1500. 69.4 x 53 cm. Augsburg, Staatsgalerie.

A charcoal drawing from life that Dürer did during the meeting of the Diet at Augsburg in 1518 (Berlin-Dahlem, Kupferstichkabinett) was used for this portrait. A copy, dated 1520, with differences suggests that another version by Dürer carried that date.

283 →
MICHAEL WOLGEMUT
With the monogram of the artist and the date 1516, corrected from 1506. Inscribed: "This portrait was done by Albrecht Dürer of his teacher, Michael Wolgemut, in [the year] 1516." Later added by Dürer: "and he was 82 years old and lived till one counted the 1519th year, he died on St. Andrew's day, before sunrise." Oil on linden wood. 29 x 27 cm. Nuremberg, Germanisches Nationalmuseum.

Albrecht Dürer served as an apprentice in Michael Wolgemut's workshop from 30 November 1486 till the end of 1489. Wolgemut lived from 1434 or 1437 until 1519.

284 → →
PORTRAIT OF A CLERGYMAN
With the date 1516, and the monogram of the artist. Oil on vellum, mounted on wood. 41.5 x 33 cm. Washington, National Gallery.

The identification of the subject as Johann Dorsch, the first Protestant minister of Schwabach, near Nuremberg, rests on a description of 1778, when the picture was in the the Praun collection, and is not certain. From 1528 to 1541, he served as minister of St. John's in Nuremberg.

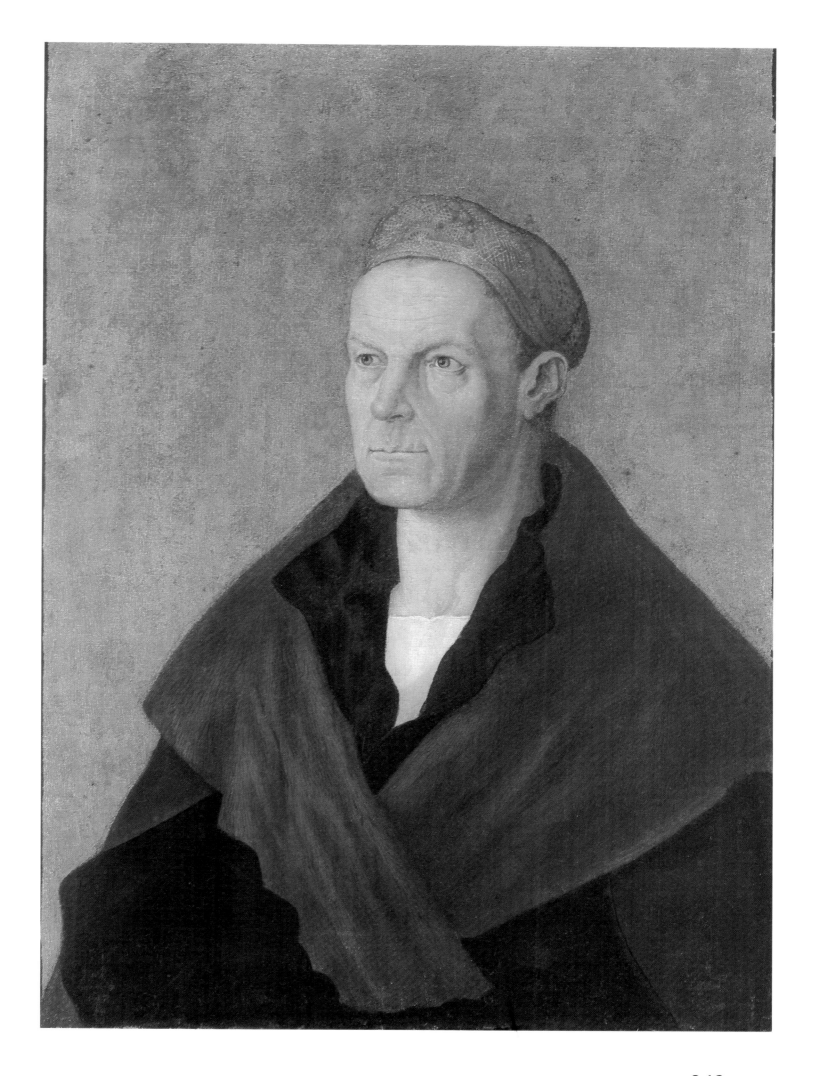

243

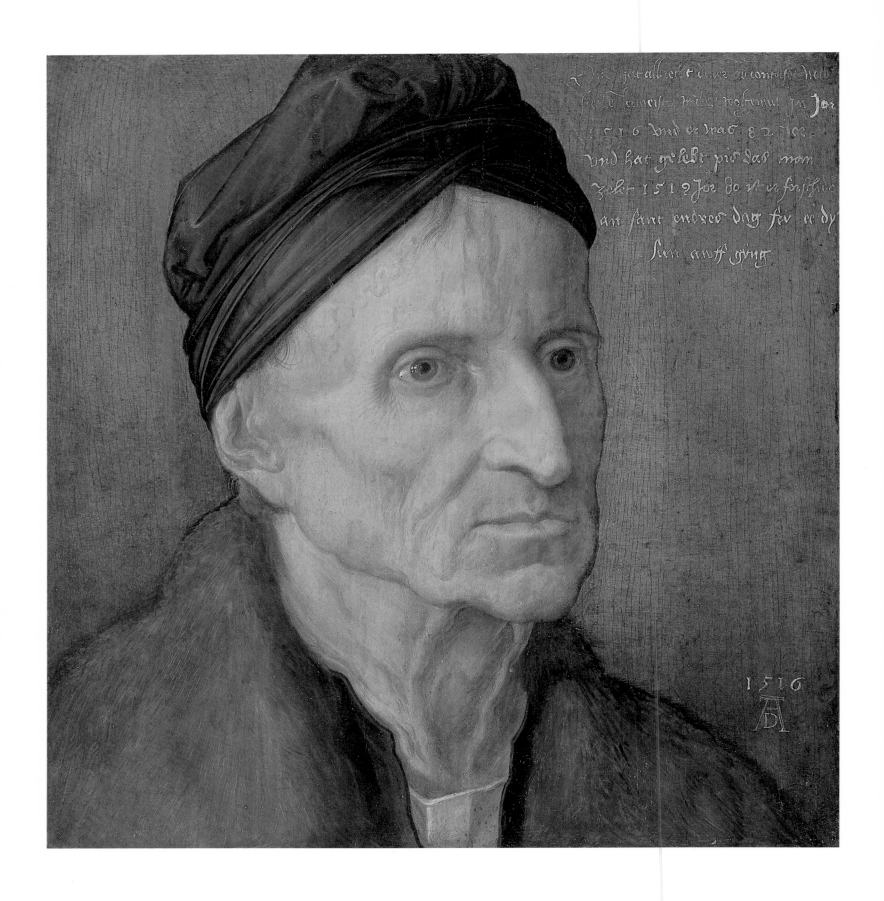

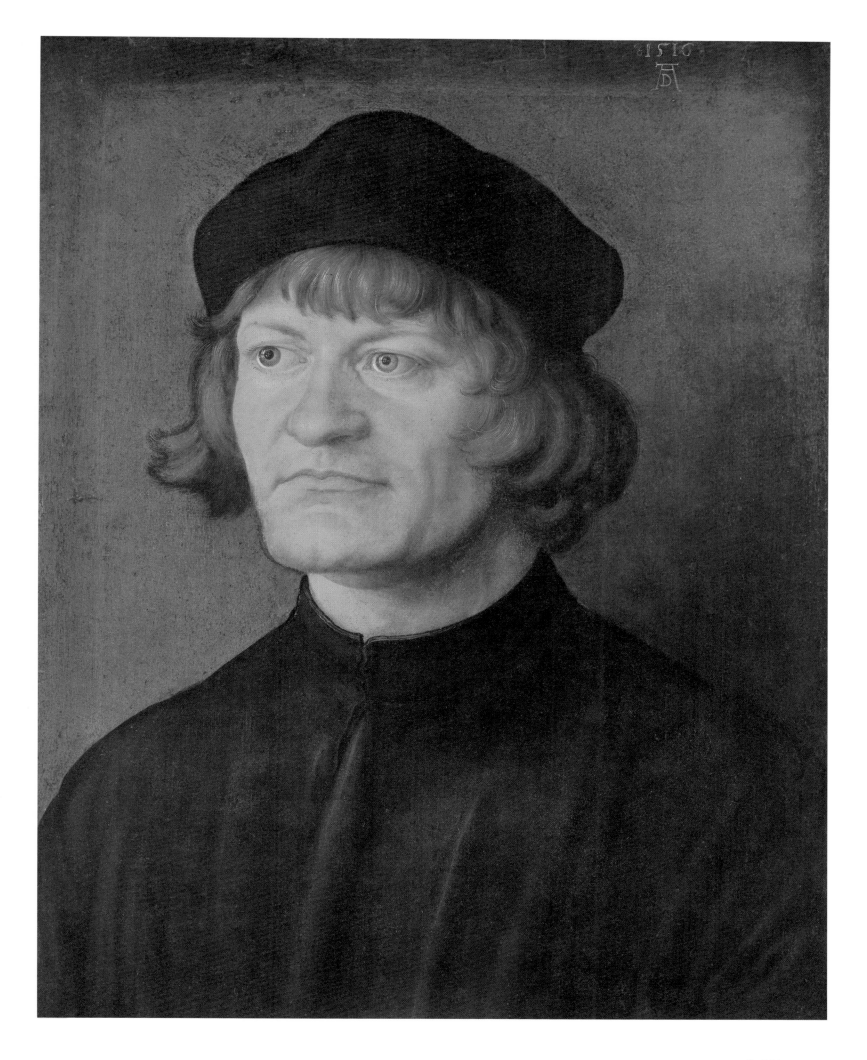

245

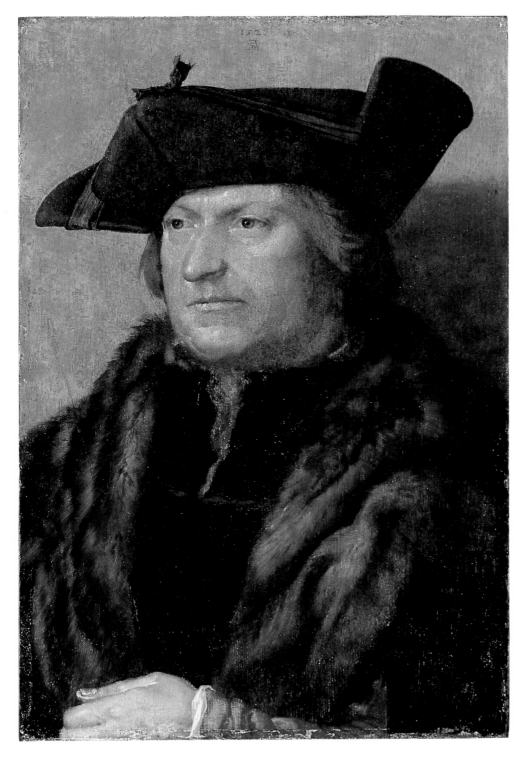

The visit to the Low Countries in 1520/21 brought the painter in touch with new approaches to the portrait and produced a change in style. Besides the signed drawings which served as bases for finished painted portraits, he had begun as early as 1503 to produce likenesses with soft charcoal or chalk pencil, likenesses which were signed and dated and meant to be autonomous works of art (276, 286, 288). This medium was unusually well suited for achieving in black and white the goal that Dürer had aimed for in color since 1506. During his stay in the Netherlands the lack of a local studio combined with the great number of requests for likenesses had compelled the painter to substitute drawings for paintings on canvas or

285
PORTRAIT OF A MAN (RODRIGO FERNANDEZ D'ALMADA)
With the monogram of the artist and the date 1521. Oil on oak. 50 x 32 cm. Boston, Isabella Stewart Gardner Museum.

The picture, which is in a good state of preservation, was probably done in the Netherlands. Following various attempts to identify the subject from the entries in the diary, Grote asserts that it corresponds to the brush drawing (157) supposedly of Rodrigo Fernandez d'Almada. The person in the drawing, however, seems to be considerably younger.

286
LIKENESS OF A YOUNG GIRL
With the date 1515 and the monogram of the artist. Charcoal drawing on paper. 423 x 294 mm. Stockholm, Nationalmuseum.

A certain relationship to the Virgin in Dürer's "St. Anne with the Virgin and the Infant Christ" (33), done around 1519 and now in New York, has led to the supposition that the artist used the drawing as a basis for the picture on canvas.

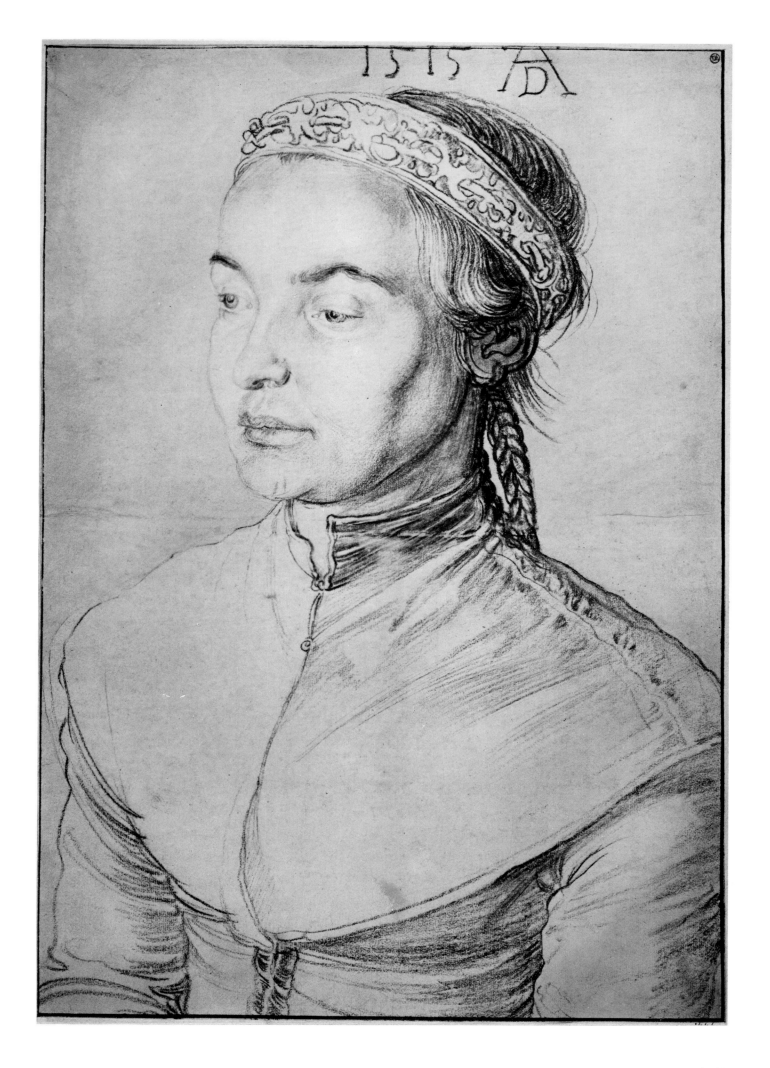

247

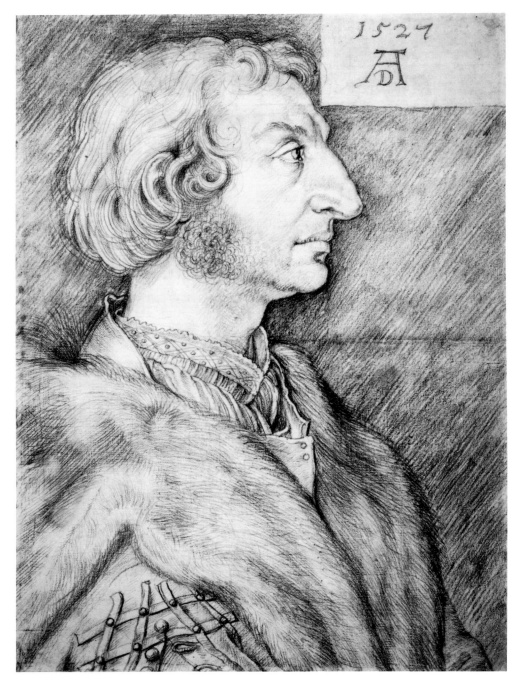

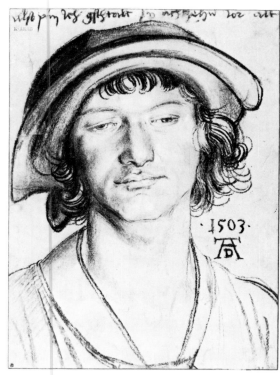

287
ULRICH STARK
The monogram of the artist and
the date 1527 are placed in a
separate rectangle, top right.
Drawing in black chalk on paper.
407 x 297 mm. London, British
Museum.

288
YOUNG MAN WITH A CAP
With the monogram of the artist
and the date 1503. Inscribed
vigorously in charcoal: "Thus I
looked at age 18." Drawing in
charcoal or black chalk on paper,
mounted on brown paper. 298 x
215 mm. Vienna, Kupferstich-
kabinett der Akademie der Bil-
denden Künste.

*One of the first likenesses done
by Dürer in the soft medium of
charcoal or black chalk. Signa-
ture and inscription mark the
drawing as an autonomous
work, not intended to be con-
verted into another medium.*

wood, and these drawings acquired, through their careful execu-
tion, the character of complete and final works of art (156). Nota-
tions in his diary and surviving portraits reveal that Dürer drew
likenesses of men of the most varied professions among the upper
classes of the artistic and commercial world. Besides these there are
sheets like the portrait of the negro woman who worked for the Por-
tuguese factor, Joao Brandao, depictions which reflect the personal
interest of the artist in the subject (289). Only two painted portraits
have come down to us from Dürer's stay in the Netherlands (160,
285). The diary speaks of another, of the fleeing Danish King Chris-
tian. To produce that painting the artist required the help of an un-
named colleague in Brussels whose apprentice Bartholomew rubbed
the colors. Dürer expressed his thanks with a tip and a set of the

248

289

THE NEGRESS KATHARINA
Inscribed: "Katharina, 20 years old," with the date 1521 and the monogram of the artist. Silverpoint on paper. 200 x 140 mm. Florence, Galleria degli Uffizi, Gabinetto Disegni e Stampe.

The subject is identified by an entry in Dürer's diary between 16 March and 6 April 1521: "I have drawn the factor, Brandao, writing, in charcoal. I have drawn his negress in [silver] point." Joao Brandao was the Portuguese consul at Antwerp 1514-1521.

290

THE PAINTER LUCAS VAN LEYDEN
With the monogram of the artist. Silverpoint on paper. 244 x 171 mm. Lille, Musée des Beaux Arts.

Dürer did this portrait of Lucas van Leyden (1494-1533) at the beginning of June, 1521. He noted in his diary: "Master Lucas has invited me to be his guest. He does engravings and is a little man, born in Leyden, in Holland, but he was in Antwerp."

291

AGNES DÜRER IN NETHERLANDISH COSTUME

Near the upper border: "Albrecht Dürer painted this picture of his wife at Antwerp, wearing the costume of the Low Countries, in the year 1521, having been married 27 years." Drawing in brown metalpoint on dark violet prepared paper. 407 x 271 mm. Berlin-Dahlem, Staatliche Museen Preussischer Kulturbesitz, Kupferstichkabinett.

The drawing was probably done on 7 July, their wedding anniversary, in Brussels, shortly before they started on the journey home on 12 July.

woodcut cycle "The Life of the Virgin." It is less significant for the pictorial effect of the portraits done during this journey that Dürer depicted the body portion customary in the Netherlands, including the hands, as that he felt himself in essential communication with his artistic surroundings, the works of the old masters encountered in churches and city halls, as well as the achievements of the living masters whom he came to know personally. The portrait of Bernhard von Reesen in Dresden is clear evidence of the reawakening, in the Netherlands, of potentialities developed as early as 1506 in Italy but since then suppressed (160).

249

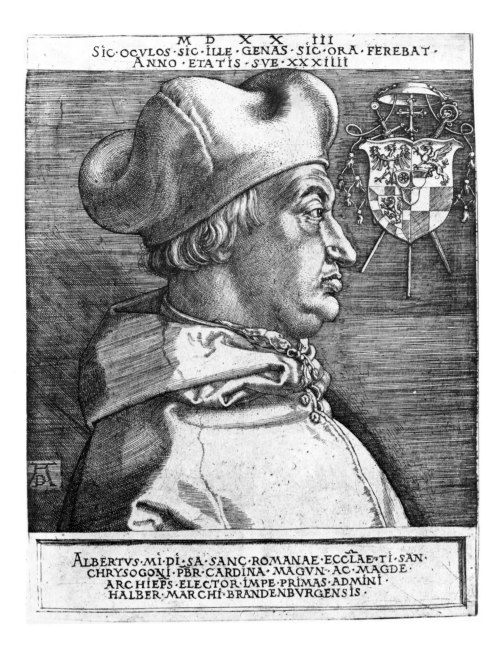

MDXX iii
SIC·OCVLOS·SIC·ILLE·GENAS·SIC·ORA·FEREBAT·
ANNO·ETATIS·SVE·XXXiiii

ALBERTVS·MI·DI·SA·SANC·ROMANAE·ECCLAE·TI·SAN·
CHRYSOGONI·PBR·CARDINA·MAGVN·AC·MAGDE·
ARCHIEPS·ELECTOR·IMPE·PRIMAS·ADMINI·
HALBER·MARCHI·BRANDENBVRGENSIS·

Beginning with the woodcut production of a portrait of the recently deceased Emperor Maximilian I, issued in 1519, Dürer linked the creation of portraits to the printing press, a practice in which Lucas Cranach had preceded him. Among those whose portraits enjoyed wide distribution because they were printed were, besides a number of ecclesiastical and secular princes, Erasmus of Rotterdam, Philip Melanchthon and Willibald Pirckheimer, each an outstanding representative of the world of science and theology (25, 49, 79). Martin Luther is missing, although Dürer would gladly have done his portrait, as he wrote to George Spalatin in 1520: "and if God will but help me to meet Dr. Martin Luther, I will diligently draw his likeness for an engraving, so as to keep long alive the memory of this Christian man, who has helped me in moments of great anxiety." Thus the engraved portraits were to be memorial portraits, a concept perhaps subconsciously related to the underlying religious and intercessional function of the earlier donor portraits, even though the engraved portraits were first and foremost memorials, serving

292
CARDINAL ALBRECHT OF BRANDENBURG IN PROFILE: THE GREAT CARDINAL
With the monogram of the artist and the coat of arms of the subject. Above the picture on a white strip: *MDXXIII / SIC. OCVLOS. SIC. ILLE. GENAS. SIC. ORA. FEREBAT. / ANNO. ETATIS. SVE. XXXIIII.* Below on a framed tablet a title corresponding to the earlier engraving, 293. Engraving. 174 x 120 mm.

Five hundred impressions of this engraving were sent to the Cardinal with the copper plate. The artist had made a new drawing of the Cardinal from life in silverpoint (Paris, Louvre; Strauss, Drawings, 1523/6) during the latter's stay in Nuremberg for the meeting of the Imperial Diet during April 1522 and from November 1522 to February 1523.

293 →
CARDINAL ALBRECHT OF BRANDENBURG: THE SMALL CARDINAL
With the monogram of the artist. In the upper left, under the cardinal's hat, appears the coat of arms of the subject, with sword, cross and staff, denoting the secular and spiritual power. Next to it is the inscription: *ALBERTVS.MI*[sericordia]. *D*[e]*I. SA*[cro]. *SANC*[tae]. / *ROMANAE. ECCL*[esi]*AE. TI*[tuli]. *SAN*[cti]. / *CHRYSOGONI. P*[res]*B*[ite]*R. CARDINA*[lis]. / *MAGVN* [tinensis]. *AC. MAGDE* [burgensis]. *ARCHI=* / *EP*[iscopu]*S. ELECTOR. IMPE*[rii]. *PRIMAS / ADMINI* [strator]. *HALBER*[stadensis]. *MARCHI*[o]. *BRANDEN-BVRGENSIS* [Albrecht, through God's grace Presbyter Cardinal of the Holy Roman Church, titular biship of St. Chrysogonos, Archbishop of Mainz and Magdeburg, Elector, Primate of the Empire, Administrator of (the Bishopric of) Halberstadt, Margrave of Brandenburg]. Below the bust: *SIC. OCVLOS. SIC. ILLE. GENAS. SIC. / ORA.*

250

FEREBAT. / ANNO. ETATIS.
SVE. XXIX / MDXIX [Thus were
his eyes, his cheeks and his
features at age 29, 1519]. Engraving. 146 x 96 mm.

*In 1520 Dürer sent the Cardinal
two hundred impressions and the
plate of this portrait. The preparatory drawing, in mirror image
based on the Viennese portrait
(294), was in Bremen until World
War II (Strauss, Drawings,
1519/3).*

294
CARDINAL ALBRECHT OF BRANDENBURG
Dürer's monogram, now scarcely
discernible, appears twice. Chalk
on paper. 428 x 323 mm. Vienna,
Graphische Sammlung Albertina.

*Dürer drew Cardinal Albrecht
(1490-1545) at the time of the
Augsburg Diet, and converted
the likeness into an engraving in
1519 (cf. 293).*

to perpetuate the importance of those depicted. This interpretation of the portraits was made clear by Dürer, in that he produced them after the fashion of Roman memorial tablets, and also used classical expressions in the inscriptions. A stone tablet surrounded by a border below the bust portrait of Pirckheimer (25) bears the inscription, *VIVITVR INGENIO CAETERA MORTIS ERVNT* [The mind endures, nothing else is immortal]. It is no longer the Christian soul that endures, but the creative spirit through its achievements and the fame of its deeds. In his engraved likeness of the Elector Frederick the Wise (298) Dürer came so close to the Roman tombstone and its inscription that without knowledge of it the abbreviations cannot be deciphered: *B*[ene] *M*[erenti] *F*[ecit] *V*[ivus] *V*[ivo] [(Albrecht Dürer) erected (this monument) to this most worthy man as a living man to the living]. The painter produced this memorial for his oldest benefactor — the first to give him a commission — in the Roman fashion, while the latter still lived. In this he succeeded in one of the major efforts of the humanists, endeavoring to infuse Christian meaning into classical form, and give it artistic quality.

295
ULRICH VARNBÜHLER
On top, on a strip above the likeness: *VLRICHVS VARNBVLER ETC*[etera] *M.DXXII.* On the right appears an insert whose inscription is partly obscured by the band of a letter holder, as customary in counting houses; filling in the gaps it reads: *Albertus Dürer Noric*[u]*s, hac imagine, Vlrichum cognom*[en]*to / Varnbuler, Ro*[mani] *Caesarei Regiminis / in Imperio, a secretis, simul*[ar]*chi / gramateum, vt quem amet / vnice, etiam posteritati*[e]*t / cognitum reddere c*[olere]*que conatur* [With this likeness Albrecht Dürer of Nuremberg wishes to both honor and make known to posterity Ulrich surnamed Varnbühler, Principal Confidential Secretary of the Imperial Roman Government, and his dearest friend]. Woodcut. 437 x 326 mm. (Cf. 296.)

296
ULRICH VARNBÜHLER
Drawing in black and brown chalk on paper. 415 x 320 mm. Vienna, Graphische Sammlung Albertina.

Dürer converted this drawing into the woodcut dated 1522 (295). The sitter was Imperial Counselor and Protonotary, and later Chancellor of the Supreme Imperial Tribunal. Since 1515 he had been a friend of Dürer and Willibald Pirckheimer.

297
FREDERICK II, COUNT PALATINE
With date, 1523, and the monogram of the artist. Silverpoint on prepared paper. 164 x 117 mm. London, British Museum.

Frederick II, Count Palatinate (1482-1556) was presiding officer of the Supreme Imperial Tribunal in Nuremberg 1521-23.

298
ELECTOR FREDERICK THE WISE
With the monogram of the artist in mirror image and the coat of arms of Electoral Saxony. Below on a framed tablet: *CHRISTO. SACRVM./ILLE.DEI VERBO MAGNA PIETATE.FAVEBAT. / PERPETVA.DIGNVS.POSTERITATE.COLI./D*[omino] *FRID*[e]*R*[ico].*DVCI. SAXON*[iae].*S*[acri]*R*[omani] *IMP*[erii]. */ ARCHIM*[areschallo] *ELECTORI. / ALBERTVS. DVRER.NVR*[imbergensis]. *FACIEBAT. / B*[ene].*M*[erenti]. *F*[ecit].*V*[ivus].*V*[ivo], *M.D.XXIII* [Sacred to Christ. He favored the word of God with great piety, worthy to be revered by posterity forever. Albrecht Dürer of Nuremberg made this for Duke Frederick of Saxony, Arch-Marshal and Elector of the Holy Roman Empire. Erected to this most worthy man as a living man to the living. 1524]. Engraving. 192 x 127 mm.

The inscription is patterned after that on Roman memorial tablets, often erected during the lifetime of the possessor. The Elector (1463-1525) was the first great patron of the artist. The relationship continued until the end of his life.

254

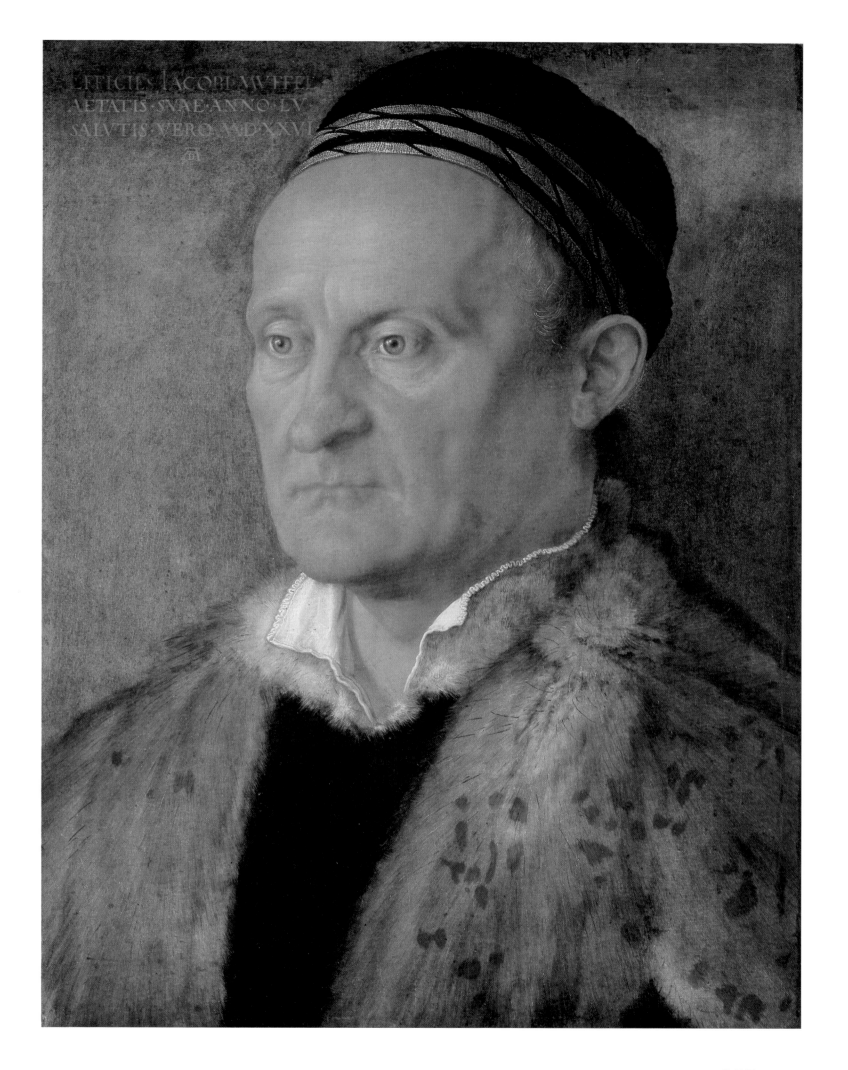

255

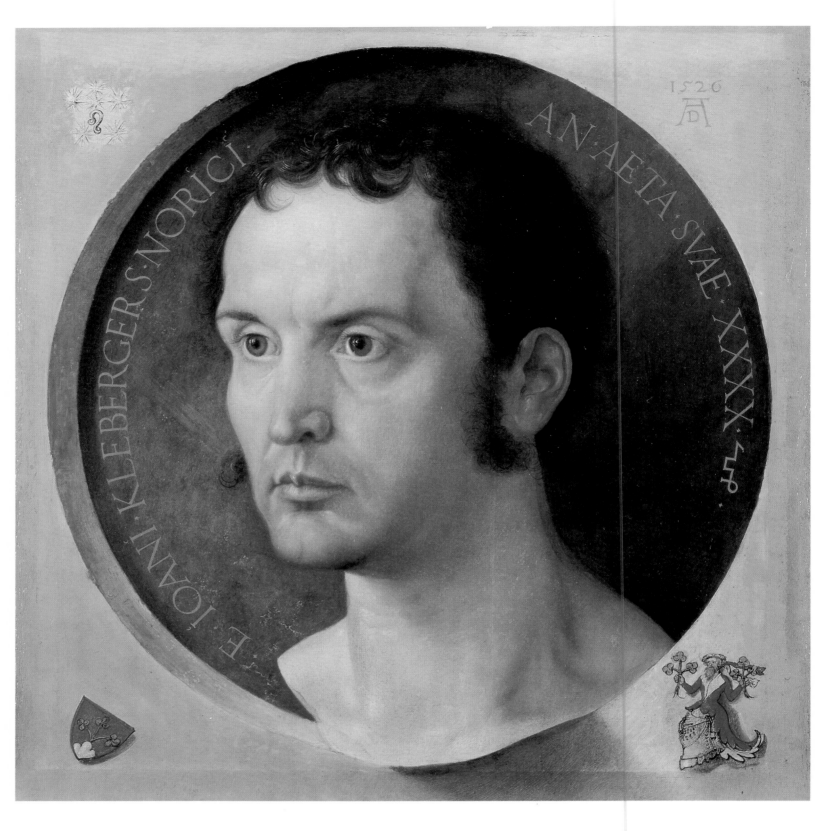

301

JOHANNES KLEBERGER

With the monogram of the artist and the date 1526 in the upper right. On the left appears the zodiacal sign of Leo, and below it the coat of arms of the sitter. In the lower right is his helmet decoration. Inscribed around the medallion: *E*[ffigies] *IO*[h]*ANI*[s]. *KLEBERGERS.NORICI.AN*[no].

AETA[tis].*SVAE.XXXX.* and ending in a cabalistic device. Oil on linden wood. 37 x 37 cm. The panel has been trimmed on all sides (the original was 34.1 x 32.6 cm) and was then again extended. Vienna, Kunsthistorisches Museum.

The cabalistic sign seems related to the symbol of Leo, the sigillum lionis. Kleberger (1485-1546), a merchant and financier of radiant appearance, returned to Nuremberg in 1526 after a long absence in France and Switzerland. In 1528 he married Willibald Pirckheimer's daughter Felicitas, widow of Imhoff, but left her after a few days and emigrated to Lyon, where he was remembered for a long time on account of his charitable actions.

256

299

HIERONYMUS HOLZSCHUHER
With the monogram of the artist
and the inscription:
*HIERONIM[us] HOLTZ-
SCHVER.ANNO DO[mi]NI.
1526.ETATIS.SVE.57.* Oil on
linden wood. 48 x 36 cm. Berlin-
Dahlem, Staatliche Museen
Preussischer Kulturbesitz, Ge-
mäldegalerie.

*There is also in existence a sliding
cover that belongs to it with the
combined coats of arms of Holz-
schuher-Müntzer. Holzschuher
(1469-1529), who had married
Dorothea Müntzer in 1498, had
been Councilor since 1499, and
served as senior burgomaster of
Nuremberg in 1509 and 1520.
Like Dürer, he belonged to the
Sodalitas Staupiciana, a society
of friends, named after Johann
von Staupitz.*

300

JAKOB MUFFEL
With Dürer's monogram and the
inscription: *EFFIGIES. JACOBI.
MVFFEL./AETATIS.SVAE.
ANNO.LV.SALVTIS.VERO.
M.D.XXVI* [The likeness of
Jakob Muffel in the 55th year of
his life, the year of salvation,
1526]. Oil on wood transferred to
canvas. 48 x 36 cm. Berlin-
Dahlem, Staatliche Museen
Preussischer Kulturbesitz, Ge-
mäldegalerie.

*Muffel (1471-1526) occupied im-
portant posts in the Nuremberg
city government. He was coun-
cilor since 1502, senior burgo-
master in 1514, and finally Sep-
temvir. He was a friend of
Albrecht Dürer and Willibald
Pirckheimer.*

Toward the end of his life the master had many skills and forms available to him in the production of portraits. 1526 saw the creation not only of the likenesses of the representatives of a tradition-encrusted government, but also the likeness of Pirckheimer's somewhat obscure son-in-law, the genial and successful merchant Kleberger (301). The names of the Nuremberg burgomasters Holzschuher (299) and Muffel (300) come to life through Dürer's portraits, even though the two men did not distinguish themselves particularly through their tenures, their positions having been merely due to their families' social standing. Both men were acquaintances of Dürer; and their likenesses seem to be related by the contrasts of their physiognomy.

The painter had once again changed his style of portraiture, as the likeness of an unknown in the Prado makes clear. The type developed in the Netherlands in which the larger portion of the upper body including the hands is shown has been given up in favor of the pure bust. In depicting the face he returns to a graphic outline of the major elements. The magnificently preserved Holzschuher portrait, which remained in the possession of the family until 1884, combines the finest of brush work—each individual hair is delicately reproduced—yet the individual parts are subordinated to the total concept and thus a comprehensive impression of the personality of the sitter is conveyed. There is scarcely any other work by Dürer in which he follows more exactly the prescriptions in his *Four Books on Human Proportion* on how to produce an exact portrayal. He demands "that the minutest details should be done in the ablest and best way, however hard one may have to work to do it, and the tiniest wrinkle and vein must not be left out as far as it is possible, for it serves no purpose to throw something hastily together, unless it needs to be ready in a hurry, in which case one must be content with it."

Dürer embarked on a wholly new approach in the composition of the portrait of Kleberger, bringing together in a novel manner inspiration from very different sources (301). The classical naked bust has been altered by a naturalistic treatment, while at the same time becoming the pictorial center of a tondo of green marble. Several forms of sculptural likenesses, all originating in classical art, can be cited as possible sources for Dürer, either in the original or through descriptions which he may have known. Artistically daring, however, is the purification of the heterogeneous elements, the free fashion in which different, often contrasting influences become mutually supportive. It is as if Dürer had taken his knowledge of the historical role of the painted portrait, and attempted, by using an illusionistic sculptural form projecting past the edge of the tondo, to give new meaning whereby the portrait becomes the vehicle to perpetuate the fame of the sitter, doing greater justice to his personality than would have been the case with a mere direct reproduction of the man's outward appearance. We cannot fathom whether the portrait of Johannes Kleberger was a one-time effort, heavily influenced by the unusual and contradictory personality of the

subject, for ill health and finally death prevented the artist from continuing work along these lines, work which might have made clearer his intentions.

Religious Subjects

Albrecht Dürer dedicated the greater part of his life's work to traditional themes, themes which by the 14th century had assumed iconographic character. They constitute, as he himself said, the primary subject matter of the art of painting, and dictate their own justification: "It cannot be denied that I describe something that is particularly useful for painting. For painting is capable of dramatizing the suffering of Christ and is of use in the service of the Church." In this Dürer chose the medium of prints for depicting the Passion of Christ, with the exception of the epitaph for the Nuremberg goldsmith Glimm that portrays the Lamentation for Christ (264). By contrast his paintings deal principally with the youth of Christ, the life of the Virgin, and individual panels devoted to the Madonna.

A large number of Dürer's prints are dedicated to popular saints whose protection was claimed by the populace and whose intercession was called upon in cases of illness or other emergencies. We must assume that these works in particular, appearing as they did on the eve of the Reformation which was to attack excesses in the cult of the saints, appealed to those elements of society for whom their artistic value was of secondary importance. A whole group of such pictorial reproductions in woodcut were described by Dürer as *schlechtes Holzwerk*, by which he meant modest, less technically demanding, and consequently cheaper prints (168).

On the other hand, there are sheets which are clearly outside the category of devotional images, and were obviously intended for a humanistically educated class of collectors. St. Jerome, learned and gifted in Hebrew, Greek and Latin and translator of the Scriptures, was himself the center of many legends, and became the patron and preferred saint of the humanists. Dürer frequently depicted this church father and hermit. In 1492, on the title sheet for the edition of the saint's letters (106) he retold in simple fashion the legend of St. Jerome, portraying the prelate at the moment when he interrupted his translation to attend to the paw of the lion who had pushed its way into his study. By contrast, one of the early engravings (c. 1496—fig. 251), as well as a steel etching of 1512 and a woodcut of the same year are directed at the other aspect of the church father, the anchorite chastising himself in the wilderness, the equivalent of the desert, and there praying or writing on a primitive slab of rock as a table. Dürer's depiction of the saint in an engraving dated 1514 links him to a multitude of concepts, showing the hermit writing against a background of a peaceful, sun-filled room (158). A

302
MELENCOLIA I
Below, right, on the forward surface of a step, the monogram of the artist; above it, the date, 1514. Above, left, on a banderole: *Melencolia I.* Engraving. 240 x 186 mm. (Cf. text, p. 260.)

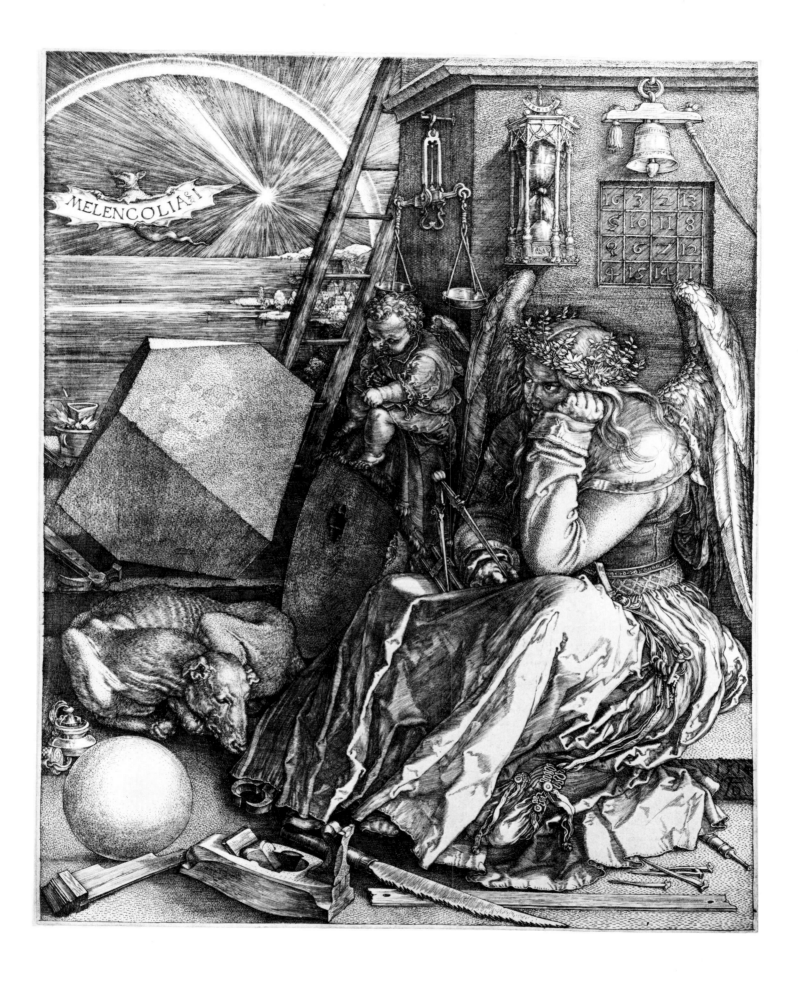

259

woodcut of 1511 anticipated this theme. The idea of wilderness and withdrawal from the world is symbolized by the lion, lying half asleep next to a fox, and by a gourd suspended from the beamed ceiling, as well as by the death's head on the window ledge. "St. Jerome in his Study" is held by some to belong together with "Melencolia I" and the slightly earlier "Knight, Death and Devil" (211).

These three sheets, of comparable size and designated as "master engravings," do not form a sequence in the sense of the series illustrating the New Testament, but they are related in their extremely high level of technical accomplishment, and still more in their theme, illustrating the possibilities of human existence and ways of experiencing it. The stylistic means, which in each case dictated the realization of Dürer's message, are varied, the products of substantially independent experiments and development. Reference has already been made (cf. pp. 178ff.) to the horseman's being the result of Dürer's studies of the proportions of horses. In the encounter with Death and the Devil, the Knight is shown to be a man whose life's course falls within the confines of the Christian order. St. Jerome represents another side of this Christian existence, for his is a life composed of silence, prayer, and spiritual exercises. Jerome appears as an immediate, contemporary presense, thanks to the details of his abode. The spatial perspective which this setting makes possible, that is, the perception and measurement of the entire depth of the room from the viewpoint of the doorway, is an essential element in creating this sense of immediacy, and has its origin in studies directed at mastering the central perspective, studies carried on by Dürer with great intensity in the first years of the 16th century and on the second trip to Italy.

The master engravings exhibit for the first time a perspective construction which reflects knowledge of the Italian art theoreticians. In the engraving entitled by Dürer "Melencolia I" in its inscription, the artist drew on a Christian humanism based on the Neoplatonism developed in Florence to create a picture of the creative man (302). The portrayal is dominated by a powerful winged female form seated on a stone ledge, with a compass in her right hand, opened for measuring. The wreathed head is supported by the left arm whose elbow rests on the left knee: this follows an old formula for a reflective pose. The eyes are turned on the background, probably on the inscription that refers to the temperament represented by a batlike creature in flight, and lighted by a comet. Next to the winged figure hovers, writing, a cherub sitting on a cloth that covers the upper part of a millstone. The two figures are hemmed in by a sleeping dog and by objects attached to the masonry foundation of a towerlike structure arising behind them. The attributes associated with melancholy as well as the tools of a practicing artisan, and the other objects, such as the circular millstone, the globe, the stone worked into a polyhedron, offered the artist a chance to depict geometric figures. The pot on the fire and the scale suggest alchemy; the magic square represents mathematics. All these symbols have multiple meanings and have been interpreted in various ways.

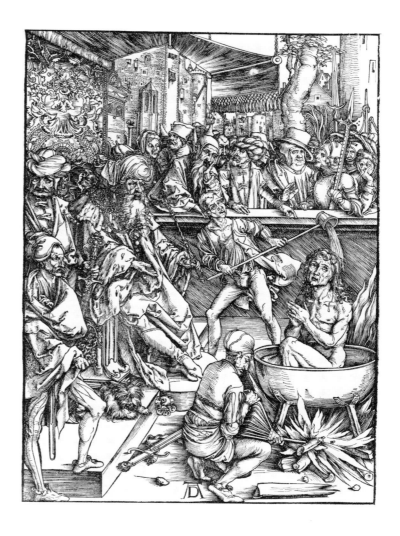

The basic purport of the engraving seems to be the representation of that melancholy and depression which affects a man who doubts the success of his endeavors, and with which Dürer must have been all too familiar. Thus melancholy, which was seen by the humanists and neoplatonists as a positive spiritual force, stands for man able to create something altogether new with mind and hand.

In dealing with the subject of Christian salvation, Dürer did not attempt new iconographic creations but sought to enhance the means of expression of form, which he subjected to continued modifications, as he gained new artistic understanding. In 1498 he published fifteen woodcuts illustrating "The Apocalypse," known also as "The Revelations of St. John the Divine." It is introduced by a representation of the torture of the saint in a cauldron of boiling oil (303-311). Other masters of engraving had for some time followed the practice of grouping together single sheets of the same size into series of related religious or secular topics. Martin Schongauer's Passion sequence was surely known in Nuremberg. Dürer's prints, on the verso of a text that relates to the next following depiction, were a novelty. By placing two sheets next to one another, text and illustration could be directly compared. The step from this point to

261

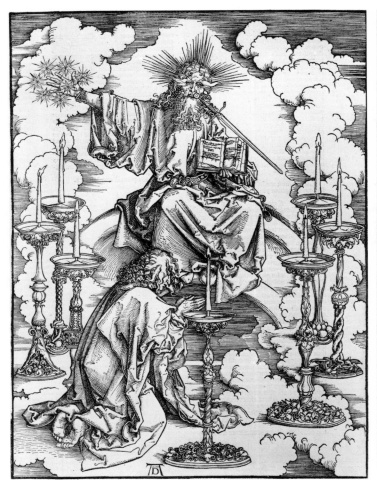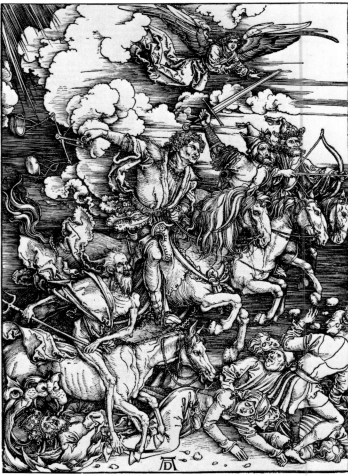

the bound book, a step Dürer was to take later, is but a short one. Sheets without text on the verso are often referred to as trial impressions, but it is by no means certain that these prints antedated those bearing text. The contemporary publication of separate editions with German and Latin texts makes clear to which audience Dürer hoped to appeal.

"The Apocalypse," which tells in magnificent tableaux of the fear of the end of the world and the coming of the Kingdom of God, has always challenged illustrators, both in its content and in its language, to represent it pictorially. In his choice of scenes, as well as in his basic organization of the topic, Dürer had his starting point in other models, chiefly the Bible printed by Anton Koberger in 1483. Its woodcuts had been produced and used earlier for an edition of c. 1478, published in Cologne. In Dürer's hands, the older, modest illustrations of the difficult text, based on a long tradition, became generally intelligible pictorial representations of visions that in their realistic portrayal equaled the power of the word. The sheets must have had an extraordinary impact on his contemporaries, and they made Dürer's name widely known.

305
THE VISION OF THE SEVEN CANDLESTICKS
With the monogram of the artist. Woodcut. 395 x 284 mm.

306
THE FOUR HORSEMEN OF THE APOCALYPSE
Below in the middle the monogram of the artist. 394 x 281 mm.

262

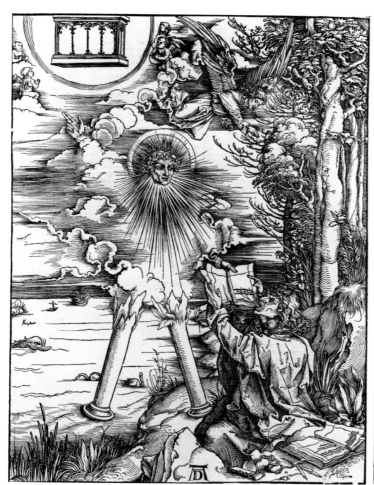

307
ST. JOHN DEVOURING THE BOOK
With the monogram of the artist.
Woodcut. 391 x 284 mm.

(308)

ST. MICHAEL BATTLING THE
DRAGON
With the monogram of the artist.
Woodcut. 394 x 283 mm.

Seen from the stylistic point of view, the success of this series lay
in Dürer's ability to unite the late Gothic occupation with move-
ment and emphasis on action with a wholly new recognition of
figure and landscape based on the study of nature. The size of 400 x
300 mm, never before attempted in woodcut, as well as the drawing
and particularly the shading used to differentiate light and dark,
placed enormous demands on the skill of the Nuremberg form-
cutters. Dürer asked more of them than they had hitherto achieved
in the *Schatzbehalter,* or in the *Nuremberg Chronicle.* The structure
of the pictorial sequence as a cycle devised by the artist, both in
selection and in the ordering of the subjects, presupposes an inten-
sive study of the text and its meaning. The subject, moreover, was
very timely, amid portents of approaching religious and social con-
flicts and the ever present external threat from the east. Thus "The
Apocalypse" was a subject that enjoyed lasting attention from social
strata that were deeply affected by these events. Dürer's sheets are
closely tied to the complex text. Nevertheless, portrayals such as
'The Four Horsemen of the Apocalypse" (306) have become part of
our heritage, and his pictorial representations of the text retain their
undiminished meaning in crisis situations up to the present day.

263

The scenes illustrating "The Apocalyptic Woman" (311), and the "Babylonian Whore" (309) with the temptation of the people by the Antichrist signify the struggle of light against darkness during the approaching end of the world. Simultaneously, Dürer was working on a Passion cycle in the same format, in which he depicted the conflict of good and evil through the suffering of Christ (313, 314). In 1510 he added to the series, which had been limited to the Passion itself, four episodes depicting "The Last Supper" (312), "Christ's Betrayal," "Christ in Limbo" (315) and "The Resurrection." Provided with Latin verses by Benedictus Chelidonius, a monk of the monastery of St. Egidien in Nuremberg, the woodcuts appeared in book form in 1511 at the same time as "The Apocalypse." Tension-laden crowd scenes are brought together into streams of movement; the principal actors are modeled as if in relief against the massed background. In the sheets bearing the date 1510 the individual figure is of great importance. Dürer was now working extensively with light so as to enhance the plastic effect of the figures and detach them by shadow from their surroundings. In place of the relieflike backdrop, clearly defined pictorial space embraces the figures standing independently within it.

After a pause following the early sheets of the Passion, an interval he used to carry out a major altar project, Dürer completed his

309
THE BABYLONIAN WHORE
With the monogram of the artist.
Woodcut. 392 x 282 mm.

310
THE ANGEL WITH THE KEY TO THE
BOTTOMLESS PIT
With the monogram of the artist.
Woodcut. 393 x 283 mm.

311 →
THE APOCALYPTIC WOMAN AND
THE SEVEN-HEADED DRAGON
Below in the middle the monogram of the artist. 392 x 279 mm.

Four Sheets from the Great Passion

The entire series consists of twelve sheets including the title page. Seven of these were produced between 1496 and 1499 and four more were added in 1510. In 1511 they appeared in book form with a Latin poem by Benedictus Chelidonius of St. Egidien in Nuremberg. On the title page of this book appears the Man of Sorrows, seated.

312
The Last Supper
With the monogram of the artist with the date, 1510, on the frame of the table. Woodcut. 395 x 284 mm.

313
Agony in the Garden
With the monogram of the artist. Woodcut. 389 x 282 mm.

315 →
Christ in Limbo
With the monogram of the artist, and on a rectangular projecting stone in the right center the date 1510. Woodcut. 392 x 280 mm.

314
The Bearing of the Cross
With the monogram of the artist. Woodcut. 389 x 282 mm.

depiction of the holy story. He chose as the subject of another cycle the events surrounding the birth of the Virgin and her life as the mother of Christ until her death and ascension into heaven. Dürer used the story as told by St. Luke and the generally known accounts of the apocryphal writings. The woodcuts of "The Life of the Virgin" are not dated, but they were produced before the second departure for Italy, with the exception of two sheets added in 1510 (316-322). In 1511 the artist issued the sequence, likewise provided with a text by Benedictus Chelidonius, in book form, simultaneously with the "Large Woodcut Passion" and "The Apocalypse." In contrast to the other two cycles, the size was reduced to 300 x 210 mm. The mood of the cycle differs from the two other series, as dictated by its content. After the highly dramatic scenes of the Passion and of the end of the world, Dürer invented for the story of the Virgin a formula of narration, lovingly rendering the scenes to appeal to the public. The human figure has been expelled from its dominating position in the foreground of the picture. In most of the sheets it has been relegated to a space composed of architectural elements whose position and structure are based on perspective schemata. Even in the cases where the action occurs in a landscape, natural features are utilized to create the pictorial space in which the figures are placed.

Seven Sheets from the Life of the Virgin

The entire series, in which the important events in the life of the Virgin and her parents are reca-

268

pitulated, consists of twenty woodcuts including the title cut for the book version of 1511. The majority were produced over an extended period between 1501 and 1505, two sheets were added in 1510. The Latin text of the book version was provided by Benedictus Chelidonius of St. Egidien in Nuremberg.

316
JOACHIM AND THE ANGEL
With the monogram of the artist to the right on a small tablet. Woodcut. 296 x 210 mm.

317
THE BIRTH OF THE VIRGIN
With the monogram of the artist. Woodcut. 297 x 210 mm.

318
THE VISITATION
With the monogram of the artist on a small tablet. Woodcut. 300 x 211 mm.

319
THE HOLY FAMILY IN EGYPT
With the monogram of the artist. Woodcut. 295 x 210 mm.

320

CHRIST AND THE DOCTORS
With the monogram of the artist.
Woodcut. 300 x 208 mm.

321
THE DEATH OF THE VIRGIN
On the chest in front of the bed,
the date 1510 and the monogram
of the artist. Woodcut. 293 x 206
mm.

322 →
THE FLIGHT INTO EGYPT
With the monogram of the artist
on a small tablet. Woodcut. 298 x
210 mm.

270

271

THE ENGRAVED PASSION

The engravings, whose imprinted dates show them as having been issued between 1507 and 1513, are not accompanied by text. The series has often been bound. The last scene really belongs to the history of the apostles. It is frequently not included with the Passion series.

323
TITLE PAGE: THE MAN OF
SORROWS AT THE COLUMN
With the monogram of the artist
and the date 1509. Engraving.
116 x 75 mm.

324
AGONY IN THE GARDEN
On a cartellino the monogram of
the artist; above it the date 1508.
Engraving. 115 x 71 mm.

325
THE BETRAYAL OF CHRIST
With the monogram of the artist
and the date 1508. Engraving.
118 x 75 mm.

326
CHRIST BEFORE CAIAPHAS
With the monogram of the artist
and the date 1512. Engraving.
117 x 74 mm.

327
CHRIST BEFORE PILATE
With the monogram of the artist
and the date 1512. Engraving.
118 x 74 mm.

328
THE FLAGELLATION OF CHRIST
With the monogram of the artist
and the date 1512. Engraving.
118 x 74 mm.

329
THE CROWNING WITH THORNS
With the monogram of the artist
and the date 1512. Engraving.
118 x 74 mm.

330
ECCE HOMO
With the monogram of the artist
and the date 1512. Engraving.
117 x 75 mm.

331
PILATE WASHING HIS HANDS
With the monogram of the artist
and the date 1512. Engraving.
117 x 75 mm.

332
CHRIST BEARING THE CROSS
With the monogram of the artist
and the date 1512. Engraving.
117 x 74 mm.

333
THE CRUCIFIXION
With the monogram of the artist
and the date 1511. Engraving.
118 x 74 mm.

334
THE DESCENT FROM THE CROSS
With the monogram of the artist
and the date 1507. Engraving.
115 x 71 mm.

335
THE ENTOMBMENT
With the monogram of the artist
and the date 1512. Engraving.
117 x 74 mm.

336
CHRIST IN LIMBO
With the monogram of the artist
and the date 1512. Engraving.
117 x 75 mm.

337
THE RESURRECTION
With the monogram of the artist
and the date 1512. Engraving.
119 x 75 mm.

338
PETER AND JOHN HEAL THE
CRIPPLE
With the monogram of the artist
and the date 1513. Engraving.
118 x 74 mm.

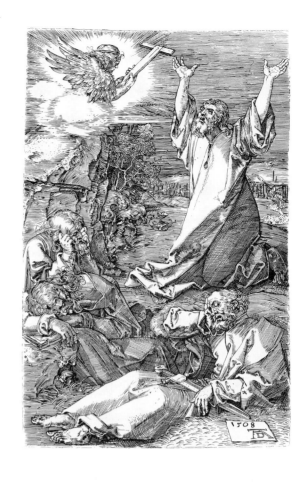

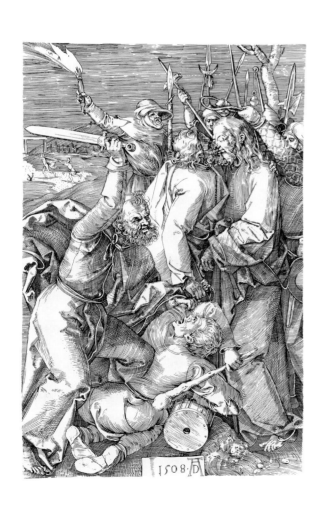

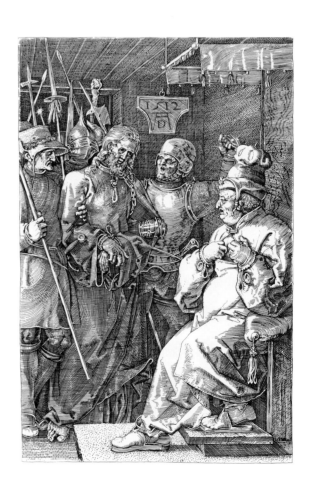

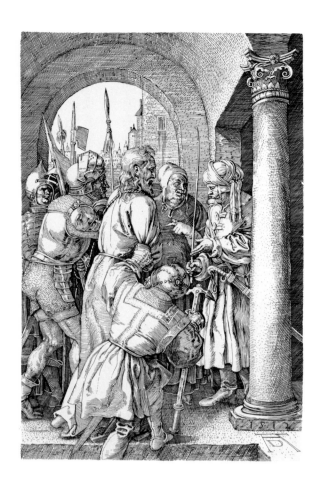

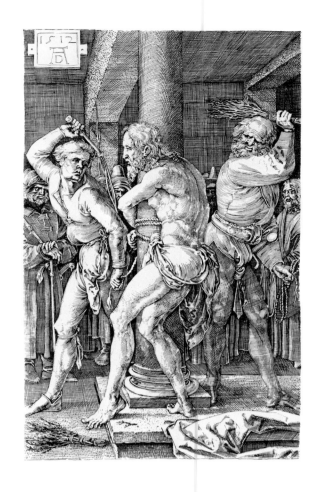

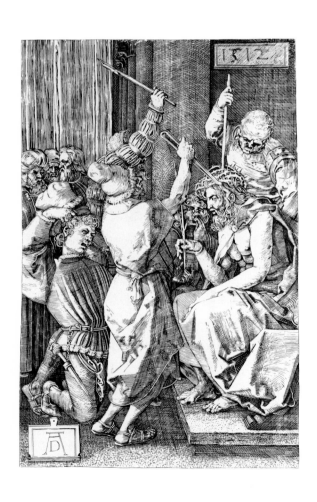

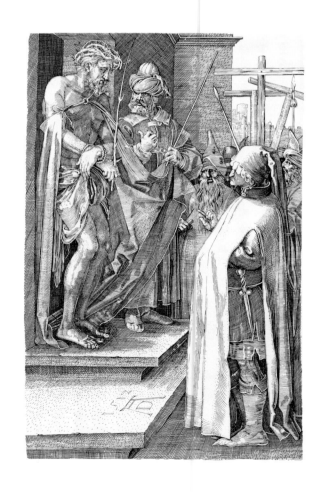

274

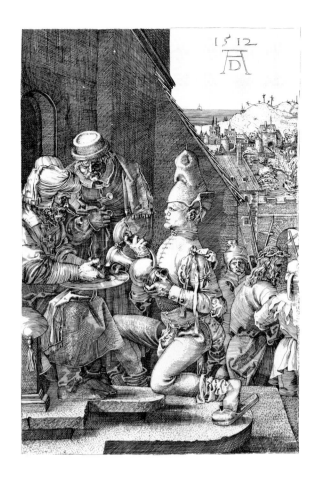

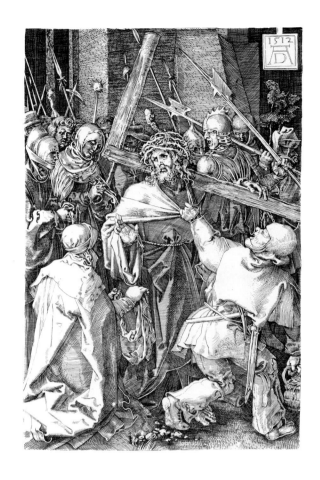

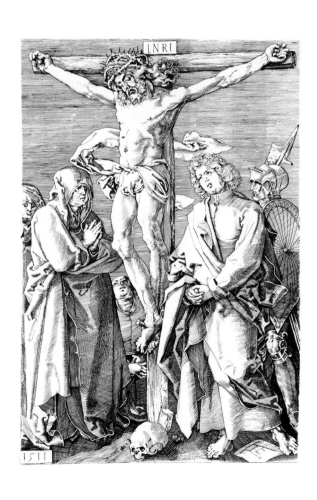

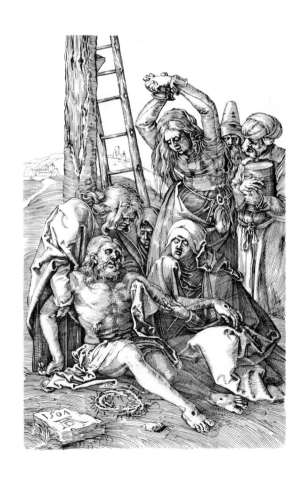

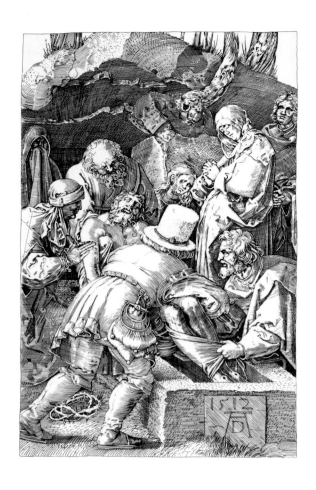

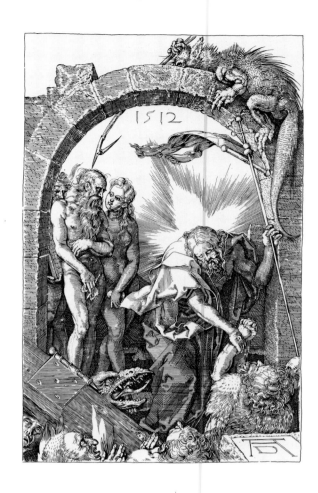

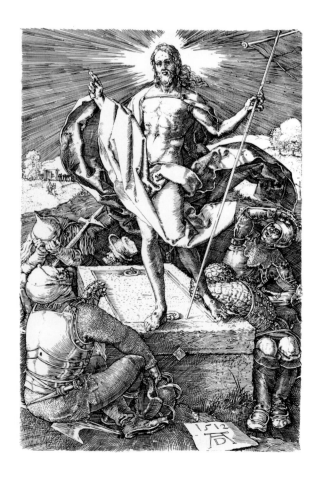

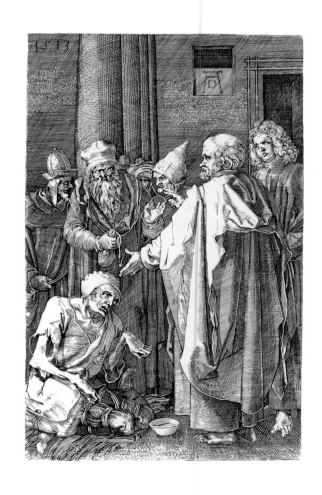

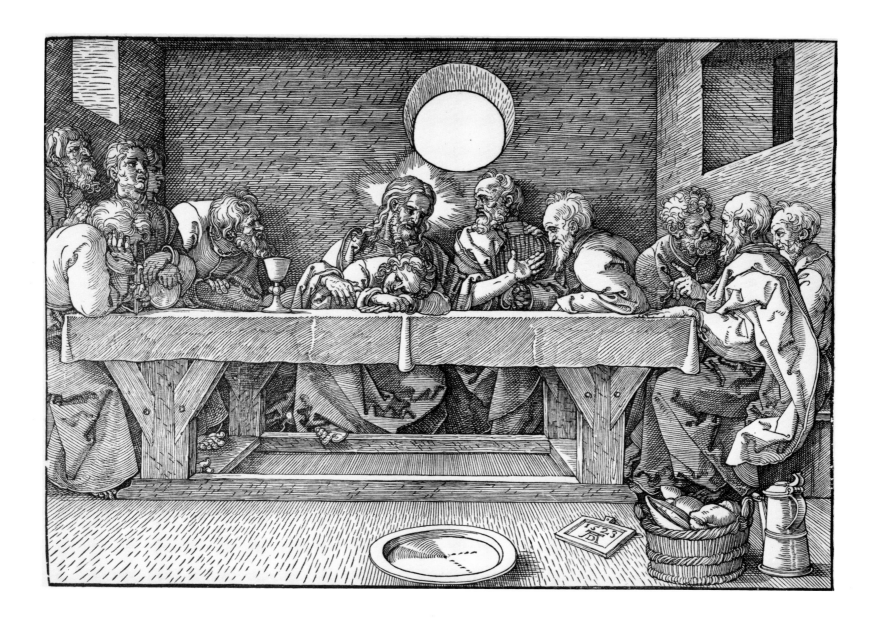

339
The Last Supper
With the monogram of the artist and the date 1523. Woodcut. 213 x 301 mm.

The eucharistic character of the meal, following the departure of Judas Iscariot, is emphasized by the bread basket and the wine jug on the floor. The emphasis placed on the chalice on the otherwise empty table refers to partaking of the body and blood of Christ in both forms even by the laity, a prime objective of the reformer. It is possible that the woodcut is related to the projected oblong passion series, of which preparatory drawings were in existence as early as 1520 (153-155).

Simultaneously with the three great books appeared a new woodcut Passion cycle in a smaller size, 126 x 97 mm (340-375). Expanded to thirty-seven scenes, the series included "The Fall of Man," "Expulsion from Paradise," and "The Last Judgment." It was produced between 1509 and 1511. In the year of its completion this series, too, appeared in book form with a text by Chelidonius.

As opposed to the four woodcut series there is only one using the engraving technique (323-338). Again Dürer chose the Passion of Christ as his subject. As evident from the dates on each of the sixteen sheets, they were produced between 1507 and 1512. Even if this series was frequently bound at a later date, being engraved, it belongs to another tradition than that of the woodcut cycles which with their text and in their genesis are closely connected to the illustrated book.

In contrast even to his teacher, Wolgemut, Dürer as a graphic artist combined in one person designer, engraver, printer, and publisher. It necessitated first the creation of a market for the products

THE SMALL PASSION

This most comprehensive series of Albrecht Dürer was produced for the most part in 1509. It includes the "Fall of Man" and the story of Christ's youth preceding the extensively related Passion itself, the Easter scenes up to Pentecost and ends with the Last Judgment. Two sheets were added in 1510. In 1511 a book edition appeared with a title page (the Man of Sorrows) and with a Latin text by Benedictus Chelidonius of St. Egidien in Nuremberg. The Rijksprentenkabinet in Amsterdam owns an uncut impression of the full sheets prior to the book edition, each with four woodcuts the illustrations are based on.

340
ADAM AND EVE
With the monogram of the artist. Woodcut. 127 x 97 mm.

341
EXPULSION FROM PARADISE
With the monogram of the artist above, and the date 1510. Woodcut. 129 x 98 mm.

342
THE ANNUNCIATION
With the monogram of the artist above in the sky over Mary's bed. Woodcut. 128 x 98 mm.

343
THE ADORATION OF THE SHEPHERDS
With the monogram of the artist in mirror writing. Woodcut. 127 x 98 mm.

344
CHRIST TAKING LEAVE OF HIS MOTHER
With the monogram of the artist. Woodcut. 125 x 96 mm.

345
CHRIST'S ENTRY INTO JERUSALEM
With the monogram of the artist. Woodcut. 128 x 98 mm.

346
CHRIST EXPELLING THE MONEY-CHANGERS FROM THE TEMPLE
With the monogram of the artist. Woodcut. 127 x 97 mm.

347
THE LAST SUPPER
With the monogram of the artist. Woodcut. 127 x 98 mm.

348
CHRIST WASHING PETER'S FEET
With the monogram of the artist. Woodcut. 127 x 97 mm.

349
AGONY IN THE GARDEN
With the monogram of the artist. Woodcut. 127 x 97 mm.

350
THE BETRAYAL OF CHRIST
With the monogram of the artist. Woodcut. 127 x 97 mm.

351
CHRIST BEFORE ANNAS
With the monogram of the artist. Woodcut. 127 x 97 mm.

278

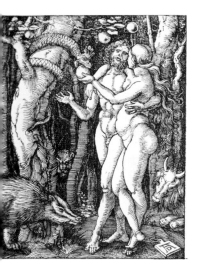
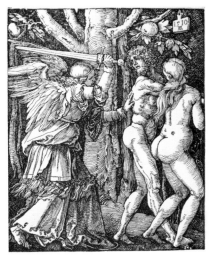
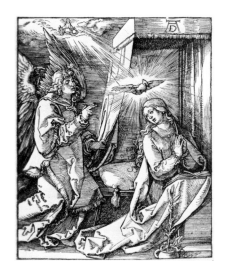
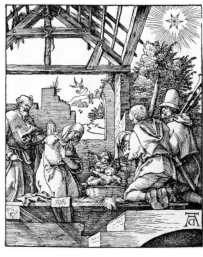

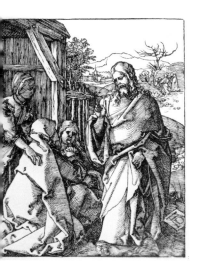
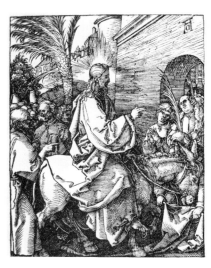
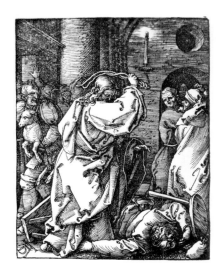
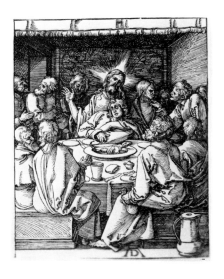

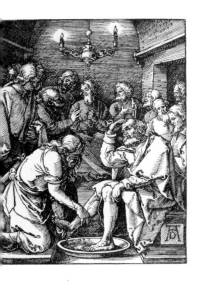
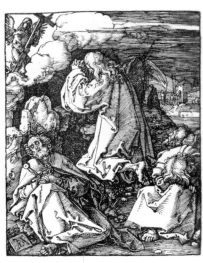
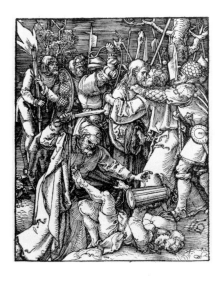
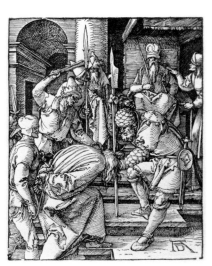

352
CHRIST BEFORE CAIAPHAS
With the monogram of the artist.
Woodcut. 127 x 97 mm.

353
THE MOCKING OF CHRIST
With the monogram of the artist.
Woodcut. 127 x 97 mm.

354
CHRIST BEFORE PILATE
With the monogram of the artist.
Woodcut. 128 x 97 mm.

355
CHRIST BEFORE HEROD
With the monogram of the artist
and the date 1509. Woodcut. 127
x 97 mm.

356
THE FLAGELLATION
With the monogram of the artist
with poorly cut D. Woodcut. 129
x 96 mm.

357
THE CROWNING WITH THORNS
With the monogram of the artist.
Woodcut. 126 x 97 mm.

358
ECCE HOMO
With the monogram of the artist.
Woodcut. 128 x 97 mm.

359
PILATE WASHING HIS HANDS
With the monogram of the artist.
Woodcut. 128 x 97 mm.

360
CHRIST BEARING THE CROSS
With the monogram of the artist
and the date 1509. Woodcut. 127
x 97 mm.

361
ST. VERONICA WITH THE
SUDARIUM BETWEEN STS. PETER
AND PAUL
With the monogram of the artist
and the date 1510. Woodcut. 127
x 97 mm.

362
THE NAILING TO THE CROSS
With the monogram of the artist.
Woodcut. 127 x 97 mm.

363
THE CRUCIFIXION
With the monogram of the artist.
Woodcut. 127 x 97 mm.

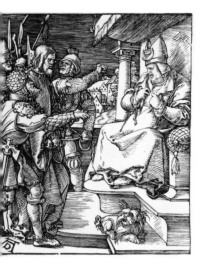 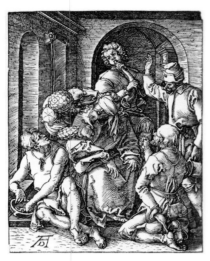 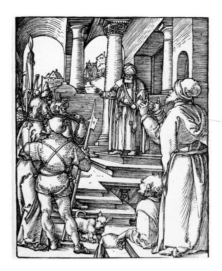 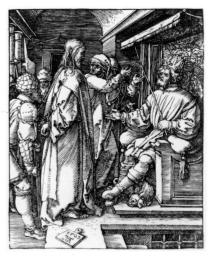

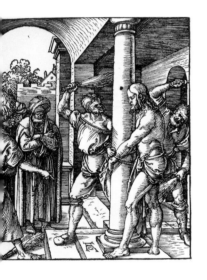 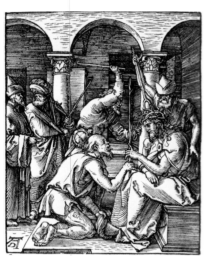 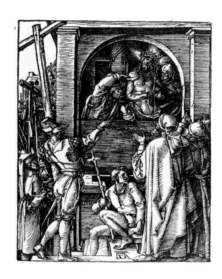 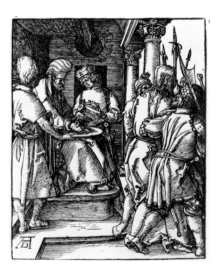

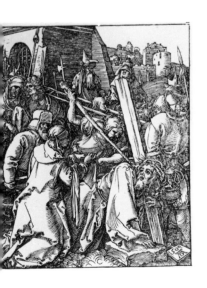 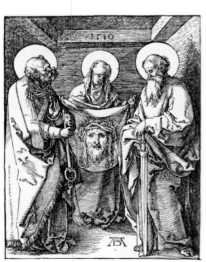 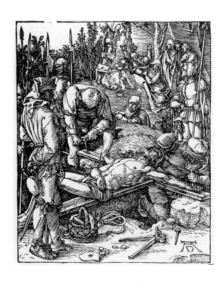 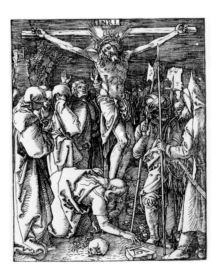

364
CHRIST IN LIMBO
With the monogram of the artist.
Woodcut. 127 x 93 mm.

365
THE DESCENT FROM THE CROSS
With the monogram of the artist.
Woodcut. 128 x 97 mm.

366
THE LAMENTATION
With the monogram of the artist.
Woodcut. 127 x 97 mm.

367
THE ENTOMBMENT
With the monogram of the artist.
Woodcut. 128 x 97 mm.

368
THE RESURRECTION
With the monogram of the artist.
Woodcut. 127 x 98 mm.

369
CHRIST APPEARS TO HIS MOTHER
With the monogram of the artist
in mirror writing. Woodcut. 127
x 96 mm.

370
CHRIST APPEARS TO THE
MAGDALEN AS A GARDENER
With the monogram of the artist.
Woodcut. 127 x 97 mm.

371
CHRIST AT EMMAUS
With the monogram of the artist.
Woodcut. 127 x 96 mm.

372
CHRIST AND THE DOUBTING
THOMAS
With the monogram of the artist.
127 x 97 mm.

373
THE ASCENSION
With the monogram of the artist.
Woodcut. 126 x 97 mm.

374
PENTECOST
With the monogram of the artist.
Woodcut. 127 x 97 mm.

375
THE LAST JUDGMENT
With the monogram of the artist.
Woodcut. 127 x 97 mm.

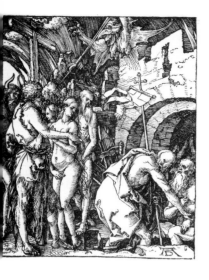

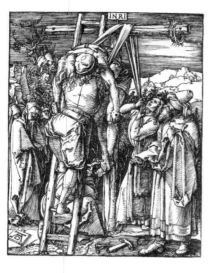

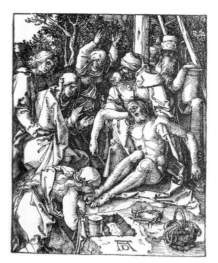

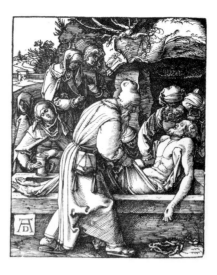

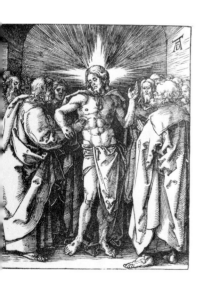

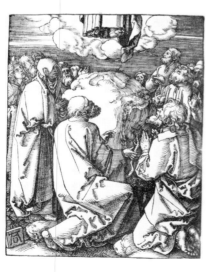

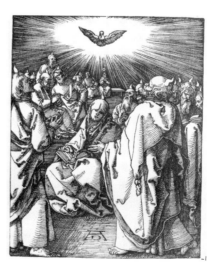

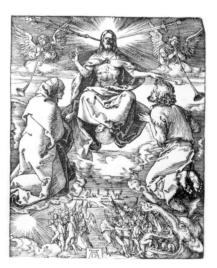

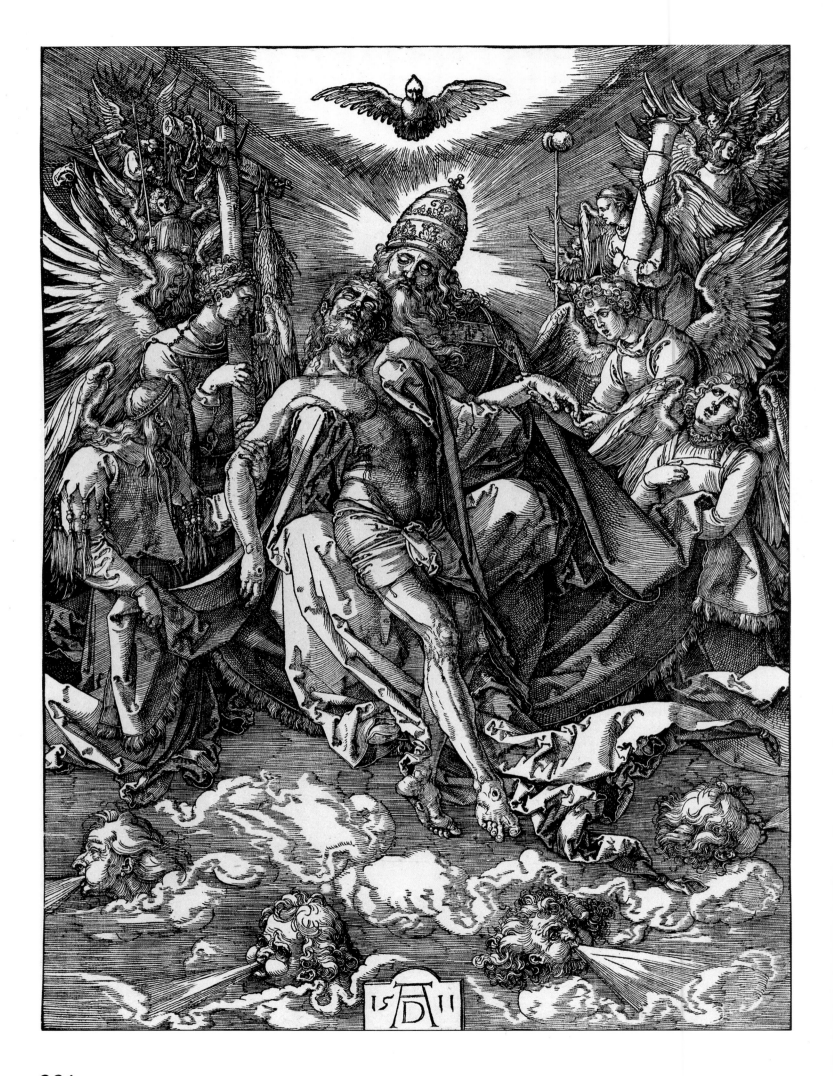

284

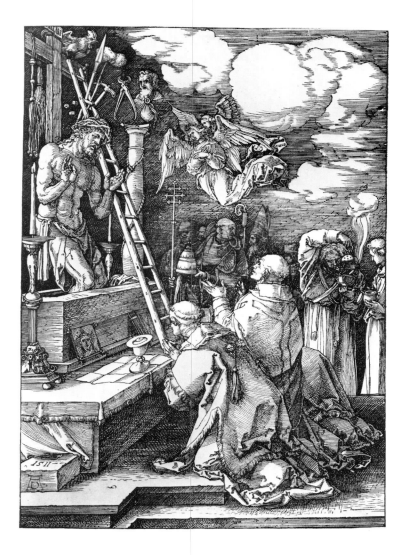

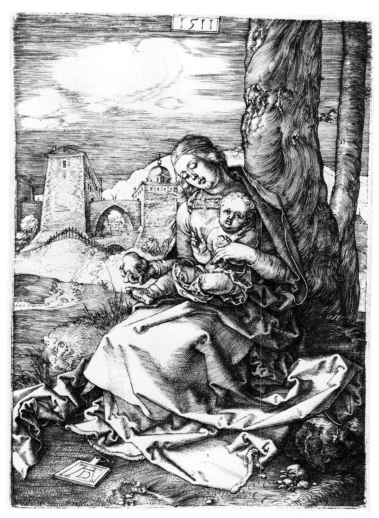

376 ←
THE HOLY TRINITY
With the monogram of the artist
and the date 1511. Woodcut. 392
x 284 mm.

*Both in form and content this
woodcut marks a high point in
the graphic work of the mature
artist. God the Father, in priestly
garb, wearing the tiara of the
Pope, holds the body of his dead
son on his lap. Angels point to
the tools of suffering which
served the salvation of man. The
deeper meaning of this picture is
the acceptance of the son's
sacrifice of death by the father.*

377
THE MASS OF ST. GREGORY
With the monogram of the artist
and the date 1511. Woodcut. 295
x 205 mm.

*During a mass Christ appeared to
Pope Gregory in the form of the
Man of Sorrows. The scene
serves as a representation of the
real presence of Christ during the
gift of the transformed bread and
wine.*

378
THE MADONNA WITH THE PEAR
With the monogram of the artist
and the date 1511. Engraving.
158 x 106 mm.

285

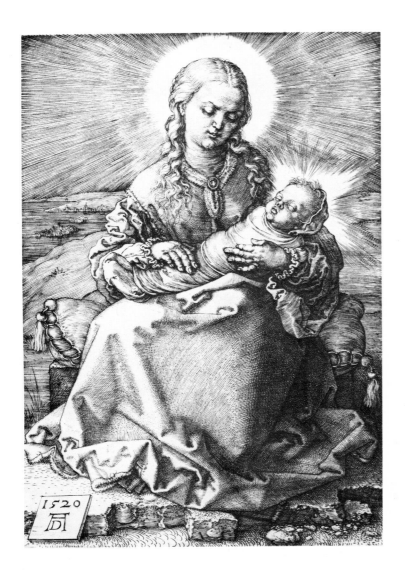

379
VIRGIN WITH THE SWADDLED
INFANT
With the monogram of the artist
and the date 1520. Engraving.
142 x 95 mm.

380
THE VIRGIN BY THE WALL
With the monogram of the artist
and the date 1514. Engraving.
147 x 102 mm.

*Produced in the same year as
"Melencolia I" (no. 302), the
figure of the Virgin, in which
Dürer dispenses with all her
customary attributes, appears
related to the winged representa-
tion of Melancholy. The special
position of the sheet within the
Virgin sequence of Dürer is
always emphasized.*

381
ST. CHRISTOPHER →
Attributed to Albrecht Dürer.
Oil on wood. 46 x 36 cm. Former-
ly Dessau, Staatliche Galerie.

*Both the relationship to Dürer
and the dating of this painting,
missing since 1945, have been
disputed. It was finally claimed
as actual work of the master by
Ludwig Grote.*

287

of his press, because it was essential to go well beyond the traditional audience for single-leaf prints, the circle of artists themselves. Two contracts of Dürer's from the year 1497 have survived, with selling agents for the distribution of engravings and woodcuts. Direct sales were made also by the artist's mother and wife at annual fairs and markets. Protection from pirated editions was given by imperial copyright and through complaints made to the appropriate governmental bodies. The situation was quite different in the case of large paintings. While Dürer, according to the records, did occasionally paint on speculation, in most cases he depended on commissions, accompanied, naturally, by strictures demanded by the person placing the order. The earliest paintings from Dürer's hand which have come down to us are the likeness of his father and the self-portrait of 1493, products of the painter's own decision. A supposed participation in the production of a winged altarpiece (Darmstadt, Hessisches Landesmuseum) for the church of a Dominican monastery would have been the result of his stay in a Strassburg workshop (113). A small panel representing Christ as Man of Sorrows (115) was probably commissioned during the time of his travels as a journeyman. Dürer's work as a painter on a larger scale commenced in Nuremberg after his return from Italy in 1495. At that time he set up his own workshop, staffed by journeymen and apprentices.

His first great patron was the humanistically trained Duke and Elector of Saxony, Frederick the Wise. The duke secured for himself Dürer's genius and the productive capacity of his workshop, since

382
THE ADORATION OF THE MAGI
Attributed to Albrecht Dürer. Oil on fir wood. 75.5 x 170 cm. Basel, Offentliche Kunstsammlung.

The panel may once have served as predella of an altarpiece. The provenance (Faesch Collection), as well as stylistic criteria speak for it having been produced in Basel. Most recently Anzelewsky and Gosebruch have asserted Dürer's authorship.

288

383

THE INFANT SAVIOR

With the initials *Ad* and the date 1493. Tempera on vellum. 118 x 93 mm. Vienna, Graphische Sammlung Albertina.

Drawn at Strassburg, this sheet is a variation of the then-popular New Year's greetings, picturing the Infant Christ naked. Dürer used vellum in Strassburg also for the portraits of his teacher in that city and the teacher's wife, both dated 1494, as mentioned in the inventory of the Imhoff collection.

384

THE HOLY FAMILY

Tempera on vellum. 160 x 112 mm. Leipzig, Museum der Bildenden Künste.

The illusionistic painted frame endows this miniature with the quality of a painting. The view of a landscape in the background is partially obscured by a curtain, similar to the early portraits. The typological relationship to the Madonna of no. 242 supports a date of c. 1496/97.

he had large artistic and political plans, among them his new palace and adjacent church at Wittenberg which he wished to embellish with paintings and altarpieces. There is a "Mater Dolorosa," today reduced in size, which was originally surrounded by seven scenes from the life of Christ (385-392 — also after recent, carefully carried out restoration of these latter, Dürer's degree of participation is not yet quite certain). A small altarpiece, painted on canvas and intended for the palace church, belongs to the earliest of the orders placed by Frederick the Wise (393). The restoration, after 1957, of this altarpiece — it had been endangered due to the use of canvas with thin tempera — returned the painting to its original condition. The central section of this triptych shows the Virgin bending adoringly towards the Infant Christ, asleep on a window ledge. St. Anthony the hermit and St. Sebastian, both below flying angels bearing martyrs' crowns, are depicted on the wings. Even the exterior organization of the three pictures differs from the scheme

THE ALTARPIECE WITH THE SEVEN
SORROWS OF THE VIRGIN
Albrecht Dürer (and assistants?).

*A preparatory drawing for the
Mater Dolorosa and the Crucifix-
ion is in Berlin (Strauss, Draw-
ings, 1502/32). The study after
nature of a man drilling (Bay-
onne, Musée Bonnat; Strauss,
Drawings, 1496/15) was used by
Dürer repeatedly. The panel, the
oldest surviving large painting by
Dürer, was commissioned by
Frederick the Wise. The work
may have been begun even be-
fore the first Italian journey.
Dürer's personal participation in
the entire altarpiece remains con-
troversial, even after the success-
ful restoration of the parts in
Dresden between 1957 and 1958.*

385
THE VIRGIN AS MATER DOLOROSA
Oil on coniferous wood. 109 x 43
cm (trimmed on top about 18
cm). Munich, Alte Pinakothek
(the remaining panels are all in
Dresden, Gemäldegalerie).

386
THE CIRCUMCISION OF CHRIST
Oil on coniferous wood. 63 x
45 cm.

387
THE FLIGHT INTO EGYPT
Bottom right, by another hand,
the monogram of the artist. Oil
on coniferous wood. 63 x 46 cm.

388
THE TWELVE-YEAR-OLD CHRIST
PREACHING IN THE TEMPLE
Oil on coniferous wood. 62.5 x
45 cm.

392 (Cf. p. 292)
THE BEARING OF THE CROSS
Oil on coniferous wood. 63 x
44.5 cm.

389
THE NAILING TO THE CROSS
Oil on coniferous wood. 62 x
46.5 cm.

390
THE CRUCIFIXION
Oil on coniferous wood. 63.5 x
45.5 cm.

391
THE LAMENTATION FOR CHRIST
Oil on coniferous wood. 63 x
46 cm. Dresden, Gemäldegalerie.

291

292

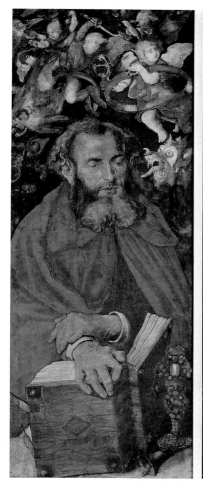
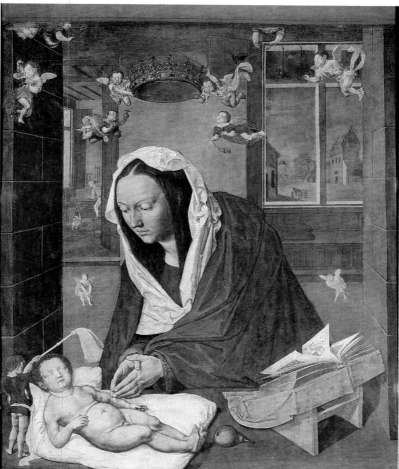
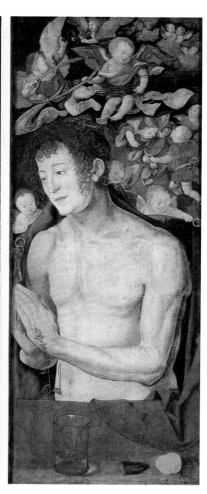

392 ←
THE BEARING OF THE CROSS
(Cf. pp. 290-91.)

393
THE VIRGIN WITH THE SLEEPING
CHILD BETWEEN STS. ANTHONY
THE HERMIT AND SEBASTIAN
Albrecht Dürer and a Dutch (?)
painter. Oil on canvas. Central
section 191 x 96.5 cm; wings each
114 x 45 cm. Dresden, Gemälde-
galerie.

*The altarpiece was commissioned
by Frederick the Wise for the
Wittenberg Palace church. Dürer
probably joined the immovable
wings to an already existing or
then being prepared central sec-
tion. The noticeable effect of
north Italian art of the Mantegna
circle, especially in the portrayal
of St. Sebastian, argues for a date
soon after Dürer's return from
the first trip, probably at the time
of his intensive ties with Frederick
the Wise soon after 1496.*

customary with movable altars. Even in their original frames, the
wings could not be closed, since neither the technique nor the sur-
face were suited for painting on both sides. This realization ac-
counts for the narrowness of the wings which would no longer
cover the central picture entirely. The somewhat reduced height, to-
day, of the picture of the Virgin is due to later trimming of the upper
border. The fact that the three pictures belong together is confirmed
by the stone parapet that continues across all three representations.
A coarser canvas was used for the central picture, a change that
becomes apparent in the overall effect of the painting. On the basis
of these technical findings, the recently reiterated opinion that
Dürer added the wings to a picture by another hand trained in the
Netherlands cannot be contradicted. This view is supported by the
presence of the perspectively constructed grid of floor tiles that does
not occur in Dürer's oeuvre. Nevertheless, the overall effect of the
central picture and the wings is decidedly one of unity, so that one
must assume at least a reworking by Dürer of today's appearance of
the central picture.

293

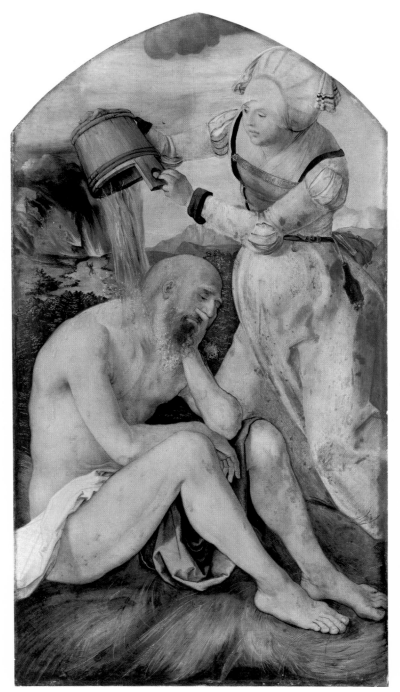 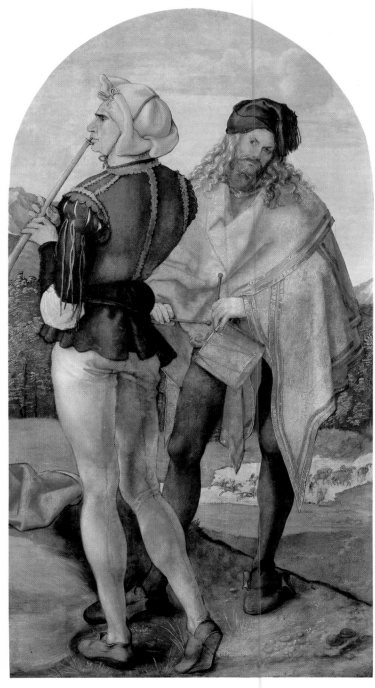

Wings for an Altarpiece
(Jabach Altarpiece)
Albrecht Dürer (and assistants?)

The central portion, either a panel or a shrine with sculptures, is missing. The wings, originally with arched tops, probably intended for the chapel in Wittenberg Palace, hung together until the end of the eighteenth century

in the house chapel of the Jabach establishment in Cologne. They were probably produced 1503/04. The assumption that Dürer had collaborators in the execution, a theory most recently advanced by E. Holzinger, has been contested in the latest literature, which sees Dürer as solely responsible for the design and the execution.

394
Job Castigated by His Wife
Exterior of the left wing. Oil on linden wood. 94 x 51 cm. Frankfurt a.M., Städelsches Kunstinstitut.

395
Piper and Drummer
Exterior of the right wing. Oil on linden wood. 94 x 51 cm. Cologne, Wallraf-Richartz Museum.

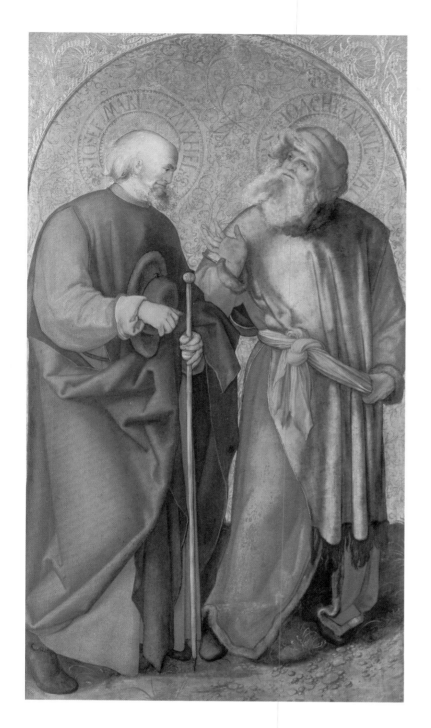

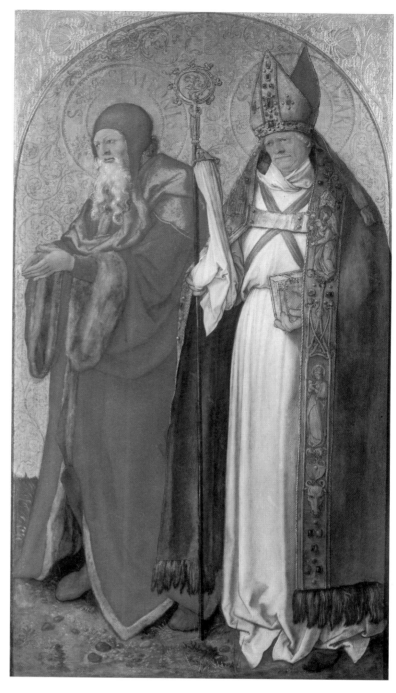

396
STS. JOSEPH AND JOACHIM
On the staff of St. Joseph the
monogram of the artist. Interior
of the left wing. Oil on linden
wood. 94 x 54 cm. Munich, Alte
Pinakothek.

397
STS. SIMEON AND LAZARUS
On the pendant insignia of the
crozier, the monogram of the art-
ist. Interior of the right wing. Oil
on linden wood. 97 x 55 cm.
Munich, Alte Pinakothek.

295

It is also likely that an altarpiece whose wings, on the inside, depict two standing saints was commissioned by Frederick the Wise (394-397). The outside scenes united into a depiction from the story of Job, who is here sitting on a dung heap and being drenched with water poured from a tub held by his wife, in the presence of a piper and a drummer. The inclusion of the musicians in this scene from the Old Testament—a rather unconventional subject for an altarpiece—has many meanings. The musicians have been seen as mocking the man who believes himself abandoned by fortune and his God, or else as cheering him, for music was regarded as able to relieve melancholy. In this instance the resemblance of the drummer to Dürer supports the latter interpretation. The original central section, which can be reconstructed by its arched top corresponding to the wings, was probably a shrine with painted figures or a painted panel. It has disappeared. Knowledge of it would surely simplify the interpretation of the Job panels. This middle section has sometimes been identified, probably erroneously, as "The Adoration of the Magi" of 1504, since it had also been at one time in Saxon hands (398). In this representation Dürer deals with problems arising from the linking of the figures with the pictorial space surrounding them, composed of architectural elements.

In a related central panel, done only slightly earlier, of an altarpiece donated to St. Catherine's Church by the Paumgartner family of Nuremberg (406-408), the adoration of the Infant Christ is structured so that the glance of the viewer is drawn from the center to the background of the picture through a narrow vista formed by architectural elements. In the "Adoration of the Magi" the movement is more subdued because the composition is arranged along a diagonal line. The unity of the figural group framed by architecture and landscape is supported by the muted color tones of the background, whereas the strongly accented color surfaces of the "Paumgartner Altarpiece" are absent here.

Dürer supplied only some very carefully executed designs for a large altarpiece featuring Christ's Passion and bearing the coats of arms of Frederick the Wise and his brother John the Steadfast (Vienna, Diözesanmuseum). It was probably intended for a church in Nuremberg. The actual execution lay in the hands of his pupil and collaborator, Hans Schäufelein. The Elector of Saxony also ordered a panel of smaller dimensions. It was done by Dürer himself, as evident from an exchange of letters with Jakob Heller in Frankfurt. The subject was the martyrdom of ten thousand Christians on Mt. Ararat, perpetrated by an oriental potentate at the command of the Roman emperors Hadrian and Antonius (402). The extensive collection of relics of the Saxon prince included some related to that event. The emphasis on the oriental character of the prince who carried out the massacre suggests that the renewed Turkish threat gave added meaning to this account that goes back to the crusades of the 12th century. Compelled to compress a multitude of moving figures into a restricted picture space, Dürer displays his genius in the

398
THE ADORATION OF THE MAGI
With the monogram of the artist and the date 1504. Oil on coniferous wood. 100 x 114 cm. Florence, Galleria degli Uffizi.

The panel was probably commissioned by Frederick the Wise. It is not established whether it was ever endowed with wings.

296

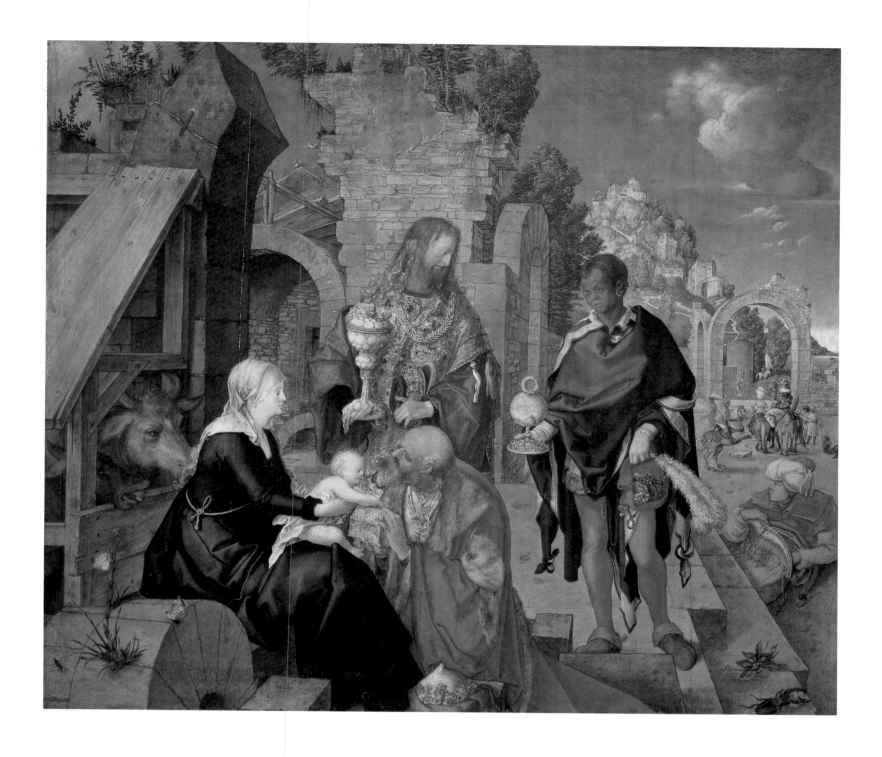

TWO WINGS OF A TRIPTYCH

399 ➡
ST. ONUPHRIUS
Oil on linden wood. 58 x 20 cm.
Bremen, Kunsthalle.

400 ➡
ST. JOHN THE BAPTIST
Oil on wood. 58 x 20 cm. Bremen,
Kunsthalle (missing).

The shape of the two panels suggests that they originally served as wings of a triptych; the middle section is thought to have been the "Salvator Mundi" (401). The reconstruction is not altogether successful because of differences in the base; the pictures of the two anchorites had probably been produced earlier, c. 1497/98.

401 ➡ ➡
SALVATOR MUNDI
Oil on linden wood. 57 x 47 cm.
New York, Metropolitan Museum of Art (Friedsam Collection).

The painting is not quite complete. It was listed as such in the inventory of 1573/74 of the Imhoff Collection. Its stylistic links to works of Jacopo de' Barbari that had been produced around 1503 suggest that it dates from the same time (cf. 399, 400).

297

298

299

construction of a unified composition. The various groups of figures, by means of porportional foreshortening, are arranged like the spokes of a wheel spreading out from a hub in all directions. In the center stands Dürer himself, with a companion who has been identified, probably correctly, as Konrad Celtis (c. 1508). A scroll attached to a staff in Dürer's hand bears the artist's signature in Latin and the date 1508. The picture was later transferred from its original wooden base to canvas. As a result, the colors have lost their radiance, but it is still possible to see that Dürer worked with the utmost care, and from an artistic point of view, successfully mastered the repelling horror of a subject so contradictory to the tolerant spirit of humanism. In the succeeding years Lucas Cranach largely replaced Dürer as court painter to Frederick the Wise, since he was resident in Wittenberg, and was retained on a regular salary. However, the tie to Dürer was never completely broken.

In a letter addressed to the burgomaster and the City Council of Nuremberg in 1524, Dürer complained about the meager number of commissions received from his hometown, in spite of his long residence there: "I have, for the thirty years I have lived here, not received orders for more than 500 florins [from the city]. . .all my poor living has been earned and garnered — God knows, it has been tough — from princes, lords and other strangers." In matters financial, the painter knew well how to complain with a loud voice, though at his death he was counted among the most prosperous citizens of Nuremberg. On the other hand, it is quite true that he had benefited little from the generous endowments provided by wealthy citizens for altarpieces in the city's churches just before the Reformation. For this, Dürer may have been largely to blame himself, since his new concept of art and artist led him to decline to produce in rapid sequence, after the traditional workshop procedure, epitaphs and winged altarpieces corresponding in price and execution to conventional expectations. "As to common paintings," he wrote to Jakob Heller, "I could produce a heap such as no man would believe possible that one man could accomplish. That way one can make a profit. But concentration on fine details is time-consuming. I'd rather devote my time to engraving."

As a consequence, only two altarpieces endowed by Nuremberg merchants have survived which Dürer produced with his own hands. The city government, having had, apart from pure craftsman's work, few commissions to hand out, ordered from Dürer in 1513 the two portraits of emperors for the Treasure Chamber (70, 71). It remains uncertain whether a sum of 60 florins, paid in 1511 for two pictures, was for these or for another order or acquisition of the Council, perhaps the pictures of Adam and Eve. In 1521, when the city fathers began to decorate the large Council Chamber with pictures, following a total reconstruction of the city hall inside and out, it was natural that Dürer should become involved. It can no longer be determined exactly for what task he received a remuneration of 100 florins in this connection, since the murals are now gone.

402
THE MARTYRDOM OF THE TEN THOUSAND
In the background, a likeness of Albrecht Dürer. On a label attached to the staff in his hand: *Iste faciebat an[n]o domini 1508 albert[us] dürer aleman[us]*. Oil on wood transferred to canvas. 99 x 87 cm. Vienna, Kunsthistorisches Museum.
This was painted for Frederick the Wise and frequently mentioned by Dürer in his correspondence with Jakob Heller (cf. 411). The man next to Dürer is probably Konrad Celtis, who died in the same year.

403 →
HEAD OF THE APOSTLE PHILIP
Inscribed: *SANCTE PHILIPPE ORA[TE* added by another hand] */ PRONOBIS 1516*; next to it the monogram of the artist. Oil on canvas. 46 x 38 cm. Florence, Galleria degli Uffizi.

404 → →
HEAD OF THE APOSTLE JAMES
Inscribed: *SANCTE JACOBE ORA / PRO NOBIS 1516*; next to it the monogram of the artist. Oil on canvas. 46 x 38 cm. Florence, Galleria degli Uffizi.

301

302

303

Two design drawings have survived with subjects appropriate to that location: "The Calumny of Apelles," as described by Lucian and recommended to painters by Alberti (Vienna, Albertina), and representations of the power of women, meant for the window wall of the chamber (New York, Pierpont Morgan Library).

The altarpiece for St. Catherine's, the church of the Dominican nuns referred to earlier, was commissioned by members of the Paumgartner family, as the coat of arms indicates. The retable is painted in its entirety and depicts the birth of Christ in the central panel. Saints George and Eustace are shown on the wings, endowed respectively with the features of Stephan and Lukas Paumgartner (406-408). Only a Virgin Annunciate has survived from the exterior of the wings. We can no longer determine with exactitude when the altarpiece was produced. A record from the 17th century mentions that in 1498 Dürer had painted Stephan Paumgartner and his brother Lukas as St. George and St. Eustace, but the advanced spatial treatment of the central panel suggests, for this picture at least, a date after the turn of the century, yet before "The Adoration of the Magi" of 1504 in Florence. In contrast to the impression of depth in the central panel, the forms of the saints on the wings, taking up all of the available space, are set against a neutral black background and, for all their vivid contours, rest upon a very narrow surface. The figures, though not quite life-size, nevertheless produce a monumental effect and reveal in the realistic quality of the likenesses a potential heretofore unknown in Nuremberg for the portrayal of individual, standing figures. Aside from his studies of the human body carried out in Venice, knowledge of Italian plastic relief work — such as the tomb in the Cathedral of Trent for Marshal Roberto Sanseverino, fallen in the service of Venice, that Dürer perhaps saw on his Italian journey — may have inspired the form of the two saints.

After the return from his second visit to Venice, Dürer received a commission for another winged altarpiece which the Frankfurt merchant, Jakob Heller, wished to donate to the church of the Dominicans of that city. An exchange of letters has come down to us, arising from delay in its execution and the dissatisfaction of the artist with the agreed-upon price of 130 florins. Nine letters written by Dürer provide insight into the progress of the project. Accordingly, the artist painted only the central panel depicting the Virgin's Ascension and Coronation. The work stretched out into the years 1508/09. Eighteen preparatory brush drawings on color-grounded paper (409, 410) — two of which were in Bremen until 1945 — and a copy of the painting by the Frankfurt artist Jobst Harrich (411) are all that remain after the original fell victim to the fire at the Munich Palace on 22 December 1729. The composition of this important work includes large figures of the apostles in varied positions reflecting astonishment before the empty tomb. A coronation group

405
THE HOLY FAMILY
With the monogram of the artist. Inscribed: *ALBERTVS DVRER / NORENBERGENSIS / FACIEBAT. POST / VIRGINIS PARTVM / 1509.* Oil on wood. 30.5 x 38.7 cm. Rotterdam, Museum Boymans-van Beuningen.

Hans Tietze and Erwin Panofsky have regarded this not particularly attractive picture as a copy, though they are probably in error.

The Paumgartner Altarpiece

406 →
The Left Wing: St. George
(Portrait of Stephan Paumgartner?)
Verso: The Virgin Annunciate (not shown). Oil on linden wood. 157 x 61 cm. Munich, Alte Pinakothek.

407 →
Right Wing: St. Eustace
(Portrait of Lukas Paumgartner?)
Oil on linden wood. 157 x 61 cm. Munich, Alte Pinakothek.

408 → →
Central Panel: The Nativity of Christ
In the background the Annunciation to the Shepherds. With the monogram of the artist. Oil on linden wood. 155 x 126 cm. Munich, Alte Pinakothek.

At the bottom are the donor, Martin Paumgartner (1436-1478) with his two sons, Lukas and Stephan, left; and his wife Barbara, née Volckamer (d. 1494) with her daughters Maria and Barbara, whose first married name was Reich. The bearded man on the left has been identi-
fied as Hans Schönbach, the second husband of Barbara Paumgartner.

The exact date of the altarpiece is disputed, made more difficult by information stemming from the 17th century that speaks of the creation of the likenesses of the Paumgartner brothers in 1498, although the central panel on stylistic grounds must have been produced between 1501/02 and 1504. The Virgin Annunciate was painted by an assistant; the angel that belongs to it is known only from copies.

305

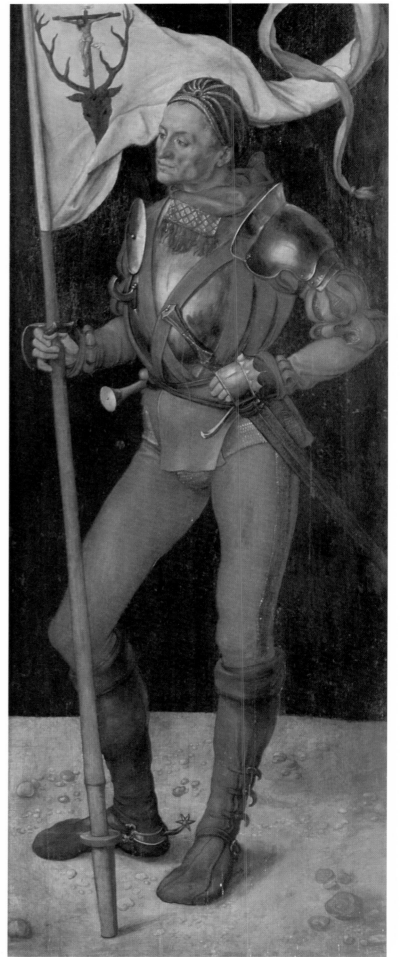

306

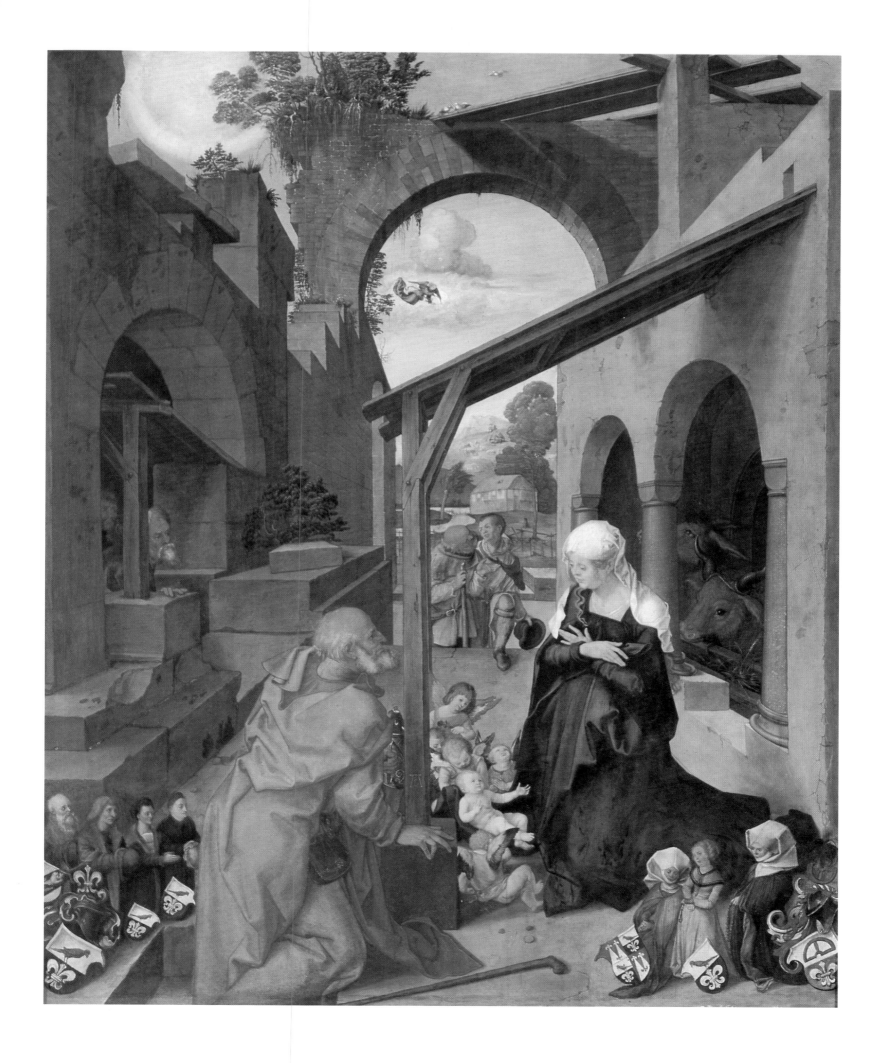

308

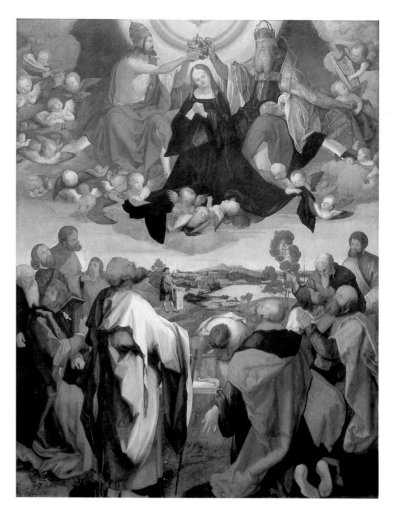

409 ←
STANDING APOSTLE: Preparatory drawing for the Heller Altarpiece
With the monogram of the artist and the date 1508. Brush drawing on green grounded paper, with wash and heightened with white. 407 x 240 mm. Berlin-Dahlem, Staatliche Museen Preussischer Kulturbesitz, Kupferstichkabinett. Cf. 411.

410
HEAD OF AN APOSTLE: Preparatory sketch for the Heller Altarpiece
With the monogram of the artist and the date 1508. Brush on green grounded paper, with wash and heightened with white. 317 x 212 mm. Vienna, Graphische Sammlung Albertina. Cf. 411.

411
THE ASCENSION OF THE VIRGIN (HELLER ALTARPIECE)
Copy by Jobst Harrich after Albrecht Dürer. In the background Albrecht Dürer with a large tablet placed on the ground, inscribed: *ALBERTVS / DVRER / ALEMANVS / FACIEBAT /*

POST / VIRGINIS / PARTU[m] */ 1509;* and the monogram of the artist. Oil on linden wood. 189 x 138 cm. Frankfurt a.M., Historisches Museum.

Nine surviving letters from the artist to the Frankfurt merchant Jakob Heller, who had ordered the picture for the Dominican Church, tell us about the creation of the original, which burned in the palace fire in Munich on 22 December 1729. The correspondence indicates that Dürer produced the central panel personally, but assigned the execution of the wings (Frankfurt a.M., Historisches Museum) to assistants (cf. 409, 410).

floats above them, and in the background a landscape extends into the distance. The Heller work anticipates a second work, the "All Saints Altarpiece," commissioned in 1511 by Matthäus Landauer for the chapel of a home for twelve indigent old men, the *Zwölfbrüderhaus* (413, 416). With it Dürer ended his activity as a painter "in the service of the Church," aside from the special group of small pictures of the Virgin. The charitable institution, modeled after the twelve apostles as well as similar homes elsewhere involving a like number of recipients, housed twelve elderly artisans who had had unexpected misfortune and were no longer able to pursue their crafts. The altarpiece, following Italian examples without wings, was displayed in a still-surviving frame designed by Dürer (414, 415), which reflects Gothic and Renaissance influence. The glass paintings in the chapel depicting the Last Judgment were likewise designed by Dürer (formerly, Berlin, Kunstgewerbemuseum; destroyed during World War II). The subject of the altarpiece is the adoration of the Holy Trinity. In the upper half of the picture God the Father, crowned as emperor, holds the Cross with the still-living Christ pinned to it. The dove of the Holy Ghost, in a glory of light and angelic cherubs, descends from the heavens towards the Father and Son. At the antipode, i.e., the earth, a landscape in the foreground appears to stretch out into infinity. The painter pictures himself standing alone next to a large memorial tablet into which is chiseled in antique capital letters the signature and the date, 1511. Floating on banks of clouds between heaven and earth is the community of the saints, men and women of the Old Testament on the right, martyrs for Christ on the left of the Holy Trinity; below them, in a wide arch stretching across the entire breadth of the picture, kneel the living, led by Emperor and Pope.

Among these the elderly donor, advanced by a cardinal, is shown experiencing the vision. A peasant has likewise found his way into this assemblage of the high and the mighty, carrying his threshing flail, turning his face, grown ugly with hard work, towards the angel who is assigned to him alone as guardian. This concern for the peasant and the implied elevation of the common man recalls a representation of the Last Judgment on the wing of an altarpiece dating from the last half of the 15th century, in the Church of Katzwang, south of Nuremberg. Whatever Dürer had learned in regard to perspective and the utilization of space he applied in this picture of the city of God, representing the ultimate secrets of Christian teachings. The impression of a vast but limited space uniformly encompassing the entire event portrayed is achieved solely from the positioning of the figures and the handling of color and light, in the absence of architectural elements. The superbly maintained surface of the painted panel, in which gold was used for the Pope's pluvial, makes very clear the importance of individual color values within the total concept of the painter.

412
THE VIRGIN IN PRAYER
With the monogram of the artist and the date 1518. Oil on linden wood. Berlin-Dahlem, Staatliche Museen Preussischer Kulturbesitz.

Right wing of a diptych; the no longer extant counterpart on the left wing presumably was the Man of Sorrows.

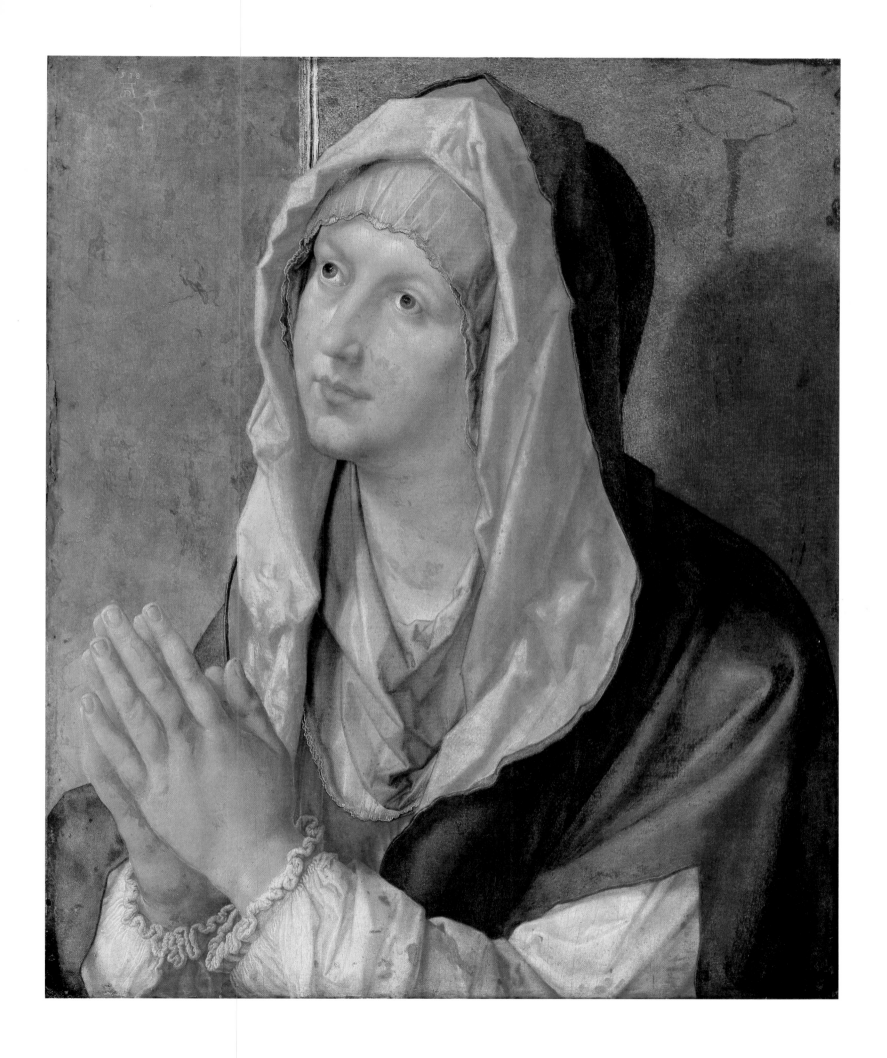

311

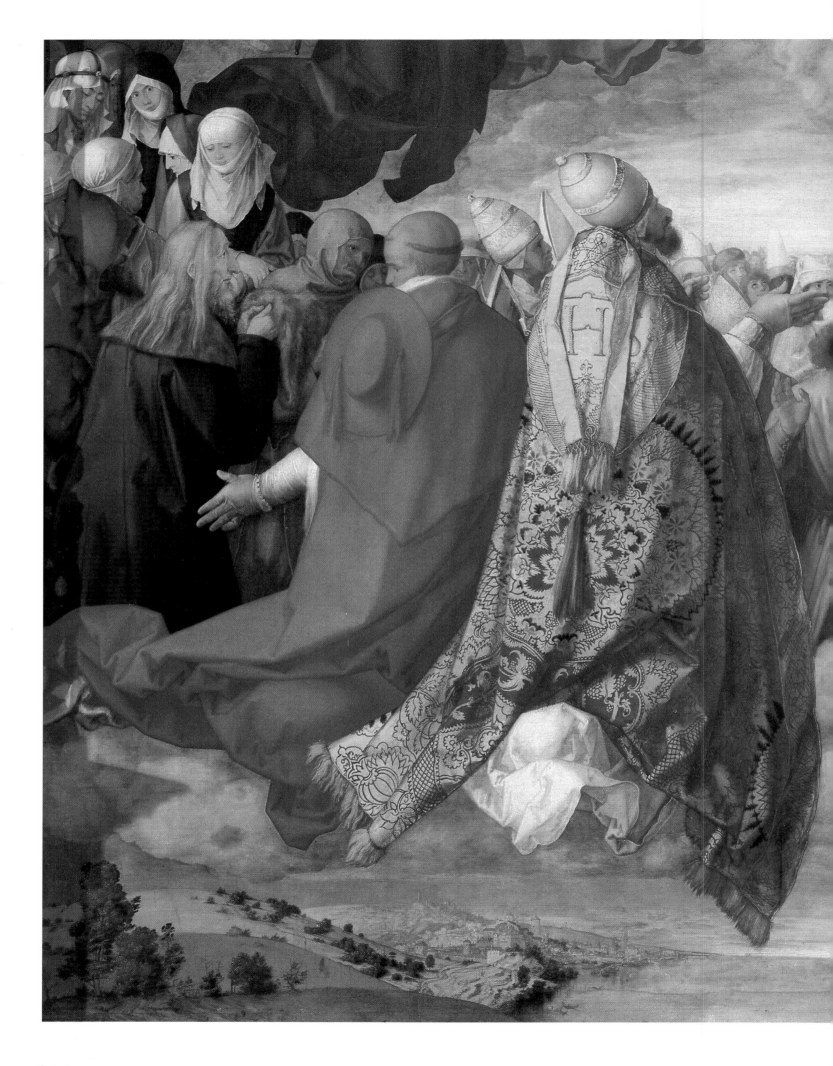

312

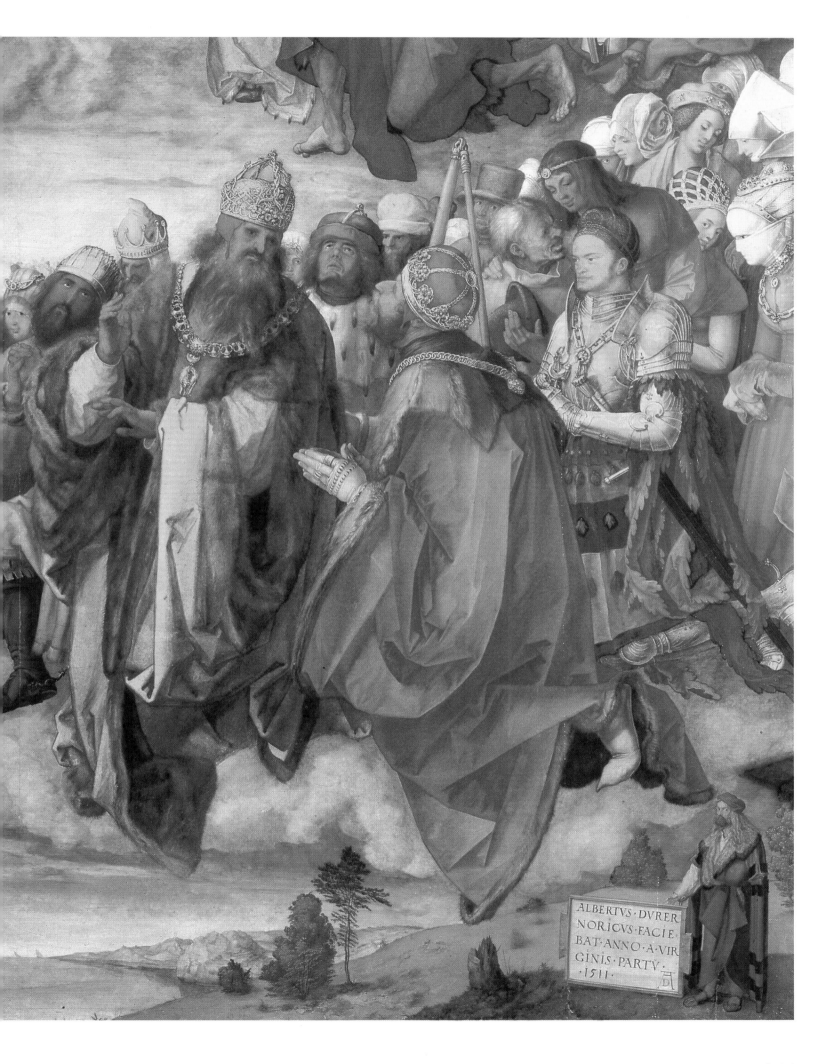

ALBERTVS · DVRER
NORICVS · FACIE
BAT · ANNO · A · VIR
GINIS · PARTV ·
· 1511 ·

313

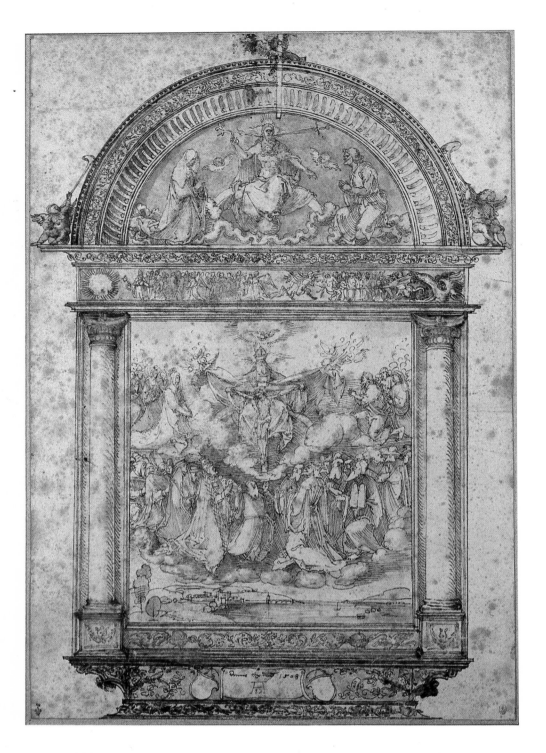

him bearing the inscription: *AL-BERTVS.DVRER/NORICVS. FACIE/BAT.ANNO.A.VIR/GINIS.PARTV./1511;* next to it the monogram. Oil on poplar. 135 x 123 cm. Vienna, Kunsthistorisches Museum.

Commissioned by Matthäus Landauer for the chapel of the Zwölfbrüderhaus, a home endowed by him for the care of twelve impoverished artisans. A portrait of the donor in profile is in Frankfurt a.M., Städelsches Kunstinstitut (Strauss, Drawings, 1511/17).

By a Nuremberg wood sculptor (Ludwig Krug?) after a design by Dürer. A tablet on the predella bears the inscription: *mathes landauer hat entlich vollbracht / das gottes haus der tzwelf brüder / samt der stiftnus und dieser thafell / noch xps* [Christi] *gepurd mcccccxj jor* [Matthäus Landauer has finally completed the house of worship of the Twelve Bretheren including the donation of this panel. After Christ's birth, the year MCCCCCXI]. The tablet is flanked by two coats of arms of Landauer. Linden wood with remnants of the old mounting and gilt. 284 x 213 cm. Nuremberg, Germanisches Nationalmuseum (Loan from the city of Nuremberg).

The carved figures represent the Last Judgment that precedes the general and permanent adoration of the Trinity. The division on the frieze of the blessed and the damned, surmounted by a depiction of the Virgin and St. John interceding with Christ as the judge of the world, is reminiscent of similar representations above the portals of Gothic cathedrals. The carver was formerly identified as the "Master of the Nuremberg Madonna" (Nuremberg, Germanisches Nationalmuseum), but more recently as the sculptor Ludwig Krug. For Dürer's designs for the altarpiece, see 413, 414, 416.

315

317

It becomes clear from some remarks in his correspondence with Willibald Pirckheimer and Jakob Heller that Dürer also painted pictures on speculation, hoping subsequently to find a purchaser. One of these depicted the Virgin, and was acquired by Johann Thurzo, Bishop of Breslau, for 72 florins. This indicates that its format was sizable. The need to possess a picture for private devotion was presumably also connected in the minds of the purchasers with the desire to own a work by a renowned artist. The inclusion of painted pictures of the Virgin in private collections helped to advance the secularization of pictorial subjects. The human relationship of a mother and child became the actual subject of these portrayals, and its religious significance remained intelligible only on the basis of tradition (419). Dürer's first painted formulation of the subject was the panel discovered in the Capuchin monastery of Bagnacavallo near Bologna. This painting has already been discussed (cf. p. 112 and no. 128).

In another painting of the Virgin, produced slightly later and commissioned by a member of the Nuremberg merchant family Haller, Dürer chose a majestic, erect stance that closely resembles a basic form used, with variations, by Giovanni Bellini, so much so that the panel was for many years held to be the work of the Italian, even though the total effect of the picture, including the landscape seen through the window and the remarkably uncomfortable position of the Infant, leave no doubt about its German origin (418). A greater riddle is provided by the verso picturing Lot's flight with his daughters from Sodom (417). The towering rocks presuppose landscapes which Dürer drew of stone quarries at the outskirts of Nuremberg in the years after his first return from Venice. The subject of the picture seems to have no relationship to the depiction of the Virgin on the recto, yet it is hard to believe that the painter would have used a panel that already bore a picture on the other side for a commission from such an important family, to boot merely a sawed-off portion from a very large picture whose subject apparently was the abduction of Lot by his daughters. One possible solution is that it was intended as the exterior of a diptych, following Netherlandish tradition, featuring the Virgin opposite a picture of the donor. The Lot story could then have formed the exterior side of the movable left wing. Relationships between recto and verso suggest that, if the destruction of the immoral city by fire searing down from heaven is viewed as the principal subject, it is emphasized by the departure of Lot, portrayed in contemporary middle-class fashion. Thus in this picture the artist addresses himself also to the idea of a sudden, catastrophic end of the world, an idea to which Dürer gave expression in his depiction of the Apocalypse. The connection with the recto would then — as postulated by contemporary theory — equate the Virgin with the Apocalyptic Woman who appears in the heavens in the final days of the world and gives birth to the Messiah.

419 ←
THE VIRGIN SUCKLING THE CHILD
With the monogram of the artist and the date 1503. Oil on linden wood. 24 x 18 cm. Vienna, Kunsthistorisches Museum.

417 ← ←
LOT FLEES WITH HIS FAMILY FROM SODOM
With the monogram *AA* or *AG* (?), not by Dürer, on a rock. Oil on linden(?) wood. 52 x 41 cm. Washington, National Gallery of Art, Samuel H. Kress Collection.

Verso of the "Haller Madonna" and probably produced at the same time (cf. 418).

418 →
THE VIRGIN AND CHILD AT A WINDOW (HALLER MADONNA)
With the coat of arms of the Nuremberg Haller family on the bottom left; the coat of arms on the right has not been identified. Oil on linden(?) wood. 52 x 41 cm. Washington, National Gallery of Art, Samuel H. Kress Collection.

The depiction, much under the influence of Giovanni Bellini, was probably produced c. 1498 (cf. 417).

319

At the same time as the great picture painted for the German merchants in Venice depicting the Virgin as queen of the Rosary, Dürer executed a smaller panel that likewise had the Virgin for its subject (420, 421). A slip of paper, which lies as if coincidentally on a table in the lower left, bears the signature in Latin and the date 1506. Unfortunately the present surface of the paint gives us but an intimation of the original radiant color with which Dürer consciously sought to compete with the Venetian painters. The Virgin is enthroned before a broad landscape replete with architectural motifs composed of Italian and German elements. Cherubs hold over her head a crown of woven foliage. The Virgin's right hand, resting on the book, suggests one of her attributes, *sedes sapientiae*, i.e., the seat of eternal wisdom. This same wisdom is expressed in the figure of the Infant Christ, seated on a cushion, the ancient symbol of the throne of the sovereign. Led by an angel carrying the symbolic staff with Cross, the young John the Baptist approaches, offering as gift to the young Savior and to the Virgin two lilies of the valley, emblematic of the Virgin. A siskin perched on the left forearm of the Infant gives the picture its name. Here Dürer brought new meaning to the conventional late Gothic handling of the Coronation of the Virgin and drew on his knowledge of Italian examples. He achieved a majesty hitherto unknown in German art, endowed with human, lovable features.

In later representations of the Virgin the portion portrayed is reduced. The interest focuses on the countenance of Mary and of the Infant Christ, and the close human tie between mother and child becomes the primary object. In the Vienna panel of 1512 (422) only the blue of the garment, and the veil and headband remain as traditional signs of the special position of the woman. She achieves her majesty from the deep earnestness with which she shows the child, lying outstretched in her arms, to the worshipers and observers. The dominant bright blue, as a "beautiful" color, together with the elegant young countenance of the mother and the appropriate depiction of the moving body of the child, may have helped make this one of the most popular of Dürer's pictures. It expresses human values which take on importance even beyond the underlying Christian theme.

After his return from the Low Countries the artist was once more intensively occupied with the subject of the Virgin; but the projected picture, about which we are informed by preparatory work, never materialized. Something of the character of this work, which was to be fashioned after the manner of the Italian *sacra conversazione*, i.e., the Virgin enthroned, surrounded by saints (148, 149, 151), found its way into Dürer's last Madonna, dated 1526, done one year after the official introduction of the Reformation in Nuremberg (423). Its type, expressing reflective silence, is prefigured in the design of a St. Barbara intended for the projected larger picture (148). The absence of the veil, taken over from Byzantine iconographic tradition, denotes that all attributes of the Virgin

420
THE INFANT CHRIST ENTHRONED: Preparatory drawing for "The Madonna with the Siskin"
With the monogram of the artist and the date 1506. Brush on blue Venetian paper, heightened with white. 403 x 266 mm. Bremen, Kunsthalle (missing since 1945).

The differences from the painting make clear that Dürer regarded the preparatory drawing as an autonomous work.

421
THE MADONNA WITH THE SISKIN
On a small piece of paper on the table in front of the Virgin: *Albert*[us] *durer germanus / faciebat post virginis / partum 1506;* next to it the monogram of the artist. Oil on poplar. 91 x 76 cm. Berlin-Dahlem, Staatliche Museen Preussischer Kulturbesitz.

have now been dropped. The picture achieves a meaning extending beyond the merely secular solely through the emotional tie between mother and child. This very close relationship finds expression, even more than in the common turning toward the fruit in the hand of the mother, in the emphatic contour that embraces mother and son. There is a hint here perhaps of the beginning of a new style of representation which would accommodate the precepts of the Reformation, an attempt to retain a place for the picture even in the new cult.

Albrecht Dürer was moved by a deep religiosity which ever and again found expression in his writings. His faith was no simple acceptance. He earnestly attempted to immerse himself in the theological issues which moved men of his era immediately before the outbreak of the Reformation. Together with a number of members of the leading families of Nuremberg, he belonged to the *Sodalitas Staupiciana*, gathered around the Augustine monk and professor of theology, Johann von Staupitz. The theologian engaged in the instruction of brothers in monasteries as well as well-to-do burghers of the cities of Southern Germany in the years after 1512. As a member of the same religious order as Martin Luther, Staupitz had been his confessor and spiritual mentor at Wittenberg, and his predecessor as professor of theology at the University.

Carel van Mander reports that the painter Scorel came from Holland to Nuremberg, probably around 1519, to work with Dürer. But when the latter began to involve himself with Martin Luther's writings, the Dutchman left. In 1525 the City of Nuremberg, following a religious debate in City Hall, formally joined the Reformation, an act which brought with it changes in the form of the religious service, the abolition of the memorial days for the dead, and the dissolution of the monasteries. The change in the centuries-old rites and ways of devotion, notwithstanding the tolerant attitude toward pictures of Luther and the reformatory preachers, could not be without effect on art, even if the firm attitude of the Nuremberg city government prevented iconoclastic excesses and attempts at social revolution. Aside from a remark in a letter of Willibald Pirckheimer in 1530 to the architect Johann Tscherte, which has been given this interpretation, we have no evidence that Dürer might have turned against the decision of the city or distanced himself from the Reformation, as did Pirckheimer and his biographer, Christoph Scheurl, after Dürer's death. In any event, his last painted work, two panels depicting Saints John, Peter, Paul and Mark in larger than life size (424, 425), shows that toward the end of his life Dürer adopted an attitude that was rather more sceptical about the religious situation in Nuremberg, which expectedly had its political overtones, in contrast to the enthusiasm expressed in his erstwhile lament for Luther in the diary from the Low Countries. The title "Four Apostles" which is usually given to these two panels is inexact, since the Evangelist Mark was not one of Christ's twelve disciples. The name was used as early as 1538, when the painter Georg Pencz received 15

422
THE VIRGIN WITH THE CHILD, HOLDING HALF A PEAR
With the monogram of the artist and the date 1512. Oil on linden wood. 49 x 37 cm. Vienna, Kunsthistorisches Museum.

322

323

florins for gilding the frame. Below the figures are inscriptions chosen by Dürer from the Scriptures, but written on the panels by the calligrapher Johann Neudörffer. They begin with the words: "All worldly rulers in this threatening time, beware not to take human delusion for the Word of God. For God wishes nothing added to his Word, nor taken from it. Take heed of the admonition of these four excellent men, Peter, John, Paul and Mark." Quotations from the writings of the four holy men follow, based on Martin Luther's translation of 1522. Warnings are given against men who lead others astray by presenting themselves as teachers and prophets, but falsify the true teaching or attempt to hide their improper doings behind the appearance of a life pleasing to God.

Dürer's admonition gains its true impact from the artistic form, by the power of the figures themselves. Implacable, like memorials, John and Paul stand in the front, covered with cloaks whose deep, shadowed folds seem as if carved from stone and whose color, a bright red and a bright, cool blue, reflect on the wearers, not on the fabric of their garb. Dürer decided to give both men the true image of spiritual immovability. St. Peter, the chief apostle of the Roman Church, is at the left, in the second row, but he is first in the order of the inscription as if to confirm his position in the hierarchy. Corresponding to him on the right panel is St. Mark. Both protagonists hold the book that contains the word of God. Peter reads with John the passage to which the book has been opened, whereas the two men on the right panel look beyond the closed tome. Aside from the inscriptions on the pictures, Sts. Peter and Paul can be identified by their attributes, the key and the sword.

Dürer prepared his work very carefully. For John there is a drawing of the entire figure dated 1525 (Bayonne, Musée Bonnat), for the remaining saints, large studies of the heads from the year 1526 (Berlin-Dahlem, Staatliche Museen Preussischer Kulturbesitz, Kupferstichkabinett; fig. 434). The pictures were not commissioned, but were painted with the spot where they were to hang in mind, so that the glances of the figures would exercise their intended effect. The artist offered them to the City Council of Nuremberg as a gift in his memory, and wrote: "Now that recently I have painted a panel and put more effort into it than other pictures, I know of no one worthier than Your Excellencies to have this as a memorial."

The panels must be regarded in connection with the furnishing of city halls as centers of municipal power and justice, but they go well beyond the usual calls for impartial justice, exemplified by representations of the Last Judgment or historical pictures depicting just and unjust judges. They address a new category of responsibility which worldly rulers had acquired from the earlier ecclesiastical supremacy. Since the City Council, in 1525, had opted for the introduction of the Reformation and had made its resources available to carry through this decision, it no longer sufficed to govern in accordance with the Word of God. It now took over from the

423
THE MADONNA WITH THE PEAR
With the monogram of the artist and the date 1526. Oil on wood. Florence, Galleria degli Uffizi.

325

episcopal authorities in Bamberg or of Rome the responsibility they no longer could exercise to insure the purity and interpretation of this word. In the "Four Apostles" Dürer wanted to portray the entire range of human character. Johann Neudörffer, Dürer's first biographer, wrote about the four life-size likenesses in his *Nachrichten von Künstlern*, published in 1547: "therein one can recognize the sanguine, choleric, phlegmatic, and melancholic temperaments." Since the writing master had himself placed the inscriptions beneath the pictures, his description of the intent of the painter is surely correct. From Johann Neudörffer we also learn that the pictures hung in the "upper government chamber" of the Nuremberg City Hall, a ceremonial room whose original purpose is not known, but which in time acquired the character of an art gallery containing important evidence of the scientific and artistic activity of Nuremberg.

His portrayal of the apostles includes reminiscences of Venice. Undoubtedly related are the images of Sts. Nicolas and Peter, as well as Sts. Benedict and Mark, on the wings of a triptych in the Church of S. Maria Gloriosa dei Frari, created in 1488 by the painter so much admired by Dürer, Giovanni Bellini. If one disregards a possible connection with the twin panel pictures of Justice which Dürer had seen in the city halls of the Low Countries, the "Four Apostles" might have been intended as wings of a triptych whose central panel was not carried out on account of the changed religious situation in Nuremberg. However, this hypothesis is not supported by technical evidence. Precise investigations by the Administration of the Bavarian Government's collection of paintings show that the two panels were planned just as they appear today and were completed without any substantial change. This also rules out Erwin Panofsky's once seemingly convincing theory that St. Paul had originally been a St. Philip related to an engraved likeness of the latter (433). Dürer's "Four Apostles" are not the result of a change of plans due to a change of rites. They were intended for the City Hall right from the beginning and owe their creation to Dürer's deep concern for the condition and the future of art, a concern which found expression in his contemporary writings.

In 1627, when Nuremberg could no longer withstand the political pressure, the Bavarian Duke and later Elector Maximilian I demanded that the pictures be moved to Munich, nor was he dissuaded from this by Dürer's own expressed wish, "to keep them in the common city in his memory, and not permit them to come into strange hands." The Council, fearing economic reprisals, sent to Munich both the originals and copies thereof, made upon Maximilian's order by the court painter Fischer, which were to hang in Nuremberg as a substitute (440, 441). It was hoped that the Jesuits at the court in Munich would object to the inscription beneath the pictures and would press for return of the originals, keeping only the copies which did not include the texts. In a Solomonic decision Maximilian had the writing sawed off and sent back to Nuremberg with the copies. It was nearly three hundred years before pictures

424
THE APOSTLES JOHN AND PETER
With the monogram of the artist and the date 1528. The open book shows the translation of the beginning of the Gospel of John (vs. 1, 2, 6, 7) partially obscured by the other portion of the book, the finger, and the clasps. Inscribed in German on the lower border, based on Rev. 22:18-19: "All worldly rulers in this threatening time, beware not to take human delusion for the Word of God. For God wishes nothing added to his Word, nor taken from it. Take heed of the admonition of these four excellent men, Peter, John, Paul and Mark." Below the figure of St. John, Peter's Epistle 2:1-3. Below St. Peter, John's Epistle 4:1-3. Oil on linden wood. 215 x 76 cm. Munich, Alte Pinakothek.

425
THE APOSTLE PAUL AND THE EVANGELIST MARK
With the monogram of the artist and the date 1526. Below the figure of St. Mark, Paul's second Letter to Timothy, 3:1-7. Below St. Paul the Gospel of Mark, 12:38-40. Oil on linden wood, 214 x 76 cm. Munich, Alte Pinakothek.

In his letter of 6 October 1526, Dürer offered both pictures to the Council of the City of Nuremberg as a gift. He was given in recompense the sum of 100 florins, plus 12 florins for his wife. The pictures were displayed in the City Hall. The inexact designation "Four Apostles" was used as early as 1538, when the painter Georg Pencz was paid 15 florins for gilding the frames. The scriptural texts written by the calligrapher Johann Neudörffer correspond to Martin Luther's Bible translation of 1522.

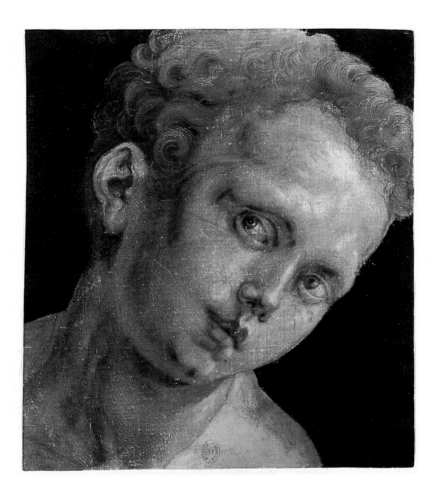

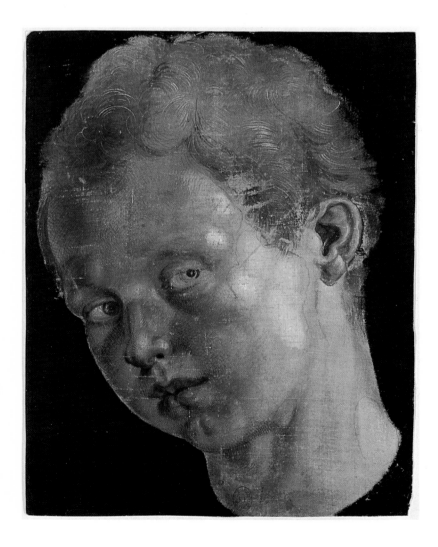

426

HEAD OF A BOY FACING TOWARD THE RIGHT

With the faint monogram of the artist in the upper left. Watercolor on paper, mounted on canvas, over underdrawing in pen and ink. 226 x 193 mm. Paris, Bibliothèque Nationale, Cabinet des Estampes.

427

HEAD OF A BOY FACING TOWARD THE LEFT

Watercolor on paper, mounted on canvas, over an underdrawing in pen and ink. 223 x 181 mm. Paris, Bibliothèque Nationale, Cabinet des Estampes.

The artist began these two studies, drawn from life, in pen and ink, then completed them with watercolor. In this respect they differ somewhat in technique from the study of a young woman (429). All three portraits were formerly in the collection of the Abbé Michel de Marolles. In the same collection was also the drawing "Three Heads of Children," dated 1506, whose background has similarly been filled in with black (Paris, Bibliothèque Nationale; Strauss, Drawings, 1506/10). The date and purpose of the two heads of a boy remain uncertain. They seem close to the preparatory drawings in large format for the paintings of 1505/06 in Venice, although the former render their models in less idealized fashion. The contour of the neck of the boy facing toward the left is reminiscent of antique coins and medals, such as that employed by Dürer in the portrait of Johannes Kleberger (301) in 1526.

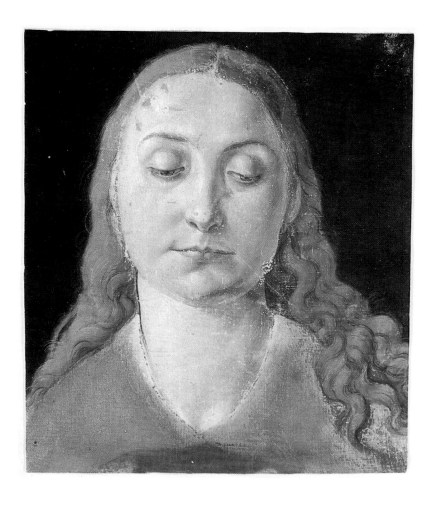

428

PORTRAIT OF A WOMAN WITH
LOOSE HAIR (AGNES DÜRER?)
In the upper right, difficult to see,
the monogram of the artist and a
date (?). Watercolor on canvas.
256 x 217 mm. Paris, Biblio-
thèque Nationale, Cabinet des
Estampes.

*Walter L. Strauss, who dis-
covered the signature, believes
that below it appears a date of
1503 or 1505. His dating has been
generally accepted, which makes
it possible to identify the sitter as
Agnes Dürer. The long, loose
hair and the lowered eyes permit
the assumption that this work
may have been intended as a
study for a painting of a Madon-
na. For the use by Dürer of fine
canvas, see p. 149.*

and writing were reunited and Dürer's work once again acquired the
full impact of its message, in which picture and words reinforce one
another.

In 1542 Christoph Scheurl dedicated a description of the family
background of his mother, Anna Zingel, to his nephew, Albrecht
Scheurl (manuscript in the Germanisches Nationalmuseum,
Nuremberg). Since Albrecht Scheurl was Dürer's godson, the elder
Scheurl also sent the then student in Paris an account of what had
happened at the death of the painter, whom he calls "the German
Apelles and the most artistic painter of his times." "Dürer died," he
wrote, "on the sixteenth of April 1528, and was buried in St. John's
cemetery in honorable fashion, but was then disinterred by artists,
so that they could make a cast of his face." His most important
pupil, Hans Baldung Grien, received a lock of his hair; it is pre-
served in the Kunstakademie in Vienna. Dürer fell victim to a brief
but severe illness. His friend Willibald Pirckheimer composed the
inscription on his gravestone. In this he took the tenor of the in-
scription Dürer had placed on his own engraved likeness, but
changed the more general epigram into a very personal expression.
Words, which could not be simpler, recorded the eternal life of the
achievements of the dead artist: *Quicquid Alberti Dureri mortale
fuit, sub hoc conditur tumulo* — What was mortal of Albrecht Dürer
lies under this stone.

329

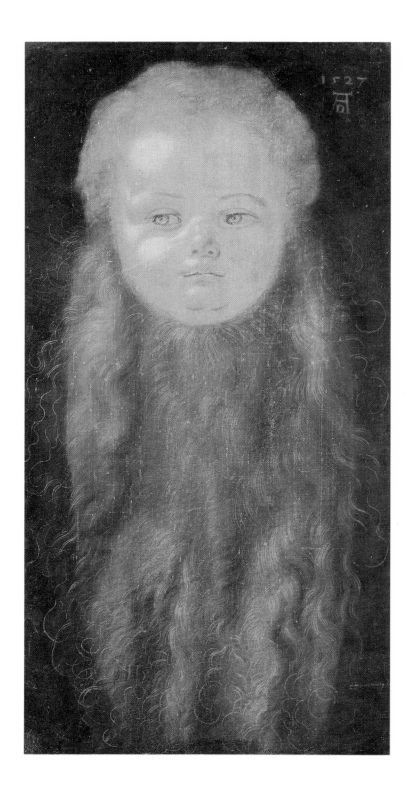

PORTRAIT OF A BOY WITH A LONG
BEARD

With the monogram of the artist
and the date 1527. Watercolor on
canvas. 552 x 278 mm. Paris,
Musée du Louvre, Cabinet des
Dessins.

*This, the last of Dürer's auto-
graph paintings, has defied inter-
pretation, but is evidence of
Dürer's unflagging interest in the
extraordinary. It is hard to
believe that a real caprice of
nature is here pictured, of the
kind that was thought to be a
portent of misfortune; nor has
any contemporary record come
down to us describing such an
oddity. Consideration has also
been given to the possibility that
a paedogeron [boyish old man] is
pictured here, allegorical of an-
cestry and posterity combined in-
to one image. But Erwin Panof-
sky has shown that this idea is
based on a misunderstanding by
Caelio Calcagnini, a humanist of
Ferrara, in connection with his
translation of Plutarch's descrip-
tion of a Greek temple of the
Egyptian goddess Neith, who
was equivalent to Athena.
Dürer's attention might have
been called to this passage by
Willibald Pirckheimer, who had
translated the* Hieroglyphicae *of
Horus Apollo from Greek into
Latin. Dürer provided illustra-
tions for that translation (cf. p.
178).*

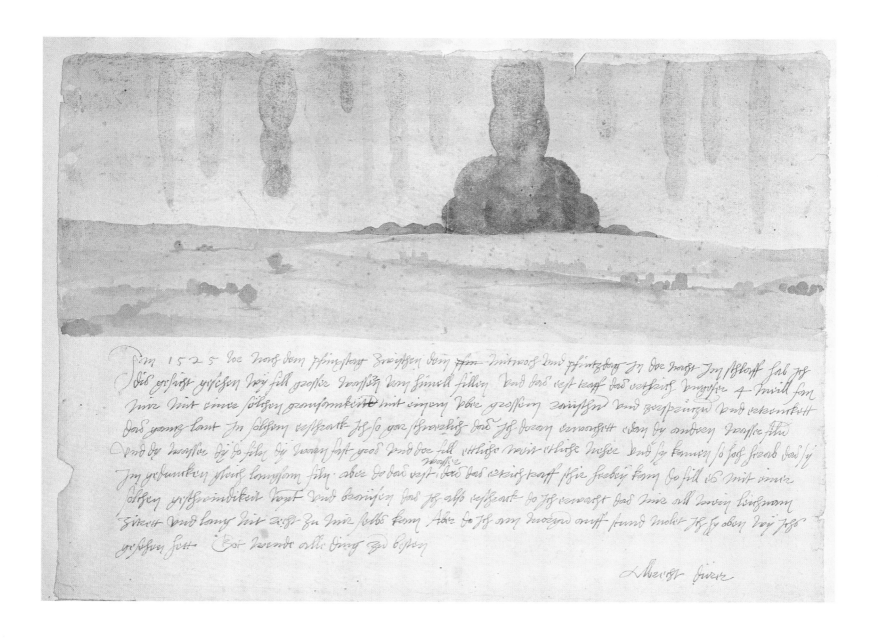

430

VISION OF A CLOUDBURST
With a long explanatory inscription by Dürer and the date 1525. Watercolor on paper. Glued into the so-called *Ambras Album* after 1822. 300 x 425 mm. Vienna, Kunsthistorisches Museum.

The watercolor and the accompanying text describe a dream Dürer had during the night between Wednesday and Thursday after Whitsuntide, 7-8 June 1525, *about a great rushing of water from Heaven. (For the text, see p. 363.) The Ambras Album contains engravings, woodcuts and drawings by Albrecht Dürer. It derives from the estate of Archduke Ferdinand of the Tyrol. This watercolor was willed to the Ambras Collection by the Innsbruck collector Anton Pfaudler (d. 1822). (Strauss, Drawings, 1525/4).*

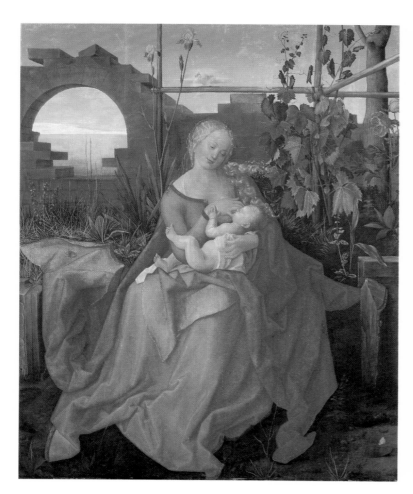 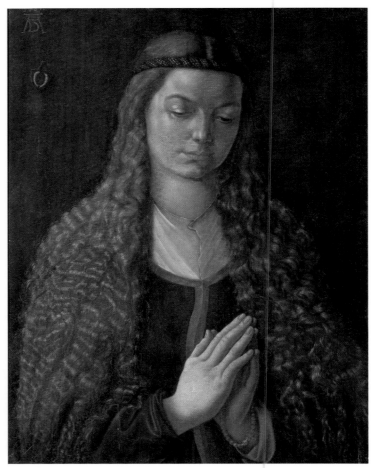

431
THE MADONNA WITH THE IRIS
Imitator of Albrecht Dürer.
With the spurious monogram of
Albrecht Dürer and the date
1508. Oil on canvas. 149 x 117
cm. London, National Gallery.

*Other versions are in Prague and
in Stift Wilhering, Austria. They
probably date from the end of the*

*16th century, based on Dürer's
motifs.*

432
YOUNG WOMAN IN PRAYER WITH
LOOSE HAIR
Copy after Albrecht Dürer.
With the monogram of the artist
and the date 1497. Below it ap-
pears the coat of arms of the
Fürleger family of Nuremberg.

Oil on canvas, mounted on
wood. 56 x 43 cm. Frankfurt
a.M., Städelsches Kunstinstitut.

*Formerly referred to as "Katha-
rine (?) Fürleger with Loose
Hair." Slightly different versions
are in Munich (Bayerische Staats-
gemäldesammlungen) and in
Budapest. It was engraved by
Wenzel Hollar.*

332

Gisela Goldberg:
A Technical Analysis of Albrecht Dürer's
"Four Apostles"

In 1931 Erwin Panofsky advanced theories which attracted wide attention about the execution of Dürer's "Four Apostles," theories based on some of his observations and those Karl Voll had proposed as early as 1906. It had been Panofsky's desire, unfulfilled in his own day, to test these theories by technical analysis:

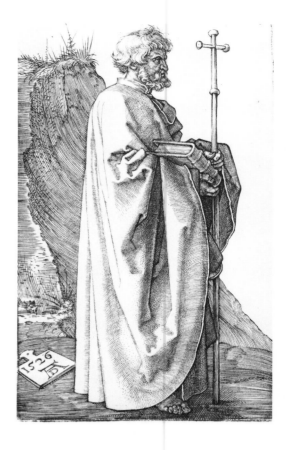

RIGHT PANEL (PAUL/MARK): Originally only one figure, that is, the one standing in the foreground, shown in strict profile, facing left. Panofsky "dared to suggest that the present Paul had originally been a St. Philip, done in 1523, and subsequently converted into a Paul." This figure corresponds to the 1523 drawing (Strauss, *Drawings* 1523/11) and to the engraving of 1526 (B. 46) (in mirror image). Consequently: originally the hair was full; in place of the sword was a staff in the form of a cross (cross reaching up as far as the top of the skull); the position of the hands differed (the right hand was above the spine of the book, holding the staff). The present head of Paul was supposedly superimposed on an already fully completed head of Philip and exhibits numerous changes: these produce the effect of enlarged size, along with conversion of a pure profile into a sort of three-quarter one. The forehead was increased some 3 cm on the left, the original outlines of the forehead now appear as "thinker's creases." The nose, already fully developed, was broadened at its base, and its tip significantly lengthened. The eyes, originally shown purely in a side view, were brought around to nearly a frontal approach, the shape of the forehead around the eye sockets was improved upon. By contrast Mark exhibits a form in motion in the head portion, indicative of an addition to an already virtually complete color layer. Should the lower border of the picture, on which the writing is contained, be original (Voll thought it was added later), then one would have to imagine a base strip containing a large, stylized inscription, such as *PHILIPPVS*.

LEFT PANEL (JOHN/PETER): In contrast to Voll, Panofsky maintained that the left panel was intended from the outset to accommodate two figures.

For both Voll and Panofsky these theories lead to a variety of conclusions which art research was supposed to re-evaluate. As an aid to this research the results of a technical analysis that has meanwhile been carried out are given below. In connection with the preparation of the catalogue of Early German Painting in the Alte Pinakothek in Munich (1963) and the observations of Kurt Martin concerning "The Four Apostles" (Reclam, 1963), Voll's and Panofsky's arguments were critically evaluated on the basis of all methods of scientific analysis that have become available. The results were reported in abbreviated form in both publications, but it was intended that Martin should repeat and expand on these observations, utilizing further details and photographs provided by the investigation of the Doerner Institute (of the Bavarian Staats Gemäldesammlungen). In carrying out this investigation, in addition to Christian Wolters and Kurt Martin, a number of others were involved: Christian Altgraf zu Salm, Johannes Taubert, Bruno Heimberg, Karl

433
The Apostle Philip
With the monogram of the artist and the date 1526, altered from 1523. Engraving. 122 x 76 mm.

This print belongs to a series of the apostles of which five sheets were issued. Two appeared as early as 1514, three others are dated 1523. In the case of Philip the date was altered to 1526 for unknown reasons.

334

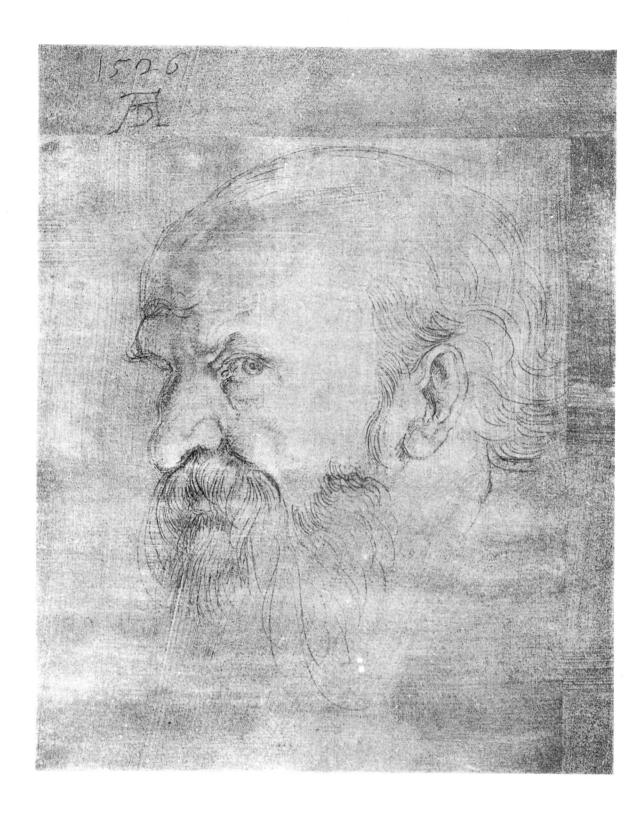

434
THE HEAD OF ST. PAUL
Preparatory drawing for the
panel "The Apostle Paul and the
Evangelist Mark"
With the date 1526 and the
monogram of the artist. Drawing
in metalpoint on brown ground-
ed paper, heightened with white.
354 x 288 mm. Berlin-Dahlem,
Staatliche Museen Preussischer
Kulturbesitz, Kupferstichkabi-
nett. Cf. 425.

Arndt, August Bresgen, and the author of this article. The death of
Kurt Martin in 1975 prevented this plan from being carried out.
Meanwhile there were yet other, more extensive investigations by
the Doerner Institute, and the entire question was again discussed
by Hubertus von Sonnenberg, Richard Lohe and the author. The
results are presented here.

RIGHT PANEL (PAUL/MARK):
Linden wood *(Tilia spp.)*, 214.5 x 76 cm. The panel consists of 14
rectangular boards of varying widths, on average 12 mm thick. The
lowest board contains the inscription sawed off in 1627 by order of
Elector Maximilian I of Bavaria and reattached in 1922.

335

PAUL: Infrared photographs of the head of Paul reveal that the contours of the head were spared out from the outset within the black background (436). This can be seen with the naked eye. What Panofsky assumed to be a first version of the skullcap is not the outline of an early form, but the contour of the spared-out area. The strongly emphasized skullcap extends beyond this area — as can also be observed, for example, in the companion panel and in "Lucretia" (230). In the forehead portion the vertical crease, with a shadow running through it, was likewise intended from the start to be a crease and not the edge of the forehead. (It should be noted that the two graphic representations of Philip cited by Panofsky exhibit a vertical forehead crease.) The lines of the neck and the cheeks show no changes. An X-ray of the skullcap, after a partial removal of the coating on the verso that was impervious to X-rays, shows that there was no hair structure under the surface (435). There is no evidence that the eyes were altered. Possibly shadow areas around the inner corner of the eye must be regarded as preparatory for an eye originally intended to be more lancet-shaped and directed more upwards. There is no evidence of pentimento in the eye but it is clearly present in the case of the ear, which was originally some 15 mm further to the left, with strands of hair already laid on. Although the sword appears particularly well-rounded, thus giving Panofsky reason (he cites an observation of Wolfgang Stechow's)

435
Albrecht Dürer's "Four Apostles," right panel (detail): head portion of Paul, and title. X-ray photograph.

436
Albrecht Dürer's "Four Apostles," right panel (detail): head of Paul. Infrared photograph.

437 →
Albrecht Dürer's "Four Apostles," right panel (detail): sword pommel and hands of Paul and Mark. X-ray photograph.

438 → →
Albrecht Dürer's "Four Apostles," right panel (detail): hands of Paul and Mark. Infrared photograph.

336

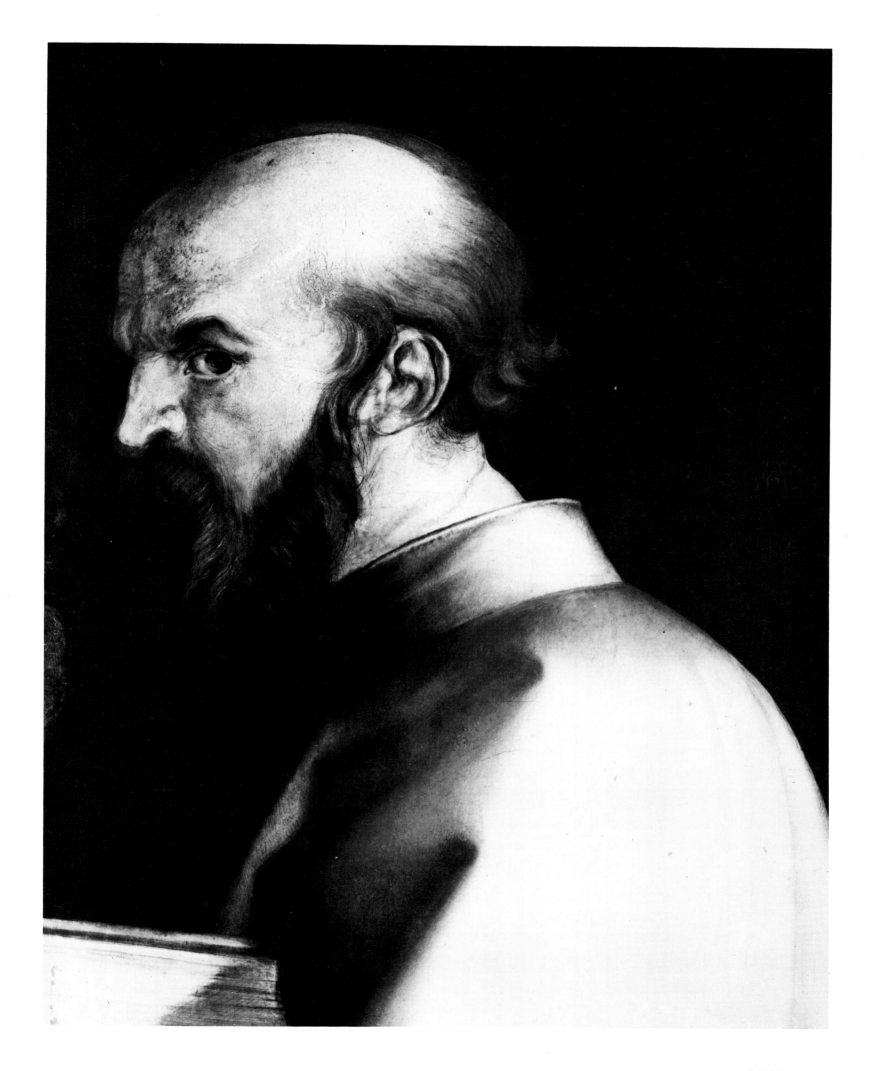

338

339

340

for his notion that the original plan called for a staff in the form of a cross. However, X-rays have provided incontrovertible evidence that this hypothesis is untenable (437, 438). Investigation centered on the pommel of the sword and the three hands, following partial removal of the X-ray-proof coating on the reverse side. The pommel of the sword was imbedded from the beginning in the background coloring; the area reveals no differences in the visible paint on the top surface: that means that the sword pommel was envisaged from inception, as also were the positions of the three hands. Nor is there any evidence to support the opinion that Paul's left middle finger was intended, as in the graphic representations, to hold a fold of the gown. Above the pommel of the sword there is no sign of the supposed continuation of the proposed staff.

MARK: The head is covered by a network of early shrinkage cracks which are, however, not present on the other flesh sections (feet, hands) (439). This must be due to the mixing of the binder. There is no evidence for assuming the presence of a white undercoat beneath the black background under the head; quite the contrary: small errors (moving left from the left nostril) extending down into the chalk ground show that there is no black background layer under the head. Furthermore, the brightness of the head, feet and hand of Mark leads to the conclusion that this form was, from the outset, spared out.

INSCRIPTIONS: Above the two figures are their titles: .S. MARCVS and .S. PAVLVS. These were later touched up with darker colors. They can be recognized in the side lighting. Since they also appear in the X-ray (only the portion above Paul was X-rayed), one must conclude that they were done with a lead-base paint (white? yellow?) (435). One has to imagine these inscriptions as they appear on the copies painted in 1627 (Nuremberg, Germanisches Nationalmuseum) (440, 441). The lower rectangular board with the lines written by Johannes Neudörffer (1497-1563) belongs to the original: the borders of both the painting and the inscription panel line up. As far as can be determined with the naked eye, the base coat on both inscription and pictorial panel is of the same thickness.

439
Albrecht Dürer's "Four Apostles," right panel (detail): head of Mark and head portion of Paul. Infrared photograph.

440, 441
THE FOUR APOSTLES (copies)
Johann Georg Fischer.
1627. Oil on linden wood. Each 208 x 77 cm. Nuremberg, Germanisches Nationalmuseum.

341

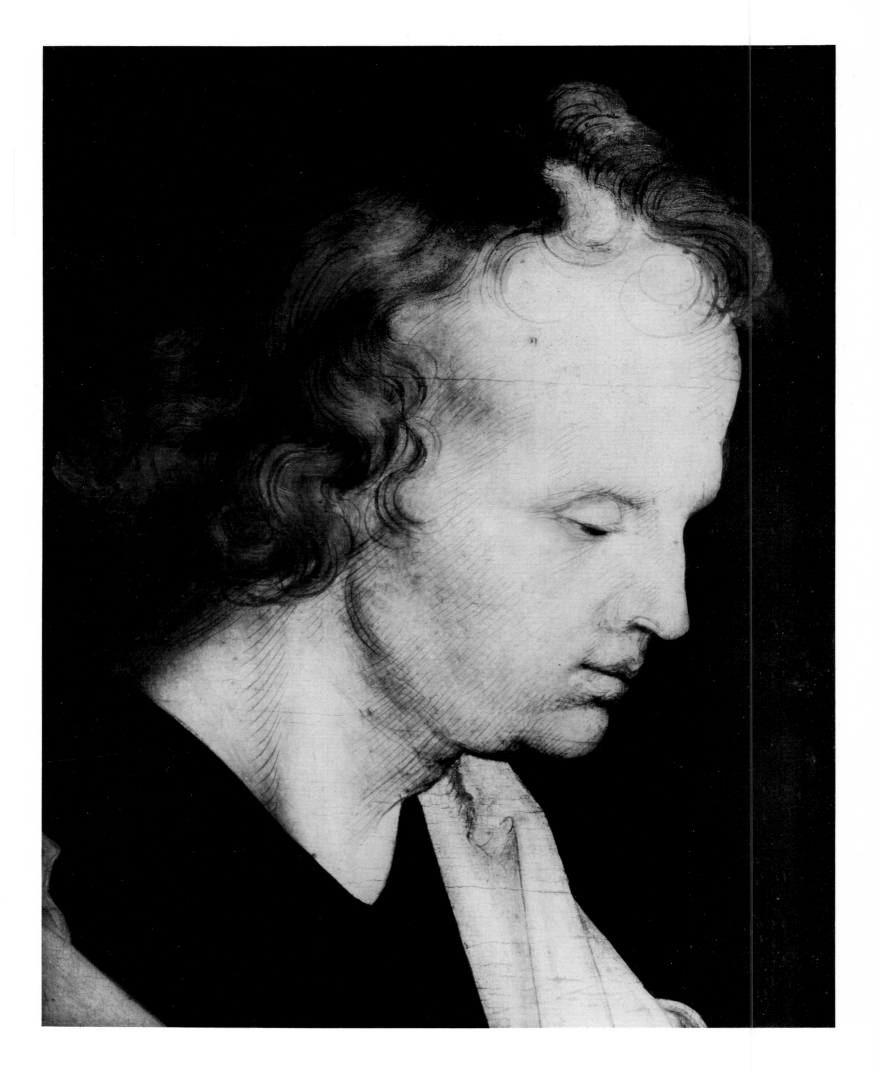

342

442
Albrecht Dürer's "Four Apostles,"
left panel (detail): head of John.
Infrared photograph.

443
Albrecht Dürer's "Four Apostles,"
left panel (detail): hands of John.
Infrared photograph.

444
Albrecht Dürer's "Four Apostles,"
left panel (detail): feet of John.
Infrared reflectogram.

LEFT PANEL (JOHN/PETER):
Linden wood *(Tilia spp.)*, 215.5 x 76 cm. The panel consists of 13 rectangular boards of varying widths and on average 12 mm thick. The lowest board is the inscription panel ordered sawn off in 1627 by Elector Maximilian I of Bavaria and reattached in 1922.

Since the paint layer is less dense than on the Paul/Mark panel, infrared photographs bring out clearly the basic drawing with its shadings of the head (442), and reveal pentimenti, e.g., Peter's nose (445; 443, 444). The spilling over of paint onto the spared-out areas from the background can be clearly seen (cf. likewise the right panel, head of Paul): specifically, on the outline of the forehead and nose of John and on the forehead and cheekbone contours of Peter.

As regards the INSCRIPTION, see that of the Paul/Mark panel. As for the titles, it should be noted that the title of Peter shows through only faintly.

343

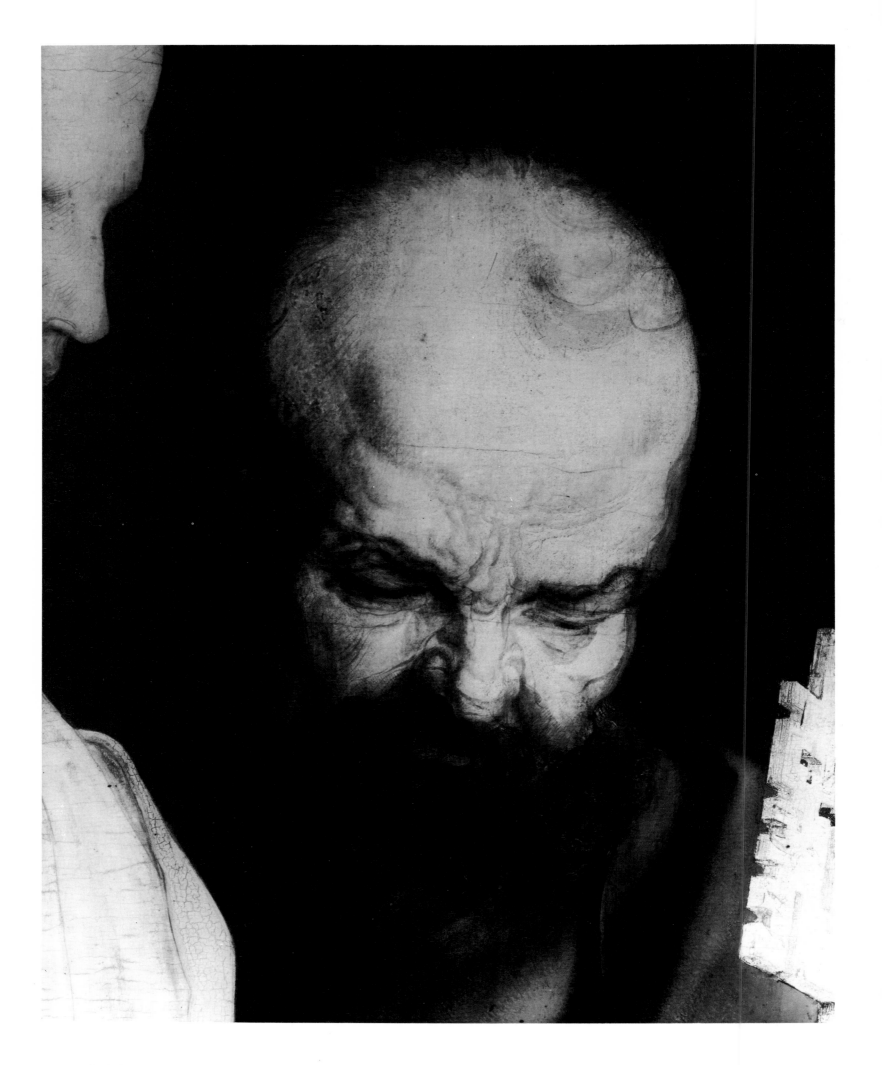

344

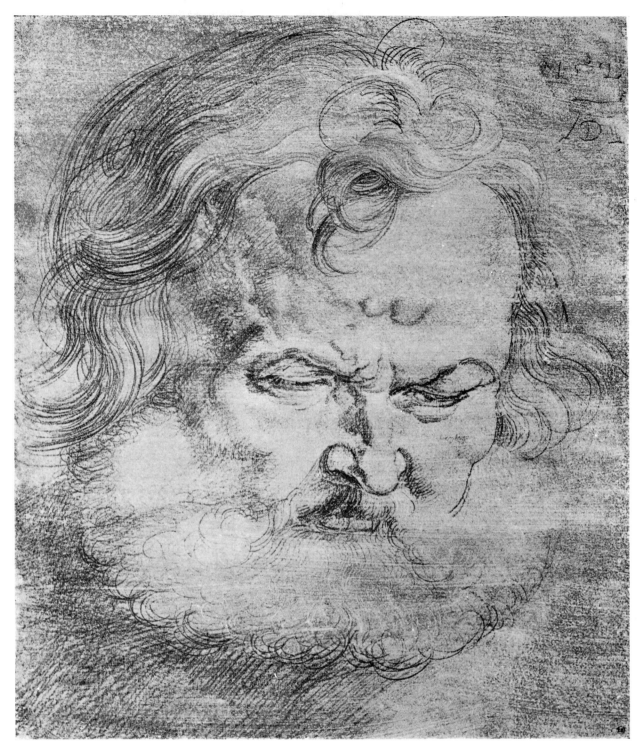

445
Albrecht Dürer's "Four Apostles,"
left panel (detail): head of Peter.
Infrared photograph.

446
HEAD OF ST. PETER
Preparatory drawing for the
panel "The Apostles John and
Peter"
With the date 1526 and the
monogram of the artist. Metal-
point on brown grounded paper,
heightened with white. 354 x 288
mm. Bayonne, Musée Bonnat.
Cf. 425.

The investigation has shown that at the outset both panels were
conceived exactly as they were carried out. The clearly recognizable
overpainting of the ear portions and the corner of Paul's eye, as well
as the brush strokes extending beyond the boundaries of the areas
left blank on the skull and nose cannot be interpreted as evidence of
a differing concept; they are but evidence of continuing creative
process.

345

The general nature of wood panels used for painting has not been investigated rigorously. The staves running parallel to the narrow side are certainly not unusual. They are found similarly in Altdorfer's "Battle of Alexander," Feselen's "History of Cloelia," Cranach's "Virgin and Child," (all these are in the Alte Pinakothek in Munich).

Thus, the technical analysis of the apostle panels shows that the Paul/Mark panel was produced in a slightly more complicated fashion, which can no longer be definitively established, than the John/Peter panel, which seems to have been produced in undisturbed circumstances.

Karl Voll. "Zur Entstehungsgeschichte von Dürers vier Aposteln." *Süddeutsche Monatshefte*, 3, 1906, pp. 73-80.

Erwin Panofsky. "Zwie Dürerprobleme (Der sogenannte 'Traum des Doktors' und die sogenannten 'vier Aposteln')." *Münchner Jahrbuch der bildenden Kunst*, new series, 8, 1931, pp. 18-48.

Alte Pinakothek, Munich. *Katalog II. Altdeutsche Malerei*, prepared by C.A. zu Salm and G. Goldberg. Munich, 1961, pp. 80-86.

Albrecht Dürer, Die Vier Apostel. Introduction by Kurt Martin. Stuttgart (Reclam), 1963.

Photographs 435-445 (except 440, 441: Germanisches Nationalmuseum, Nuremberg) from the Bavarian Staategemäldesammlungen, Munich.

JOSEPH HARNEST:
DÜRER AND PERSPECTIVE

"Perspective is a Latin word, and means a 'seeing through'," wrote Dürer in his "Nourishment for Young Painters," and meant by it the exact representation of space, seen in perspective, just as we still understand and practice it today. For the artist, instruction in this area was just as important a part of his theoretical training and creative effort as instruction in any other discipline up to and including specific rules of how to live. Thus, knowledge of perspective had an essential role to play in "incorrect painting," so that "anger" could be avoided. "For the chief and most prized of the human senses," wrote Dürer, "is that of seeing," and it is very easy to insult.

In order to achieve a proper "seeing through," a "light consisting of straight lines" is required that serves as "the medium between the eye and the object it sees." The means for this is the transparent picture plane on which, as on a window, the object is drawn by the eye, and which has, since c. 1420, enabled artists to delineate optically correct spatial relationships of bodies on the picture area. In this Dürer was in the difficult situation of having to catch up, learn and complete what his Italian colleagues, as geographical heirs of the classical world, had amassed much earlier, in a gradual developmental process to attain the new principles of spatial relationships. That was why he arrived at proper pictorial perspective only after substantial effort, often by leaps and bounds, along a meandering path whose actual course can now be plotted.

Those of Dürer's works which are important for this discussion and our modern experience in perspective drawing make it possible for us to trace Dürer's uneven but always logical development in dealing with optical rules. But before we attempt to follow him on this journey, it is important to explain the simple device of the *ars perspectiva*, as the 15th century produced it and passed it on to succeeding generations.

Fundamentally, the perspective of interior or exterior architectural spaces was constructed fontally by the Italian artists and by Dürer, that is, so that the picture surface acted like a large window that took the place of the forward wall, through which the viewer looked into the room behind it. The back wall thus was positioned parallel to the picture surface, and was likewise seen frontally. This entire "peep show" was never positioned diagonally or crosswise to the pictorial surface so that a corner of it would have touched the "box," unless the quadrangle of the ground was extended along a diagonal line deep into the background that may on occasion have included a bench or the like. The basis of spatial construction was thus always a groundplan consisting of a square grid. In order to convert a square area into a perspective picture, it was necessary to master two basic steps (447a). The lines of the monogram tablet, in reality parallel, must become converging lines ending in a central vanishing point which Dürer called the *nahe Aug* [near point of

348

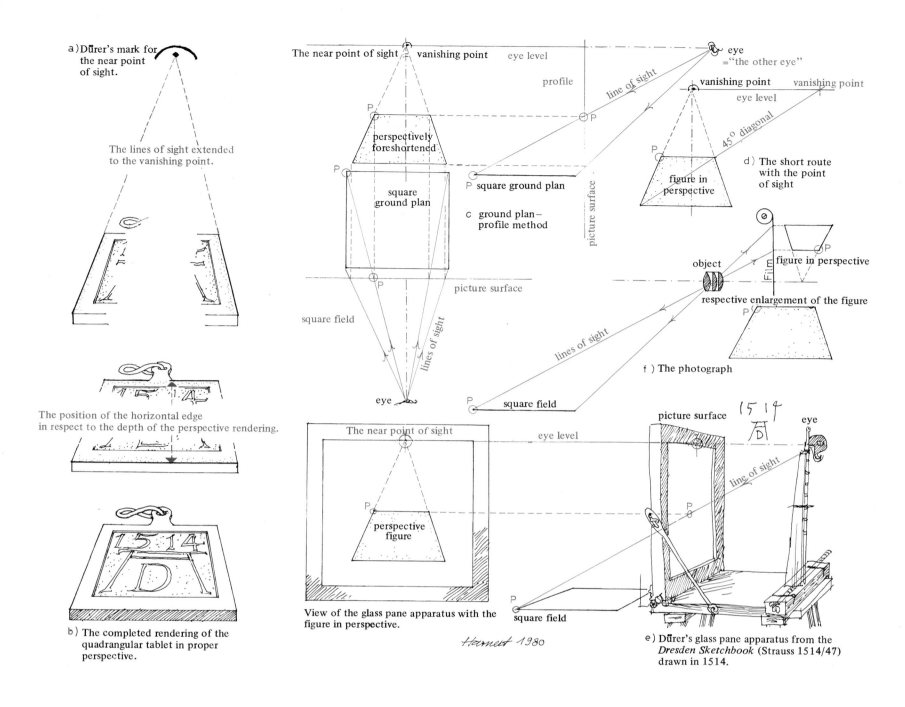

447. *Various techniques for drawing a figure in perspective.*

sight], marked with the well-known symbol, so that it looks like a fermata. In addition, the fixed height of the transverse edges of the tablet must be projected properly on the basis of correct division of the depth. If both conditions are met, the tablet can be drawn in exact and correct perspective (447b).

If the optical arrangement for a square field, as shown in fig. 447, and the same perspective principle are constantly maintained, then, no matter what drawing method is used, the same pictorial figure will obviously result. The simple rule of central projection is the

349

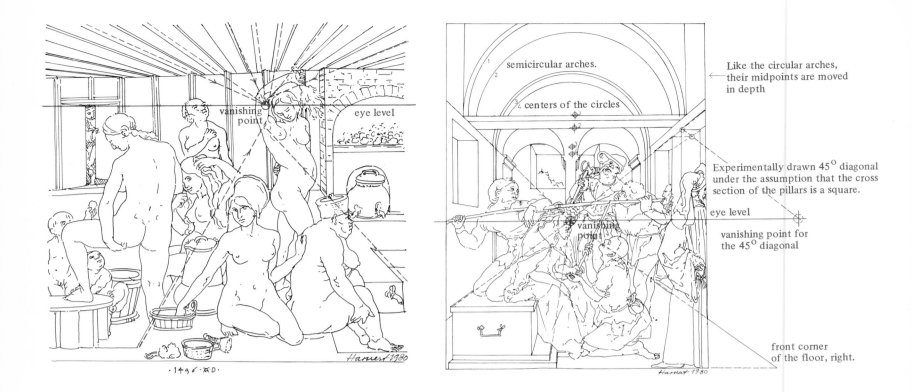

Labels in figure 448:
vanishing point
eye level
·1496·ⱯD·
Harnest 1980

Labels in figure 449:
semicircular arches.
centers of the circles
vanishing point
Like the circular arches, their midpoints are moved in depth
Experimentally drawn 45° diagonal under the assumption that the cross section of the pillars is a square.
eye level
vanishing point for the 45° diagonal
front corner of the floor, right.
Harnest 1980

448. "Women's Bath," drawing (Strauss 1493/4), one of the earliest examples of the use of a central vanishing point in Dürer's work.

449. "The Mocking of Christ," drawing (Strauss 1504/32), with imposed central vanishing point.

basis of both the "groundplan-profile" procedure (447c) as well as the "45° diagonal" system, also referred to as "distant point-of-sight" procedure, as used with the glass pane device (447d, 447e) and in photography (447f). It differs only in the degree of accuracy, suitability, and applicability. Thus a constructed drawing is somewhat more accurate than the picture produced by the glass pane device. Obviously, one cannot photograph what does not exist. But one can draw on the drafting board non-existent buildings on the basis of plans in proper perspective, and so forth.

One should not seek in a painter like Dürer the kind of progress in perspective representation that would be apparent had he gone from the glass pane to the distant point-of-sight procedure, or if it had been possible, to photography. It is rather a question of whether the basic rule of perspective was understood as such, and applied. As will be seen, it was precisely Dürer who used varying procedures, according to the requirements and the special circumstances of each pictorial task. Research has given too much weight to the difference of the individual systems in relation to objectives and results within the development of the perspective rendering of space. It is really of secondary importance to know that Piero della Francesca used the groundplan-profile system, that would soon thereafter be regarded as idiotic, or not to know which procedure Michael Pacher used for his extraordinarily exact depictions of space.

350

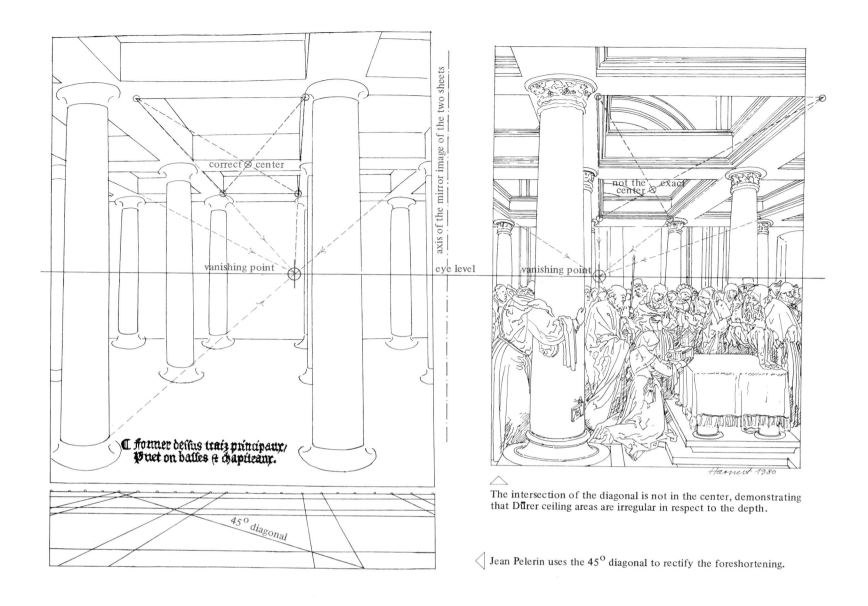

Within the figure:

correct ⊗ center

vanishing point →⊕

axis of the mirror image of the two sheets

eye level

*C former deffus traiz principaux,
Puet on baffes et chapiteaux.*

45° diagonal

not the exact center ⊗

vanishing point ⊕

Hamerst 1980

△ The intersection of the diagonal is not in the center, demonstrating that Dürer ceiling areas are irregular in respect to the depth.

◁ Jean Pelerin uses the 45° diagonal to rectify the foreshortening.

450. *"Hall of Columns" from Jean Pélerin,* De Artificiali Perspectiva *(2nd ed., fol. 21v, 1509), and "The Presentation in the Temple" (c. 1503/04) by Dürer for comparison.*

In his drawing of "The Women's Bath" (c. 1496, formerly in Bremen), Dürer has left us one of the earliest examples that show us how he developed the orientation of the depth lines toward a central vanishing point, the near point of sight (448). To be sure, some of the depth lines pass the vanishing point at a slight distance, and it may be that the young artist through oversight drew lines on the wrong side of the ruler. However, it appears as if the point on the underside of the raised arm of the standing woman may be regarded as the vanishing point. Accordingly, the eye level, called the horizon, runs approximately at the level of the head of the standing persons, including that of the man on the left looking through the door. There is no evidence of the usual and well-known points of reference used during the construction for the gradation in depth of the picture space. Dürer divides these distances freehand but with a remarkable feeling for three-dimensionality. He merely retains the

central vanishing line while observing the horizontal and vertical lines of the interior space. The preparatory drawing for "The Mocking of Christ" of the "Green Passion" (before 1504) serves as a clear example of this early method of constructing space, a method Dürer used till around 1510-1514 (449). As an additional perspective detail, the midpoints of the semicircles of the architectural members are placed very low within the freely drawn spatial scheme.

This form of perspective as used by Dürer is clearly illustrated in a woodcut depicting a hall of columns in the 1509 edition of a manual by Jean Pélerin, called Viator (450). Here the interior architecture of Dürer's "Presentation in the Temple" from "The Life of the Virgin" (c. 1503/04) is reproduced exactly and in the same size (in mirror image for reproductive reasons), obviously to correct Dürer's freely drawn arrangement of the ceiling beams. Pélerin achieves this by means of the 45° diagonal method. As late as 1514 Dürer still lacked full mastery of spatial perspective methods available and utilized in artistic practice. As the sheets from "The Life of the Virgin" show, he lacked full knowledge of the laws governing the distribution of depth, such as Dirk Bouts and the Italian masters of the Quattrocento correctly employed. They produced this by the correct division in depth of square grids on floors and ceilings, a method Dürer studiously avoided, if we exclude the center panel of the Dresden Altarpiece (393). Dürer's announced visit to Bologna, in order to learn the secrets of perspective, had therefore no other purpose than to find out about the spatial application of perspective on the drawing board.

Yet, after his return from Italy, Dürer failed to produce the expected spatial renderings of architecture and objects in his paintings or graphics. Instead he painted two different spatial concepts, distinguished by groupings of people and landscapes in depth clearly conceived without compass or ruler. They were "The Martyrdom of the Ten Thousand" of 1508 (402) and the Landauer Altarpiece of 1511 (413-416). Dürer's sources for his perspective therefore remain obscure and the trip to Bologna for that purpose has little significance for our conclusions as does the edition of Euclid that Dürer acquired in Venice. This book could offer no help because the axioms of the Greek defined only single visual images but offer no clue for the procedures of central projection with which we are dealing here.

Rather late, probably just shortly before he began the so-called "master engravings," Dürer came to grips with some procedures for the rendering of space (451). After several initial attempts to see whether the canon of spatial depth might be done through diagonals (Strauss HP 1513/55, 1506/37), we find him arriving at the 45° procedure, obviously based on Piero della Francesca, as evident from several drawings in the *Dresden Sketchbook*. These demonstrate

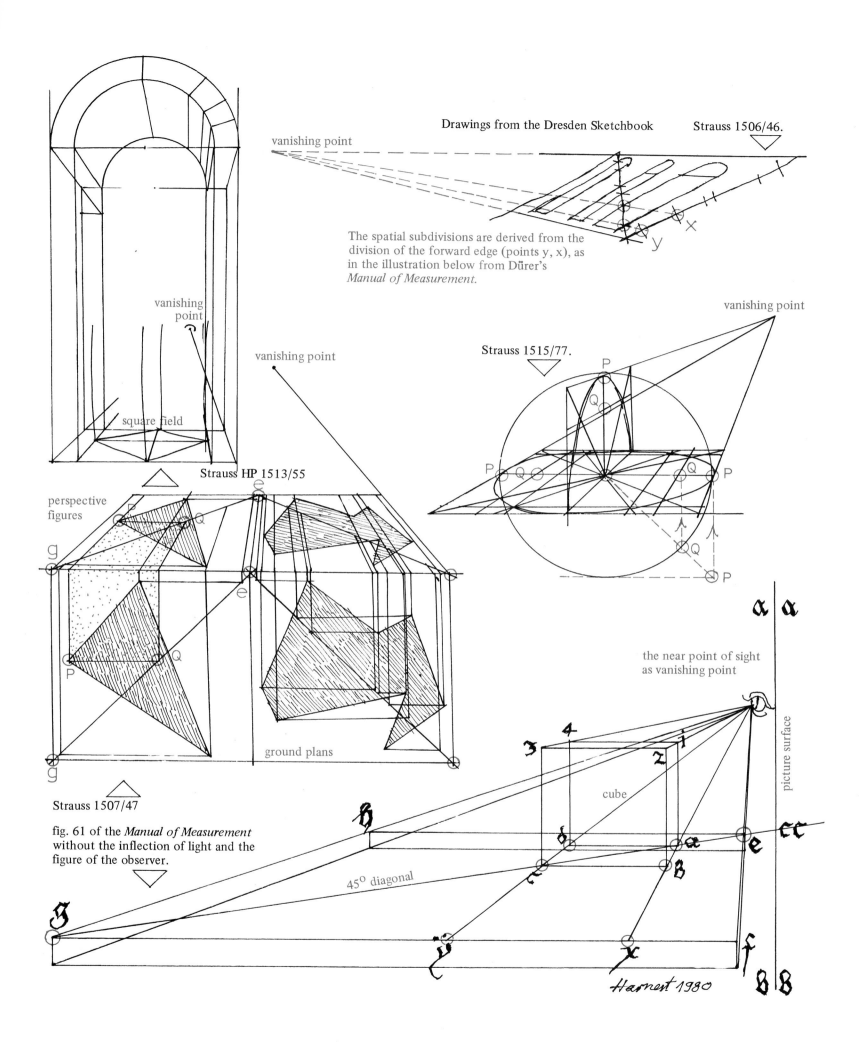

Drawings from the Dresden Sketchbook

Strauss 1506/46.

vanishing point

The spatial subdivisions are derived from the division of the forward edge (points y, x), as in the illustration below from Dürer's *Manual of Measurement.*

vanishing point

Strauss 1515/77.

vanishing point

vanishing point

square field

vanishing point

Strauss HP 1513/55

perspective figures

ground plans

Strauss 1507/47

fig. 61 of the *Manual of Measurement* without the inflection of light and the figure of the observer.

the near point of sight as vanishing point

picture surface

cube

45° diagonal

Harnest 1980

451. *Dürer's spatial distribution of 45° diagonals within a quadrangle.*

that he applied the method only within the perspectively foreshortened quadrangle erected on its groundplan by proceeding from its forward edge along a diagonal and dissecting it progressively in order to draw accurately the designed figure, such as a cube. This procedure becomes very clear in figure 61 and its points x and y in the *Manual of Measurement* published by Dürer in 1525 (451). With this division within the perspectively drawn quadrangle the artist took the first partial step towards a total perspective, since the diagonals should really extend to their vanishing points, which lie on the horizon an equal distance on the left and right of the central vanishing point.

Dürer achieved this completeness in figures of the *Dresden Sketchbook* (Strauss, *Drawings* 1515/49), in which the diagonally placed inner square is extended to two vanishing points, which are located at equal height and distance from the near point of sight. To be sure, neither the level of the eye, as horizon, nor the spaces between the vanishing points are actually put down as distances. But we can reconstruct how Dürer used this procedure in his engraving "St. Jerome in His Study" in 1514 by his handling of the table, meant to be recognized as square, and the bench standing at an angle. The rest of the interior decoration is drawin freely, as before, merely having a single vanishing point which is moved out to the right edge of the picture (452; cf. 447b). Sketch 134 (452) of the *Dresden Sketchbook* suggests an early, fleeting consideration of the perspective of such an arrangement. The pictorial distance or focus, easy to determine, is much too short for the engraving and lies on the border of our natural vision. Thus one can conclude that Dürer was not altogether certain how to use this procedure for handling the distant point, even if he employs it properly.

Three particular sheets that have come down to us from Dürer's work document the final stage of development of his perspective. First among these is an exemplary text of the groundplan-profile procedure, namely the drawing of arches (Strauss, *Drawings* XW.259, undated). All the details important for their construction are entered by Dürer, even if the near point of sight for both the groundplan and the profile is missing, perhaps because the sheet was later trimmed, and several lines are not complete but merely indicated. The near point of sight is easy to establish and with that the basic distance of 23 cm, which is very well suited as a range of vision (453; cf. 447c). The groundplan is at an angle and positioned parallel to the profile. The perspectively drawn picture is hinged to the part of the profile so as to be visualized. The fanlike extensions of the points on the picture plane are very informative (left, next to the monogram), and also the numerals, which make for easy comprehensibility. That is how Piero della Francesca did it and that is how we still do it today on the drawing board. The further details of the constructions can be deduced from the illustration. Thanks to this perspective arrangement, the drawing falls into place among those which led to Dürer's final conception of perspective, but it should be noted that all similar ruins in the backgrounds of his

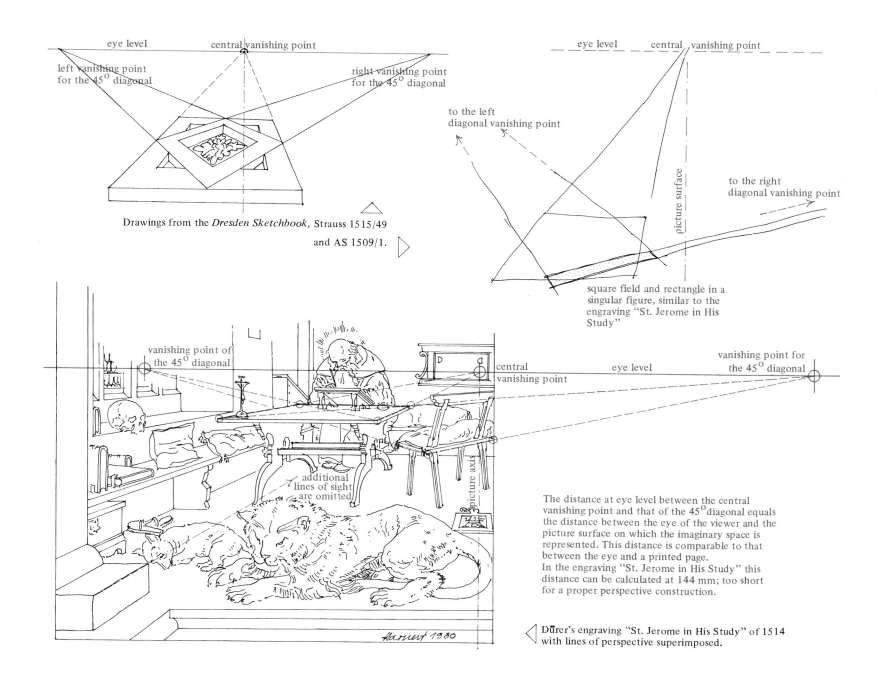

Drawings from the *Dresden Sketchbook*, Strauss 1515/49 and AS 1509/1.

square field and rectangle in a singular figure, similar to the engraving "St. Jerome in His Study"

The distance at eye level between the central vanishing point and that of the 45°diagonal equals the distance between the eye of the viewer and the picture surface on which the imaginary space is represented. This distance is comparable to that between the eye and a printed page.
In the engraving "St. Jerome in His Study" this distance can be calculated at 144 mm; too short for a proper perspective construction.

Dürer's engraving "St. Jerome in His Study" of 1514 with lines of perspective superimposed.

452. *Dürer's spatial distribution of 45° diagonals extending to their vanishing points.*

panel paintings are not designed in this manner. The theoretical basis for this is the line-of-sight construction in the *Manual of Measurement,* as it appears in the figure on page PIII and in fig. 59. To be sure, the latter has been converted into a profile procedure, in that the forward edge of the perspective field likewise represents the surface in profile, making the groundplan unnecessary. Thus, one could speak here of a "half-way" near point-of-sight method (453), if the distant point-of-sight method is understood as the actual technique Dürer sought.

355

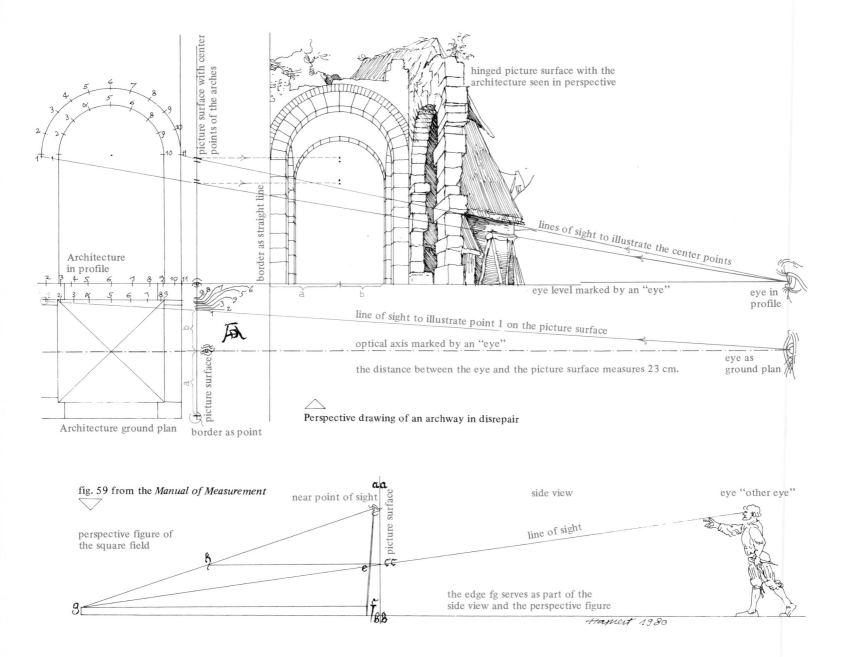

453. *Dürer's groundplan and profile procedure.*

Even the greatest of efforts would have been inadequate during
Dürer's time to achieve accurate perspective of intricate geometric
bodies. Therefore Dürer traced the polyhedron for his engraving
"Melencolia" of 1514 with the help of the glass pane apparatus, like
the draftsman who traces a portrait from the *Manual of Measure-
ment* (454). This unexceptional (from the perspective point of view)
and a trifle inexact preparatory drawing is in the *Dresden Sketch-
book* (Strauss 1514/22). Dürer transferred the figure to the block, as
can be seen in the illustration, without changing its size, using the
near point of sight that is located exactly on the horizon of the sea
below the flying dragon. Incidentally, starting from this point the
idea that the stone is a truncated cube can be refuted by recon-
struction. Via the lines 1-5 and 6-9 (454), which run 30° below the

356

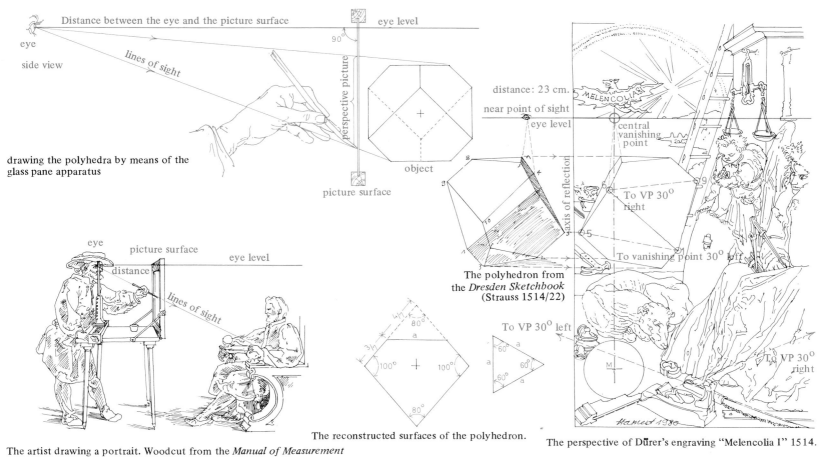

Abb. 8. Dürer's glass pane apparatus and its use for the engraving "Melencolia I."

Distance between the eye and the picture surface

eye level

90°

eye

side view

lines of sight

perspective picture

drawing the polyhedra by means of the glass pane apparatus

object

picture surface

eye

picture surface

distance

eye level

lines of sight

The artist drawing a portrait. Woodcut from the *Manual of Measurement*

distance: 23 cm.

near point of sight

eye level

MELENCOLIA

central vanishing point

To VP 30° right

To vanishing point 30° off

The polyhedron from the *Dresden Sketchbook* (Strauss 1514/22)

axis of reflection

To VP 30° left

To VP 30° right

80°

100° 100°

80°

60° a 60°

a a

60° 60°

The reconstructed surfaces of the polyhedron.

The perspective of Dürer's engraving "Melencolia I" 1514.

454. *Dürer's glass pane apparatus and its use for the engraving "Melencolia I."*

picture plane, the distance can be determined, which, astonishingly, measures again 23 cm. Thus the actual proportions of the surfaces of the polyhedron can be determined (454, center below). All other objects in the engraving are freely positioned and foreshortened, oriented only to the vanishing point which was taken over with the polyhedron, or drawn freely. Two exceptions are the carpenter's square and the keyhole saw next to the sphere in the lower part of the print. They can be extended into the vanishing points for the lines 1-5 and 6-9 considerably beyond the edge of the sheet on the horizon. The fact that the sphere's center is placed directly below the near point of sight hints that this is not coincidence but rather a playful geometrical ploy on the part of the artist.

357

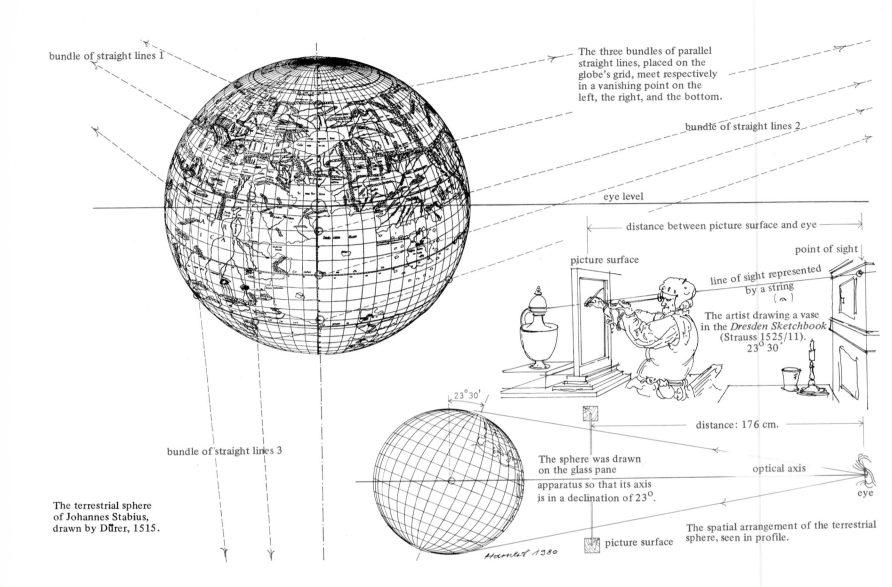

455. *Dürer's glass pane apparatus for distances greater than arm's length, and its use for the terrestrial sphere of Stabius.*

It was possible to conveniently depict objects by means of the glass pane apparatus if the distance involved was less than the arm's length of the artist. For greater distances it became necessary to find a way to extend the device. In fact, a drawing of this kind survives in Dürer's woodcut of the terrestrial sphere based on the determinations of Johannes Stabius, in 1515 (455). Heretofore it was assumed, incorrectly, that the globe was an orthogonal, parallel projection. In fact, the grid of the sphere is seen perspectively from a far point of sight, as evident from the parallel straight lines of equal width and height converging in bundles into their vanishing point. The optical axis and the level of the eye extend through the midpoint of the sphere, by which means its circumference remains a circle, and the axis of the earth is from the north pole inclined towards the viewer at an angle of 23°30' (455). At the same time the considerable distance seems to be almost exactly 176 cm. It was possible for Dürer to construct the sphere, measuring more than 60 cm in height and at a substantial distance from the point of sight, by means of a

device such as is suggested by the draftsman drawing a vase in the *Dresden Sketchbook* (455 right) and in a posthumous woodcut. In this device the line of sight is represented by a string that is fastened to a hook on the wall that takes the place of the eye. The artist sights along the string, using a special end piece, as over a notch, scanning each point of the object onto the glass plate. Dürer had devised and drawn this end piece very carefully. Since the sphere could only be placed behind the pane of glass from the standpoint of the viewer, it is possibe to determine the minimum size of the globe model that was used. The diameter must have been at least 73.5 cm. This unique accomplishment in the application of perspective ends Dürer's occupation with this subject.

It was a magnificent accomplishment that demonstrates how logically Dürer proceeded to arrive at a practical pictorial perspective, and despite or perhaps because of the peculiar difficulties he had to overcome, he acquired a flexibility in his drawing techniques that was without parallel. Thus Dürer was a painter who made a meticulous and special effort, in the manner of an architect, to construct his perspective representation from a groundplan and section, or attempted to produce complex spatial structures by means of various glass pane devices. All these methods of representation were equally complicated and demanding.

The artist laid great stress on "faithfully communicating his experiences to posterity," so that these would grow not as a "wild, unpruned tree." Admittedly, his theoretical recommendations on perspective in the *Manual of Measurement* strike us as a bit one-track. Besides that, a most regrettable error crept into Plan 61 (451). Quite incorrectly, the 45° diagonal and the line of sight of the viewer become one and the same. Altogether, the aspiring artist who wishes to teach perspective does not appear here to his best advantage. It explains why his widow felt called upon to insert, at the end of the edition of *Four Books on Human Proportion* in 1528: "...he had intended particularly to describe and publish a longer and clearer perspective than what he had done before." This authentic pronouncement rounds off the picture of Dürer as an extraordinary master of the art of perspective. Why Dürer did not utilize his perspective capabilities in painting after 1514 may be explained on the one hand by the fact that in Nuremberg the time of great altarpieces was largely over, mostly on account of the religious upheaval, on the other by the fact that he laid no particular value on always incorporating his newest accomplishment into his painting. If, on the one hand, the first intimations in the "dangerous times" emanated from major personalities such as the so-called "Four Apostles" (424, 425), yet on the other hand the artist in effect created his own "little university" in his studio, like a scholar teaching the basic principles of form. Both had their own sources and direction, and were not necessarily causally interrelated. Finally, the master had the uncomfortable premonition that his own time might be short.

Although Dürer was unable to carry out many of his projects and thus left many of his wishes unfulfilled, he still occupies a leading position as pathbreaker and later perfecter of the study of perspective, an accomplishment which placed him at the opposite pole of his Italian colleagues. With this attempt to display through groups of illustrations the individual steps in Dürer's progress in perspective, we may have provided that overview which corresponds in its general outline to the compendium of "longer and clearer" instruction in perspective that the master had wanted to issue.

From Dürer's Writings

FROM THE DÜRER "FAMILY CHRONICLE."
After Christmas, 1524, Nuremberg.
Like his relatives, Albrecht Dürer the Elder was born in the Kingdom of Hungary, in a village by the name of Ajtos, located not far from a small town called Gyula, eight miles south of Grosswardein. His kin made their living by raising horses and cattle. My father's father was named Anton Dürer. As a young man, he became apprenticed to a goldsmith in said little town and learned the craft. Later, he married a girl named Elisabeth, who bore him a daughter, Catherina, and three sons. The first boy he named Albrecht. He was my dear father. He also became a goldsmith, a sincere and skillful man. The second son was named Ladislaus; he was a saddler. His son, my cousin Nicolaus Dürer, called Niklas the Hungarian, is now living in Cologne. He too is a goldsmith, having learned his craft here in Nuremberg from my father. The third son was called John. He studied and later became a parson at Grosswardein for some thirty years.

So Albrecht Dürer, my dear father, came to Germany after having spent a long time with the artists of the Netherlands. He came hither to Nuremberg in the year 1455, reckoned from the birth of Christ, on St. Eulogius' Day [June 25]. On that same day, Philipp Pirckheimer celebrated his wedding feast at the castle, where there was a great dance under the old linden tree. For a long time thereafter, my dear father, Albrecht Dürer, served and worked for my grandfather, old Hieronymus Holper, until the year 1467 after Christ's birth. Then my grandfather gave him his daughter for his wife, a pretty upright girl, aged fifteen and named Barbara. He was wed to her eight days before St. Vitus' Day [August 6, 1467].

November 30, 1486.
And my father took special pleasure in me because he saw that I was diligent in striving to learn. So he sent me to school. When I had learned to read and to write, he took me away from it and taught me the goldsmith's craft. But,

after I was able to work neatly, my liking drew me rather to painting than to work as a goldsmith. So I laid it before my father. He was not well pleased and regretted the time lost while I had been learning to become a goldsmith. Still, he let it be as I wished and, in 1486, reckoned from the birth of Christ, on St. Andrew's Day [November 30], my father bound me as apprentice to Michael Wolgemut to serve him for three years. During that time, God gave me diligence, so that I learned well, although I had to suffer much from his men.

April 11, 1490 [written by Dürer].
When I had finished my apprenticeship, my father sent me away and I stayed abroad for four years until he called me back again. I went forth in the year 1490 after Easter.
July 7, 1494.
And after I returned from my travels, Hans Frey treated with my father and gave me his daughter Agnes for a wife. With her he gave me the sum of 200 guilders, and the wedding was held on Monday before St. Margaret's Day in 1494.

FROM A FRAGMENT OF THE "MEMORIAL BOOK."
Now you must know that in the year 1513, on Tuesday before Rogation Week [April 26], my poor mother, whom I had taken into my house two years after my father's death, as she was quite poor, and after she had lived with me for nine years, was suddenly taken deathly ill, so that we had to break into her chamber, else we could not have opened it or have gotten to her. So we carried her into a room downstairs and she received both Holy Sacraments, for everyone thought she was going to die. She had not been well after my father's death, and had spent most of her time in church. She always rebuked me if I did not do right, and she always worried greatly about my sins and those of my brothers. Whether I came in or went out, she invariably said, "Go in the name of Christ." She would constantly and diligently give us devout

362

admonition and was always concerned for our souls. I cannot praise enough her good deeds and her compassion toward everyone. This pious mother of mine bore and reared eighteen children. She suffered often from the plague and many other diseases, saw great poverty, despair and adversity, derision and fear. Yet she was never vindictive.

FROM DÜRER'S DIARY OF HIS TRIP
TO THE LOW COUNTRIES.

From there we travelled to Arnemuiden, and I paid 15 stuivers for expenses. We went by a sunken place, where we saw the tops of the roofs standing up above the water, and we went by the island of Wolfersdyk, and passed the little town Kortgene on another island nearby. Zeeland has seven islands, and Arnemuiden, where I stayed the night, is the biggest. From there I travelled to Middelburg. There in the abbey Jan de Mabuse has made a picture, not so good in the draftsmanship as in the coloring. From there I went to the Veere, where ships from all lands lie. It is a very fine little town. But at Arnemuiden, where I landed, a great misfortune happened to me. As we were coming to land and getting out our rope, just as we were getting on shore, a great ship ran into us so hard that in the crush I let everyone get out before me, so that no one but myself, George Kötzler, two old women, the sailor, and a little boy were left in the ship. When the other ship knocked against us again and I and the others were on the ship and could not get out, the strong rope broke, and at the same moment a violent wind arose which forcibly drove back our ship. So we all called for help, but no one would risk himself and the wind carried us back out to sea. Then the skipper tore his hair and cried aloud, for all his men had landed and the ship was unmanned. It was a matter of fear and danger, for there was a great wind and no more than six persons in the ship, so I spoke to the skipper that he should take heart and have hope in God, and should take thought for what was to be done. He said that if he could pull up the small sail, he would try if we could come again to land. So we all helped one another and pulled it halfway up with difficulty, and went on again towards the land.

And when those on the land who had already given us up saw how we helped ourselves, they too came to our aid, and we got to land.

VISION OF A CLOUDBURST

In 1525, during the night between Wednesday and Thursday after Whitsuntide (June 4), I had this vision in my sleep, and saw how many great waters fell from heaven. The first struck the ground about four miles away from me with such terrible force, enormous noise and splashing that it drowned the entire countryside. I was so greatly shocked at this that I awoke before the cloudburst. And the ensuing downpour was huge. Some of the waters fell some distance away and some close by. And they came from such a great height that they seemed to fall at an equally slow pace. But the very first water that hit the ground so suddenly, had fallen at such velocity, and was accompanied by wind and a roar so frightening that when I awoke my whole body trembled and I could not recover for a long time. When I arose in the morning, I painted the above as I had seen it. May the Lord turn all things to the best.

FROM A LETTER TO WILLIBALD PIRCKHEIMER
Venice, February 7, 1506.

How I wish you were here at Venice. There are many fine fellows among the Italians. The longer I stay, the more they seek my company . . . but I have many friends among the Italians who have warned me not to eat or drink with their painters. Many of them bear me enmity. They copy my works in churches and wherever they can find them. They are critical and say that they are not done in the accepted and customary manner and therefore are no good. However, Sambelling [Giovanni Bellini] has praised me before many nobles. He wanted to have a sample of my work and came himself to ask me to paint something for him, offering to pay me well for it. Everyone tells me what an upright man he is. I am really friendly with him. He is very old [then 76] but still the best of the painters. But the works which pleased me

eleven years ago [during Dürer's first trip to Italy] no longer appeal to me. If I had not seen it for myself, I would not have believed anyone who told me such a thing. . . .

FROM A LETTER TO JAKOB HELLER.
Dürer to Heller, August 26, 1509.
It is done with the best colors I could obtain. I used good ultramarine for the undercoat, and the painting itself, applied in five or six coats, and after it was finished, I added two more coats, so that it will last for a long time. Do not permit anyone to varnish it, because all other varnishes are yellow, and they would ruin the panel. I would be very sad if a work which took me more than a year would be spoiled. (Rupprich, vol. 1, p. 72).

DRAFT OF THE DEDICATION TO WILLIBALD PIRCKHEIMER OF "THE FOUR BOOKS ON HUMAN PROPORTION."
In 1523, on October 18 at Nuremberg.
To the prudent, most worthy, and honorable Willibalden Bÿrkamer, former Councillor and Advisor to His Imperial Majesty, Maximilian, of most praiseworthy memory; also of the Council of the City of Nuremberg, my gracious Sir, I, Albrecht Dürer, in all humility wish peace in the Lord Jesus Christ, our Savior.

On several occasions when we were discussing art, I inquired whether there existed books treating the subject of the human figure and its measurements. You responded by saying that such books had existed but were now lost. I considered this and began to investigate on my own how this [forgotten] skill might be attained. Whatever I discovered I brought to you for your opinion. You suggested that I publish but I feared that this would be foolhardy, as it would expose me to criticism, especially if the works of the ancients are found. Then my work would come to naught. Still, you wanted me to bring to light what I had done. I would have preferred others to find out by themselves, which would do me no harm. However, because of your repeated entreaties and desires, I could no longer refuse, as my refusal might seem ungrateful to you, my special and trusted master, to whom I owe willing obedience.

Therefore, in order to console you, my patron, I shall write down all I know in the following books and dedicate them to you as my gracious master and great, praiseworthy friend. If they are not written in elegant phrases, as they should be, you will consider that I have spent my days on other matters than to how I say it, and to command that no one condemn me without having read these books from cover to cover and having understood the contents. I know only too well that it is easier to criticize than to do better. Herewith I commend myself to Your Honor, who, as my gracious patron, will have the kindness to accept this work from me. (Rupprich I/105; Dresden Rupprich 147/4).

FROM A LETTER TO THE CITY COUNCIL OF NUREMBERG, 1524.
I can truthfully say that for the thirty years in which I have been a resident of this city I have not received commissions from it of as much as 500 florins, which is a laughable sum; and of that not even a fifth represents profit. Rather, I have earned my living, and a hard one it has been, God knows, entirely from princes, lords and other strangers, so that that which I have earned outside the city I consume within it. And your Excellencies should also know that Emperor Maximilian of esteemed memory wished years ago to confer upon me tax exemption in this city, and this entirely of his own free will and generosity, in return for the many services I had done him; but I voluntarily declined at the instance of several of the city fathers who, in the name of the Council, treated with me and secured my willingness in order to uphold their privileges, customs and immunities. Likewise, nineteen years ago the government of Venice wanted to contract with me and pay me a salary of two hundred ducats a year. Further, the Council of the City of Antwerp, when I was in the Netherlands a short while ago, wanted to give me an annual salary of 300 Philip florins, confer tax exemption on me, and make available to me a well-built house in my honor. And

beyond that both places wanted to pay me for everything I did for their excellencies. All this I declined, out of love and affection for your esteemed virtues and for this honorable, my native city, and I preferred to live in a modest house among your Excellencies, rather than become rich and admired elsewhere.

INSCRIPTION ON THE WOODCUT WITH THE RHINOCEROS, 1515.

After Christ's Birth, the year 1513, on May 1, this animal was brought alive to the great and mighty King Emmanuel at Lisbon in Portugal from India. They call it Rhinoceros. It is here shown in full stature. Its color is that of a freckled toad and it is covered by a hard, thick shell. It is of the same size as an elephant but has shorter legs and is well capable of defending itself. On the tip of its nose is a sharp, strong horn which it hones wherever it finds a stone. This animal is the deadly enemy of the elephant. The elephant is afraid of it because upon meeting it charges with its head between the elephant's legs, tears apart his belly, and chokes him while he cannot defend himself. It is also so well armored that the elephant cannot harm it. They say that the Rhinoceros is fast, cunning, and daring.

POEM FROM THE YEAR 1509.
Strive with all your power
That God gives you true wisdom
For he will readily be called a wise man
Who is alike indifferent to riches and poverty.
The man who bears equably happiness
 and sadness,
That man cultivates great wisdom.
And he who can bear honor and shame
 equally,
He is surely a very wise man.
He who knows himself and casts out evil,
That man is on the path of wisdom.
He who seeks not revenge but shows pity to
 his friend,
His wisdom chases away hell's fires.
He who recognizes the temptation of the devil
And withstands it, God sends him wisdom.
He who in all things preserves purity of heart,
He has chosen the crown of wisdom.
And he who intensively loves God,
He is a wise and devout Christian.
 (From a 17th-century copy)

From Writings about Dürer

JAKOB WIMPHELING, 1502.
(Martin Schongauer's) student Albrecht Dürer, likewise a South German, is especially prominent at this time. He paints in Nuremberg, and the most polished pictures—pictures brought by dealers to Italy where they are likewise valued by the most prominent painters as equivalent to the panels of Parrhasius and Apelles.

CHRISTOPH SCHEURL, 1508.
What else should I say about Albrecht Dürer of Nuremberg, whom all in our century acknowledge to be of the first rank both in painting and in sculpture? Not long ago, when he traveled once again to Italy, he was greeted in Venice and in Bologna as a second Apelles; at which occasions I often served him as an interpreter... The Germans living in Venice point out that the best picture in the entire city was created by him, a picture in which he has depicted the Emperor so accurately that he lacks nothing but the breath of life. Three pictures by him also grace the Church of All Saints in Wittenberg, near the altar. With these three paintings he believed he could compete on equal terms with Apelles. And just as a happy spirit animated these old painters—as indeed all men of culture —so our Albrecht is cheerful, friendly, pleasant, and imbued with a high sense of propriety, for which he is greatly admired by all esteemed citizens; above all he is loved as a brother by Willibald Pirckheimer, a man who is highly educated in Greek and Latin, and as well an outstanding public speaker, councilor, and army commander. (*Libellus de laudibus Germaniae.* Leipzig, 1508.)

JOACHIM CAMERARIUS, 1532.
We know that our Albrecht is of Hungarian origin, but that his ancestors immigrated to Germany. No more needs to be said about his ancestry and origins. And however honorable his forebears were, it is clear that they derive more honor from him than he from them.

Nature gave him a build and a bodily development that, as is right and proper, fits supremely well with the magnificent spirit it encloses... He has an expressive head, glittering eyes, an attractive nose, which the Greeks would call perfect, a somewhat long neck, a broad chest, a taut body, powerful thighs, firm legs; but a finer thing than his fingers no man has seen. His manner of conversation was so pleasant and appealing, that his listeners regretted more than anything else his ceasing to speak. To be sure, he did not involve himself in literary studies, but that which was contained within them, most especially natural science and mathematics, he had notwithstanding mastered. And just as he knew so well how to take that which he had comprehended and render it back in his art, so he also was able to express it clearly in speech. His geometrical writings show that most clearly, and I don't know what more any man who believes he must deal with this science could ask. His glowing spirit led him to conduct himself in proper fashion according to all moral codes, and in this he so excelled that he rightly became known as a man of honor. Yet he had nothing of a dour strictness or antagonistic rigidity about him, he was indeed throughout his life not indifferent to that which commonly contributes to the gaiety and pleasure of life and is yet consistent with honor and justice, and as an old man he accepted that which age had allowed us of sport and music. (From the foreword to Camerarius' Latin translation of Dürer's *Four Books of Proportion.*)

PHILIP MELANCHTHON, 1546.
I recall that the painter Albrecht Dürer, a man of the highest talent and skill, once said that in his youth he loved paintings with lively and sparkling colors, and he enchanted an admirer of his works with the marvelous variety of his palette. Later, as an old man, he began to look closely at nature, and attempted to convey its actual appearance; in the process he realized that it was precisely this same simplicity which was the greatest achievement of art. Since he

could not reach it he had, as he said, ceased to admire his own work but often sighed, when he looked at his paintings, and thought of his own weaknesses. (From a Latin letter to Georg von Anhalt, 17 December 1546.)

JOACHIM VON SANDRART, 1681.
Rest here in peace, prince of artists! You more than great man! There is nowhere your equal in the many fields of art. The earth was painted out, now the heavens have you; now you paint in heavenly manner there, for the honor of God. The arts of building, of sculpture, of painting name you as patron and now, in death, they place the laurel wreath upon your head. *Vixit Germaniae suae Decus ALBERTUS DURERUS Artium Lumen, Sol Artificum. Urbis Patr. Nor. Ornamentum, Pictor, Chalcographus, Sculptor Sine Exemplo, quia Omniscius, Dignus Inventus Exteris, Quem imitandum censerent. Magnes Magnatum, Cos ingeniorum, Post Sesqui Seculi Requiem, Qui Parem non habuit. Solus Heic cubare jubetur. Tu flores sparge Viator. A.R.S. MDCLXXXI. J. De S.* [The jewel of his Germany, Albrecht Dürer, is dead. The glitter of the arts, the sun of artists. The gem of Nuremberg, his native city, which had not his like as painter, engraver, sculptor. Because he was knowledgeable in all fields, foreigners regarded him highly, so highly that they set him up as model. He was a magnet who drew noblemen to himself, a stone on which others sharpened their wits, even after 150 years. Because no one is his equal, he must lie here alone. Traveler, cast flowers on his grave!] J. von Sandrart dedicated these words to this man of the highest distinction in the year 1681. (Inscription on Dürer's grave [refurbished by von Sandrart] in St. John's Cemetery in Nuremberg.)

JOHANN JOACHIM WINCKELMANN, 1764.
For Holbein and Albrecht Dürer, the fathers of German art, exhibited a truly astonishing talent; and if they, like Raphael, Correggio and Titian, had been able to look at and to imitate the works of the ancients, they would have become as great as these, indeed perhaps even excelled them. (From: *Geschichte der Kunste der Altertums.*)

JOHANN GOTTFRIED HERDER, 1788.
Among all the paintings here, those by Dürer interest me the most: I wish I had been such a painter. He conquers all that is here. His Paul among the apostles, his own picture above the door, and his Adam and Eve are figures which remain in the soul; and I have seen other beautiful, beautiful things by him. (From a letter from Nuremberg to his wife.)

JOHANN WOLFGANG VON GOETHE, 1786.
If only luck had led Albrecht Dürer deeper into Italy! In Munich I saw a couple of things by him of unbelievable greatness. The poor man, how he miscalculated in Venice, and made a deal with the clergy that cost him weeks and months! How, on his trip to the Netherlands, he traded his works of art through which he hoped to make his fortune, for parrots, and drew portraits of waitresses who brought him fruit, in order to save the tip! Such a poor fool of an artist moves me deeply, because at bottom that is my fate too, it's just that I know a bit better how to help myself. (From *Italienische Reise,* Bologna, 18 October 1786.)

JOHANN CASPAR LAVATER, 1791.
Dürer was inexhaustible, untiring, finishing everything; he could not leave anything half done if it were at all possible to bring it to fruition. What he did not do well, that he could not do well; what he did not thoroughly work out, that lay outside the range of his art and outside the scope of his skill. His will was always equal to his skill. The drive to let nothing leave his hands incomplete, yes, the hatred and antipathy against every half-done thing is that overriding quality which, of all that we know of him, strikes one most forcefully. This explains

his often painful stiffness, his often scarcely bearable tastelessness, as it does the multitude of errors that he, the first teacher of perspective, committed in perspective. Everything derives from his conscience-driven love for exactitude... His strength was not the high, the holy, the idealistic, but the firm, the forcefully expressed, the decisively characterized, that which in nature has a strong character—the domestic, the intimate, the ordinary. And the more ordinary, heavy-laden, extensive something was, the more it had folds, decorative features, character, the more welcome it was to him. Nonetheless, he occupied himself chiefly with large and serious, holy and biblical subjects. . . . It would be useful work, that described with true exactitude the spirit, the method, and the wealth of this unique man on the basis of all his often very poor, often incomparable, and immortal works. It seems to me, even if one had to subtract a good deal, that there would still be more left than in the case of a hundred artists of our own time, should they be judged ever so gently. (From a manuscript in the *Zentral-bibliothek*, Zurich.)

E.T.A. HOFFMANN, 1822.
Dürer's countenance was powerful and highly expressive of a well-developed mind. The features were a bit too vigorous, yet not to upset the harmony of formation that makes a countenance beautiful. The thoughtful artist is revealed in enthusiastic appearance, expressed in his eyes frequently gleaming beneath his bushy connected brows. This amiable man had an indescribably infectious smile, which pulled at his lips as he spoke. Many thought they detected in Dürer's eyes traces of a certain morbid quality which could also be discerned in the not altogether natural color of the cheeks, suggestive of an inner, secret distress. One sometimes finds this coloring in Dürer's pictures, especially in those of monastic types, and used with remarkable effect, suggesting that Dürer was not unaware of his own taint. Dürer did not disdain to dress elegantly, and thus to do justice to his well-built frame whose members often served him as a model. His entire figure was a holiday delight. He wore the customary

cloak of black Lyons silk. The collar and the sleeves carried an elegant decoration of cleverly worked velvet of the same color. The shirt, visible in the wide cut-out, was made of colorful Venetian fabric woven with threads of gold. The puffy, heavily pleated trousers reached only to the knee. In addition, for this holiday attire Dürer wore, as was customary, white silk stockings, wide bows on his shoes, and a beret that covered but half his head, and which was decorated only with a small, frizzy feather and a magnificent precious stone, an honor conferred on him by the Emperor. (From the fragmentary novel, *Der Feind* [the enemy].)

FRIEDRICH CAMPE, 1840.
The three hundredth memorial celebration for Albrecht Dürer, linked to laying the cornerstone of his memorial, is among the most glorious, most meaningful of the celebrations of the German nation. This fête took place in Nuremberg, his native city, on the 6th and 7th of April 1828, and was accompanied by vast enthusiasm on the part of participants from all parts of Germany. The celebration is unique, and will never reoccur in this fashion. Subject, time and place made this possible, for the heavens were then untroubled; other celebrations of a more doubtful character had not yet aroused suspicion. It was the first memorial celebration; later there was one in honor of Gutenberg, then one for Schiller, etc., etc. (From *Nürnbergsche Denkblätter*.)

LUDWIG I, KING OF BAVARIA, 1842.
Dürer got his training with Michael Wolgemut, the Nuremberg painter, who had received it in the Netherlands and north Italy. No southern German had such lively color, no German such accurate drawing, but like the best of the old German pictures, expressing emotions, not intellect, yet some of his, like Raphael, expressing both, magnificent. Yet what different circumstances! Raphael under the clear skies of Rome, where nature befriends man, in joyous surroundings, admired by all; Dürer under the

mostly overcast skies of Nuremberg, in the North, where nature is man's enemy, depressed by an unhappy marriage. The handsome, masculine Dürer, gifted with ready, persuasive speech, showed himself adept as engraver, xylographer, etcher, ivory-carver, and woodcarver. He was equally skilled in the design of fortifications and in mathematics, for it was he who introduced the principles of perspective drawing into Germany. The greatest of all the old German painters. After his death there was no great, old German painter. The Reformation began, the creative arts succumbed. (From: *Walhalla's Genossen*, Munich, 1842.)

EUGÈNE DELACROIX, 1849.
In the morning visited M. de T. His Albrecht Dürer grabbed me as never before. It struck me, both in his St. Hubertus and in his Adam and Eve, that the true painter is he who knows all of nature. With him human forms are not more complete than are those of animals of all kinds, the trees, and so on. He does everything equally well, as one did in his day. He is an instructive painter. With him one can always learn something. I have seen an engraving which I did not know before, the obese canon asleep next to his stove. The devil shows him a naked woman, in a more elegant pose than is customary, a quite lame Cupid tries to stand up on stilts. (Diary entry.)

JULIUS HÜBNER, 1871.
Dürer shines like a lonely star at night, making his way through the darkness, sending his heavenly beam through dark clouds to the slumbering earth below; wholly recognized only by those few who do not sleep in the night, in order to garner thoughts of eternity into their hearts in divine silence! He is like the heavenly giant, Orion with his gleaming belt and his sparkling shield! All mortals see him who look upward in the evening, as the heavenly hordes man the ghost watch, but how few sleepless eyes follow his lighted path from rising to setting! These few, however, who persist in this

"observation of strict desire," to watch the greatest secrets of the heavens in the light of unearthly suns—they can shake with astonishment when they begin to realize that these suns of night are giants compared to the sun of day! And it is not in vain that we encounter the strong radiant form of the transfigured master here, at the gates of this new German Reich, regained after bitter struggles of the Teuton might against the presumptive Latin world! Like Master Eckart he comes to us, to warn us of the deception and the hedonism of the *Venusberg*, to point out to us the highest, most honorable goals of life! Even in our art the Latin spirit is in conflict with the German! In him, however, the most German of the German masters, in Dürer we can recognize the essence of the German spirit again and again! (From the address at the Dürer celebration of the *Dresdner Kunstgenossenschaft* [Dresden Art Society], 25 June 1871.)

FRIEDRICH LEITSCHUH, 1884.
As to Dürer's mode of expression, I agree with Wilhelm Schmidt when he says that "Dürer's style is no model of logic, but one must concede it shows more simple sequential clarity than mere unclear construction." These words refer to Dürer's letters from Venice, but also apply to some degree to his diary, although it cannot be denied that the letters contain a greater number of unclear statements. Still, that is due to the circumstances. The allusions which Dürer uses in writing to Pirckheimer were intended to be subjective in character; but the diary—in contrast to the letters—a more serious, coldly calculating tone is directed to other purposes. Still, in tune with the letters, even the diary reveals his genuine and naive spirit. It was supposed to be a personal record full of wholly objective observations, paralleling the *Sketchbook*, with which it goes pretty much hand in hand. (From the foreword to the edition of Dürer's *Diary of the Trip to the Low Countries*, Leipzig, 1884.)

AUGUSTE RODIN, 1912.
Albrecht Dürer, so it is said from time to time, employed a hard and dry color. On the contrary. But he is a German, a generalizing artist; his compositions are precise and correct like logically constructed sentences; his figures are solid, weighty, principal types. For that reason his drawing is so emphatic and his coloring so idiosyncratic. Holbein belongs to the same school. His drawings do not possess the grace of the Florentine and his coloring lacks the Venetian magic; but line and color with him have a force, an earnestness, an inner meaning which one finds with scarcely any other painter. In general one can say that very thoughtful, meditative artists, like these, possess a very compact drawing style and a coloring which in its precision has the effect of a mathematical verity. (From Art: *Die Kunst Gespräche des Meisters*, collected by Paul Gsell, Leipzig, 1912.)

WILHELM HAUSENSTEIN, 1928.
"My Agnes": an ill-natured, humorless creature with stringy hair, standing in the way of every hope: supporting her chin on her hand, glancing out into space—this in such a way that one's heart shivers; no bodily magic, however distant, concealed within this wretched specimen of a Nuremberg merchant's daughter. And on the other hand he, the young, manly Albrecht, possessed of something like a talent for dandyism, an almost precious elegance, more nobleman than merchant, delicate, refined, sensitive —and, alas, right from the start, one must say it, condemned to disfavor, to experience sadness. His beautiful expression already shows a fear of the awful aspects of life, although in this year, 1493, a year before his marriage, Dürer was but 21 years old (he was born on 21 May 1471). No, let's have no illusions about it, this was a frightful marriage. To be sure, the wife sits at markets and fairs and hawks the printed creations of her husband; but it is less the touching gesture of a loving sacrifice than the frightful, the greedy competence of the bourgeois housewife. It fits the situation that Dürer escapes as often as he can. It is not often: he probably slipped out, disappointed, im-

mediately after the marriage; he slipped out again, some ten years later, in 1505, and for a good while, till 1507. Both times he sought out Venice. It is not necessarily appropriate to use the "playboy" expression: he "found consolation elsewhere." To be sure, he did it, and royally; but he had the unlimited sensitivity of the melancholic man. And that sensitivity is truly limitless, akin to the metaphysical: if the Venetian Dürer appears frivolous, he is not frivolous without being much more than frivolous, namely, despairing. Perhaps, too, he is not very skilled in love: the picture of the Venetian lady (his Venetian) that one finds in Nuremberg next to the Paris "Self-Portrait" and the copy of the "Self-Portrait" in the Prado [at the exhibition in the Germanisches Nationalmuseum], this picture of a Venetian woman does not lead one to think of Dürer as a lover with a talent for love; Goethe's Venetian must have looked different, and, viewed differently, must have been touched differently. (From: *Die Neue Rundschau*, 2, 1928.)

MAX SLEVOGT, 1928.
For some time now we have once again been reading about German art in German journals: about Albrecht Dürer. People are thinking again about this great master because the calendar shows that he died 400 years ago, and one celebrates the immortal as if one had always held it close. The frivolous custom of interviews and polls does not stay clear of this serious subject. All department heads, now feeling a commitment to their own world and to culture in general, have an opinion about him—and even those whose hearts beat gaily only in Paris and whose minds regard their German fellow citizens—themselves and a few others excepted —as slightly inferior, concede that in this they are perhaps original Germans! There is then something marvelous about the unifying force of a great man—naturally, a very great man of whom even the rest of the world wants to know something. It is very curious, with this emotional surge and with the substantial chronological gap, that thought patterns return that one in today's art world suffers with a sigh. But one must stop here. Two views are important

for this general conception of Albrecht Dürer: on the one hand a nationalistic one with its self-evident limitations, on the other a glorification of things foreign that gives insufficient recognition to the national element. One maintains that Dürer should never have subjected himself to Italian influences (read: French art), the other that in some things you just can't properly help a German, namely, in the matter of painting. . . It has, indeed, become something like a constitutional reflection that even Dürer had lived in China—there they simply don't paint in oils—all these critical heads admire East Asian art without reservation. . . Dürer would, if he were alive today, also seek out places where his artistic goals could be fulfilled. To be sure, were he alive today, Dürer would not paint as he did in his own time, nor would he draw that way. But to say that, in his time, Dürer was weaker as a painter, that is nonsense. Quite apart from the tragic fact that in our eagerness to maintain his pictures as our proudest possession we have maintained them to death, so that we scarcely ever see one as it left his hand: what we see there and what alienates us, what seems not to be "painted" is not Dürer's heirloom. Simply because he drew better than he painted it is inappropriate that we should make a virtue of necessity. (From: *Kunst und Künstler*, 26, 1927/28.)

THOMAS MANN, 1931.
German mastery—we want to love it and glorify it, out of a sense of association which nobody should undervalue. Dürer's world oriented itself with this word, with all that Goethe called its "manliness and propriety," with its knighthood between death and the devil, with its attachment to the passion, its parade of mourning and its atmosphere of the crypt, its Faust-like melancholia, its demoralizing pettiness, possessing a view into eternity. In all this the graphic elements dominate the coloristic element. Decency, honest work, genuineness, art and maturity are united here in a properly intellectual leadership that is part of the concept. The daring is converted into the reputable. Diligence becomes profundity, exactitude—greatness. Patience and heroism, worth

and issues, regard for tradition and attribution of the unexpected, these all go together, they become one. Ah, and what else is there that has not been passed on, in the way of national and fundamentally natural inadequacy, of angular ineptitude in this exactly confused, this meditative, childlike-elderly, scurrilous-demonic, infinity-ill world of German art, full of shame and yet sincerely open: philistinism and pedantry, contemplative problematic self-torture, calculating anxiety—altogether and merging into one with that unconditional, persistent insufficiency and extreme need, which comes to fruition in bravery: this give-yourself-nothing, this seeking out of the last difficulty, this rather-spoil-a-work-and-let-it-go-for-nothing than not go to the extreme with it—yes, all that is German mastery. But inseparable from it, especially in its great and greatest examples, inseparable from the concept is something further and ultimate: insufficiency in itself, the need for completion and salvation by something quite different, the South, the brightness, clarity, lightness, the gift of the beautiful. Goethe complained of Dürer's "troubled form and groundless phantasy"—from the Mediterranean spirit, from fundamental resistance to the "grimace" of the North. But the half-Hungarian Nuremberger and he, Goethe, were in fact brothers in a Germanness which was in itself not satisfying, expansive and transcendental; these two, these most German Germans "shivered for the sun." We know the role that Mantegna and Venice played in Dürer's life; and that in Goethe the juxtaposition of Walpurgis night and classicism remains a symbol. (From: *Vom Beruf des deutschen Schriftstellers in unserer Zeit, Ansprache an den Bruder.*)

EMIL WALDMANN, 1941.
People often imagine Albrecht Dürer's personality and type quite erroneously: they think, when his name is mentioned, almost automatically of Dürer's self-portrait, painted around 1500 and preserved in Munich. In that the artist had stylized his countenance in accordance with the ideal of an aristocratic christlike head, and the total effect through clothing and the orderly arrangement of the

hair in accordance with the idealized Renaissance man. Standing before this somewhat ceremoniously constructed portrait, one thinks that the subject must have been a tall, broad-shouldered man of a commanding and powerful impression, intellectually important and, judging from his thoughtful expression, quite remarkable, but also physically a man full of vigor and power. In reality Dürer did not always look like that but only when he stood before the mirror to appear, as he did here, as a representative of the golden age of art to those who came after. Otherwise he was a rather delicate man, perhaps not even very tall, certainly not broad-shouldered but rather of a slight build and with a narrow head. A countenance that we know well from the time shortly before that Munich painting, when he depicted himself as he did in 1494 and 1497: the delicate counterplay of the opposing surfaces, an aristocratic, expressively curved forehead, a beautifully flowing nose in its outline, beautiful, very very beautiful if not very large eyes with a melancholy glance, a mouth not large, but full of sensitivity. Add to that a pair of very expressive hands, slender and aristocratic, with marked articulation at the wrist and the finger joints. Behind all that stands something quite different from the powerful Renaissance man: a sensitive yet passionate, a sharp-eyed yet responsive, a meaningful yet amiable nature. "Emotional and strict." (From *A. Dürer*, Leipzig, 1941.)

GEORG KAUFFMANN, 1965.
If we ask at what juncture Dürer was submerged in the stream of tradition, two points deserve mention. The one is Leonardo, to whom Dürer, as is widely known, owed much, so that the preparatory studies of draperies for the Heller altar have their immediate model in comparable achievements of Leonardo. With reference to the physiognomic problem, Leonardo's experiments are of significance, in the sense of the antique canon in seeing warrior

and horse as a unit, the wild expression of the fighter with the bared teeth of the steed. Moreover, Dürer took over a Leonardesque horse's head in his engraving "The Small Horse." But we also mentioned a second point of contact. I mean literature. In the Renaissance, classical concepts of physiognomy came alive again in Petrus d'Albano's *Liber compilationis phisionomie* (Padua 1474). It was followed by what was to become the standard work, the tract by Cocles Bologna (Bologna, 1503). It was precisely in the year 1503 that Dürer began his intensive preoccupation with drawn portraits with that of Pirckheimer, now in Berlin. . . That brings us to the last question, the intrinsic Dürer question: Is it not true for him, the German master from Nuremberg, the first artist of our fatherland, that these sentences denote the foundation of his entire oeuvre? Was he not the first German who addressed himself to the Renaissance struggle with nature, the coming to terms with "reality"—not on account of its physical but on account of its intellectual existence? It is only since Dürer that there has been in Germany a fundamental interest in art that is pertinent to life. It was in this way that Dürer overcame the Middle Ages. As early as the middle of the 16th century Cosimo I, the Grand Duke of Tuscany, had a medallion picture of Dürer—it has disappeared, but I imagine it was modeled after the one by Hans Schwarz—included in his collection of famous men, a collection in which only three other artists were represented: Leonardo, Titian, and Michelangelo. Thus we find the first Dürer picture outside Germany instantly incorporated into the circle of the great masters, indeed in Florence, precisely the place where the cradle of the Rinascimento had stood. (From the Inaugural Lecture in Münster/Westphalia, 18 December 1965.)

DIGNUS EST ARTIFEX QUI NUNQUAM MORIATUR. [HE IS AN ARTIST, WORTHY NEVER TO DIE] (Erasmus of Rotterdam.)

APPENDIX

Bibliography
Abbreviations
Iconographic Register
Index

Bibliographical References

*Denotes works in English

ALBRECHT DÜRER OF NUREMBERG

LIFE AND PERSONALITY

* Conway, William Martin. *Literary Remains of Albrecht Dürer.* London 1889.

Cremer, E. Dürers verwandtschaftliche Beziehungen zu Innsbruck. *Festschrift Nikolaus Grass*, vol. 2. Innsbruck-Munich 1975, pp.125-130.

Lutz, H. Albrecht Dürer und die Reformation. Offene Fragen, *Miscellanea Bibliothecae Hertzianae zu Ehren von L. Bruhns, F. Graf Wolf Mettermich, L. Schudt.* Munich, 1961, pp. 175-83.

_____.Albrecht Dürer in der Geschichte der Reformation. *Historische Zeitschrift 206*, 1968, pp. 22-44.

Pfeiffer, G. Albrecht Dürer und Lazarus Spengler, *Festschrift für M. Spindler zum 75. Geburtstag.* München 1969, pp. 379-400.

Rupprich, Hans. *Dürer. Schriftlicher Nachlass*, vols. 1-3. Berlin 1956-69.

Schwemmer, W. Albrecht Dürers Grab auf dem Johannisfriedhof. *Mitteilungen des Vereins für Geschichte der Stadt Nürnberg 62*, 1975, pp. 279-284.

Weckerle, J. Neue Forschungen zur Herkunft Albrecht Dürers. *Südostdeutsche Vierteljahresblätter*, 3rd series, 21, 1972, pp. 176-180.

Zahn, P. "Dornach will ich mit dem negsten potten kumen." Albrecht Dürers Reise-, Fracht- und Botenkosten, aus seinen Briefen von Venedig und aus dem Tagebuch der Reise in die Niederlande. *Fränkische Postgeschichtsblätter 29,* Nuremberg 1971, pp. 5-9.

WRITINGS ON ART

Braunfels, S. Vom Mikrokosmos zum Meter. *Der "vermessene" Mensch. Anthropometrie in Kunst und Wissenschaft.* Munich 1973, pp. 43-73.

Dürer, Albrecht. *Vier Bücher von menschlicher Proportion.* Facsimile of the first edition. Preface by A. Wagner. London 1970.

_____. Etliche Underricht zu befestigung der Stett, Schloss und Flecken. Facsimile of the first edition. Commentary by A. J. Jaeggli. Dietikon-Zürich 1971.

_____. *Della simmetria dei corpi humani. Nuovamente tradotti dalla lingua Latina nella Italiana.* Facsimile of the Venetia edition: Nicolini 1591. Milan 1973.

Jamnitzer, Lencker, Stoer. Drei Nürnberger Konstruktivisten des 16. Jahrhunderts. Exhibition of the Albrecht Dürer Gesellschaft. Nuremberg 1969.

Palm, E. W. Tenochtitlan y la Ciudad ideal de Dürer. *Journal de la Société des Américanistes,* n.s. 50, 1951, pp. 59-66.

Reitzenstein, A. von. Etliche underricht zu befestigung der Stett, Schloss und flecken. Albrecht Dürers Befestigungslehre. *Albrecht Dürers Umwelt.* Nuremberg 1971, pp. 178-192.

Rupprich, Hans. Die kunsttheoretischen Schriften L. B. Albertis und ihre Nachwirkungen bei Dürer. *Schweizer Beiträge zur Allgemeinen Geschichte 18/19*, 1960/61, pp. 219-239.

* Shelby, L. R. *Gothik Design Techniques: The Fifteenth-Century Design Booklets of Mathes Roriczer and Hanns Schuttermayer.* Carbondale and Edwardsville, Southern Illinois University Press 1977.

* Strauss, Walter L. *Albrecht Dürer, The Human Figure. The Complete Dresden Sketchbook.* New York 1972.

* _____. *The Painters Manual. A Manual of Measurement of Lines, Areas and Solids by Means of Compass and Ruler. Assembled by Albrecht Dürer...* New York 1977.

THE NUREMBERG ENVIRONMENT

Eckert, W. P. — Chr. von. Imhoff. *Willibald Pirckheimer. Dürers Freund im Spiegel seines Lebens, seiner Werke und seiner Umwelt.* Cologne 1971.

Mende, M. *Das alte Nürnberger Rathaus. Baugeschichte und Ausstattung des grossen Saales und der Ratsstube*, vol. 1. Nuremberg 1979.

Schnelbögl, F. Das Nürnberg Albrecht Dürers. *Albrecht Dürers Umwelt.* Nuremberg 1971, pp 56-77.

* Strauss, Gerald. *Sixteenth-Century Germany. Its Topography and Topographers.* Madison 1959.

_____. *Nuremberg in the 16th Century.* New York 1966.

Stromer, W. von. Innovation und Wachstum im Spätmittelalter: Die Erfindung der Drahtmühle als Stimulator. *Technikgeschichte*, vol. 44. 1977, pp. 89-120.

THE EMPEROR AND THE IMPERIAL CITY

Kaiser Maximilian I. (1459-1519) und die Reichsstadt Nürnberg. Exhibition of the Germanischen National-Museum Nuremberg 1959.

Kircher, A. *Deutsche Kaiser in Nürnberg. Eine Studie zur Geschichte des öffentlichen Lebens der Reichsstadt Nürnberg von 1500-1612.* Nuremberg 1955.

Leidinger, G. *Albrecht Dürers und Lucas Cranachs Rand-*

zeichnungen zum Gebetbuch Kaiser Maximilians I. in der Bayerischen Staatsbibliothek zu München. Munich 1922.

Schnelbögl, J. Die Reichskleinodien in Nürnberg 1424-1523. *Mitteilungen des Vereins für Geschichte der Stadt Nürnberg*, vol. 51, 1962, pp. 78-159.

* Strauss, Walter L., editor. *The Book of Hours of Emperor Maximilian I. Decorated by Albrecht Dürer, Hans Baldung Grien, Hans Burgkmair the Elder, Jörg Breu, Albrecht Altdorfer and Other Artists.* Facsimile edition. New York 1974.

Tavel, H. Ch. von. Die Randzeichnungen Albrecht Dürers zum Gebetbuch Kaiser Maximilians. *Münchner Jahrbuch für bildende Kunst.* 3rd series, vol. 16, 1965, pp. 55-120.

Vetter, E. M. — Brockhaus, Chr. Das Verhältnis von Text und Bild in Dürers Randzeichnungen zum Gebetbuch Kaiser Maximilians. *Anzeiger des Germanischen Nationalmuseums* 1971/72, pp. 70-121.

Encounters

Michael Wolgemut and the Tradition of the Nuremberg School of Painting

Rücker, E. *Die Schedelsche Weltchronik.* Munich 1973.

Schramm. A. *Der Bilderschmuck der Frühdrucke*, vols. 1-23. Leipzig 1920-43 [Nuremberg printers, vol. 17, 1943 and vol. 18, 1935].

* Sladeczek, Leonhard. *Albrecht Dürer und die Illustrationen zur Schedelchronik.* Baden-Baden — Strassburg 1965.

Strieder, P. Le rôle de Nuremberg dans les débuts de l'activité d'Albert Dürer. *Hommage à Dürer. Strasbourg et Nuremberg dans la première moitié du XVI siècle.* Strassburg 1972, pp. 37-44.

* Wilson, A. The Early Drawings for the Nuremberg Chronicle. *Master Drawings*, vol. 13, 1975, pp. 115-130.

* Wilson, A. assisted by Wilson, J. L. *The Making of the Nuremberg Chronicle.* Introduction by P. Zahn. Amsterdam 1976.

Zahn, P. Neue Funde zur Entstehung der Schedelschen Weltchronik 1493. *Renaissance Vorträge Museen der Stadt Nürnberg 2/3.* Nuremberg 1973.

Basel and Strassburg

Kredel, Fritz. Die Zeichnungen Albrecht Dürers zu dem Lustspiel Andria von Terenz. *Philobiblon 15*, 1971, pp. 262-276.

Mardersteig, G. Albrecht Dürer in Basel und die illustrierten Terenz-Ausgabenseiner Zeit. *Philobiblon 16*, 1972, pp. 21-33.

Rosenfeld, H. Sebastian Brant und Albrecht Dürer. Zum Verhältnis von Bild und Text im Narrenschiff. *Gutenberg-Jahrbuch* 1972, pp. 328-336.

Schefold, R. Gedanken zu den Terenz-Illustrationen Albrecht Dürers. *Illustration 63. Zeitschrift für die Buchillustration* 1975, pp. 16-20.

Wackernagel, W. D., Sack, V., Landolt, H. Sebastian Brants Gedicht an den heiligen Sebastian. Ein neu entdecktes Basler Flugblatt. *Basler Zeitschrift für Geschichte und Altertumskunde* vol. 75, pp. 7-50.

Winkler, Friedrich. *Dürer und die Illustrationen zum Narrenschiff. Die Baseler und Strassburger Arbeiten des Kunstlers und der Altdeutsche Holzschnitt.* Berlin 1951.

Italy

Homolka, Jaromir. *Albrecht Dürer: The Feast of the Rose Garlands.* London 1961.

Pignatti, Teresio. The Relationship between German and Venetian Painting in the Late Quattrocento and Early Cinquecento. *Renaissance Venice.* J. R. Hale, editor. London 1973, pp. 244-273.

Salvini, R. Paralipomena su Leonardo e Dürer. *Studies in Late Medieval and Renaissance Painting in Honor of Millard Meiss.* I. von Lavin and J. Plummer, editors. New York 1977, pp. 377-391.

Schweikhart, G. Novità e bellezza. Zur frühen Dürer-Rezeption in Italien. *Festschrift Herbert Siebenhüner zum 70. Geburtstag.* E. von Hubala and G. Schweikhart, editors. Würzburg 1978, pp. 111-136.

Simonsfeld, H. *Der Fondaco dei Tedeschi in Venedig und die deutsch-venetianischen Handelsbeziehungen*, 2 vols. Stuttgart 1887.

Weitnauer, A. *Venezianischer Handel der Fugger. Nach der Musterbuchhaltung des Matthäus Schwarz.* Munich-Leipzig 1931.

Winzinger, Franz. Dürer and Leonardo. *Pantheon*, vol. 29, 1971, pp. 10-13.

* Yassin, Robert A. *Dürer's Cities, Nuremberg and Venice.* Exhibition Catalogue. Ann Arbor 1971.

Netherlands

Châtelet, Albert. Dürer und die nördlichen Niederlande. *Anzeiger des Germanischen Nationalmuseums* 1975, pp. 52-64.

Evers, H. G. *Dürer bei Memling.* Munich 1972.

* Fry, Roger, editor. *Records of the Journeys to Venice and the Low Countries by Albrecht Dürer.* Boston 1913.

375

The Oeuvre

Chadabra, R. *Dürers Apokalypse. Eine ikonologische Deutung.* Prague, 1964.

Fiore-Herrmann, K. Das Problem der Datierung bei Dürers Landschaftsaquarellen. *Anzeiger des Germanischen National-museums* 1971/72, pp. 122-142.

———. *Dürers Landschafts-aquarelle. Ihre kunstgeschicht-liche Stellung und Eigenart als farbige Landschaftsbilder.* Bern, Frankfurt a.M. 1972.

Harnest, J. Das Problem der konstruierten Perspektive in der Altdeutschen Malerei. *Disserta-tion Technische Universität.* Munich 1974.

Hofmann, W. J. *Über Dürers Farbe.* Nuremberg 1971.

Juraschek, F. *Das Rätsel in Dürers Gottesschau. Die Holz-schnittapokalypse und Nicolaus von Cues.* Salzburg 1955.

* Klibansky, Raymond, Panof-sky, Erwin, and Saxl, Fritz. *Saturn and Melancholy, Studies in the History of Natural Philosophy, Religion, and Art.* London 1964.

Kuhrmann, D. Über das Verhältnis von Vorzeichnung und ausgeführtem Werk bei Albrecht Dürer. *Dissertation.* Berlin 1964.

Mende, Matthias. *Albrecht Dürer. Das Frühwerk bis 1500.* Herrsching/Ammersee 1976.

Pfaff, A. *Studien zu Albrecht Dürers Heller-Altar.* Nuremberg 1971.

Pfotsch, K. Die Farbe beim jungen Dürer. *Dissertation.* Brunswick 1973.

Simon, Erika. Dürer und Mantegna 1494. *Anzeiger des Germanischen Nationalmuseums* 1971/72, pp. 21-40.

Selected Publications Concerning Dürer's Theoretical Works

Brion-Guerry, L. *Jean Pélérin Viator. Sa place dans l'histoire de la perspective.* Paris 1962.

Bruck, Robert. *Das Skizzenbuch von Albrecht Dürer in der königlichen öffentlichen Biblio-thek zu Dresden.* Strassburg 1905.

Dürer, Albrecht. *Underweysung der messung mit dem zirckel und richtscheyt in Linien ebnen und gantzen corporen....* Nuremberg 1525 and 1538.

———. *...vier bücher von menschlicher Proportion....* Nuremberg 1528.

Euclid. *The Elements.* With an introduction by Thomas L. Heath. New York 1933.

* Grayson, Cecil. *Leon Battista Alberti — On Painting and On Sculpture, the Latin texts of De Pictura and De Statua.* London 1972.

Harnest, J. *Das Problem der konstruierten Perspektive in der altdeutschen Malerei.* Munich 1971.

———. Theorie und Ausführ-uhrung in der perspektivischen Raumdarstellung Albrecht Dürers. *Festschrift Luitpold Dussler.* Munich 1972.

———. Zur Perspective in Altdorfers Alexanderschlacht. *Anzeiger des Germanischen Nationalmuseums* 1977, pp. 67-77.

* Ivins, William Mills. On the Rationalization of Sight: with an Examination of Three Renais-sance Texts on Perspective. *Metropolitan Museum of Art Papers,* no. 8. New York 1938.

Panofsky, Erwin. *Dürers Kunst-theorie, vornehmlich in ihrem Verhältnis zur Kunsttheorie der Italiener.* Berlin 1915.

———. Die Perspektive als symbolische Form. *Aufsätze zu Grundfragen der Kunstwissen-schaft.* Berlin 1964, pp. 99-167.

* ———. *The Life and Art of Albrecht Dürer,* 2 vols. Princeton 1943.

* Richter, J. P. *The Literary Works of Leonardo da Vinci,* 2 vols. London 1883. 3rd ed. New York 1970.

Schröder, Eberhard. *Dürer: Kunst und Geometrie.* Basel, Boston, Stuttgart 1980.

Schuritz, Hans. *Die Perspektive in der Kunst Albrecht Dürers, ein Beitrag zur Geschichte der Perspektive.* Frankfurt a.M. 1919.

Steck, Max. *Dürers Gestaltlehre der Mathematik und der bildenden Künste.* Halle/Saale 1948.

* Strauss, Walter L. *The Complete Dresden Sketchbook.* New York 1972.

* Viator. *De Artificiale Perspec-tiva.* Facsimile edition. New York 1973.

Weiss, E. Albrecht Dürers geographische, astronomische und astrologische Tafeln. *Jahr-buch der kunsthist. Sammlung-en des Allerhöchsten Kaiser-hauses,* vol. 7. Vienna 1888, pp. 208-209.

Wieleitner, H. Zur Erfindung der verschiedenen Distanzkon-struktionen in der malerischen Perspektive. *Repertorium für Kunstwissenschaft* 42, 1920, pp. 249-262.

Winterberg, C. *Petrus Pictor Burgensis. De Prospectiva Pingendi.* Strassburg 1899.

* Wittkower, Rudolf. Brunelleschi and Proportion in Perspective. *Journal of the Warburg and Courtauld Institutes,* vol. 16, 1953, pp. 275-291.

Supplementary References

Bibliographies and Bibliographical Reviews

Berbig, H. J. Sammelbericht über die Literatur zum Dürer-Jahr 1971. *Archiv für Kultur-geschichte 55,* 1973, pp. 35-55.

Bräutigam, G. and Mende, M.

Mähen mit Dürer. Literatur und Ereignisse im Umkreis des Dürer-Jahres 1971. *Mitteilungen des Vereins für Geschichte der Stadt Nürnberg 61,* 1974, pp. 204-282.

Mende, M. *Dürer-Bibliographie* (Germanisches Nationalmuseum Nürnberg). Wiesbaden 1971.

Sperlich, M. Perspektive und Proportion bei Dürer. Ein Nachtrag zum Literaturbericht. *Zeitschrift für Kunstgeschichte 26,* 1963, pp. 179-180.

* Stechow, Wolfgang. State of Research. Recent Dürer Studies. *The Art Bulletin,* vol. 56, 1974, pp. 259-270.

Strieder, Peter, Die Malerei und Graphik der Dürerzeit in Franken. Literatur von 1945-1962. *Zeitschrift für Kunstgeschichte 26,* 1963, pp. 169-178.

Vaisse, P. Albrecht Dürer. Ecrits récents et états des questions. *Revue de l'Art,* vol. 19, 1973, pp. 116-124.

Catalogues Raisonnés

Anzelewsky, Fedja. *Albrecht Dürer. Das malerische Werk.* Berlin 1971.

Bartsch, Adam von. *Le peintre graveur,* vols. 1-3. New edition. Leipzig 1854; vols. 4-11. Vienna 1805-08. [Albrecht Dürer: vol. 7, 1808].

* Geisberg, Max. *The German Single-Leaf Woodcut 1500-1550.* Walter L. Strauss, Editor. vols. 1-3. New York 1974.

* Hollstein, F. W. H. *German Engravings, Etchings, and Woodcuts ca. 1400-1700,* vols. 1-10, 16-19. Amsterdam 1954ff. [For Dürer see vol. 7, 1962].

Meder, Joseph. *Dürer-Katalog. Ein Handbuch über Albrecht Dürers Stiche, Radierungen, Holzschnitte, deren Zustände, Ausgaben und Wasserzeichen.* Vienna 1932.

* Panofsky, Erwin. *Albrecht Dürer,* vol. 1: Biography. vol. 2: Hand List. 3rd ed. Princeton 1948. 4th ed. *The Life and Art of Albrecht Dürer* (with addenda to the Hand List). Princeton 1955.

Passavant, I. D. *Le peintre-graveur,* vols. 1-6. Leipzig 1860-64. [Albrecht Dürer: vol. 3, 1862].

* Strauss, Walter L. *The Complete Drawings of Albrecht Dürer,* vols. 1-6. New York 1974.

* _____. *Albrecht Dürer. Intaglio Prints, Engravings, Etchings and Drypoints.* New York 1975.

* _____. *Albrecht Dürer, Woodcuts and Woodblocks.* New York 1980.

* _____, General Editor. *The Illustrated Bartsch,* vols. 1-50. (Vol. 10 is devoted to Dürer.) New York 1978 — .

Tietze, Hans — Tietze-Conrat, Erika. *Kritisches Verzeichnis der Werke Albrecht Dürers.* 3 vols. Augsburg 1928; Basel-Leipzig 1937/38.

Winkler, Friedrich. *Die Zeichnungen Albrecht Dürers.* vols. 1-4. Berlin 1936-39.

Monographs

Flechsig, Eduard. *Albrecht Dürer. Sein Leben und seine künstlerische Entwicklung,* vols. 1-2. Berlin 1928-31.

Heller, Joseph. *Das Leben und die Werke Albrecht Dürers,* vols. 2-3 (vol. 1 was not published): *Dürers Bildnisse — Kupferstiche — Holzschnitte und die nach ihm gefertigten Blätter.* Bamberg 1827.

Jantzen, H. *Dürer der Maler.* Bern 1952.

* Levey, Michael. *Dürer.* London 1964.

Mende, Matthias — Dewitz, U. von. *Albrecht Dürer.* Königstein i.T. 1970.

Musper, H. Th. *Albrecht Dürer.* Cologne 1971.

Oettinger, Karl — Knappe, Karl Adolf. *Hans Baldung Grien und Albrecht Dürer in Nürnberg.* Nuremberg 1963.

Strieder, Peter. *Dürer.* Milan 1976.

_____. *Die grossen Meister der Malerei. Albrecht Dürer. Das Gesamtwerk.* Frankfurt a.M.-Berlin-Vienna 1979.

* Thausing, Moritz. *Albrecht Dürer, His Life and Works.* London 1882.

Timken-Zinnkann, R. F. *Ein Mensch namens Dürer. Des Künstlers Leben, Ideen, Umwelt.* Berlin 1972.

Waetzoldt, Wilhelm. *Dürer und seine Zeit.* 5th ed. Königsberg 1942. Reprint, Munich 1943.

* White, Christopher. *Dürer, the Artist and His Drawings.* New York 1971.

Winkler, Friedrich. *Dürer. Des Meisters Gemälde, Kupferstiche und Holzschnitte. Klassiker der Kunst.* 4th ed. Berlin-Leipzig 1928.

_____. *Albrecht Dürer, Leben und Werk.* Berlin 1957.

Winzinger, Franz. *Albrecht Dürer in Selbstzeugnissen und Bilddokumenten.* Reinbeck/Hamburg 1971.

* Wölfflin, Heinrich. *The Art of Albrecht Dürer.* London 1971.

Zampa, G. — della Chiesa, A. Ottino. *L'opera complete di Dürer.* Classici dell'arte 23. Milan 1968.

Selections

Bernhard, M., Editor. *Albrecht Dürer 1471 bis 1528. Das gesamte graphische Werk,* vols. 1-2. Munich 1970.

Knappe, Karl Adolf. *Dürer. Das graphische Werk.* Vienna-Munich 1964.

Koschatzky, Walter. *Albrecht Dürer: Die Landschafts-Aquarelle. Örtlichkeit, Datierung, Stilkritik.* Vienna-Munich 1971.

Lippmann, F. *Zeichnungen von Albrecht Dürer in Nachbild-*

ungen, vols. 1-7. Berlin 1883-1929.

COMPENDIA

Albrecht Dürers Umwelt. Festschrift zum 500. Geburtstag Albrecht Dürers am 21. Mai 1971. Verein für Geschichte der Stadt Nürnberg. Nuremberg 1971.

* Dodwell, C. R., Editor. *Essays on Dürer* (M. Levey, P. Skrine, J. Byam, et al). Manchester 1973.

La Gloire de Dürer. Colloque organisé par la faculté des Lettres et des Sciences Humaines de l'Université de Nice. Actes publiés par J. Richer. Paris 1974 (Actes et Colloques no. 13).

Hommage à Dürer. Strasbourg et Nuremberg dans la première moitié du XVI siècle. Actes du colloque de Strasbourg (19-20 novembre 1971). Textes de A. Chastel, A. Châtelet, M. A. Chevallier). Strassburg 1972.

Janeck, A. Bericht über ein Dürer Colloquium im Germanischen Nationalmuseum Nürnberg am 27-28 Januar 1972. *Kunstchronik*, vol. 25, 1972, pp. 85-213.

Schade, H., Editor. *Albrecht Dürer. Kunst einer Zeitwende* (H. Bauer, K. Bosl, W. Braunfels). Regensburg 1971.

Ullmann, E., Grau, G., and Behrends, R., Editors. *Albrecht Dürer. Zeit und Werk. Eine Sammlung von Beiträgen zum 500. Geburtstag von Albrecht Dürer.* Karl-Marx-Universität, Leipzig 1971.

Ullmann, E., Editor. *Albrecht Dürer. Kunst im Aufbruch.* Leipzig 1972.

EXHIBITION CATALOGUES

* *Albrecht Dürer. Master Printmaker.* Department of Prints and Drawings. Museum of Fine Arts, Boston 1971.

1471 Albrecht Dürer 1971. Germanisches Nationalmuseum, Nuremberg. Munich 1971.

Anzelewsky, F., Mende, M. and Eeckhout, P., Editors. *Europalia 77, Bundesrepublik Deutschland. Albert Dürer aux Pays-Bas. Son voyage (1520-1521), son influence.* Brussels 1977.

Deutsche Kunst der Dürer-Zeit. Dresden 1971.

* *Dürer in America. His Graphic Work.* National Gallery of Art, Washington 1971.

Dürer und seine Zeit. Staatliche Graphische Sammlung, Munich 1968.

* Field, Richard S. *Albrecht Dürer 1471-1528. A Study Exhibition in Connoisseurship.* Philadelphia Museum of Art, Philadelphia 1970.

* *The Graphic Work of Albrecht Dürer.* The British Museum, London 1971.

* Held, Julius S., Editor. *Dürer Through Other Eyes.* Williamstown (Mass.) 1975.

* Koschatzki, Walter — Strobl, Alice. *Dürer Drawings in the Albertina.* Greenwich (Conn.) 1972.

Vorbild Dürer. Kupferstiche und Holzschnitte Albrecht Dürers im Spiegel der europäischen Druckgraphik des 16. Jahrhunderts. Germanisches Nationalmuseum Nuremberg. Munich 1978.

Abbreviations

The following abbreviations are used in the main text and the picture captions.

1971 Washington =
see p. 378, Exhibition Catalog, Washington

Panofsky =
see p. 377, Oeuvre Catalogs, 1948

Passavant =
see p. 377, Handbooks, 1860-64

Rupprich =
see p. 374, Life and Personality, 1956

Schnelbögl =
see p. 374, The Nuremberg Environment, 1971 ·

Strauss =
see p. 377, Oeuvre Catalogs, 1974

Strauss, Woodcuts =
see p. 377, Oeuvre Catalogs, 1980

Tietzes =
see p. 377, Oeuvre Catalogs, 1928

W=
Winkler =
see p. 377, Oeuvre Catalogs, 1936-1939

Anzelewsky =
see p. 377, Oeuvre Catalogs, 1971

B. =
see p. 377, Handbooks, 1854

Fiore-Herrmann =
see p. 376, The Oeuvre, 1971/72

Koschatzky =
see p. 378, Partial Edition, 1971

Meder =
see p. 377, Oeuvre Catalogs, 1932

1968 Munich =
see p. 378, Exhibition Catalog, 1968

1971 Albertina =
see p. 378, Exhibition Catalog, Vienna.

1971 Dresden =
see p. 378, Exhibition Catalog, Dresden

1971 London =
see p. 378, Exhibition Catalog, 1971

1971 Nuremberg =
see p. 378, Exhibition Catalog, Nuremberg

Iconographic Register of the Illustrations with Bibliographical References

The Abbreviations are explained on p. 379. The regular numbers refer to the pictures, the italic ones to the text.

383

Index